PETER ADRIAENS
MARS MUUSSE
PHILIPPE J. DUBOIS
FRÉDÉRIC JIGUET

# GULLS

## of Europe, North Africa, and the Middle East AN IDENTIFICATION GUIDE

Princeton University Press

Princeton and Oxford

Copyright © 2022 by Princeton University Press

Originally published as *Les Laridés du Paléarctique occidental*
©Delachaux et Niestlé, Paris, 2021

Published by Princeton University Press
41 William Street, Princeton, New Jersey 08540
6 Oxford Street, Woodstock, Oxfordshire OX20 1TR

press.princeton.edu

Library of Congress Cataloging-in-Publication Data

Names: Adriaens, Peter, author.
Title: Gulls of Europe, North Africa, and the Middle East : an
  identification guide / Peter Adriaens, Mars Muusse,
Philippe J. Dubois, Frédéric Jiguet.
Other titles: Les Laridés du Paléarctique occidental. English
Description: Princeton : Princeton University Press, [2022] |
Originally published as Les Laridés du Paléarctique
occidental ©Delachaux et Niestlé, Paris, 2021.
Identifiers: LCCN 2021008009 | ISBN 9780691222837
(paperback) | ISBN 9780691230498 (ebook)
Subjects: LCSH: Gulls--Europe--Identification. | Gulls--Africa,
  North--Identification. | Gulls--Middle East--Identification.
Classification: LCC QL696.C46 J5413 2022 | DDC
598.3/38094--dc23
LC record available at https://lccn.loc.gov/2021008009

British Library Cataloging-in-Publication Data is available

Editorial: Robert Kirk and Abigail Johnson
Production Editorial: Ellen Foos
Text Design: D & N Publishing, Wiltshire, UK
Cover Design: Wanda España
Production: Steven Sears
Publicity: Matthew Taylor and Caitlyn Robson
Copyeditor: Lucinda Treadwell

This book has been composed in Unit Slab Pro and
IBM Plex Sans

Printed on acid-free paper. ∞

Printed in Spain

10  9  8  7  6  5  4  3  2  1

# Contents

# Preface

This book is for those weird but wonderful people who enjoy identifying birds—all birds. It is human nature to make sense of the world around us by classifying things, and for birders, trying to put a name to every bird they see is a reason for living. For many, it is not just a hobby but a passion, and some dedicate their whole life to it. One would think that for such keen and driven people, all birds are equal, but in reality some seem less equal than others. Gulls, in particular, have suffered a bad reputation; they are considered mean, noisy, aggressive, and so variable that looking at even a small flock of them can make your head hurt. *Larophobia*, the fear of Laridae or gulls, is a serious modern condition that has claimed many victims already among birders, and which may have a strong impact on birding skills. Gulls are after all abundant in many places around the world, and it is difficult to find places where there are no flocks of them. If you go out into the field and do not pay attention to them, is your hobby really birding or is it 'ignoring birds'? Does this not affect your ability to put a name to the birds you see?

We can sympathise, though. Gulls indeed show a bewildering range of individual and age-related variation, and some species look very much alike. On top of that, species that already look quite similar may be prone to hybridising, producing offspring that are even harder to recognise. This makes identifying gulls a real challenge. For many people this is off-putting, but others like a challenge and embrace it as an opportunity to learn. Certainly, telling apart multiple gull species of different ages in the field, each with a variety of different plumages, is a process that requires patient study, a keen eye for detail, and a feather by feather approach. Then again, it is not quantum physics, and we believe anyone can do it if they apply themselves to it. The rewards are great. In many ways, gulls teach you how to properly identify birds: not just by impression, but also by careful attention to feather minutiae. Putting the right name to a bird is always a delightful event, and identifying a difficult gull correctly can be very satisfying. It will take your birding skills to the next level.

These days, the whole learning process has become much simpler due to the amount of information available. When the authors of this book started birding and looking at gulls, there was not much information; the field guides did not illustrate the immature plumages of gulls properly, nor did they show the primary pattern of adults in any detail. The first monograph on gulls, by P. J. Grant, was published in 1982, and revised in 1984. It was a very insightful and progressive book at the time, but with pen drawings and black and white photographs only. This guide was the starting point for anyone who wanted to learn how to recognise the various species of gulls, but the process took many years of trial and error. You could try to name all the gulls you were seeing on your local patch, but without photographs to show to other people, how could you be sure that you were assigning these birds correctly? It was very much a hit-and-miss thing back then. This all changed with the rise of modern, digital cameras, the internet, and extensive colour-ringing projects. Suddenly, people were taking lots of pictures of all kinds of gulls, and the internet became a huge database of photographs illustrating the whole range of variation in every species. Colour-ringed gulls, whose identity and age could simply be inferred from the code on the ring, also provided new and very instructive insights on identification, age criteria, and moult. Moreover, it now became possible to quickly exchange photographs and verify one's identifications among knowledgeable people. All of this led to an explosion of new information, with many identification papers published over the course of the past 30 years, and to several revisions of taxonomy. New gull monographs also saw the light, notably by Olsen and Larsson in 2004 (*Gulls of Europe, Asia and North America*), Howell and Dunn in 2007 (*Gulls of the Americas*), and Olsen in 2018 (*Gulls of the World*). The year 2018 also saw the publication of another gull book, *Gulls Simplified*, by Dunne and Karlson. As the title implies, this (American) book tried to lower the bar and make the process of identifying gulls less technical.

With several gull books now available, is there really a need for another one? We feel that this is the case. The excellent *Gulls of the Americas* has been out of print for many years now and does not cover the Western Palearctic region. *Gulls* by P. J. Grant is a little bit outdated, the Olsen and Larsson book is now 16 years old, and Olsen's 2018 book uses much of the same text as the latter. We wanted to present a clear and concise guidebook in which we compare similar species side by side, point out the important identification criteria on the photographs themselves, and limit the text to differences between similar species. This book combines the knowledge of four dedicated gull enthusiasts and incorporates all recently published information, such as on the Common Gull complex and the various subspecies of Yellow-legged Gull. It also includes information that has not been published before (such as on 'Viking Gull'—a hybrid between European Herring and Glaucous Gull). The photographs show typical, textbook individuals of each taxon, providing a 'search image' for birds that can be identified with confidence outside their usual range. We hope that this book invites people to take up the challenge of studying gulls and start learning.

# Acknowledgements

ur thanks go to all the people involved in building
e website www.gull-research.org, those who helped
ith texts, and those who collected PDF files to make
formation public. We would also like to thank all the
ull ringers and ring readers. Much is still to be learned
out gulls and much more has to be studied, and
nged birds are invaluable in this process, since they
ovide unequivocal examples of birds whose age and
rigin are known, as well as a major resource for better
nderstanding of plumage development, moult strategies,
nd moult timing in gulls. Last but certainly not least,
book like this would not have been possible without
e help of a large number of photographers. We want
thank all of them explicitly: Alex Abela, Ross Ahmed,
sier Aldalur, Ruud Altenburg, Imanol Amestoy, Tormod
mundsen, Steve Arena, Akimichi Ariga, Yuri Artukhin,
urélien Audevard, Amar Ayyash, Renato Bagarrao,
arl Baggott, Mónika Ballmann, Max Baumgarten, Tom
enson, Joachim Bertrands, Yves Blat, Richard Bonser,
n-Kees Bossenbroek, Phil Boswell, Bernard Bougeard,
erman Bouman, Joey Braat, Dave Brown, Brynjúlfur
rynjólfsson, Andreas Buchheim, Roland-Jan Buijs,
laudia Burger, Pierre Cabard, Albert Cama Torrell, Pierre
amberlain, Kees Camphuysen, Andrew Cannizzaro,
hn Cant, Kuzey Cem Kulacoglu, Lancy Cheng, Ekaterina
hernetsova, Rúben Coelho, Fred Cottaar, Milosz Cousens,
erre-André Crochet, Pierre Crouzier, Alan Curry, Edouard
ansette, Douwe de Boer, Alain De Broyer, Bernd de
ruijn, Alix d'Entremont, Albert de Jong, Peter de Knijff,
lip De Ruwe, Armin Deutsch, Diederik D'Hert, Manfred
ornhäuser, Amir Ben Dov, Ken Drozd, Daan Drukker,
aul Dufour, Leon Edelaar, Marcin Faber, Wouter Faveyts,
iuseppe Fiorella, Steve Fisher, Renaud Flamant, Guy
ohart, Jack Folkers, Alain Fossé, Nobuo Fukushima,
laude Gaillemin, Salvador García, Mario Vincent Gauci,
hris Gibbins, Thijs Glastra, Julien Gonin, Delfín González,
akim Granholm, Karl-Johan Granholm, Lee Gregory,
etlef Gruber, Antonio Gutierrez, Mohamed Habib,
ob Halff, John Heidecker, Morten Helberg, Alexander
ellquist, V. Hesse, Pieter Hilgeman, Alain Hofmans,
ranck Hollander, Douglas Hommert, Frits Hoogeveen,
arry Hussey, Petteri Hytönen, Nidal Issa, Mikael Jaffre,
abrice Jallu, Wietze Janse, Johannes Jansen, Justin
nsen, Alvaro Jaramillo, Dave Johnson, Marnix Jonker, Jan
Jörgensen, Luka Jurinovic, Risto Juvaste, James Kennerley,
Leander Khil, Gerrit Kiekebos, Pete Kinsella, Keisuke
Kirihara, Jens Kirkeby, Ronald Klein, Marcel Klootwijk,
Yann Kolbeinsson, Juho Könönen, Hannu Koskinen,
Kirsten Krätzel, Edo Kreuzen, Jargalsaikhan Lamjav,
Thomas Langenberg, Sam Langlois, Hans Larsson, Greg
Lavaty, Walther Leers, Vincent Legrand, Robert H. Lewis,
James Lidster, Wich Yanan Limparungpatthanakij, Merijn
Loeve, Daniel López Velasco, Richard Lowe, Bernard
Lucas, Bert-Jan Luijendijk, Bruce Mactavish, Frank
Majoor, Frank Mantlik, Annelies Marijnis, Mason Maron,
José Marques, Sönke Martens, Gabriel Martín, Jonathan
Mays, Christina McClarren, Leo McKillop, Ed McVicker,
Ger Meesters, Avi Meir, Ronald Messemaker, Kent Miller,
Richard Millington, Stefan Monecke, Cristian Montevecchi,
David Montreuil, Keith Mueller, Killian Mullarney,
Theo Muusse, Yann Muzika, Jeroen Nagtegaal, Grzegorz
Neubauer, Samaritakis Nikos, Bjorn Nordestgaard Frikke,
Silas Olofsson, Jamie Partridge, Samuel Patinha, Kjeld
Pedersen, Tommy Pedersen, Strahil Peev, Trevor Persons,
Julien Piette, Dan Prima, Marcin Przymencki, Thierry
Quelennec, Stefán Ragnarsson, the late Visa Rauste,
Andy Reago, Sébastien Reeber, Sylvain Reyt, Carlos
Ribeiro, Christoffer Rødbro, Paul Roper, Elise Rousseau,
Jean-Sébastien Rousseau-Piot, Omar Runolfsson, Irina
Samusenko, Jean-Michel Sauvage, Jurgen Schneider, Paul
Schrijvershof, Kim Seog-Min, Dubi Shapiro, Brendan
Shiels, Hadoram Shirihai, Liam Singh, Leo Snellink,
Alexander Stöhr, Rob Struyk, Brian Sullivan, Kensuke
Tanaka, Jasper Temme, Job ten Horn, Jean-Michel Thibault,
Jeffrey Thomas, Danni Thompson, Purevsuren Tsolmonjav,
Leo Tukker, Toomas Tuul, Yusuke Umegaki, Hans Peter
Utoft, Bart van Beijeren, Ruud van Beusekom, Jos van den
Berg, Ben van den Broek, Vincent van der Spek, Bas van
Gennip, Maarten van Kleinwee, Peter van Rij, Chris van
Rijswijk, Johan van 't Bosch, Matthieu Vaslin, Michel Veldt,
Koen Verbanck, Mariet Verbeek, Edward Vercruysse, Paul
Veron, Fred Visscher, Mats Waern, Ipe Weber, Ingo Weiss,
Jan Ekke Wigboldus, Edwin Winkel, Pim Wolf, Stanislas
Wroza, Mark Zevenbergen, Piotr Zielinski, Pierre Zimberlin
and Jan Zorgdrager.

Many thanks also to our editors Stéphanie Zweifel and
Joris Lautard for their patience, their competence, and
their commitment to the project, as well as to Fabienne
Gabaude, who designed the whole book.

# Introduction

## Geographical scope of this book

This book deals with all gull taxa that have been recorded in the wider Western Palearctic at least once. The 'wider Western Palearctic' is defined in the *Handbook of Western Palearctic Birds* (Shirihai and Svensson 2018) as the area covering Europe (including European Russia west of the Ural Mountains and the Caspian Sea), Asia Minor, the Middle East, North Africa (Morocco, western Sahara, Algeria, Tunisia, Libya, and Egypt), Iran, and the Arabian Peninsula. Also included are the Cape Verde Islands, Azores, Canary Islands, Madeira, Iceland, Jan Mayen, Svalbard, and Franz Josef Land.

## Taxonomy

In general, the taxonomy in this book follows that of the International Ornithological Committee (IOC; www.worldbirdnames.org), with two notable exceptions:

- Short-billed Gull *Larus brachyrhynchus*. Referring back to Zink et al. (1995)[1], the IOC stated that DNA of *brachyrhynchus* has been compared only with that of *kamtschatschensis*, but this is incorrect. There are several more recent references in which the DNA of all Common Gull taxa is compared with that of *brachyrhynchus* and in which the genetic distinctiveness of the latter is confirmed (Johnsen et al. 2010; Sternkopf 2011; Kwon et al. 2012; Sonsthagen et al. 2012). Short-billed Gull is also morphologically and vocally distinct (Adriaens and Gibbins 2016) and we therefore treat it as a full species.
- Thayer's Gull *Larus thayeri*. This taxon has a checkered taxonomic history and has recently been 'downgraded' to a subspecies of Iceland Gull *Larus glaucoides* by the North American

1. As of July 2021, IOC have accepted the split between Short-billed and Common Gull.

Classification Committee. The IOC World Bird List now includes it as *Larus glaucoides thayeri*. We question this decision, however, since we have not seen any strong evidence that these two taxa (nominate *glaucoides* and *thayeri*) behave like subspecies; large-scale interbreeding has not been demonstrated, not even with the intermediate taxon *kumlieni*. On the other hand, field studies have indicated clear morphological differences between all three taxa (Howell and Elliott 2001; Howell and Mactavish 2003; Howell and Dunn 2007; Gibbins and Garner 2013) as well as vocal differences (Pieplow 2017). None of these references were mentioned in the NACC proposal. The three taxa also have separate breeding ranges, wintering ranges, and migration routes. The differences in morphology, vocalisations, and distribution are differences that are expected between species, not subspecies, and we have therefore maintained Thayer's Gull as a full species.

## How to identify gulls

Gulls can be a challenging group of birds to identify. To the untrained eye they all look alike, yet, at the same time, in the case of the large gulls, one could say that no two birds look the same! It is true that most gulls give either a white and grey impression or a brown one, and that the key field marks can be subtle and variable. Then again, the number of species is relatively small; for example, this book deals with 34 species (and 10 subspecies), of which only 12 are regular in Western Europe. Geographic location already limits the number of possible candidates for that difficult gull that you are looking at. Also, gulls often flock together, which means that odd birds can often be compared with the gulls next to it. There is no denying, however, that gull identification can be difficult, and that is particularly true for the so-called 'large white-headed gulls'.

There are several reasons why identification of large white-headed gulls can be challenging but inspiring at the same time:

- The different taxa have evolved relatively recently. Gull taxonomy is still in its infancy, and visible differences between the species are often subtle and sometimes not well understood. Then again, this means that all observations of gulls may contribute to our general knowledge about this group.

| SMALL | MEDIUM-SIZED | LARGE | |
|---|---|---|---|
| Black-headed Gull | Black-legged Kittiwake | American Herring Gull | Lesser Black-backed Gull – *graellsii/ intermedius* |
| Bonaparte's Gull | Common Gull – *canus* | Armenian Gull | |
| Brown-headed Gull | Common Gull – *heinei* | Audouin's Gull | Lesser Black-backed Gull – *heuglini* ('Heuglin's Gull') |
| Franklin's Gull | Common Gull – *kamtschatschensis* | Caspian Gull | |
| Grey-headed Gull | | European Herring Gull | Pallas's Gull |
| | Ivory Gull | Glaucous Gull | Slaty-backed Gull |
| Laughing Gull | | Glaucous-winged Gull | Thayer's Gull |
| | Relict Gull | Great Black-backed Gull | Vega Gull |
| Little Gull | | Iceland Gull – *glaucoides* | Yellow-legged Gull – *atlantis* ('Azores Gull') |
| | Ring-billed Gull | Iceland Gull – *kumlieni* ('Kumlien's Gull') | |
| Mediterranean Gull | Short-billed Gull | Kelp Gull | Yellow-legged Gull – *lusitanius* ('Cantabrian Yellow-legged Gull') |
| Ross's Gull | | Lesser Black-backed Gull – *barabensis* ('Steppe Gull') | |
| Sabine's Gull | Sooty Gull | | Yellow-legged Gull – *michahellis* |
| Slender-billed Gull | White-eyed Gull | Lesser Black-backed Gull – *fuscus* ('Baltic Gull') | |

**Table 1.** *Classification of the gull taxa treated in this book according to size category*

Another consequence of their recent taxonomic evolution is that some species may hybridise in certain areas on a fairly regular basis, and that hybrids may be fertile makes identification even more fun.

Large gulls take several years (3–5) to acquire their adult plumage. Simply speaking, their plumage gradually and slowly evolves from all-brown to white with grey and/or black throughout the years. Their general aspect therefore varies not only according to species but also with age. The often slow and protracted transitions from one plumage to the next make gulls an excellent subject for learning about moult in birds.

There is also extensive regional variation in most species. Such subtle but extensive regional variation is fascinating because it often allows for guessing the origin of the bird.

Adult and subadult birds do not have many identification features, and they may be more difficult to identify than younger birds (contrary to popular belief). The primary pattern is one of the main features, but it is more easily studied from photographs than in the field.

In addition, there is a lot of individual variation within each species. The plumage varies so extensively that in some cases two individuals of the same age and same species may look completely different. As a result, all plumage features overlap with those of similar species, and identification will not normally be possible on the basis of a single feature only. Careful examination of plumage details will therefore be necessary (feather group by feather group), and identification should be based on a combination of as many characters as possible. The good news is that gulls are often quite approachable and lend themselves well to such detailed study. Also, the seemingly endless variation means that you never get bored looking at gulls!

So where to start? How do you learn to identify gulls? The key elements here are patience and practice. Take the time to become familiar with your local gulls, to gain experience and study their variable plumages. Once you really know the common birds, it becomes easier to spot the odd one out. Don't be afraid to make mistakes, since that is an inevitable part of gaining experience. Rest assured that nobody in the world can correctly identify each and every gull that they come across.

Identifying gulls is a step-by-step process. The first step is to assign the gull to the right size category. There are small gulls, medium-sized gulls, and large gulls.

## Smaller gulls

This group includes one of the most familiar and abundant gulls in Eurasia, the Black-headed Gull. This species is slightly bigger than a feral pigeon, though with a clearly larger wingspan. The species in this group are listed in **Table 1**. They are all roughly comparable in size, while Little Gull is the smallest. Most of these species show a dark hood in breeding plumage and a dark ear spot or other dark head markings in nonbreeding plumages. Most are also characterised by showing more white than black on the outer wing. In flight, they are agile and more quickly manoeuvrable than larger gulls, and their wingbeats are faster.

## Medium-sized gulls

The most familiar species representing this group is Common Gull, which is approximately one head bigger than Black-headed Gull. Sooty and White-eyed Gulls are outliers having dark plumage with dark head in all plumages, but the other species in this group lack strong head markings and show relatively pale plumage with a small, at least partly yellowish bill (when adult). With the exception of Ivory Gull, all species in this group show black wingtips.

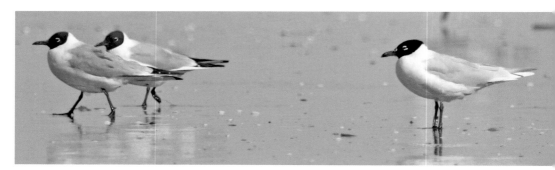

**Plate 1.** *A quick glance is enough to see that the bird in the foreground, right, looks different from the two Black-headed Gulls to the left; overall, it appears whiter and bulkier. This quick, holistic view may be enough to suspect it is a Mediterranean Gull. A closer, more analytical look reveals white instead of largely black wingtips, a differently shaped hood, and a stronger, brighter red bill, which confirm the identification. This bird was ringed in Poland.* **Belgium, 25 March 2008 (Peter Adriaens)**

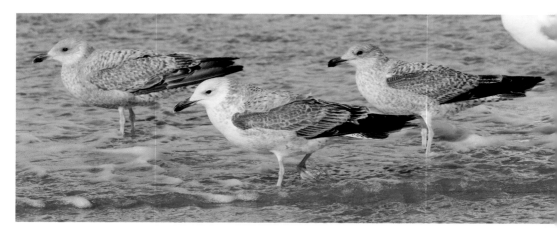

**Plate 2.** *Even at a cursory glance, the central gull in this small flock looks 'different': its white head and breast stand out like a sore thumb when compared with the brown gulls left and right of it. A brief, holistic view is therefore enough to suspect that it may be a different species. However, closer scrutiny and an analytical approach are needed to make sure that the perceived difference is not due just to bleaching or a different age class. Bill shape and the pattern of the wing coverts, tertials, and scapulars confirm that the central bird is a (first-cycle)\* Caspian Gull; the birds immediately left and right are (first-cycle) European Herring Gulls.* **The Netherlands, 1 March 2020 (Mars Muusse)**

\* See the glossary on p.12 and age terminology on p.13.

## Large gulls

All the other species in this book can be considered large gulls, with European Herring Gull as their main representative. They are clearly larger and bulkier than Common Gull, with an obviously heavier bill. With the exception of Audouin's Gull, which has a red bill, all species in this group are characterised by a yellow bill with red spot on the gonys when adult. All show a white head in breeding plumage, except for Pallas's Gull, which has a black hood. The wingtip can be all white (Glaucous and Iceland Gull), but in most species it is mainly black.

## Holistic versus analytical approach

Some recent books on bird identification have put strong emphasis on a holistic approach, in which they recommend looking at the whole bird rather than studying its plumage part by part. This kind of birding by impression rather than by analysis is advocated in, for instance, the recent *Gulls Simplified* (Dunne and Karlson 2018). As described above, assigning the bird to the right size category is an example of a holistic approach. So which one is best, identifying the bird by impression, or by careful study of its feathers? With gulls the answer is: you need to do both, and in the right order.

The first step consists of putting the bird into the right size category. Assessing the whole bird is the second step in the identification process. Compare its size and shape to the gulls next to it. Do you see any subtle differences? Does it have a slightly stouter bill? A bulkier body with shorter rear end? A different head shape? Also look at the overall colour of the plumage, for example, the grey tone of the upperparts. In immature large gulls, which often look mainly brown, try to assess the amount of contrast in the plumage, for example, between the upperparts and underparts, or between the upperparts and head. The holistic step often seems easier to many people, since it requires no memorisation of plumage details. However, it is also very prone to error. For instance, a juvenile Lesser Black-backed Gull can easily give the impression of a Yellow-legged Gull, and vice versa.

The third and final step consists of plumage analysis. It involves looking at the plumage in detail, feather group by feather group. Especially when trying to identify immature large gulls this is an essential step. The field marks of immature large gulls are like pieces of a puzzle, and all pieces may be needed to solve it. This is where knowledge of topography, ageing, and moult comes in. In adult large gulls, plumage analysis often means studying the primary pattern, which is easiest from photographs of the bird in flight. However, useful information can often be gleaned from looking at the underside of the wingtip on a perched bird (Plate 3).

We have tried to make this final step of identification easier by indicating important field marks on the photos themselves and captioning them.

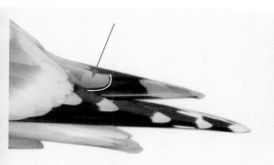

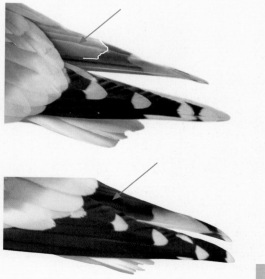

**Plate 3.** *An analytical look at the wingtips of adult large gulls. In the Caspian Gull on the top left, the pale tongue on the underside of the wingtip ends in a characteristic, neat 90° curve upwards. In the adult **argentatus** Herring Gull on the top right, the tongue has a much more irregular shape at the end. In adult **argenteus** Herring Gull and Yellow-legged Gull (bottom right) the underside of the wingtip is usually blackish, without a pale tongue. Subtle details like these can be very helpful in the identification process once learnt.*

**Plate 4.** *Adult Yellow-legged Gull, Portugal, 16 November 2018. In many gulls the secondaries are not visible at rest because they are completely covered by the greater coverts, but here their white tips extend just beyond these coverts. Note that the first primary past the tertials on a full-grown wing is usually P6.*

red gonys spot

upperparts

white tertial crescent

white primary tips (numbered)

p6  p7  p8  p9

underparts

white tips of the secondaries

mirror

orbital ring   crown

upper mandible

lore

culmen

nape

gonydeal angle

chin

lower mandible

**Plate 5.** *Head of an adult Caspian Gull, Georgia, 30 January 2014.*

p10
p9
p8
p7
primaries (numbered)   p6
p5
p4
p3
p2   p1

(grey) tongues

primary coverts

shaft

(pale) tongue

(dark) medial band

white tongue-tips

(white) mirror

secondaries

(black) subterminal band

(white) tip

**Plate 6.** *Upperwing of an adult European Herring Gull, Belgium, 30 March 2008. In gulls, primaries are numbered outwards (away from the body).*

**Plate 7.** *Underwing of an adult Thayer's Gull, California, USA, 28 January 2011. A dark medial band is an important field mark in some gulls like Thayer's Gull and Caspian Gull.*

*(Birds not to scale)*

moulted scapulars (grey)

juvenile scapulars (brown)

tertials

**Plate 8.** *First-cycle Common Gull, Netherlands, 24 November 2019.*

lesser coverts

median coverts

primaries

greater coverts

moulted scapulars

juvenile scapulars

tertials

lesser coverts

primaries

median coverts

vent

undertail coverts

**Plate 9.** *First-cycle Great Black-backed Gull, Portugal, 7 December 2016.*

greater coverts

greater coverts

uppertail coverts

scapulars

rump

primary coverts

secondaries

median coverts

**Plate 10.** *First-cycle European Herring Gull, Boulogne, France, 5 March 2016. An individual with unusually dark tail.*

lesser coverts

greater coverts

primaries

axillaries

**Plate 11.** *First-cycle European Herring Gull, Belgium, 11 October 2009.*

# Glossary of topographical terms

**arrested moult** a complete moult that stops before it is completed and is not resumed later on. Typically, the moult stops when new feathers are fully grown; there are no obvious moult gaps

**axillaries** the feathers in the armpit, at the base of the underwing (Plate 11)

**backcross** offspring of a hybrid and a pure individual of one of the hybrid's parent species

**chin** the part of the head immediately below the base of the lower mandible (Plate 5)

**complete moult** a moult that involves the whole plumage, including primaries and primary coverts

**crescent** something shaped like a crescent moon

**crown** the top part of the head

**culmen** the dorsal ridge of the upper mandible (Plate 5)

**cycle** approximately one-year period extending from one complete moult to the following complete moult (i.e., when the innermost primary has been dropped); typically runs from one spring to the following spring

**ear coverts** small feathers behind the bird's eye which cover the ear opening

**ear-spot** a dark spot behind the eye, as seen for example in nonbreeding Black-headed Gull

**eyelids** the movable folds of skin and muscle that can be closed over the eyeball

**gape** the side of the mouth

**gonydeal angle** the angular expansion on the lower ridge of the lower mandible (Plate 5)

**gonys** the prominent ridge along the line of union of the two halves of the lower mandible

**greater coverts** the largest wing coverts. In a perched bird they are located between the tertials and the flank (Plate 8; Plate 9); in a flying bird they can be seen on the inner wing, on top of the secondaries (on both upper-

and underwing) (Plate 10; Plate 11)

**hand** (on spread wings), the outermost, backward-angled portion of a bird's wing, consisting of the carpal area, primary coverts, and primaries

**hindneck** the lower rear part of the neck, close to the mantle

**hood** a dark colour that covers the head and sometimes neck, and that is conspicuously different from the rest of the body

**immature** all of the non-adult plumages, from juvenile to subadult

**juvenile** the first plumage acquired when all of the downy feathers have been replaced by 'real' feathers

**lesser coverts** the smallest wing coverts, located between the scapulars and median coverts in a perched bird (Plate 8; Plate 9), and along the front of the arm in flight. Unlike the greater and median coverts there are several rows of lesser coverts

**lore** the area between the eye and bill (Plate 5)

**malar** the part of the head immediately below the gape; also 'cheek'

**mandible** either the upper or lower part of the bill of a bird (Plate 5)

**mantle** the top part of the body, between the hindneck and scapulars

**medial band** a dark band crossing the pale areas of a feather (Plate 7)

**median coverts** the row of coverts between the greater and lesser coverts (Plate 8; Plate 9)

**mirror** a white subterminal spot on the outermost primaries (Plate 6). It is usually surrounded by black, but in some birds the white mirror merges with the white primary tip

**nape** the rear of the head (Plate 5)

**orbital ring** a ring of bare skin immediately surrounding a bird's eye (Plate 5). Not to be confused with eye-ring, which consists of tiny feathers that surround the orbital ring

**partial moult** a moult that involves only parts of the plumage, often only the body contour feathers

**prebreeding moult** a moult conducted sometime between the autumn migration and the spring migration, generally on the wintering grounds

**post-juvenile moult** the first partial moult after fledging, in which the juvenile scapulars are replaced

**primaries** the outer flight feathers of the wing, which are attached to the fused bones of the bird's 'hand' (Plate 6). Gulls have 11 primaries, but only 10 are visible in the field. Primaries in gulls are numbered outwards; that is, P1 is closest to the body and P10 is the outermost visible feather

**primary coverts** the feathers covering the bases of the primaries (Plate 6)

**primary projection** the extension of the primaries beyond the tertials in a perched bird. Not to be confused with wing projection (which see). Beware that moulting birds may lack their outermost primaries and thus exhibit a much shorter primary projection than usual

**primary tip** the very tip of the primary. In adult gulls, this tip is often white (Plate 7)

**rectrices** tail feathers

**remiges** the flight feathers of the wing: the primaries, secondaries, and tertials

**retarded plumage** plumage that looks more immature than usual. Note that the immature look is most likely the result of a retarded hormonal state of the bird, not delayed moult. Healthy gulls replace their entire plumage annually; they do not skip a moult. There are a few exceptions, but after the annual complete moult, gulls as a rule do not retain feathers from a previous plumage or cycle. Even though the plumage of some birds can look more retarded than that in other birds of the same age, in reality it is just as old. Conversely, advanced plumages also occur, in which birds look older, more adult-like than they really are

**rump** the part of the body immediately above the tail

**scapulars** body feathers that cover the top of the wing when the bird is at rest; 'shoulder feathers'

**secondaries** inner flight feathers of the wing, located on the 'arm' of the bird.

These feathers form the trailing edge of the wing between the primaries and the body

**secondary skirt** part of the secondaries extending beyond the greater coverts on folded wing

**shaft** the stem or central axis of a feather

**stepwise moult** the presence of more than one moult wave within the same set of primaries

**string of pearls** a string of rounded white subterminal spots across the outer primaries, formed by the white tongue-tips (as in, e.g., adult Slaty-backed Gull)

**subadult** a bird that is not fully adult yet, but shows very similar plumage

**suspended moult** a complete moult that stops before it is completed, but is resumed later on

**tarsus** part of the leg between knee and foot

**tertials** the innermost secondaries, adjacent to the body on the spread

wing; prominent on folded wing, with primaries projecting beyond them (Plate 8; Plate 9)

**throat** part of the head between the chin and neck

**tibia** part of the leg above the knee

**tongue** on a feather: a pale (usually grey) wedge into the black pattern of the outer primaries. Tongues are usually restricted to the inner webs of the primaries and therefore most visible on underwing

**tongue-tip** the point at which the tongue reaches the subterminal black pattern on primaries. In many (sub) adult gulls, most tongue-tips are white (Plate 6)

**underparts** the lower parts of the body, including breast, belly, flanks, vent, and undertail coverts

**undertail coverts** the feathers covering the underside of the tail base

**upperparts** the upper parts of the body, including mantle, scapulars, back, rump, and uppertail coverts

**uppertail coverts** the feathers covering the upperside of the tail base

**vent** the part of the body between the undertail coverts and belly. In a standing bird, it is often the area immediately behind the legs

**web** the part of the feather on either side of the shaft. The inner web is closest to the body, while the outer web is away from the body. On a spread wing, the outer webs of the flight feathers cover most of the inner webs; therefore, on the upperwing it is mainly the outer webs that are visible, while on the underwing it is mainly the inner webs

**window** refers to the inner primaries when they form a pale patch between dark outer primaries and dark secondaries

**wing coverts** the contour feathers that cover the bases of the flight feathers of the wing

**wing projection** the extension of the primaries beyond the tail in a perched bird. Not to be confused with primary projection

# Topography

Studying a gull's plumage is possible only if the important parts of that plumage can be named. On the upperparts and, especially, wings, the feathers are arranged in rows, and each row has its own name. The outermost, longest feathers (primaries) of the wing can also be conveniently numbered. This is normally done from the inside out, with 1 being the innermost primary and 10 the outermost visible one.

# Ageing

Ageing is a helpful step in the process of gull identification. In the small gulls it is relatively straightforward because these species take only one year to attain an adult-like plumage. Also, the immature plumages are clearly different from adult plumages. Large gulls, however, take about 4–5 years to mature, and they replace feathers almost continuously. This makes the characters that may be useful for ageing tremendously variable. In addition,

identification characters such as colour of the bare parts and pattern of scapulars and wing coverts may depend on the hormonal state of the bird, not just on its age.

In this book we avoid lengthy descriptions of age criteria in the species chapters. We focus primarily on identification features, and while we fully acknowledge that ageing is important, we feel that in many cases it is not essential. Instead, we present general guidelines on determining age here.

## Age terminology

(For a comprehensive overview, see the section on moult cycles in gulls on p.19.) We use the term 'cycle' to describe age classes. This term helps to avoid problems with using calendar years or terms such as 'first-winter', 'second-winter', etc. Large gulls do not abruptly change their plumages but have rather continuous, protracted moults that can last for 6 months or more. It is not always realistic to divide their plumages into separate winter and summer plumages, since these birds are in transition from one plumage

to the next for much of their lives. We have therefore adopted the cycle terminology, which has the added benefit that it can be used to describe age across both hemispheres. A first-cycle bird is a first-cycle bird, whether it lives north or south of the equator. Simply put, 'first cycle' is more or less synonymous with the first 12 months in gulls, 'second cycle' with 'second year' and so on, but the cycle terminology is better defined. A plumage cycle runs from a given plumage or complete moult to the next occurrence of a complete moult. The first cycle starts with juvenile plumage, the second with the onset of the complete moult in the bird's second calendar year, and so on. The start of a complete moult is indicated by the replacement of the innermost primary. Over the next 12 months, the plumage changes slowly but dramatically, especially in immature birds. In fact, when you compare birds in May of one year to birds in March of the next year, the plumage may be completely different, though technically it still occurs within the same cycle. In most gulls, a cycle consists of one complete moult (into nonbreeding plumage) and one or two partial moults. One important caveat that should be added here is that several taxa in this book may replace a number of flight feathers twice during their annual cycle, including the inner primaries: once during the complete, postbreeding moult, and once during an extensive prebreeding moult. The latter is not considered the start of a new moult cycle, since it is a second moult in the annual cycle and is not complete in all birds.

## Ageing the small gulls

In their first cycle, small gulls can be readily aged by their brown lesser and median upperwing coverts, dark tertial centres, black tail band, dark secondaries (except in Ross's and Sabine's Gulls), and dark pattern on the primary coverts. Adults have plain grey upperwing coverts and tertials (the latter with white tips), white tail, and pale secondaries, and, except for Sabine's Gull, they lack dark markings on the primary coverts. Mediterranean Gull and Little Gull have distinct second-cycle plumages, similar to adults, but with a variable amount of black on the outer primaries. In all other small gulls the second-cycle plumages are (nearly) identical to those of the adult, and their identification is therefore not discussed separately here.

First-cycle Laughing and Mediterranean Gulls replace wing coverts rather early with fresh grey feathers, which make the plumage look superficially similar to adult. The odd Slender-billed and, rarely, Black-headed Gull may also replace wing coverts during the post-juvenile moult. Such birds can still easily be aged in flight when they reveal the black tail band, dark secondaries, and dark pattern on the primary coverts.

Some Brown-headed and Grey-headed Gulls may undergo an extensive partial moult during their first cycle, resulting in an advanced plumage in spring with plain grey wing coverts, tertials, and secondaries, as well as an all-white tail. At rest, such birds may look very much like adults, but most will show a dark iris (pale in adults), and in flight they will reveal a dark pattern on the primary coverts.

Two exceptions in this group are Sabine's Gull and Franklin's Gull. These species have a (nearly) complete moult already during their first cycle. As a result, they attain adult-like plumage much sooner. First-nonbreeding Sabine's Gulls show plain grey upperwing coverts and white tail, and can only be told from nonbreeding adults if their bill tip is dark instead of yellow. In Franklin's Gull, it is the first-breeding plumage that is similar to adult, but with more extensive black pattern on the outer primaries and no white mirrors. Also, the white band across the outer primaries is lacking.

An unresolved question is whether adult Franklin's Gulls always show a white mirror on the outermost primary. Given the large amount of white in the wings of adult birds, we suspect that they do. In this book, any adult-looking bird that lacks the mirror on P10 is therefore labelled as 'second-cycle type'. It is hoped that future research, such as the colour-ringing of pulli in breeding colonies, will shed more light on this issue.

## Ageing the medium-sized gulls

Except for Ivory Gull, birds from this group can be categorised into three age classes: first cycle, second cycle, and adult. The differences between the age classes are relatively clear, due to distinct patterns on the wing coverts, tail, and outer wing.

First-cycle Black-legged Kittiwake is easily aged by its black bar on the upperwing coverts, black tertial centres, black collar on hindneck, black tail band, and large, whitish wing panel. Adults have grey wings, small black wingtips, and a clean white tail. Second-cycle birds differ only subtly from adult by showing dark markings on the primary coverts, among other characters.

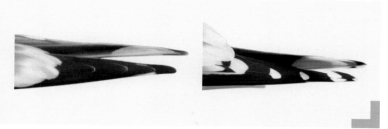

**Plate 12.** *Wingtips of second-cycle (left) and adult Common Gull (right). The folded wingtip is a useful feature for ageing; second-cycle birds lack the bold white tips on the longer (i.e., outermost) primaries.*

In Common, Short-billed, and Ring-billed Gulls, first-cycle birds show brown lesser and median upperwing coverts, dark tertial centres, dark secondaries, and black tail band. In adults, the wings are plain grey with broad white trailing edge, the wingtips are black with white mirrors and primary tips, and the tail is all white. Second-cycle birds differ from adults in showing narrower white tertial crescent, blackish marks on the primary coverts, smaller white mirrors, and in lacking a white tip on P8–P9. Some birds show remnants of the black tail band. A few birds looking almost identical to adults but with a little black on the alula or in the primary coverts could be labelled 'third-cycle types', but a few fully adult birds (even when more than 20 years old) may retain such immature traits too, and some advanced second-cycle birds can look very similar as well. For identification purposes, it is important to realise that the primary pattern of second-cycle birds (and some retarded third cycle) is not as developed as that of adults and therefore somewhat less useful.

A few second-cycle Common and Short-billed Gulls can show very retarded plumage, with all-brown wing coverts and complete black tail band. Such birds can be similar to first-cycle birds although they usually show a number of advanced, adult-like secondaries (bluish-grey, with broad white tips) and often a bluish tinge on the innermost primaries. The presence of two white mirrors on the wing (on P9–P10) should exclude first-cycle birds, but note that one white mirror (on P10) can be shown by some of the latter, just as in many second-cycle birds. Conversely, mirrors may be lacking (almost) completely in a few second-cycle Kamchatka and Short-billed Gulls. If any juvenile scapulars are retained, this should safely exclude a second-cycle bird. A few first-cycle birds may already show an advanced, adult-like pattern on some of their secondaries and inner primaries, and such birds, when they have already replaced all of their juvenile scapulars, can be near-impossible

to age correctly. If they retain a brown rump they can be more easily told from retarded second-cycle birds, but otherwise ageing comes down to correct assessment of the median and lesser coverts: juvenile feathers have a warm brown centre with a neatly defined pale fringe, while in retarded second-cycle birds the coverts are paler, more washed out, and lacking the solid brown centre. In addition, many second-cycle birds already show a number of plain grey, adult-like lesser coverts.

Sooty and White-eyed Gulls have rather dark plumage throughout their entire life and are therefore less easily aged. First-cycle birds show pale fringes on the brown wing coverts, a dark tail band, and only thin white tips on the secondaries. Adults show plain brown-grey wing coverts and tertials without any hint of pale fringing, an all-white tail, and a broad white trailing edge on the secondaries. In breeding plumage, adults also show a prominent white patch on both sides of the neck. Second-cycle birds are similar to adults, and it is probably best to age only those birds that still retain some black marks on the tail.

Ivory Gull shows only two types of plumage: juvenile (which is spotted black all over) and adult (which is entirely white). During the moult from juvenile to adult, the plumage may be a mixture of white and spotted feathers.

## Ageing the large gulls

Two of the most consistent ageing features in the large white-headed gulls are the shape and colour of the primaries. Another important aspect is wear, which can sometimes be used to estimate the age of feathers. Juvenile feathers in particular are less resistant and durable than older feathers. This may even cause an essentially brown gull to become whitish in some parts near the end of its first cycle. Worn feathers show frayed edges and tips, as if they have been eaten by moths.

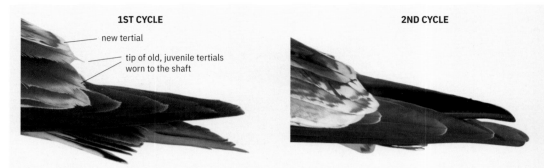

**Plate 13.** *Wingtips of Yellow-legged Gulls showing differences between first-cycle (juvenile) and second-cycle flight feathers. On the first-cycle bird (**left**), note that primaries are dark brown, rather pointed, and frayed at the edges. Second-cycle primaries (**right**) are wider, more blackish, with rounded tips and clean edges. In autumn, they are new and fresh, and hence look in much better condition than juvenile primaries (which are several months old). The difference is particularly noticeable on the underside of the wingtip. Note also how the juvenile tertials (**left**) are much browner than second-generation tertials (**top left, and right**), with clearly less white at their tips. The tips also look a bit damaged already. **Both birds photographed in Portugal, late November 2016.***

## GENERAL

### ▶ First cycle

Juvenile primaries are characterised by their rather thin and pointed shape. They are often also less blackish and more brownish than older primaries (except in the taxa that show white wingtips, of course). The rest of the plumage shows a regular pattern; the greater coverts, for instance, often show neat dark bars that run parallel to one another. The dark tertials have moderately thin, pale tips, whereas the white tertial tips are often clearly wider in the second cycle. The juvenile median and lesser coverts usually have large dark (brown) centres, and this is also true of the juvenile scapulars. New scapulars (acquired during the post-juvenile moult) lack this brown centre and usually show a dark anchor pattern instead. When most of the scapulars have been replaced, they often create the impression of a 'saddle' that contrasts with the juvenile wing coverts, which look less strongly patterned and more worn. The iris remains dark (it may become paler near the end of the first cycle in a few birds), and the bill usually lacks an obvious pale tip.

In some taxa, like Yellow-legged Gull, many birds undergo a rather extensive post-juvenile moult (see 'Moult' below) in which they acquire new wing coverts and tertials that look very much like those in second-cycle birds, and which contrast with any retained brown, juvenile wing coverts. In Kelp Gull

and *graellsii/intermedius* Lesser Black-backed Gull, the post-juvenile moult may even include all tail feathers and secondaries. This may complicate correct ageing, but these new feathers contrast with the retained brown juvenile primaries. The shape and colour of the primaries remain the most reliable age criteria. See also the paragraph about Baltic and Heuglin's Gulls below.

### ▶ Second cycle

Second-generation primaries are broader and more rounded than juvenile ones. The outer primaries are blackish (except in the taxa that show white wingtips), while the inner primaries look more dirty greyish or brownish, at least on their inner webs. In some taxa, notably Caspian, Great Black-backed, Scandinavian Herring, and Kumlien's Gull, many birds already show a white mirror on the outermost primary (P10). The plumage looks less regular than in first cycle; the greater coverts may show many thin, dark, wavy bars that converge and diverge (like vermicelli or spaghetti). The tertials show broad whitish tips, and so do the secondaries. Many (but far from all!) birds of this age acquire an adult-like mantle feathers and scapulars, creating a bluish-grey or blackish saddle (depending on the species) that makes them obviously different from first-cycle birds. The bill often has a wide pale tip or may gain some yellow colour, especially towards the end of the second cycle.

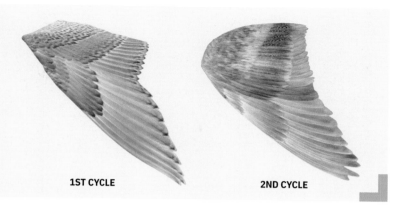

**Plate 14.** *Wings of first-cycle (left) and second-cycle Glaucous Gull. Note the thin, dark 'arrowheads' near the tips of the flight feathers on the first-cycle wing. The primaries are also more pointed, and the greater coverts show distinct, parallel barring.* **Left:** *Belgium, 7 November 2010; right: Newfoundland, Canada, 1 February 2013.*

**1ST CYCLE**      **2ND CYCLE**

### Third cycle

The primaries generally differ from second-generation feathers in their bold white tips, visible at rest (except in the taxa that show white wingtips). However, some birds have a more retarded look, and in that case the inner primaries need to be studied: third-generation feathers usually show the same colour as in adults, with broad white tips, while in second cycle they are dirty greyish or brownish without the prominent white tips. A few third-cycle birds look so retarded all over that the colour of the inner primaries may be the only clue to their true age. Generally, though, third-cycle birds have acquired more adult-like wing coverts and tertials than younger birds, as well as rather adult-like bare parts. A few birds may show two white mirrors already on the outer primaries (P9–P10), which is never the case in second cycle. Yet another few birds may look so advanced at this age that they cannot reliably be told from fourth-cycle birds.

### Fourth cycle

As in adult birds, the outer primaries have prominent, rounded white tips and usually at least one mirror (on P10). The rest of the plumage and the bare parts are usually as in adults too, but fourth-cycle birds more often retain immature markings on the primary coverts, on the tail, and near the bill tip. Fourth-cycle birds often show more pigmentation in the primaries than adults. Advanced birds may look very similar to adults, which may occasionally retain immature markings, and in such cases distinguishing between the two age classes will not be possible. At the other extreme, retarded fourth-cycle birds retaining, for example, brown markings in the tertials or greater coverts may not be possible to tell from

third-cycle birds. Therefore, we often use the term 'subadult' to refer to both third-cycle and fourth-cycle birds.

For identification purposes, it should be kept in mind that the primary pattern of third- and even some fourth-cycle birds is not as developed as in adults, and therefore less helpful.

### Adult

The upperparts show a uniform colour without any brown, immature markings. The tail is all white. There are usually no extensive dark markings on the primary coverts (but see previous paragraph). The underwing coverts are all white (including the primary coverts).

The above criteria are less applicable to a few taxa in this group; these are discussed below.

### SPECIFIC CASES

### White-winged gulls (Iceland and Glaucous Gull)

The shape of the primaries is a good ageing feature in these two species, but the colour of these feathers remains pale at all ages. However, first-cycle birds often show a thin, brown subterminal spot on the inner primaries, shaped like an arrowhead—a pattern that is absent at all other ages. First-cycle birds also show brown axillaries (white in other age-classes) and their iris is dark. The greater coverts show more regular, parallel barring than in second cycle. If any clean grey feathers are present on the upperparts, this rules out first-cycle birds. Third-cycle birds differ from second cycle by their adult-like, bluish-grey inner primaries, while the outer primaries show less extensive bluish-grey colour than in adults (often none).

| | First cycle | | Second cycle | Third cycle | Adult |
|---|---|---|---|---|---|
| **Primaries** | dark brown; pointed | | blackish; at most 4 grey inner primaries | black, with small white tips; 5–6 grey inner primaries; usually no mirror on P10 | black, with white tips; white mirror on P10 (rarely lacking) |
| **Secondaries** | dark brown | | black, with distinct white tips | (partly) grey | grey |
| **Upperwing coverts** | many brown feathers | | largely grey; just a few brown lesser and outer greater coverts | grey | grey |
| **Primary coverts** | dark | | dark | inner feathers grey; outer feathers dark | grey, or with just a few black marks |
| **Tail** | dark | | white, with black tail band | white, sometimes with short black tail bar | white |
| **Underwing coverts** | pale panel framed by dark pattern | | white, with dark trailing edge | pale | pale (grey) |
| **Bill** | dark to yellowish | | yellowish to orange | yellowish to red | red |
| **Head and body** | clouded brown pattern on breast | | mainly white, with brown streaks on head/neck | often faint streaks on head in winter | white head pale grey body |

**Table 2.** *Summary of age criteria for Audouin's Gull (based on Reyt & Prunier 2021)*

#### ▶ Audouin's Gull

This species acquires adult-like features more quickly than most of the other large gulls. From midwinter on in the first cycle, some birds acquire many plain grey scapulars and wing coverts, making the bird look more mature than it really is. In the second cycle the inner primaries can already have an adult-like grey colour, and the central primaries can show small white tips. Still, ageing is not too difficult if the right criteria are used. In first-cycle birds, this includes the shape and colour of the primaries, the all-dark tail, extensive brown lesser and median underwing coverts, and dull bill colour. Second-cycle birds are characterised by more rounded primary tips, all-white underwing coverts, a white tail with a thin black band, broad white tips on the secondaries, and yellowish to orange-red bill colour. A maximum of 4 inner primaries can be bluish-grey. When perched, advanced first-cycle birds can look similar to second cycle, but they usually show a few remaining brown wing coverts, as well as dull bill colour. Second-cycle birds have cleaner grey, more adult-like upperparts and upperwing, although often with a few dark marks on the lesser coverts and blackish streaks on the outer greater coverts, unlike third cycle. They also show all-dark primary coverts, unlike older birds. When perched, third-cycle Audouin's Gulls strongly resemble adults, but nonbreeding birds show delicate dark streaks or spots on crown and nape, as well as slightly duller bill colour. The absence of a white mirror on P10 is a sign that the bird is likely not a full adult, although a few adults do lack the mirror. The size of the white primary tips is not a good age character. In flight, third-cycle birds differ from adults by their blackish outer primary coverts, and sometimes partly blackish secondaries. They differ from second cycle in that 5–6 inner primaries are adult-like bluish-grey, and the inner primary coverts are clean grey. The tail is often all white.

#### ▶ Pallas's Gull

This species also acquires many clean grey scapulars and wing coverts early on in the first cycle. When perched, advanced first-cycle birds differ from second cycle in their pointed and brown primaries, as well as in their few remaining brown wing coverts and dark bill tip. In flight, they show dark secondaries, dark primaries, and dark primary coverts. Second-cycle birds have clean grey upperwing coverts, black outer primaries with one or two white mirrors, largely white primary

coverts creating a white leading edge on the outer wing, and adult-like, bluish-grey secondaries and inner primaries. The plumage therefore looks one year older than in most second-cycle large gulls. It differs from third cycle by the black spots on primary coverts, black tail band, and shorter tongue on the underside of P10. Third-cycle birds are very similar to adults, but show more extensive black pattern on outermost primaries, covering more than half the length of the outer web of P9–P10.

Note that the age criteria for this species have never been studied on ringed birds, so the degree of overlap between second- and third-cycle birds is unknown.

### ▶ Baltic and Heuglin's Gulls

Baltic Gulls and a few Heuglin's Gulls acquire a much more advanced plumage during their first cycle than most other Lesser Black-backed Gulls. Some birds have already moulted their whole plumage including all primaries at the end of their first winter, and thus resemble second-cycle *graellsii/intermedius*. However, at that time of year (late winter–spring) they show fresh, glossy jet black primaries, while in

second-cycle *graellsii/intermedius* these feathers are old and look dull blackish. The colour of the bill and legs is often duller, and scattered brown spots may be present on the mantle, scapulars, or flanks. Second-cycle Baltic Gulls (and some advanced Heuglin's) cannot safely be aged since they already look very similar to adults and their plumage overlaps completely with that of a few (retarded) third-cycle birds. Most third-cycle birds, however, are so similar to adults that they too cannot safely be aged.

## Moult

Knowledge of moult can be very useful for ageing and identifying birds (not just gulls!). For instance, a skua with two simultaneous moult waves in its primaries should be a Pomarine Skua, since simultaneous moult waves have not been found in other skua species. For some gull taxa, like Baltic and Heuglin's Gulls, moult is even an essential part of the identification process.

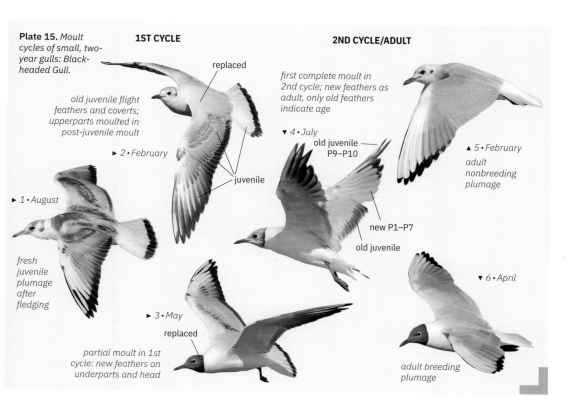

**Plate 15.** *Moult cycles of small, two-year gulls: Black-headed Gull.*

**1ST CYCLE**

**2ND CYCLE/ADULT**

*old juvenile flight feathers and coverts; upperparts moulted in post-juvenile moult*

replaced

▶ 2 • *February*

juvenile

▶ 1 • *August*

*fresh juvenile plumage after fledging*

▶ 3 • *May*

replaced

*partial moult in 1st cycle: new feathers on underparts and head*

*first complete moult in 2nd cycle; new feathers as adult, only old feathers indicate age*

▼ 4 • *July*

old juvenile P9–P10

new P1–P7

old juvenile

▲ 5 • *February*

*adult nonbreeding plumage*

▼ 6 • *April*

*adult breeding plumage*

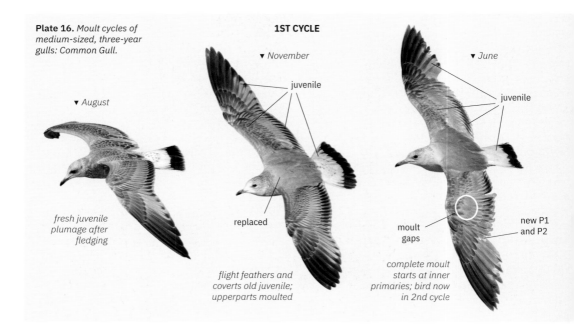

**Plate 16.** *Moult cycles of medium-sized, three-year gulls: Common Gull.*

**1ST CYCLE**

▼ *November*

juvenile

▼ *June*

juvenile

▼ *August*

*fresh juvenile plumage after fledging*

replaced

moult gaps

new P1 and P2

*flight feathers and coverts old juvenile; upperparts moulted*

*complete moult starts at inner primaries; bird now in 2nd cycle*

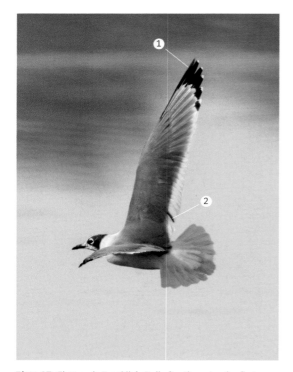

**Plate 17.** *First-cycle Franklin's Gull after the extensive first prebreeding moult. Nearly all feathers were replaced, except for the outermost primary (1) and one inner secondary (2), which are still juvenile. Before the northbound migration, moult was arrested.* **Texas, USA, 14 May 2005 (Greg Lavaty)**

## Moult in small gulls

Adult (and second-cycle) birds undergo a complete moult to nonbreeding plumage, which starts during the breeding season and finishes 3–4 months later. The moult to breeding plumage is partial and occurs mostly during late winter and spring.

First-cycle birds undergo two partial moults: an autumn moult ('post-juvenile'), in which the juvenile plumage is replaced, and a spring moult to 'first-breeding plumage'. The latter may produce an adult-like hood in some 'advanced' birds, but many others again show a nonbreeding head pattern, even though they underwent the same moult. Moult and plumage colours are not necessarily intertwined; the plumage aspect depends more on the hormonal state of the bird. The first spring moult may include a number of wing coverts and tail feathers. In Brown-headed and Grey-headed Gulls, it may even include all of these feathers and all secondaries, resulting in a unique combination of adult-like plumage with 10 juvenile primaries.

Two exceptions in this group are Sabine's Gull and Franklin's Gull. Sabine's Gull moults mainly in its winter quarters, south of the equator. Adult birds often start moulting their head and body feathers during southward migration, but wing moult starts only when they have reached the wintering grounds. While they are replacing their primaries

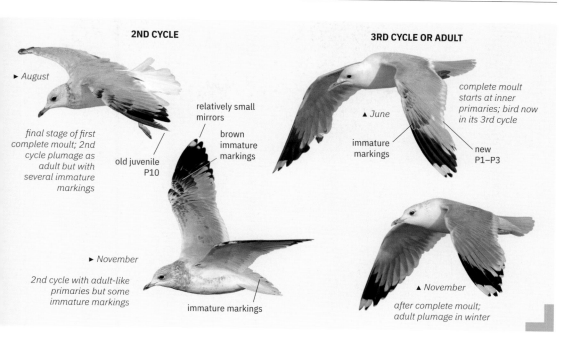

**2ND CYCLE**

► *August*

*final stage of first complete moult; 2nd cycle plumage as adult but with several immature markings*

*relatively small mirrors*

*old juvenile P10*

*brown immature markings*

► *November*

*2nd cycle with adult-like primaries but some immature markings*

*immature markings*

**3RD CYCLE OR ADULT**

▲ *June*

*complete moult starts at inner primaries; bird now in its 3rd cycle*

*immature markings*

*new P1–P3*

▲ *November*

*after complete moult; adult plumage in winter*

(in December–March), they also undergo the partial prebreeding moult (in which they acquire their characteristic head pattern). In first-cycle birds, the post-juvenile moult is protracted and complete. The juvenile plumage is retained during the southward migration; body moult does not start until October–November. Wing moult occurs from December to March or April, immediately followed by the partial first prebreeding moult in April–May. Franklin's Gull is unique in that it has two complete moults annually, except in its first cycle. The post-juvenile moult is the only partial one; the first prebreeding moult is (nearly) complete, unlike in the other small gulls. As a result, the 'first-summer' plumage already resembles that of adults.

## Moult in the medium-sized and large gulls

Moult in the larger gulls is often a slow and protracted process (the complete moult may take about 6 months) and the partial and complete moults may overlap to some extent, which makes it difficult to perceive how many moults really occur in a year, especially in first-cycle gulls. Research has shown that there is basically only one moult during the first cycle, which means that there is no distinct 'first-summer' plumage. Instead, the whole plumage just gradually wears and bleaches during the first spring.

Some birds (e.g., some Yellow-legged Gulls) do appear to undergo a second moult during their first cycle, but it is very limited, for example, restricted to the head and neck.

### ▶ First cycle

During the first cycle, most taxa undergo a protracted partial moult between late July and May, which may be slowed or suspended over midwinter. In European Herring Gulls and most Great Black-backed Gulls, typically only body feathers (including scapulars) are replaced, and all wing coverts are usually retained at least until April. Some (northern) *argentatus* and Great Black-backed Gulls, however, retain full juvenile plumage until March. The same is true for many birds of other northern taxa, such as Glaucous, Iceland, Kumlien's, Thayer's, and Glaucous-winged Gulls. Black-legged Kittiwake also retains its juvenile plumage for quite a long time, until midwinter, after which the plumage changes little.

In 'southern' taxa, such as Sooty, White-eyed, Audouin's, Kelp, Pallas's, Yellow-legged, Steppe, Armenian, and Caspian Gulls, the partial moult is not limited to the body but often includes some or even all wing coverts and tertials too. Some birds also replace a number of tail feathers. The post-juvenile moult is also quite extensive in Ring-billed Gull. In Lesser Black-backed Gull, this moult is very

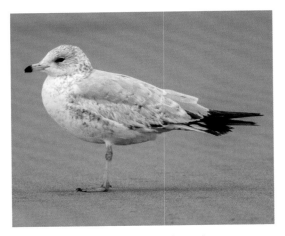

**Plate 18.** *A first-cycle Ring-billed Gull that underwent an extensive partial post-juvenile moult, including the upper tertials and a number of inner wing coverts. Replaced feathers are grey and contrast with the pale brown, juvenile coverts that remain. The primaries are still juvenile (brown, narrow, and pointed). California, USA, 30 December 2016 (Alex Abela)*

moulted

juvenile

**Plate 19.** *First-cycle Yellow-legged Gull, Portugal, 20 November 2016. The partial post-juvenile moult has been quite extensive in this bird, and has included not only the scapulars but also the inner greater, inner median, and scattered lesser coverts, as well as the uppermost tertials. Moulted coverts show the same contrasting black and white pattern as the scapulars and are clearly different from the more worn, frayed, pale brown juvenile feathers.*

variable. In *graellsii* it may include a number of wing coverts, tertials, and tail feathers; in *intermedius* it may also include the secondaries and—very rarely—a few inner primaries. In many *fuscus* it is postponed or suspended during autumn migration and resumed in the winter quarters. It may then be very extensive, including all wing coverts, some or all tail feathers, some or all secondaries, and a variable number of primaries. First-cycle *fuscus* may replace all primaries during the first prebreeding moult. Wing moult is then arrested, which may result in a moult contrast with two generations of primaries (second generation and juvenile), all fully grown. Heuglin's Gull may replace all wing coverts, tail feathers, and secondaries during the first prebreeding moult, but usually no primaries. Some birds, however, do replace a variable number of primaries. A unique feature of such birds is that primaries may be replaced in a random order; for example, primaries P5 and P7 can be renewed, after which moult is arrested, leaving all other primaries juvenile. In all other large gull taxa, primaries are normally replaced in a systematic order, that is, from P1 outwards.

### ❱ Second cycle

The second cycle starts with a complete moult during the breeding season, when P1 is dropped. Moult of

the tail feathers starts approximately when P7 and P8 are growing in, which is roughly the moment when the secondary moult also starts. Overlapping with the end of the complete moult, replacement of body feathers and a number of wing coverts occurs in a partial prebreeding moult, which may be suspended in midwinter.

This sequence is not followed by many *fuscus,* some *intermedius*, some Heuglin's, and some Kelp Gulls, though. As birds of these taxa (particularly *fuscus*) may have already moulted some primaries during their first cycle, the complete moult of the second cycle may be postponed until summer and then suspended, which means that these birds may migrate to their wintering area with a few (outer) juvenile primaries left. Before moult is suspended, a third moult wave may start in a few autumn *fuscus*, resulting in three different generations of primaries.

### ❱ Third cycle

The medium-sized gulls attain adult plumage in this cycle. In large gulls, the third-cycle moult is similar to second cycle but slightly later (by approximately 1 month). The plumage acquired by the complete moult is highly variable; newly grown tail feathers, for instance, may range from all white to all dark. A few *graellsii* temporarily suspend their primary moult during spring (Stewart 2006; Muusse et al 2011).

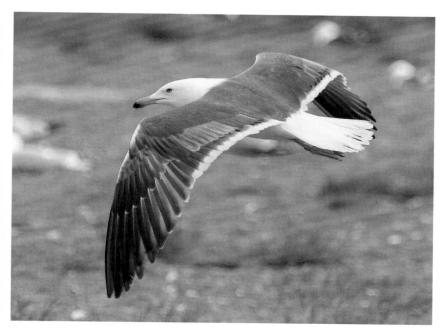

**Plate 20.** *Second-cycle Lesser Black-backed Gull. The partial prebreeding moult in this bird was extensive: it included not only a large number of wing coverts, but also all tail feathers and all secondaries. The latter are grey with broad white tips and contrast clearly with the old, brown, second-generation primaries. This bird was ringed as a pullus in Belgium in July 2008; its age is therefore confirmed. Belgium, 11 May 2010 (Peter Adriaens)*

Again, many *fuscus*, some *intermedius*, and some Heuglin's Gulls follow a different moult timing and strategy. As in second cycle (and older), these taxa tend to partly postpone primary moult to later in the year (e.g., to summer rather than spring) and then suspend for migration. Most of the primary moult continues in the wintering quarters. In order to finish their moult in time for the northbound migration, they often use stepwise moult, which involves replacing the primaries in two simultaneous waves outwards (e.g., one starting from the innermost primary and one from the suspension point).

### ▶ Fourth cycle
The fourth-cycle moult (in large gulls) is similar to third-cycle moult but slightly later, although this timing does not apply to many *fuscus* and some *intermedius*. Some *graellsii* temporarily suspend their primary moult during spring.

### ▶ Adult cycle
In most large gulls, the fifth cycle leads to the adult plumage and starts with the inner primaries during the breeding period. The timing is variable and also depends on the taxon involved: in some adult Yellow-legged Gull, it has already started in mid-April, whereas in a few *graellsii* it does not start until early August. Tail and secondary moults

start approximately when P6 is growing. Dusky winter head markings usually appear when P7 to P8 are shed. The complete moult finishes when the outermost primary becomes full grown. At this moment, the partial prebreeding moult starts and is followed by gradual whitening of the head. This results in the full breeding plumage, usually well before the breeding season starts. Bare parts become brighter too.

Adult *fuscus* and *intermedius* may postpone the complete moult until after the breeding season, moult a few inner primaries, and then suspend for the southward migration. Their primary moult continues in the winter quarters. Some adult *graellsii* appear to moult one or two inner primaries earlier than usual (sometimes even as early as February–March, prior to northbound migration) and then temporarily suspend.

### ▶ Exceptions
One major exception to the above pattern is the Ivory Gull, which has no partial moults, only complete moults. In this high-Arctic species, the primary moult is mostly completed in spring, *before* the breeding season. Adult Ivory Gulls suspend their wing moult during breeding and then finish moult of the outer primaries in August–September, before the Arctic winter sets in. Some birds do not succeed in replacing

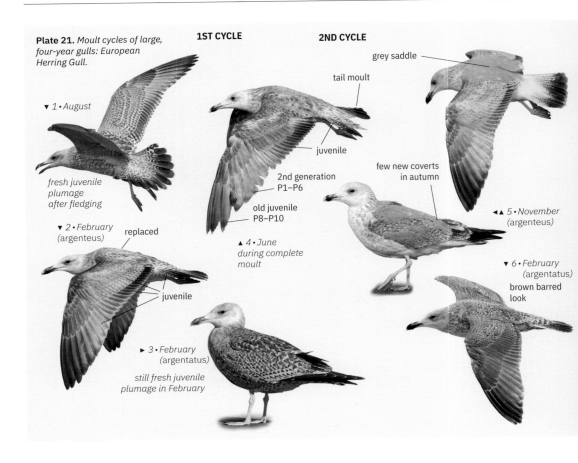

**Plate 21.** *Moult cycles of large, four-year gulls: European Herring Gull.*

**1ST CYCLE**

**2ND CYCLE**

grey saddle

tail moult

▼ *1 • August*

juvenile

*fresh juvenile plumage after fledging*

2nd generation P1–P6

old juvenile P8–P10

few new coverts in autumn

▼ *2 • February* (argenteus)  replaced

▲ *4 • June during complete moult*

◄▲ *5 • November* (argenteus)

juvenile

▼ *6 • February* (argentatus) brown barred look

► *3 • February* (argentatus)

*still fresh juvenile plumage in February*

juvenile

all primaries on time, and they retain one or two old outer primaries through to the next spring. Ivory Gull also differs from all other gulls in that it has no partial prebreeding moult and therefore lacks a separate breeding plumage. There is also no partial moult during the first cycle; birds retain their juvenile plumage throughout winter and then moult straight into adult plumage.

### Final comments on moult

We would like to conclude this section with some general remarks. It is important to know that the appearance of feathers acquired in the same moult cycle can change depending on the hormonal state of the bird. Thus, feathers of the same generation may look very different in some cases. For example, new scapulars grown early in the second cycle of a large white-headed gull will usually have a rather 'immature' look (e.g., pale, with a dark brown anchor pattern), while those acquired later in the

same cycle may be plainer and greyer (slightly more adult-like).

It is also important to realise that moult is a process that may vary depending on external factors, probably the most important of which is the daylight period. When the days are getting longer, moult is stimulated. Thus, the location of the wintering areas may influence the moult activity and extent. A gull that winters in the Southern Hemisphere (as some *fuscus* do) may be more prone to replacing all its plumage in winter than a gull staying in Western Europe.

Lastly, factors like illness, lack of nutrition, etc., may cause a bird to get behind in its moult schedule. Moult requires a lot of energy, but it is a yearly necessity or the feathers become inadequate for insulation and flight. For large gulls, which have numerous and often large feathers to replace, moult is a default ongoing activity that is interrupted only during energy-demanding phases, such as breeding and migration.

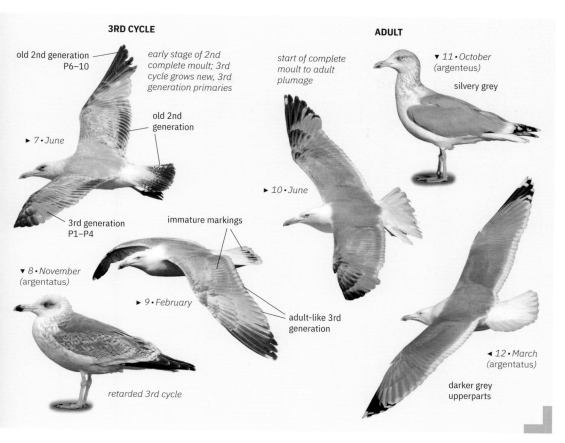

**3RD CYCLE**

old 2nd generation — P6–10

early stage of 2nd complete moult; 3rd cycle grows new, 3rd generation primaries

old 2nd generation

▶ 7 • June

3rd generation P1–P4

immature markings

▼ 8 • November (argentatus)

▶ 9 • February

retarded 3rd cycle

**ADULT**

start of complete moult to adult plumage

▼ 11 • October (argenteus)

silvery grey

▶ 10 • June

adult-like 3rd generation

◀ 12 • March (argentatus)

darker grey upperparts

## How to learn more

The best way to make progress in identification is to study your local gulls in the field and become familiar with their variations. Taking photographs and submitting them to knowledgeable people for advice will speed up the learning process. Nowadays there are online databases where you can upload your photos, which will be reviewed by a panel of validators. A few of the biggest are the following:

www.observation.org
www.ebird.org

Do not be afraid to ask for feedback if you picked the wrong species or age and cannot see where you went wrong.

Another important part of the learning path is self-study. Many specialised papers are freely available on the internet these days, for example, on http://gull-research.org/papers/paper.html. The main website (www.gull-research.org) presents hundreds of photos of most gull species, ordered by month, so you can see the changes in plumage throughout the year and compare the gull you observed to photos from the same time of year. The online databases mentioned above also hold lots of photographs, which can be filtered by month or by season.

One more way to make progress is to focus on colour-ringed gulls. Many gulls in Europe have been fitted with a plastic ring around one of their legs, on which an individual code is engraved. This is for scientific research, but anyone reading and reporting the code will get the life history of the specific bird, which will normally include the name of the species and the age. Contact details of the various ringing projects can be found at www.cr-birding.org.

## MAPS

Maps are shown for those taxa that breed within the borders of the Western Palearctic. Breeding ranges are shown in red, wintering ranges in dark blue.

# Black-Legged Kittiwake
## *Rissa tridactyla*

▶ **STRUCTURE**
Kittiwake is a medium-sized gull with a large head and virtually no neck. It has very short legs, which may give the impression that the bird is resting on its tarsi. Compared with the compact body with large head, the folded wings look short, but in flight they become long and pointed. They are often held in a W-shape in strong winds, when elastic wingbeats are alternated with gliding flight. In calm weather the flight at sea is more direct and energetic. The tail is subtly forked and the bill is short and pointed, with a slight gonydeal angle. The legs and bill are clearly shorter than in Common Gull. The bill is stouter than in Little Gull, and the wings look more pointed.

## Adult

Differs from Common Gull in its short, black legs, the lack of white tips on the outer primaries, and a uniformly grey hindneck in winter. At rest, the wingtip looks partly grey, with an isolated black spot visible just beyond the tertials (on P6), unlike Common Gull. Adult birds show a yellow bill and black legs that may turn a little paler in winter, when they may show a dark reddish tinge. The iris is blackish with a thin red orbital ring in breeding plumage; the gape is also red. Black markings are present near the tip of 5, sometimes 6, primaries, and most of these feathers except the outermost two show small white tips that quickly wear off. There is a uniform, rather extensive grey 'shawl' on the hindneck in winter and two large, smudgy dark grey ear spots on the head connected by a greyish band across the crown. The grey colour on the primaries and primary coverts is paler than that on the wing coverts and may create the impression of a pale triangle on the wing. The tertials show only thin and indistinct white tips, unlike Common Gull.

**SIMILAR TAXA**

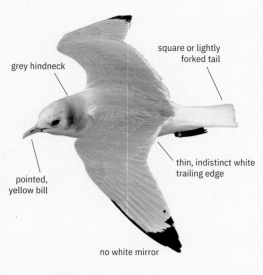

grey hindneck

square or lightly forked tail

pointed, yellow bill

thin, indistinct white trailing edge

no white mirror

**KITTIWAKE ADULT** *nonbreeding*

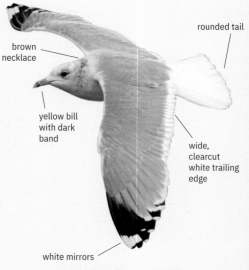

rounded tail

brown necklace

yellow bill with dark band

wide, clearcut white trailing edge

white mirrors

**COMMON GULL ADULT** *nonbreeding*

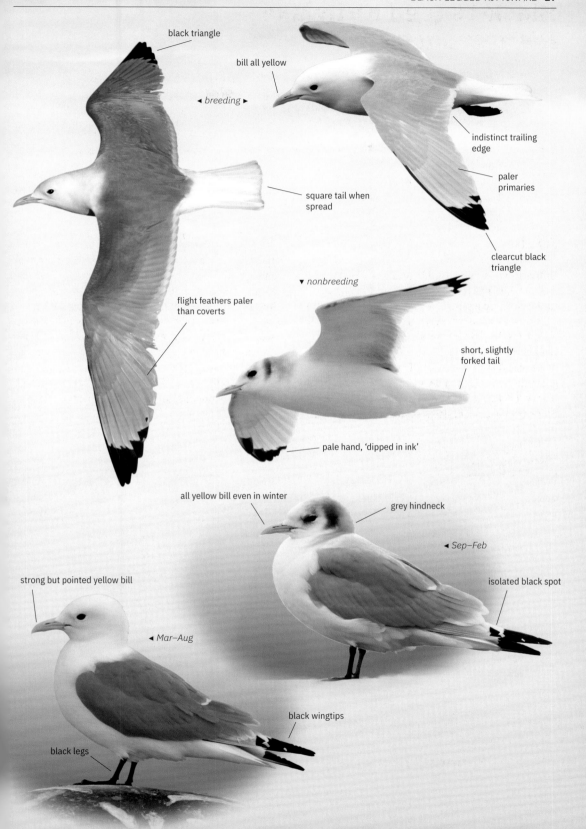

black triangle

bill all yellow

◄ *breeding* ►

indistinct trailing edge

paler primaries

square tail when spread

clearcut black triangle

▼ *nonbreeding*

flight feathers paler than coverts

short, slightly forked tail

pale hand, 'dipped in ink'

all yellow bill even in winter

grey hindneck

◄ *Sep–Feb*

strong but pointed yellow bill

isolated black spot

◄ *Mar–Aug*

black wingtips

black legs

# First cycle

In flight it resembles first-cycle Little and Sabine's Gulls (see those species). The plumage of first-cycle birds is tricoloured white, grey, and black.

Compared with Little Gull, the secondaries are white and the inner primaries very pale grey, contrasting strongly with the rest of the upperwing. Since the crown is white, the head appears paler than in Little and contrasts with the well-defined, bold black bar on hindneck. First-cycle Little Gull shows a dark bar on the secondaries, blackish inner primary coverts, and pink legs (blackish or brownish-pink in first-cycle Kittiwake). Compared with juvenile Sabine's Gull, the upperparts are plain grey, the wings partly grey with a black V formed by the black outer primaries and black diagonal band across the wing coverts, and the head pattern is quite different, white with a smudgy dark ear spot and a sharply demarcated, bold black bar on the hindneck. The underwings are more uniformly white than in Sabine's.

A few odd birds occur that may show a complete black upperwing (rarely).

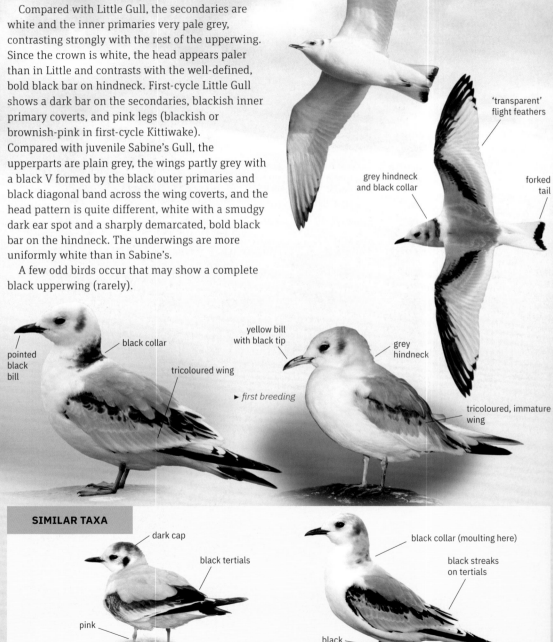

thin black edge

'transparent' flight feathers

grey hindneck and black collar

forked tail

pointed black bill

black collar

tricoloured wing

yellow bill with black tip

grey hindneck

▶ *first breeding*

tricoloured, immature wing

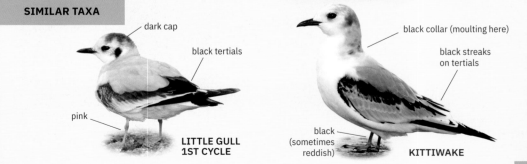

**SIMILAR TAXA**

dark cap

black tertials

pink

**LITTLE GULL 1ST CYCLE**

black collar (moulting here)

black streaks on tertials

black (sometimes reddish)

**KITTIWAKE**

# Second cycle

After the complete postbreeding moult the plumage resembles that of adults, but with more extensive black running upwards to the primary coverts on the outer primaries. Often, the outer webs of P9 and P10 are entirely black. The larger black wingtip compared with adults may invite confusion with adult or second cycle Common Gull, especially in winter when both species show a variable 'shawl' on the hindneck, but Common Gull shows white mirrors on one or two outer primaries in flight, a well-defined, broad white trailing edge on the secondaries, and long grey or yellow legs. The black wingtips are always more extensive than in second-cycle Kittiwake.

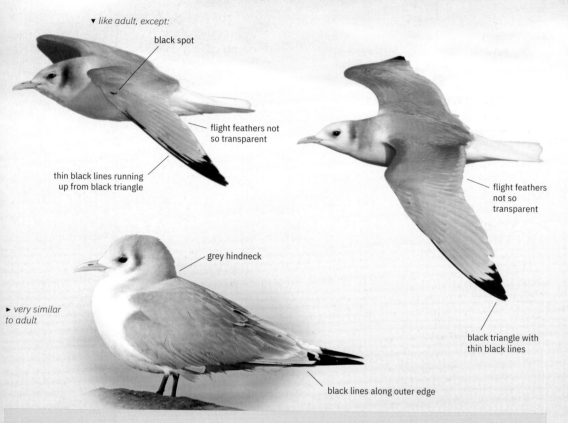

▾ *like adult, except:*

black spot

flight feathers not so transparent

thin black lines running up from black triangle

flight feathers not so transparent

grey hindneck

► *very similar to adult*

black triangle with thin black lines

black lines along outer edge

## ▶ RANGE

Black-legged Kittiwake breeds along the temperate and northern coasts of the Atlantic (ssp. *tridactyla*) and Pacific (ssp. *pollicaris*) Oceans, as well as in the Arctic region on all of the greater Siberian islands, on Greenland, and along the adjacent Canadian coast. The breeding range extends south down to Portugal. In winter it occurs in all cold and temperate seas of the Northern Hemisphere, but not in tropical waters. Vagrants are sometimes found inland on the European continent, in the Middle East, and on the Black and Caspian Seas.

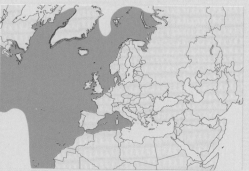

# Ivory Gull
## *Pagophila eburnea*

> ▶ **STRUCTURE**
> A medium-sized gull with a rather compact body but long and pointed wings which are fairly wide at the base.
> The legs are short and the nails are well developed (to walk on ice). At all ages the legs are black.

## Adult
—

Adult birds have an immaculate white plumage. The bill is tricoloured, greenish-blue with a yellow and orange tip (orange especially on the upper mandible). May be confused with leucistic Common Gull or Black-legged Kittiwake (which occur very occasionally), but adult Ivory Gull has a characteristic bill pattern and black legs. Adult Mediterranean Gull in nonbreeding plumage has a bright red bill and dark marks on the head. Lastly, the species has been confused with white domestic pigeons!

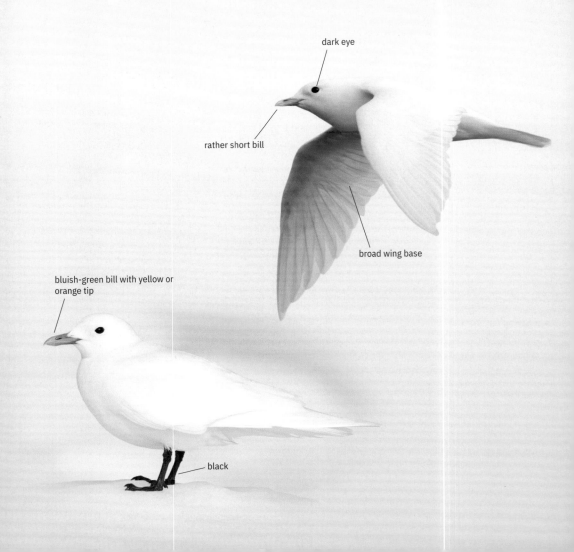

dark eye

rather short bill

broad wing base

bluish-green bill with yellow or orange tip

black

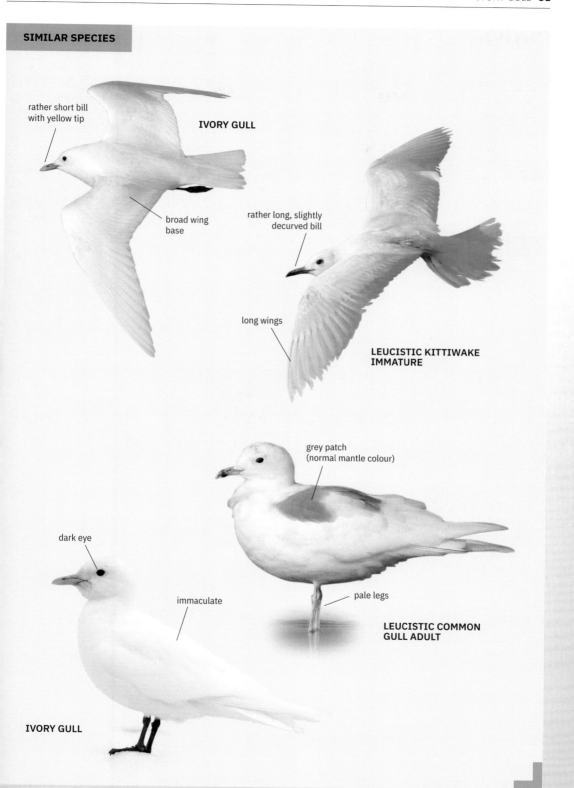

**SIMILAR SPECIES**

rather short bill with yellow tip

**IVORY GULL**

broad wing base

rather long, slightly decurved bill

long wings

**LEUCISTIC KITTIWAKE IMMATURE**

grey patch (normal mantle colour)

dark eye

immaculate

pale legs

**LEUCISTIC COMMON GULL ADULT**

**IVORY GULL**

# First cycle

Birds of this age category can easily be recognised by their white plumage with scattered black spots on the wings and upperparts. The number of black spots is individually variable, and some birds show them only on the tips of the flight feathers, the tail, and the head. There is often a brownish-black area in front of the eye (around the bill base), which creates the impression of a dirty face. The bill pattern is similar to that of adults, but duller and darker, less intense (with orange colour hardly visible or absent).

There are no confusion species at this age.

Has already acquired adult plumage in its second year of life, after a complete moult that lasts until August–September. Towards the end of this active moult it resembles adult, but with a few black spots remaining on feathers that have not yet been replaced, such as a few underwing coverts, flight feathers, and tail feathers.

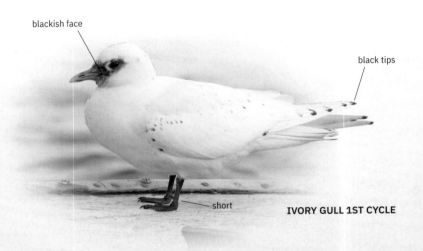

blackish face

black tips

short

**IVORY GULL 1ST CYCLE**

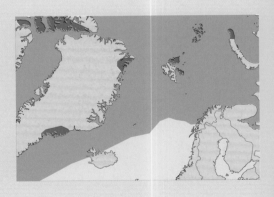

**▶ RANGE**

Ivory Gull is a circumarctic species. On the American continent, it breeds in Arctic Canada, from Ellesmere to northern Baffin Island, and further east it can be found locally in Greenland (especially in the northeast and southeast), Svalbard, and the Siberian Arctic, particularly on Franz Joseph Land, Novaya Zemlya, and Severnaya Zemlya.

The species winters along the edge of the pack ice anywhere in the Arctic region, but especially in the Bering Sea, Chuckchi Sea, Labrador Sea, and Davis Strait in North America, as well as the Barents Sea, Kara Sea, and East Siberian Sea further east.

Further south, the species is a vagrant to the coasts of the United States and the Great Lakes. Vagrants also regularly reach Northwest Europe (especially Iceland, Norway, and the British Isles) and have also been recorded in France, the Netherlands, Germany, Switzerland, Poland, Italy, and Portugal. In Asia, vagrants have reached China, South Korea, and Japan. Most records refer to immature birds. The species is often found around carcasses of marine mammals.

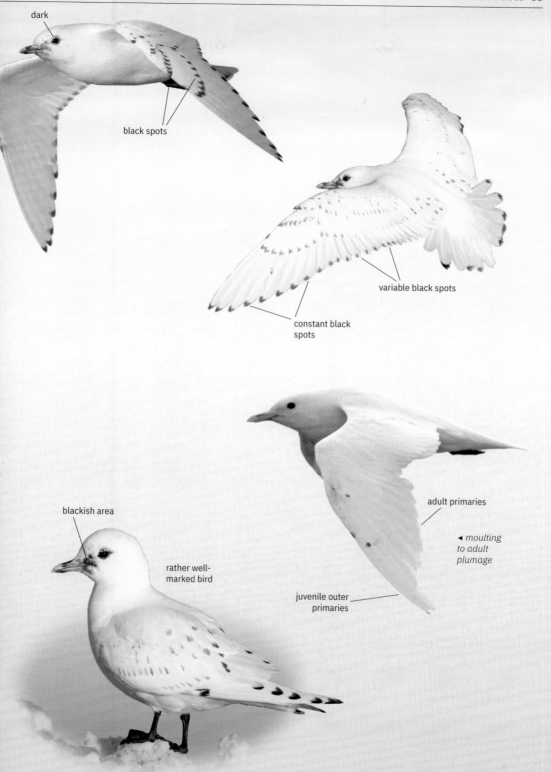

dark

black spots

variable black spots

constant black spots

blackish area

rather well-marked bird

adult primaries

◄ *moulting to adult plumage*

juvenile outer primaries

# Sabine's Gull
## *Xema sabini*

▶ **STRUCTURE**
A small gull. Adults show a characteristic combination of grey (brown in juveniles), black and triangluar white pattern on upperwing, a forked tail, and a short, thin bill that is black with a yellow tip. At all ages may show a dusky diagonal bar on underwing. The flight is elegant and slightly reminiscent of a tern.

## Adult

The pattern of the upperwing is remarkable: the black outer hand forms a dark triangle, the white inner primaries, secondaries, and outer greater coverts also form a triangular area, and a third, grey patch is formed by the rest of the wing coverts. In breeding plumage, the head is covered by a dark grey hood with black lower border. In nonbreeding birds, the head is mainly white with a grey or blackish wash on the nape.

Nonbreeding birds could be confused with worn first-cycle Black-legged Kittiwake, especially in flight from a distance. However, the latter shows a diagonal black bar across the upperwing and its pale wing panel is greyish-white rather than strikingly pure white. The head pattern is also different.

Confusion is also possible with first-cycle Little Gull, but that species is slightly smaller, with a black diagonal bar across the upperwing, and it lacks the white triangular wing panel because its secondaries are dark.

On perched birds, the dark grey upperparts of Sabine's Gull may recall those of Franklin's, but the former species does not show white eye crescents, has a yellow bill tip (except in immature birds), and often shows a continuous white line just below the greater coverts.

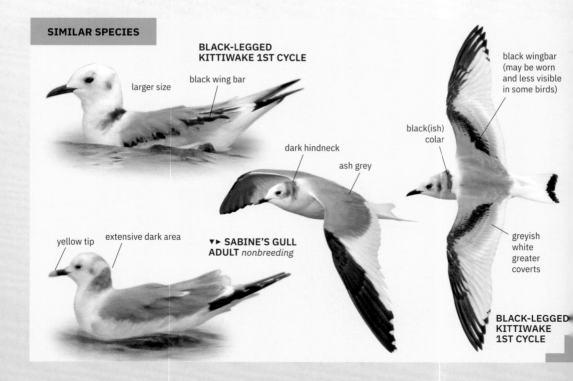

**SIMILAR SPECIES**

BLACK-LEGGED KITTIWAKE 1ST CYCLE

larger size

black wing bar

black wingbar (may be worn and less visible in some birds)

black(ish) colar

dark hindneck

ash grey

yellow tip

extensive dark area

▾▶ **SABINE'S GULL ADULT** *nonbreeding*

greyish white greater coverts

BLACK-LEGGED KITTIWAKE 1ST CYCLE

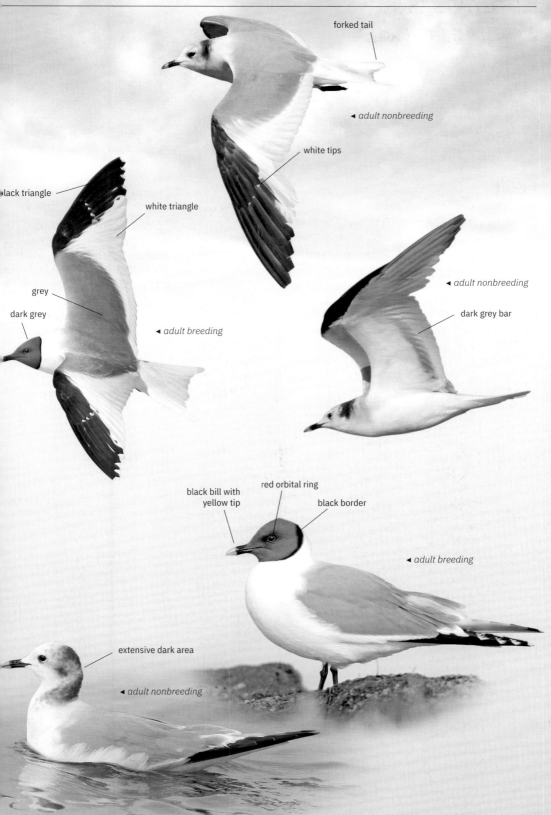

forked tail

*adult nonbreeding* ◄

white tips

lack triangle

white triangle

grey

dark grey

*adult breeding* ◄

*adult nonbreeding* ►

dark grey bar

black bill with
yellow tip

red orbital ring

black border

*adult breeding* ►

extensive dark area

*adult nonbreeding* ◄

# First cycle

In autumn, juvenile Sabine's Gulls can be confused with Black-legged Kittiwakes of the same age, especially in flight from a distance, when in certain conditions the black diagonal bar across the upperwing of the latter may appear rather brown and wide. Still, Kittiwake is bigger, its wings look narrower, its flight is generally more 'shearing' with high arches, and its head looks mainly white.

First-cycle Little Gull may also recall juvenile Sabine's Gull in flight from a distance, but its smaller size, less contrasting upperwing pattern with dark secondaries, and lack of a dark bar across the underwing (unlike Sabine's) should readily allow identification.

The post-juvenile moult is complete and results in a plumage that is very similar to that of adult non-breeding, but with a more extensive dark wash on the hindneck and sometimes an all-dark bill. For separation from other species, see p.34 under Adult

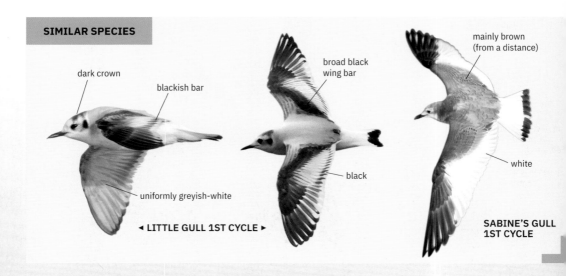

SIMILAR SPECIES

dark crown

blackish bar

uniformly greyish-white

◄ LITTLE GULL 1ST CYCLE ►

broad black wing bar

black

mainly brown (from a distance)

white

SABINE'S GULL 1ST CYCLE

▶ **RANGE**

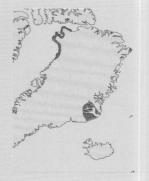
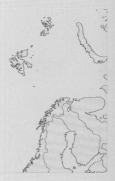

This gull species breeds from western and northern Alaska through the extreme north of the Canadian Arctic to northern Greenland. Small numbers also breed in the southeast of Greenland, as well as in northern Svalbard from time to time. In Siberia, breeding occurs from the Taimyr Peninsula and Lena delta to the shores of the Bering Sea and Wrangel Island (a discontinuous range).

Birds from central and eastern Siberia (as well as western Siberia to some extent?), Alaska, and parts of northern Canada winter in the cold subtropical waters of the eastern Pacific (from Mexico south to Chile). Those from eastern Canada, Greenland, and undoubtedly western Siberia, winter in the tropical and subantarctic waters of the eastern Atlantic, from Angola to South Africa. In the Canadian high Arctic, some birds may migrate to the Atlantic, while others from the same breeding colony may move to the Pacific. The species is

a rare visitor to inland Europe and a vagrant to the Mediterranean Sea and Middle East. Up to four subspecies have been described, but differences are minimal and their validity has been disputed.

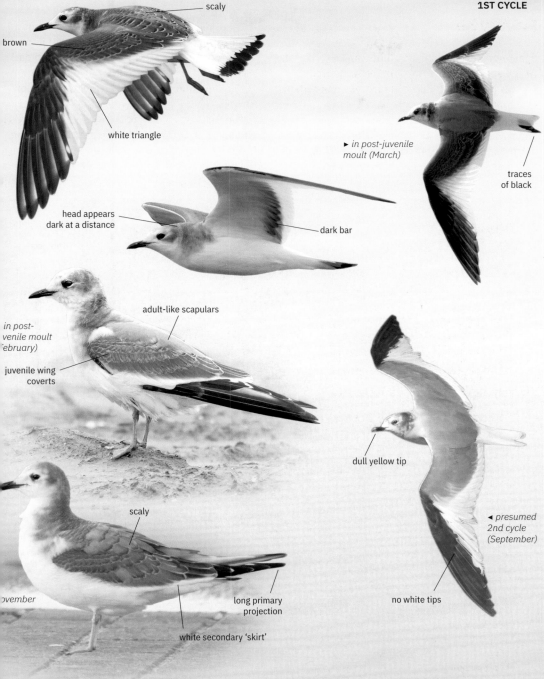

scaly

brown

white triangle

▶ *in post-juvenile moult (March)*

traces of black

head appears dark at a distance

dark bar

adult-like scapulars

*in post-venile moult (February)*

juvenile wing coverts

dull yellow tip

◀ *presumed 2nd cycle (September)*

scaly

ovember

long primary projection

no white tips

white secondary 'skirt'

## Second cycle

here is no evidence yet that second-cycle birds can e reliably told from adults, but subtle characters, uch as a black mark on P5 or the absence of small white tips on the primary coverts (present in adult Sabine's) might perhaps indicate subadult plumage. Such characters, however, can probably also be shown by advanced first-cycle birds, after the post-juvenile moult.

# Slender-billed Gull
## *Chroicocephalus genei*

▶ **STRUCTURE**

Even though it does not sport a dark hood in breeding plumage, Slender-billed Gull is one of the small gulls. It is slightly larger than Black-headed Gull, with which it shares a similar primary pattern. Compared with that of Black-headed, the structure is more elongated, with slightly slimmer, longer wings, longer neck, flat head, and slightly longer bill, which overall create a slimmer, more elongated profile. At rest, the wing projection is approximately equal to the bill length, whereas it is clearly longer than the bill in Black-headed. The head is more angular, less rounded, with sloping forehead. The legs are long and the body also looks long and slender. When feeding in shallow water, may spin around almost like a phalarope.

## Adult

Due to the pale grey upperparts, white leading edge on outer wing, and black tips on outer primaries, the plumage strongly recalls that of Black-headed Gull. However, the head is white throughout the year, except for an indistinct, rounded dark spot behind the eye in nonbreeding plumage. This spot is never as distinct as in Black-headed and is often absent altogether. Particularly at the height of the breeding season, the body can show a strong pink tinge. The primary pattern is similar to that of Black-headed, but the white primary tips average smaller. The legs are bright red, becoming even garnet red during breeding; the bill is uniformly red, becoming dark red or even nearly blackish during breeding. The dark orange iris becomes dark red during the breeding season, with a bright red orbital ring.

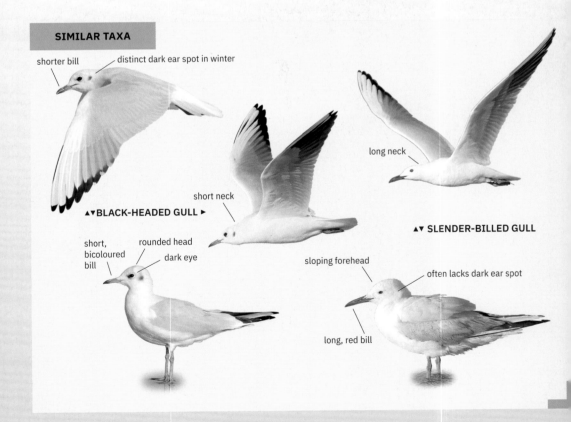

**SIMILAR TAXA**

shorter bill

distinct dark ear spot in winter

short neck

▲▼BLACK-HEADED GULL ▶

short, bicoloured bill

rounded head

dark eye

long neck

▲▼ SLENDER-BILLED GULL

sloping forehead

often lacks dark ear spot

long, red bill

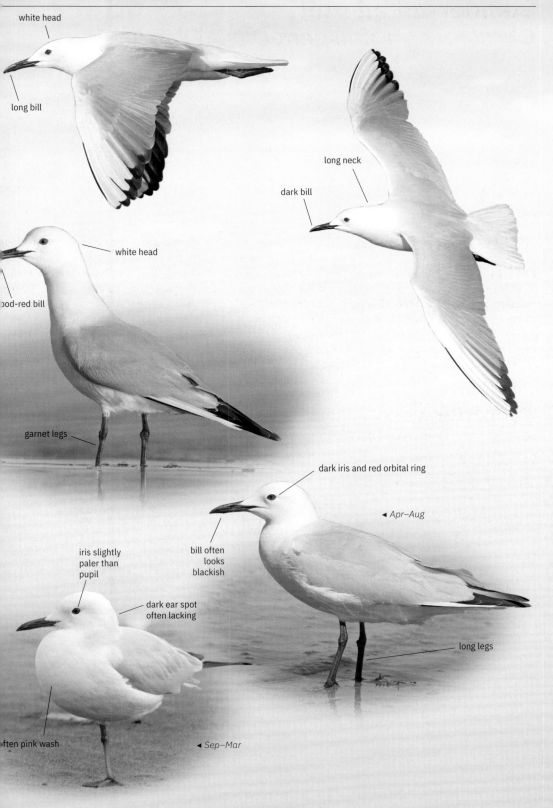

white head

long bill

long neck

dark bill

white head

blood-red bill

garnet legs

dark iris and red orbital ring

◄ *Apr–Aug*

iris slightly paler than pupil

bill often looks blackish

dark ear spot often lacking

long legs

often pink wash

◄ *Sep–Mar*

# First cycle

The plumage is again similar to that of Black-headed Gull. In flight, the wing pattern is nearly identical, but dark marks are present only on the inner primary coverts, not the outers. The head is white with an isolated, indistinct, rounded grey ear spot, lacking the grey bands across the crown that are present in most Black-headed Gulls (and in fresh juvenile Slender-billed, though only for a short period of time). The bill is dull orange with an indistinct, darker tip, and the legs are also orange. The iris is blackish at the time of fledging but quickly turns pale during the first winter. The post-juvenile moult is often more extensive than in Black-headed and may include all wing coverts, resulting in a much plainer, grey, more adult-like wing.

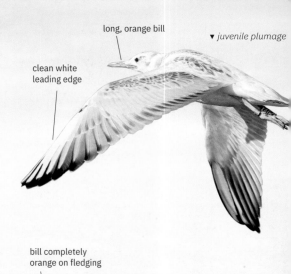

long, orange bill

clean white leading edge

▼ *juvenile plumage*

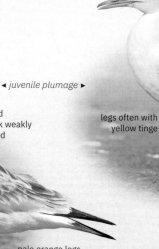

bill completely orange on fledging

brown scapulars with grey fringes

legs often with yellow tinge

◄ *juvenile plumage* ►

head and hindneck weakly patterned

pale orange legs

long bill with small dark tip

▼ *during post-juvenile moult (August)*

vague ear spot

pointed, pale bill

pale iris

▼ *1st cycle, nonbreeding (February)*

orange-pink

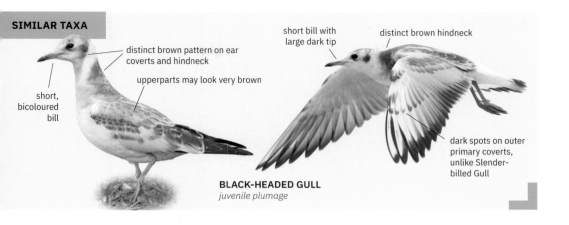

**SIMILAR TAXA**

distinct brown pattern on ear coverts and hindneck

upperparts may look very brown

short, bicoloured bill

short bill with large dark tip

distinct brown hindneck

dark spots on outer primary coverts, unlike Slender-billed Gull

**BLACK-HEADED GULL**
*juvenile plumage*

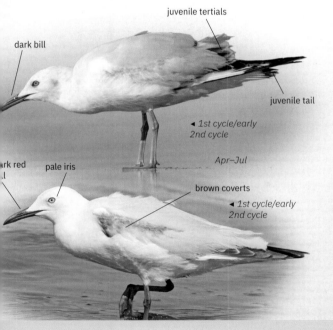

juvenile tertials

dark bill

juvenile tail

◄ *1st cycle/early 2nd cycle*

*Apr–Jul*

rk red l

pale iris

brown coverts

◄ *1st cycle/early 2nd cycle*

## Second cycle (not illustrated)

After the complete postbreeding moult the plumage of second-cycle birds is similar to that of adults, though sometimes with dark spots at the base of the tertials. The bill and legs are orange-red, slightly paler than in most adults. The differences from Black-headed Gull are the same as in adult birds.

**▶ RANGE**

Slender-billed Gull breeds along the coasts of the Mediterranean, Black, and Caspian Seas, but also inland in Central Asia. Isolated populations are found in the Persian Gulf and in Mauritania–Senegal. In winter, the species is found along the coasts of Northern Africa, the Adriatic, Black, Caspian, and Red Seas, and the Persian Gulf east to India, as well as in West Africa south to Guinea. Vagrants regularly reach Western and Northern Europe and have occurred as far north as Sweden, Lithuania, and Finland.

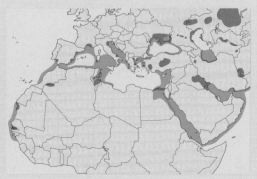

# Bonaparte's Gull
## *Chroicocephalus philadelphia*

**▶ STRUCTURE**

A small gull, clearly smaller than Black-headed Gull, with which it shares a similar structure, and visibly larger than Little Gull. The bill looks thinner than in Black-headed, and the wings are fairly long. The flight style is agile, sometimes tern-like. In all plumages the bill is black and the underside of the hand is pale, with white outer primaries and pale grey inners. The pale underside of the hand can often be seen in perched birds too, whereas the underside of the folded wingtip is black with a white wedge in Black-headed. In immature and nonbreeding plumages, a grey hindneck is characteristic.

## Adult

Birds in breeding plumage show a black hood. The upperparts are slightly darker grey than in Black-headed Gull. As in that species, the white outer primaries form a white leading edge on the outer wing, but the underside of the hand is paler since there is no blackish patch on the inner primaries. In flight, the white leading edge contrasts well with the strong grey colour of the rest of the upperwing. The hindneck is grey in most plumages (though it may look whiter in strong light), whereas it is always white in Black-headed Gull. The legs are fairly short and are orange-red in summer.

Adult Black-headed Gull shows a brown hood (in breeding plumage), paler grey upperparts, a large blackish patch on the underside of the hand in flight, a less rounded head shape, and a slightly longer, stronger bill that is (dark) red. Its legs are darker red.

In nonbreeding plumage, the crown may look slightly paler than in Black-headed Gull.

Adult Little Gull is a smaller and more compact bird with paler upperparts, white wingtips, and blackish-grey underwings. Second-cycle birds of this species may show black markings on the wingtips, but the pattern is that of isolated spots, not a continuous black trailing edge like Bonaparte's. In breeding plumage, the black hood reaches down to the hindneck, and white eye crescents are lacking; in nonbreeding plumage, the crown is darker than in Bonaparte's. The legs show a stronger pink colour in winter. In flight, Little Gull also looks more compact and lacks the white leading edge of Bonaparte's on the outer wing.

**SIMILAR TAXA**

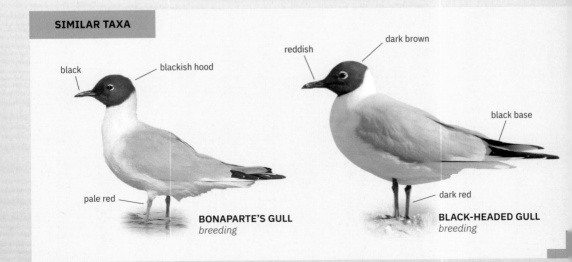

black · blackish hood · reddish · dark brown · black base · pale red · dark red

**BONAPARTE'S GULL**
*breeding*

**BLACK-HEADED GULL**
*breeding*

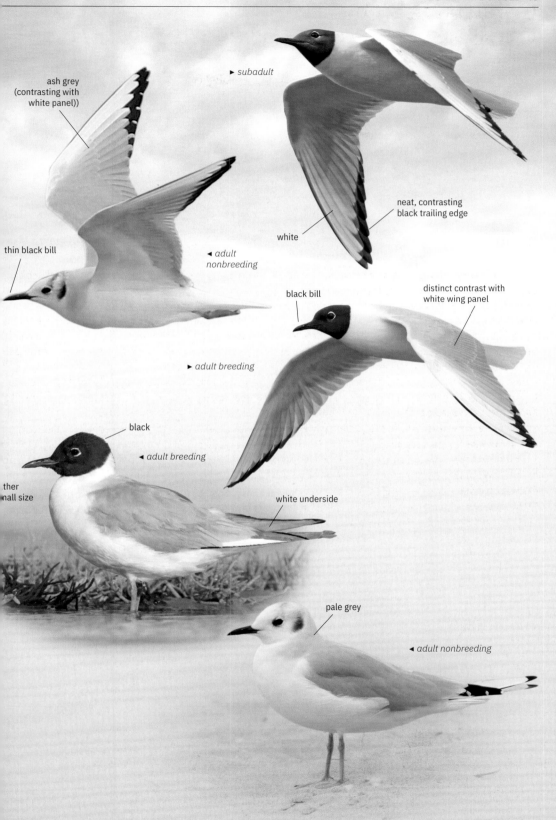

ash grey (contrasting with white panel))

► *subadult*

neat, contrasting black trailing edge

white

thin black bill

◄ *adult nonbreeding*

distinct contrast with white wing panel

black bill

► *adult breeding*

black

◄ *adult breeding*

ther
nall size

white underside

pale grey

◄ *adult nonbreeding*

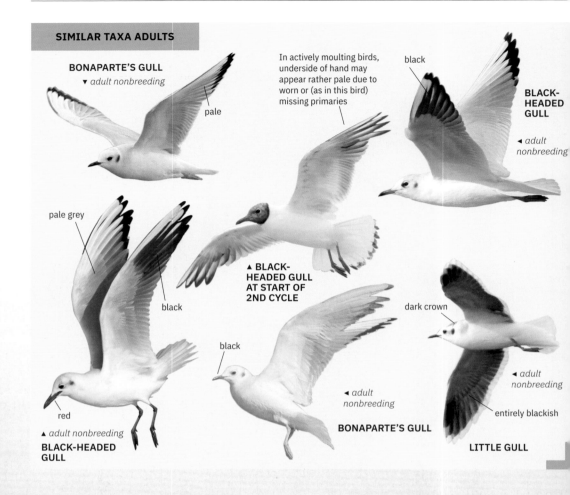

**SIMILAR TAXA ADULTS**

BONAPARTE'S GULL
▼ *adult nonbreeding*

pale

In actively moulting birds, underside of hand may appear rather pale due to worn or (as in this bird) missing primaries

black

BLACK-HEADED GULL

◄ *adult nonbreeding*

pale grey

black

▲ BLACK-HEADED GULL AT START OF 2ND CYCLE

dark crown

black

black

red

▲ *adult nonbreeding*
BLACK-HEADED GULL

◄ *adult nonbreeding*

BONAPARTE'S GULL

◄ *adult nonbreeding*

entirely blackish

LITTLE GULL

# First cycle

After the postjuvenile moult, the upperparts show a strong grey colour. The bill is thin and mainly black. The grey wash on the hindneck often runs down onto the breast sides (like a grey shawl). The legs are pale pink. In flight, the pale underside of the hand is striking. On the upperwing, the outer primary coverts show strong black markings, especially in fresh plumage. The black trailing edge on the flight feathers is slightly more contrasting and clear-cut than in Black-headed Gull.

First-cycle Black-headed Gull shows a reddish bill with black tip (not a completely black bill), reddish legs (not pink), and a white hindneck (not grey). Its upperparts are also paler grey. The juvenile scapulars, lesser coverts, and tertials are rufous brown when fresh (blackish or cold grey-brown in Bonaparte's). The outer primary coverts are largely white and the inner ones are darker than in Bonaparte's. At rest, the lowest tertial of first-cycle Bonaparte's Gull is more extensively grey than in Black-headed. Care should be taken with worn Black-headed Gulls at the end of their first cycle, which may show only a limited amount of black on the underside of the hand.

First-cycle Little Gull may look superficially similar to Bonaparte's Gull but has a more compact body shape and a stronger, more extensive black pattern on the wing coverts. In flight, the upperside of the hand is mainly black (lacking the white outer primaries of Bonaparte's). The crown shows a darker, blackish cap.

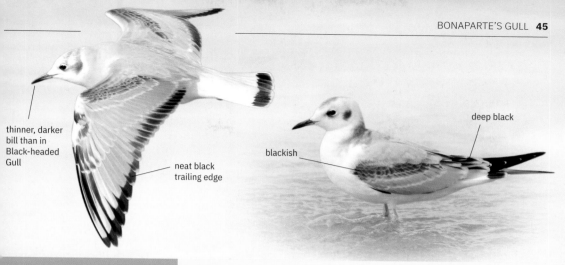

thinner, darker bill than in Black-headed Gull

neat black trailing edge

deep black

blackish

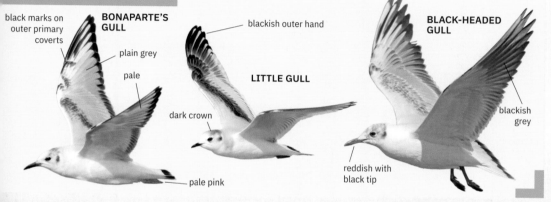

**SIMILAR TAXA 1ST CYCLE**

**BONAPARTE'S GULL**

black marks on outer primary coverts

plain grey

pale

pale pink

blackish outer hand

**LITTLE GULL**

dark crown

**BLACK-HEADED GULL**

blackish grey

reddish with black tip

# Second cycle

Very similar to adult nonbreeding, from which it may sometimes be told by the presence of black marks on a few tertials, primary coverts, or tail feathers. In breeding plumage, the black hood may still retain a number of scattered white spots.

Birds of this age class differ from Black-headed and Little Gulls in much the same way as adults.

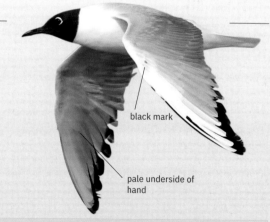

black mark

pale underside of hand

## ▶ RANGE

A Nearctic species that breeds mainly in the boreal and subarctic regions, often along the edge of boreal forest, from southwest Quebec to Alaska. Winters mostly in the east and southeast of the United States and in Cuba, but also along the Pacific coast of the US and in northern Mexico. Along the Atlantic coast, birds seem to show a tendency to remain north more often in recent years. The species migrates through the whole width of the North American continent.

Bonaparte's Gull is a vagrant to Europe (especially along the Atlantic coast), Japan, and Hawaii. It is monotypic.

# Brown-headed Gull
## *Chroicocephalus brunnicephalus*

> ▶ **STRUCTURE**
> Very similar to Black-headed Gull but slightly larger and a little bulkier, with slightly longer, more rounded wings and slightly thicker bill, though all of these differences are variable.

## Adult

Differs from Black-headed Gull mainly by the solid black triangle on the wingtip with two white mirrors (on P10 and P9, rarely also on P8). The eyes are pale instead of blackish, as in adult Grey-headed Gull, with which it shares the same wing pattern. Differences from the latter species include the colour of the head in breeding plumage, with a dark brown instead of ash-grey hood, the paler grey upperparts, and pale grey underwing (dark grey in Grey-headed Gull).

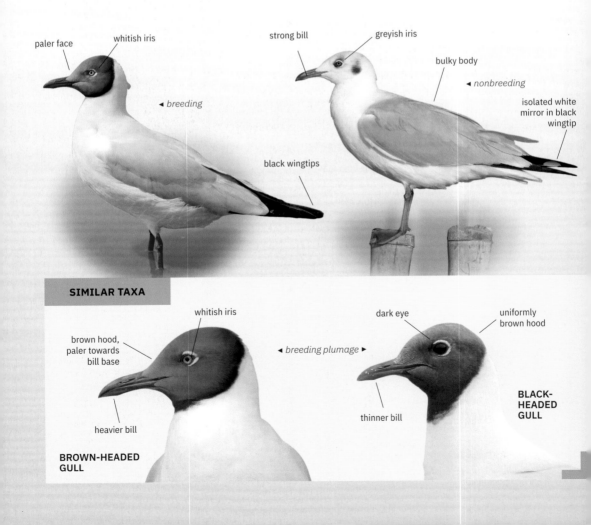

paler face

whitish iris

◄ *breeding*

black wingtips

strong bill

greyish iris

bulky body

◄ *nonbreeding*

isolated white mirror in black wingtip

**SIMILAR TAXA**

whitish iris

brown hood, paler towards bill base

◄ *breeding plumage* ►

heavier bill

**BROWN-HEADED GULL**

dark eye

uniformly brown hood

thinner bill

**BLACK-HEADED GULL**

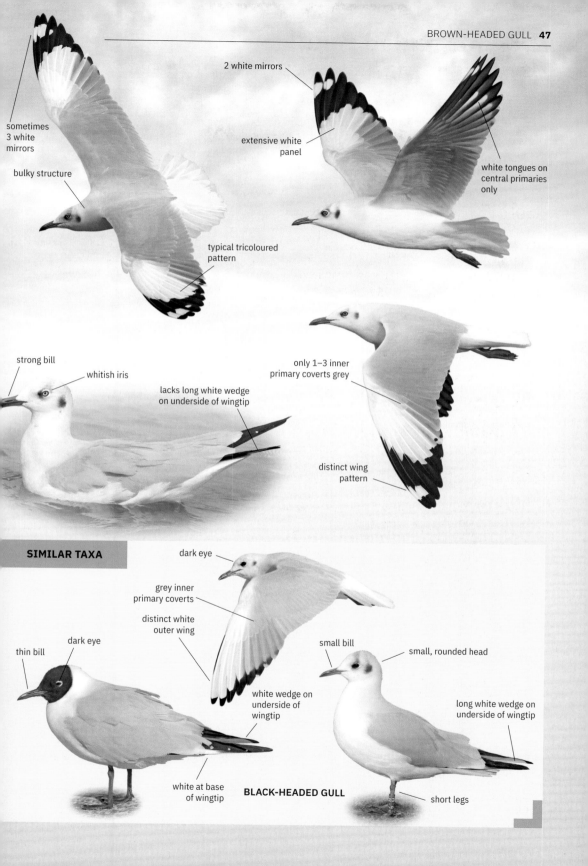

2 white mirrors

sometimes
3 white
mirrors

extensive white
panel

white tongues on
central primaries
only

bulky structure

typical tricoloured
pattern

strong bill

whitish iris

lacks long white wedge
on underside of wingtip

only 1–3 inner
primary coverts grey

distinct wing
pattern

**SIMILAR TAXA**

dark eye

grey inner
primary coverts

distinct white
outer wing

thin bill

dark eye

small bill

small, rounded head

white wedge on
underside of
wingtip

long white wedge on
underside of wingtip

white at base
of wingtip

**BLACK-HEADED GULL**

short legs

# First cycle

In addition to subtle differences in structure, first-cycle Brown-headed Gull shows a wing pattern that is different from young Black-headed Gull, particularly due to the solid black wingtip. The outer primaries show only a little white at the base, and the inner primaries show prominent, rounded white tips, which are lacking in Black-headed. A few Black-headed Gulls have very dark outermost primaries that may even lack white tongues, but the inner primary coverts of such birds always show black markings on a grey background, whereas these feathers are white and show few or no dark markings in Brown-headed. In such dark first-cycle Black-headed Gulls, P8 shows a white inner web that is very visible even on the upperwing, while this primary is almost completely black in Brown-headed Gulls of this age class.

The partial prebreeding moult at the end of the first cycle (in February–March) can be very extensive, with some birds replacing all wing coverts, secondaries, and tail feathers, resulting in a characteristic, advanced 'first-summer' plumage that looks much like adult but with juvenile primaries and primary coverts retained.

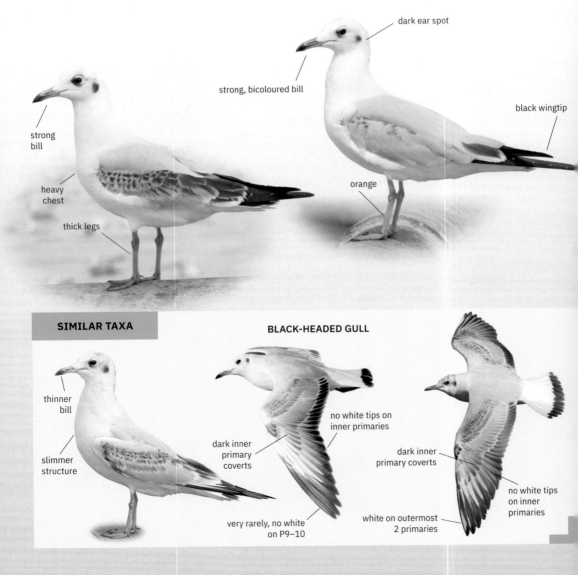

strong bill

heavy chest

thick legs

dark ear spot

strong, bicoloured bill

black wingtip

orange

**SIMILAR TAXA**

**BLACK-HEADED GULL**

thinner bill

slimmer structure

dark inner primary coverts

no white tips on inner primaries

dark inner primary coverts

no white tips on inner primaries

very rarely, no white on P9–10

white on outermost 2 primaries

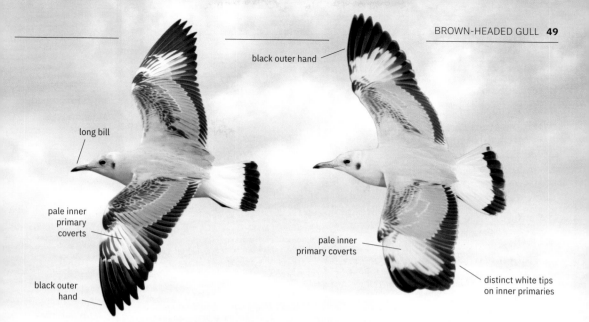

black outer hand

long bill

pale inner primary coverts

black outer hand

pale inner primary coverts

distinct white tips on inner primaries

## Second cycle

Very similar to adult, but with subtle dark marks on a number of secondaries and inner primaries, and with smaller white mirrors on P9–P10. The eyes are often still dark, but otherwise identification is much the same as in adult.

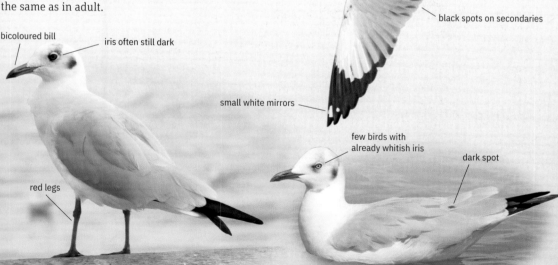

black spots on secondaries

small white mirrors

bicoloured bill

iris often still dark

red legs

few birds with already whitish iris

dark spot

### ▶ RANGE

This Asian gull breeds on the Tibetan plateau in Central China and winters from the Indian Peninsula to southern China, mainly along the coasts but also inland into Nepal. It is most numerous from Pakistan to Thailand; in Hong Kong it is rare but regular. Accidental in Iran and Iraq. There is also one accepted record from Israel in May 1985 and a very recent sighting in Kuwait in December 2020.

# Black-headed Gull
## *Chroicocephalus ridibundus*

▶ **STRUCTURE**
A small gull with long wings and thin bill. It is smaller than Common Gull but larger than Little Gull; its size is comparable to that of Slender-billed Gull.

In all plumages, Black-headed Gull shows a characteristic white leading edge on the outer wing, an extensive blackish patch on the underside of the hand, and a typical head pattern.

## Adult

The upperparts are pale grey; the white underparts may show a slight pinkish tinge in spring. The outer primaries are white with black marks at the tips and contrast with the rest of the upperwing. The bill is dark red in summer (looking black from a distance) and slightly brighter red at the base in winter. In breeding plumage a brownish-black hood covers the head and does not reach far down at the rear (not onto the white hindneck). In nonbreeding, the head is mainly white, except for a small black mark behind the eye and vague grey smudges across the crown. Bonaparte's Gull has similar plumage and is a potential confusion species (see p.42).

Adult Mediterranean Gull is slightly larger with bulkier body. It shows whiter upperparts with white wingtips, a jet-black hood in breeding plumage that reaches further down on nape, and a stronger, bright red bill with black subterminal bar. The white eye crescents are bolder. Nonbreeding adults show a blackish 'mask' around the eye. Note, however, that adult Black-headed Gull can occasionally show a similar 'mask' during the prebreeding moult. Second-cycle Mediterranean Gull often shows a black pattern on its wingtips, but in perched birds the white primary tips are clearly larger than in Black-headed, while flying birds lack the white leading edge on the primaries as well as the blackish patch on the underside of the hand.

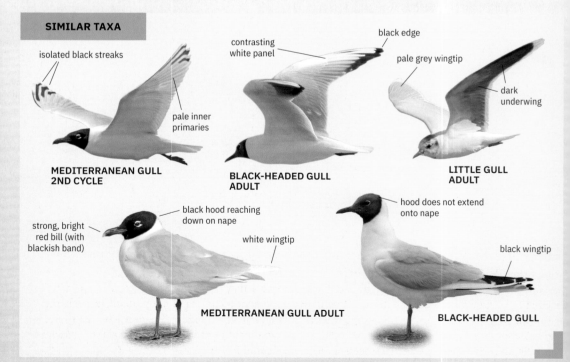

**SIMILAR TAXA**

isolated black streaks

pale inner primaries

**MEDITERRANEAN GULL 2ND CYCLE**

contrasting white panel

**BLACK-HEADED GULL ADULT**

black edge

pale grey wingtip

dark underwing

**LITTLE GULL ADULT**

strong, bright red bill (with blackish band)

black hood reaching down on nape

white wingtip

**MEDITERRANEAN GULL ADULT**

hood does not extend onto nape

black wingtip

**BLACK-HEADED GULL**

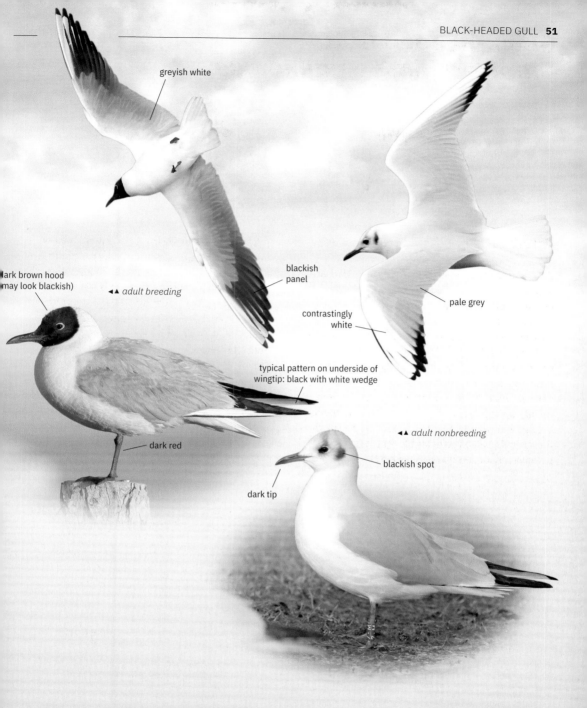

greyish white

blackish panel

dark brown hood (may look blackish)

◄▲ *adult breeding*

pale grey

contrastingly white

typical pattern on underside of wingtip: black with white wedge

dark red

◄▲ *adult nonbreeding*

blackish spot

dark tip

Little Gull is smaller and whiter overall, with white wingtips or, in second-cycle birds, with isolated black marks on the wingtips (unlike Black-headed Gull, in which the black pattern at the tips is continuous). Its underwings are dark greyish-black. Slender-billed Gull (see p.38) is approximately the same size as Black-headed but has longer and darker bill. In flight and from a distance, the two species can easily be confused where they occur together, but bill shape and overall structure are important differences. In nonbreeding plumage, the dark ear spot is more prominent in Black-headed Gull compared with Slender-billed.

# First cycle
———

At this age, the plumage is characterised by a mixture of brown and grey feathers, while the wingtips look black (in perched birds). Fresh juveniles show a scalloped brown pattern on mantle and scapulars, but these are quickly replaced by grey feathers during the post-juvenile moult.

Juvenile Mediterranean Gull looks colder brown overall, with heavier structure, stronger bill, and dark legs. In flight, it shows a very different wing pattern. After the post-juvenile moult, it shows a strong contrast between the pale silvery grey upperparts and the blackish lesser and median coverts. The bill is still darker than in Black-headed.

Can be confused with first-cycle Bonaparte's Gull (see p.42), but is always larger. First-cycle Little Gull is much smaller and has more contrasting black and grey plumage, with more extensive dark pattern on the head, and a black patch at the base of the underwing, close to the body. It has no white leading edge on the outer wing.

Confusion is also possible with Slender-billed Gull at this age (see p.38), but note that the post-juvenile moult is often more extensive in that species and may include all wing coverts, resulting in a much plainer grey, more adult-like wing than in Black-headed. The legs are pink or orange and long, with clearly visible tibia. The bill is longer and often entirely orange-red.

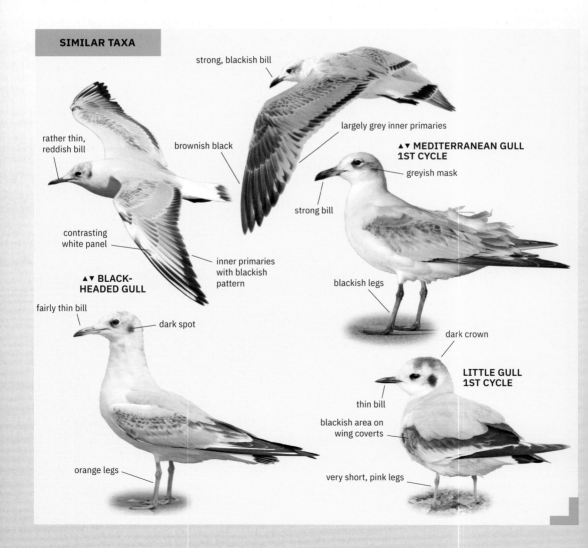

SIMILAR TAXA

strong, blackish bill

rather thin, reddish bill

brownish black

largely grey inner primaries

▲▼ MEDITERRANEAN GULL
1ST CYCLE

greyish mask

strong bill

contrasting white panel

inner primaries with blackish pattern

▲▼ BLACK-HEADED GULL

blackish legs

fairly thin bill

dark spot

dark crown

LITTLE GULL
1ST CYCLE

thin bill

blackish area on wing coverts

orange legs

very short, pink legs

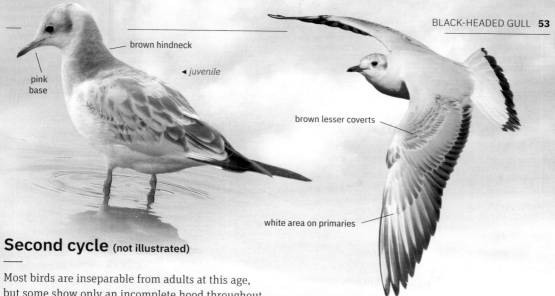

brown hindneck

◄ *juvenile*

pink
base

brown lesser coverts

white area on primaries

## Second cycle (not illustrated)

Most birds are inseparable from adults at this age, but some show only an incomplete hood throughout the breeding season, with whitish mottling around the bill base.

Second-cycle Mediterranean Gull shows a variable amount of black on the outer webs of the outer primaries, but its underwings are white, lacking the blackish patch on inner hand of Black-headed. Second-cycle Little Gull shows a black underside of the hand which continues broadly across the secondaries.

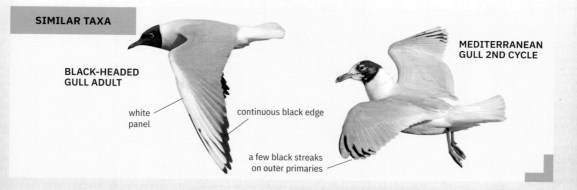

### SIMILAR TAXA

**BLACK-HEADED
GULL ADULT**

white
panel

continuous black edge

**MEDITERRANEAN
GULL 2ND CYCLE**

a few black streaks
on outer primaries

### ▶ RANGE

A Holarctic species, breeding from Western Europe east throughout Siberia to Kamchatka. Breeding range reaches south to Spain and Iran, and north to Iceland, southern Greenland, and Lapland. In North America it breeds only in Newfoundland and the Gulf of Lawrence (Canada). The wintering range reaches from Japan to Malaysia and also includes the Indian subcontinent, the Persian Gulf, the Red Sea, the Nile Valley, the coast of West Africa, the African Great Lakes, and all of Europe. Very small numbers winter along the East Coast of North America, especially in Newfoundland. There are two subspecies, nominate *ridibundus* and the Siberian subspecies *sibiricus*, which cannot reliably be separated in the field.

# Grey-headed Gull
## *Chroicocephalus cirrocephalus*

▶ **STRUCTURE**
Grey-headed Gull is slightly larger than Black-headed Gull, with bulkier body, stronger bill, and more sloping forehead. When alert, often adopts an elongated posture, which emphasizes the slightly longer neck than Black-headed. The structural differences may be subtle, but they are important for identification.

In all plumages it shows characteristic dark underwing and large white patch on outer upperwing.

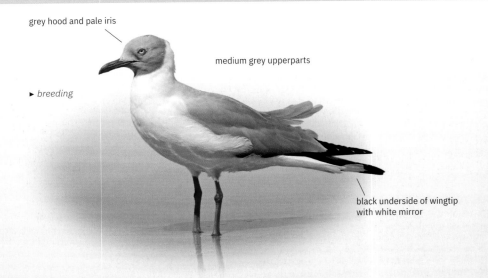

grey hood and pale iris

medium grey upperparts

▶ *breeding*

black underside of wingtip with white mirror

## Adult

The upperparts of Grey-headed Gull are darker grey than in Black-headed, and the iris is pale. In breeding plumage, the grey hood is unmistakable, but nonbreeding birds are more similar to Black-headed, with just a vague grey smudge on the ear coverts. The underside of the wingtip is mainly black with an oval-shaped white mirror. In flight, the upperwing clearly differs from that of Black-headed in the largely black outermost primaries (with two white mirrors), whereas these are mainly white in adult Black-headed Gull. In good light, the secondaries appear darker grey than the wing coverts. The underwing coverts are white in Black-headed Gull, and the underside of the hand shows a variegated pattern of grey inner, blackish middle, and white outermost primaries.

Brown-headed Gull is another potential confusion species, especially in the Middle East, where both species may turn up as vagrants. It has approximately the same size and shape as Grey-headed, a very similar wing pattern, and also a pale iris. It differs in the following ways:

- In flight, the underwing coverts are pale grey, and in good light conditions the underwing therefore does not appear as uniformly dark as in Grey-headed.
- The upperparts are pale grey like Black-headed or only fractionally darker.
- The blackish spot on ear coverts is better defined, and there is often also a blackish spot immediately in-front of the eye, more obviously so than in Grey-headed.
- The white eye crescents are bolder and more prominent.

On the upperwing, there is very little difference in tone between the secondaries and the wing coverts.

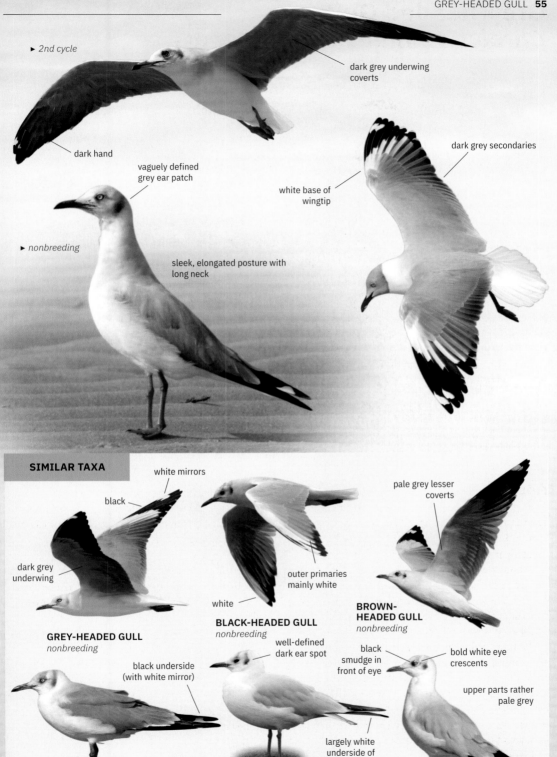

► *2nd cycle*

dark grey underwing coverts

dark hand

vaguely defined grey ear patch

dark grey secondaries

white base of wingtip

► *nonbreeding*

sleek, elongated posture with long neck

**SIMILAR TAXA**

white mirrors

black

pale grey lesser coverts

dark grey underwing

outer primaries mainly white

white

**BLACK-HEADED GULL**
*nonbreeding*

**BROWN-HEADED GULL**
*nonbreeding*

**GREY-HEADED GULL**
*nonbreeding*

well-defined dark ear spot

black smudge in front of eye

bold white eye crescents

black underside (with white mirror)

upper parts rather pale grey

largely white underside of wingtip

# First cycle

The juvenile plumage is somewhat colder brown than that of Black-headed Gull, and the greater coverts are darker grey. The folded wingtip shows a completely dark underside, lacking the long white wedge of Black-headed. In flight, the uniform dark underwing is again characteristic, and the upper hand shows 3–4 black outermost primaries, which contrast strongly with the white panel on outer wing. The juvenile upperparts are moulted quickly, and vagrants may seem not very likely to turn up in this plumage, yet the Gibraltar bird in August 1992 was a juvenile.

After the post-juvenile moult, the mantle and scapulars are plain grey, darker than in Black-headed Gull. The subsequent, partial moult to first-summer plumage can be extensive and often includes all wing coverts and tertials, which means that advanced birds can combine adult-like plumage with a full set of juvenile primaries (brown, pointed, and often worn). This combination is not usually seen in Black-headed Gull. It is possible that in some birds, at least in Senegal and The Gambia, the moult even includes the tail and all secondaries, as has been documented in Brown-headed Gull. This creates a unique plumage in which an all-white tail and grey secondaries are combined with a full set of juvenile primaries.

It should be noted that there is some variation in the wingtip pattern of first-cycle Black-headed Gull.

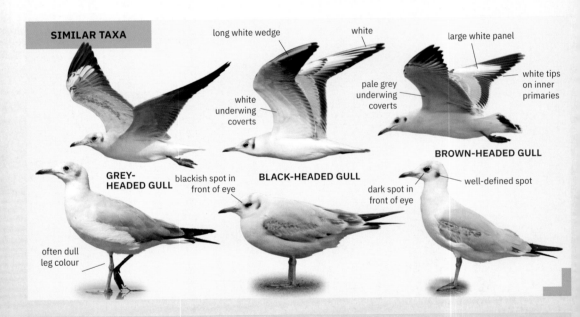

SIMILAR TAXA

long white wedge — white — large white panel

white tips on inner primaries

pale grey underwing coverts

white underwing coverts

BROWN-HEADED GULL

GREY-HEADED GULL — blackish spot in front of eye — BLACK-HEADED GULL — dark spot in front of eye — well-defined spot

often dull leg colour

## ▶ RANGE

The subspecies *poiocephalus* breeds on the African continent south of the Sahara in two separate populations, one in West Africa and the other extending from Sudan and Ethiopia south through Uganda, Tanzania, eastern DRC, Zambia, and Angola to southern Africa (including Madagascar). In West Africa, breeds from Mauritania south to Guinea-Bissau, but also well inland from Mali to Chad and Cameroon. The winter range includes all of sub-Saharan Africa, with large concentrations at Lake Chad, Lake Victoria, and Lake Nakuru. Also common along the coast of Senegal and The Gambia in winter.

Vagrant to Morocco (9 records), Tunisia, Algeria, Egypt, Jordan, Saudi Arabia, Red Sea, Yemen, Spain (5, including the Canary Islands and Gibraltar), Italy, and Israel (4).

The nominate subspecies breeds in South America and has occurred as a vagrant as far north as Florida and New York, USA.

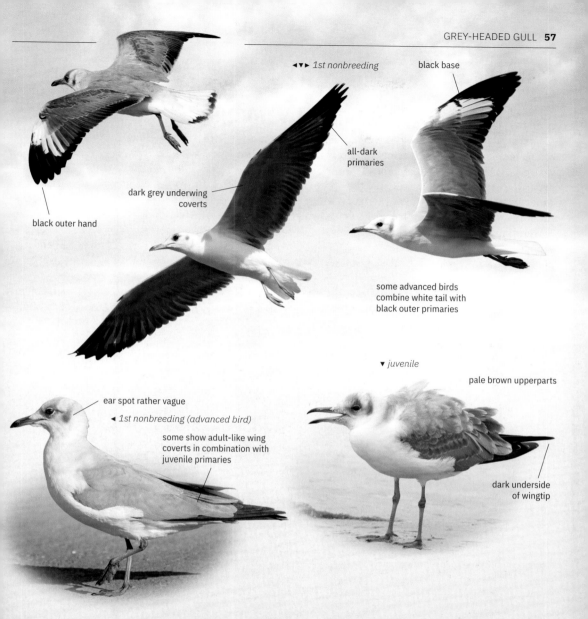

◄▼► *1st nonbreeding*

black base

all-dark primaries

dark grey underwing coverts

black outer hand

some advanced birds combine white tail with black outer primaries

▼ *juvenile*

pale brown upperparts

ear spot rather vague

◄ *1st nonbreeding (advanced bird)*

some show adult-like wing coverts in combination with juvenile primaries

dark underside of wingtip

While most birds have mainly white outermost primaries, some show a partly black pattern on these feathers, and in extreme cases the outermost 2–3 primaries are largely black, thus resembling Grey-headed.

First-cycle Brown-headed Gull is very similar, but its upperparts are paler grey than in Grey-headed, and the head shows a better defined, blackish ear spot as well as bolder white eye crescents. In flight, a useful difference is the bold white tips on the inner primaries, more obvious and more rounded than in Grey-headed. The underwing coverts are pale grey.

## Second cycle

Second-cycle birds differ only very subtly from adults and can therefore be identified by the same features, although the iris may still be dark.

# Little Gull
## *Hydrocoloeus minutus*

**▶ STRUCTURE**
The smallest gull in the world, which attracts attention by its small size and agile flight. The flight style may recall that of a tern. The wingbeats are slightly quicker (more tern-like) than in Black-headed Gull. The general impression is that of a bird with rounded wings and short bill.

## Adult

The upperparts are pale grey and the wingtips are white. The underwing is blackish-grey, darkest on the remiges. Birds in breeding plumage show a black hood that reaches down to the lower nape. The small, thin bill is brownish-red (looking black from a distance) and the legs are bright red. In nonbreeding plumage the head is white with a black spot behind the eye and a dark area on the crown. The nape is pale grey.

Adult Black-headed Gull is larger in size, more elongated, with more neutral grey upperparts and just a greyish-black patch on the underside of the primaries (the rest of the underwing is white). The summer hood is browner in this species, the eye crescents are white, and the folded wingtips look black.

Adult Ross's Gull is slightly bigger than Little Gull, with wedge-shaped tail and longer, more pointed wings (see p.64).

SIMILAR TAXA

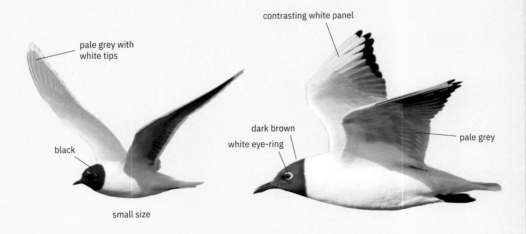

pale grey with white tips

black

small size

contrasting white panel

dark brown
white eye-ring

pale grey

**LITTLE GULL ADULT**
*breeding*

**BLACK-HEADED GULL ADULT**
*breeding*

white tips

rounded shape

black

► *adult*

thin white trailing edge

dark bill

► *probable 2nd cycle*

some show pink wash

no white eye crescents

deep black

◄ *adult breeding*

rounded

short, red legs

blackish

black

dark crown

◄ *adult nonbreeding* ►

dark

thin bill

small and compact shape

bright pink

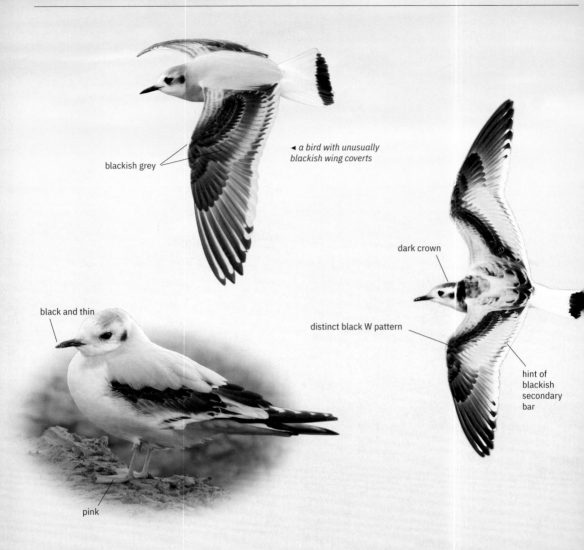

blackish grey

◄ *a bird with unusually blackish wing coverts*

dark crown

distinct black W pattern

hint of blackish secondary bar

black and thin

pink

## First cycle

Birds of this age class have the same shape as adults, but the lack of contrast between the pale grey upperparts and white wingtips diminishes the impression of rounded wings. In flight, a black W is visible on the upperwings, formed by the black outer hand and black diagonal bar across the arm. In juvenile birds, the black scapulars add to the effect. The underwing is pale greyish-white, unlike in adults. The rear crown is blackish-grey. During winter the black pattern tends to fade rapidly, especially on the wing coverts and tertials, and the black W becomes less contrasting. The juvenile scapulars are quickly replaced by

uniformly grey upperparts during the post-juvenile moult.

May be confused with first-cycle Black-legged Kittiwake, but that species is bigger, bulkier, and has a more direct, less fluttering flight. Its upperparts are slightly darker grey than in Little Gull, and the wings show a large, triangular white patch across the secondaries and inner primaries (greyish in Little). It also shows a black collar at the base of the hindneck.

Especially from a distance, confusion is possible with first-cycle Ross's Gull (see p.64). First-cycle Black-headed Gull shows less contrasting pattern on upperwing, a more elongated shape, white outer primaries (mostly black in first-cycle Little), and a longer bill, which is red with a black tip.

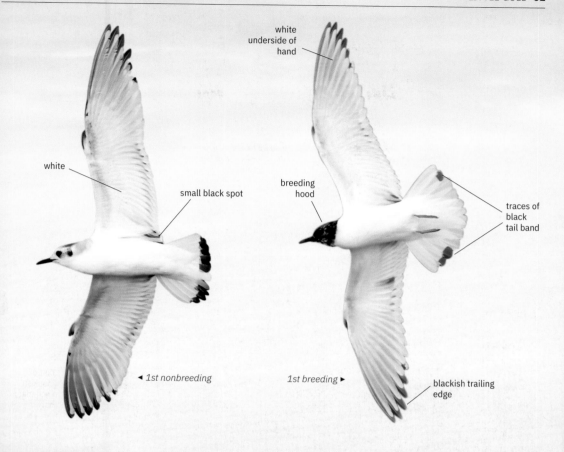

white underside of hand

white

small black spot

breeding hood

traces of black tail band

◄ *1st nonbreeding*

*1st breeding* ►

blackish trailing edge

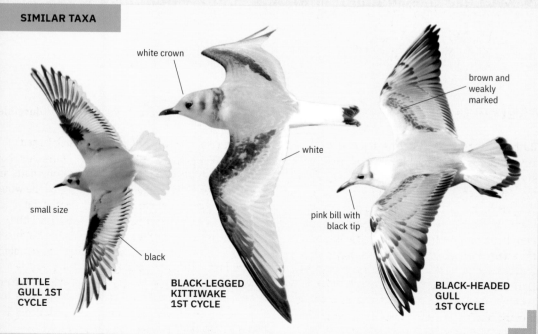

## SIMILAR TAXA

white crown

brown and weakly marked

white

small size

pink bill with black tip

black

**LITTLE GULL 1ST CYCLE**

**BLACK-LEGGED KITTIWAKE 1ST CYCLE**

**BLACK-HEADED GULL 1ST CYCLE**

## Second cycle

Resembles adult, but the underwing is less extensively dark, with more contrast between whitish underwing coverts and blackish-grey flight feathers. The upperwing looks mainly similar to that of adult birds, being pale grey with well-demarcated white wingtip creating the impression of a rounded wing. However, there are variable blackish marks on the tips of the outer primaries. The plumage may therefore vaguely recall that of second-cycle Mediterranean Gull, but that species is clearly bigger, with stronger bill and nearly white wings (thus lacking the well-demarcated white trailing edge of Little Gull).

Birds in breeding plumage develop a more or less complete greyish-black hood that is spotted white.

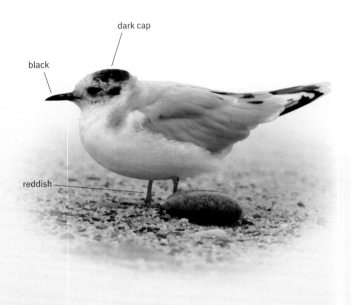

dark cap

black

reddish

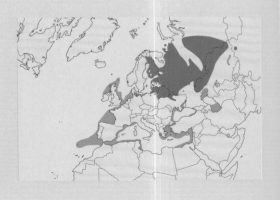

**▶ RANGE**
A boreal species that breeds from the Scandinavian Peninsula and the Baltic region to Russia (central Siberia) and northern Kazakhstan. Further east there is also a breeding population from Lake Baikal to the Sea of Okhotsk. The species has bred in North America (during the 1980s), especially along the Great Lakes and Hudson Bay. It winters in the eastern Atlantic south to Morocco, but also in the English Channel, the southern Baltic Sea, the Mediterranean Sea, and the Black Sea (and rarely along the southern shores of the Caspian Sea). Accidental in West Africa and South America.

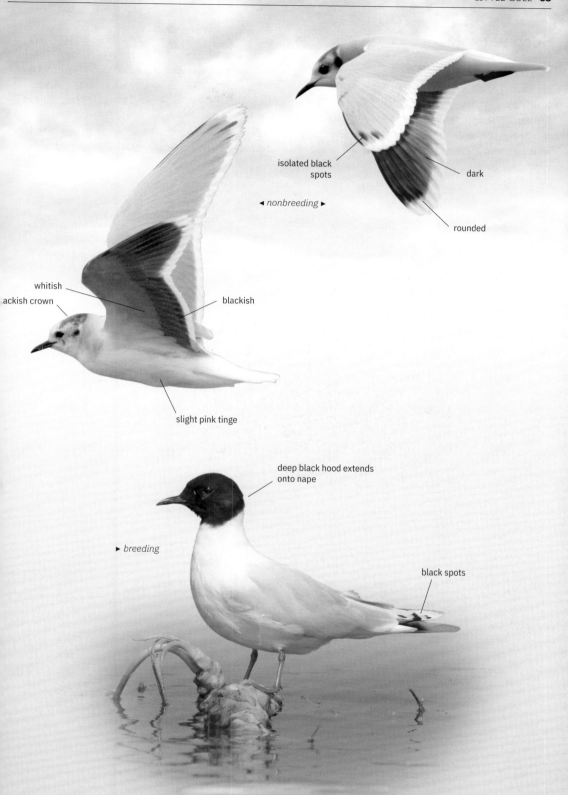

isolated black
spots

dark

◄ *nonbreeding* ►

rounded

whitish

ackish crown

blackish

slight pink tinge

deep black hood extends
onto nape

► *breeding*

black spots

# Ross's Gull
## *Rhodostethia rosea*

> ▶ **STRUCTURE**
> Ross's Gull is a small gull with rather compact body, a fairly big head, short neck ('head resting between the shoulders'), long wings, and a rather long, graduated, wedge-shaped tail with protruding central tail feathers. The bill is short and black, with a blunt tip. In flight, the bird looks slim and elegant.

## Adult

Can be confused only with adult Little Gull, in bad conditions. That species, however, is slightly smaller with a square, not graduated tail and shows blackish underwings with a clear-cut white trailing edge that extends onto the outer primaries (unlike in Ross's Gull).

The plumage is entirely remarkable. The upperparts are very pale grey without dark marks on the wingtips. The underwing coverts are greyish and contrast slightly with the white trailing edge on the secondaries and inner primaries. The underparts show a pink wash that is individually variable (and may be present all year). The short legs are bright red, and in breeding plumage so is the orbital ring. Breeding birds show a thin but complete black neck-ring, which is absent in nonbreeding plumage. The head is always white, but with subtle grey marks on the crown and around the eye in nonbreeding.

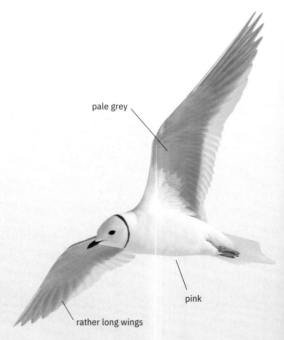

pale grey

pink

rather long wings

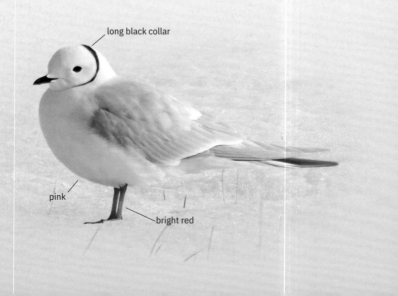

long black collar

pink

bright red

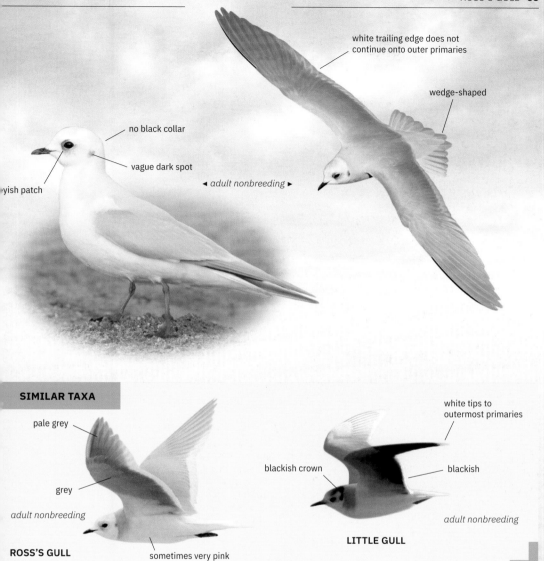

white trailing edge does not continue onto outer primaries

wedge-shaped

no black collar

vague dark spot

◄ *adult nonbreeding* ►

~yish patch

**SIMILAR TAXA**

pale grey

grey

*adult nonbreeding*

**ROSS'S GULL**

sometimes very pink

blackish crown

white tips to outermost primaries

blackish

*adult nonbreeding*

**LITTLE GULL**

# First cycle

~ay be confused with first-cycle Little Gull, but that ~ecies is smaller, shows a smaller white panel on ~pperwing (because the secondaries are always ~ark), a blackish cap on the crown (pale grey and ~ore restricted in Ross's), a square tail shape (when ~en up close), and a slightly longer bill. Note also ~at first-cycle Ross's Gull has white inner and ~ntral primaries with thin black tips, while these ~athers are dark grey with white tips in first-cycle

Little. The underwing shows a greyish wash contrasting with a triangular white pattern on inner hand (whereas in Little the underwing is mainly white). There is a blackish ear spot on the head and the legs are pink. On the folded wingtip the white fringes often look more prominent and more complete than in Little Gull, especially close to the tertials.

First-cycle Black-legged Kittiwake is larger and shows a black half-collar on hindneck, a bigger, more vertical ear spot, and blackish legs. In flight,

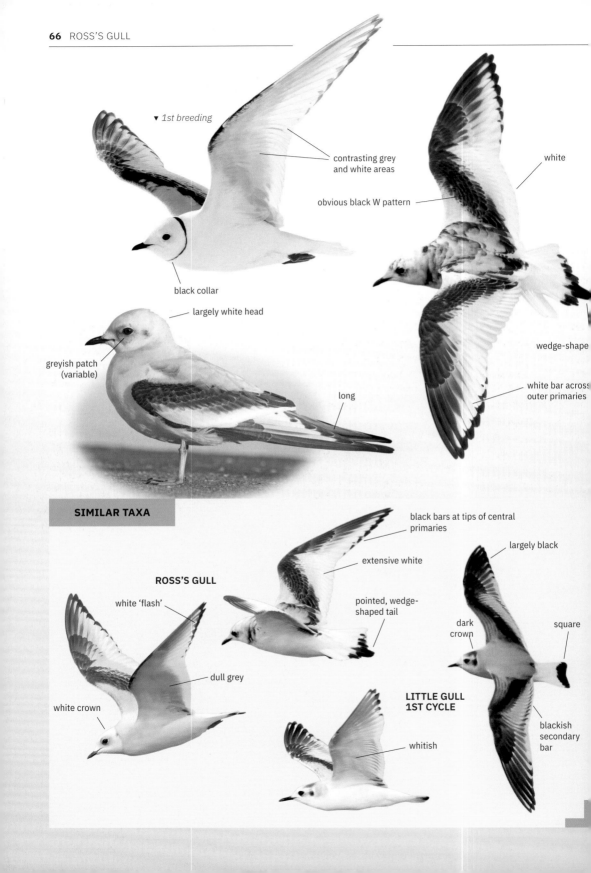

▼ *1st breeding*

contrasting grey
and white areas

obvious black W pattern

white

black collar

largely white head

greyish patch
(variable)

long

wedge-shape

white bar across
outer primaries

### SIMILAR TAXA

black bars at tips of central
primaries

largely black

**ROSS'S GULL**

white 'flash'

extensive white

pointed, wedge-
shaped tail

dark
crown

square

dull grey

white crown

**LITTLE GULL
1ST CYCLE**

blackish
secondary
bar

whitish

s inner primary coverts are very pale grey,
hereas they are black in Ross's, protruding
wards.

Sabine's Gull is slightly larger and lacks the black
iagonal bar across the upperwing. In addition, it
has a forked tail and completely white inner
primaries (without black tips).

After the prebreeding moult, some first-cycle
Ross's Gulls may show a black neck-ring like adults,
though often a bit thinner.

## Second cycle

irds of this age class are similar to adults (with
lack neck-ring in breeding plumage and pink tinge
n underparts) but sometimes retain traces of
nmaturity, such as black marks on the outer
rimaries, primary coverts, or tertials. The leg colour
ay be duller than in adults.

Compared with those of second-cycle Little Gull,
he black subterminal marks on the outer primaries
re more subtle, less prominent, the underside of
ese feathers is pale grey (blackish in Little), the
hite trailing edge on the wing is broader and
ore concentrated on the inner hand, and
e crown is paler.

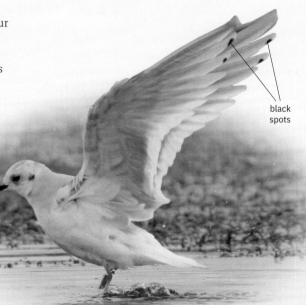

black
spots

## ▶ RANGE

Ross's Gull has a circumarctic range that is not precisely
known. It breeds in northeastern Siberia, from the
Taimyr Peninsula in the west to the Kolyma delta in the
east. It also breeds very locally in Greenland. It used to
breed near Churchill, Canada, but no longer seems to be
present there. Big autumn movements towards the Sea
of Beaufort (with thousands of birds observed at Barrow,
Alaska) occur from early September to early October,
then in the other direction in October–November. The
species winters along the edge of the pack ice, at least
in the Labrador Sea; other wintering populations have
not been located yet.

Ross's Gull is a vagrant to most of the North American
coasts in winter, and also to Northwestern Europe

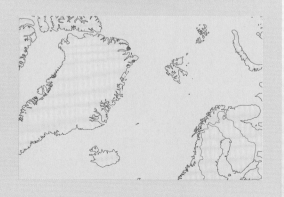

(especially the British Isles, but birds have occurred as
far south as Spain and Italy) and in Asia south to Korea.

# Laughing Gull
## *Leucophaeus atricilla*

▶ **STRUCTURE**
A medium-sized gull with slender, elegant body and long wings. In size between Black-headed and Common Gulls, but closer to the latter. Fairly long bill with pointed tip.

## Adult

With their dark, slaty-grey upperparts, dark bill, and blackish legs, adult Laughing Gulls can really be confused only with Franklin's Gull. Common Gull has pale legs, pale bill, slightly paler, more bluish-grey upperparts, different head pattern, and more white on wingtip. Adult Laughing Gull has extensive black wingtip, with at most small white tips on the outer primaries but no white mirror. In adult Franklin's Gull, on the other hand, the wingtip is a bold mixture of black and white colours. In winter plumage, Laughing shows a thin dark mask around the eye, while Franklin's shows an extensive dark, 'half-hooded' pattern with bolder white eye crescents. Beware, however, of moulting Laughing Gulls that have not acquired the full dark summer hood yet, so check the amount of white on wingtip,

as well as general size and structure (longer legs, longer, more pointed bill and long, pointed wings).

An important potential pitfall is young Franklin's Gull with maximum amount of black on wingtip. Franklin's Gull is quite unique in that it has a complete moult not only in autumn as most gulls but also in spring. In the first cycle, this may produce an advanced 'first summer' plumage that resembles adult but with more black on the wingtips. Since such birds lack the extensive white pattern of adults, they are rather similar to adult Laughing Gull. In addition to size and structure, an important difference is that they show grey colour at the base of all primaries (usually including the outermost), while in adult Laughing the outermost 2–3 primaries are completely black (up to the primary coverts), creating a solid black outer hand. This difference

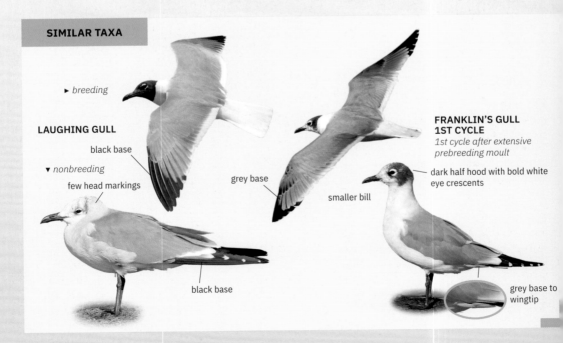

**SIMILAR TAXA**

LAUGHING GULL

▶ *breeding*

black base

▼ *nonbreeding*

few head markings

grey base

black base

smaller bill

**FRANKLIN'S GULL 1ST CYCLE**
*1st cycle after extensive prebreeding moult*

dark half hood with bold white eye crescents

grey base to wingtip

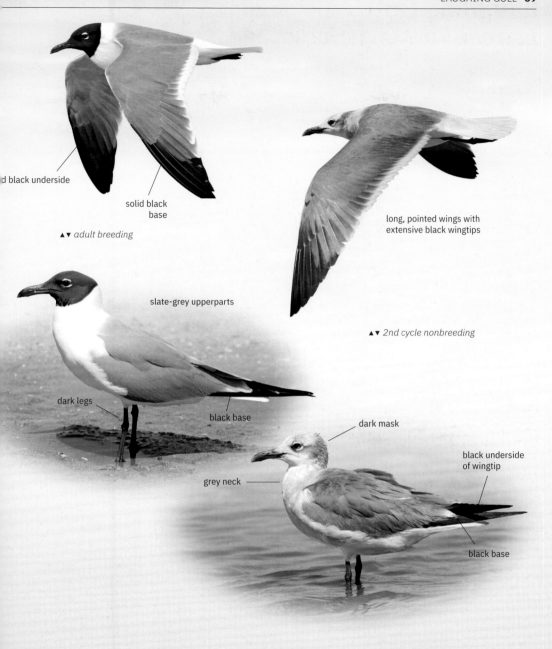

d black underside

solid black
base

▲▼ *adult breeding*

long, pointed wings with
extensive black wingtips

slate-grey upperparts

▲▼ *2nd cycle nonbreeding*

dark legs

black base

dark mask

grey neck

black underside
of wingtip

black base

evident on the upperside as well as underside
the outer wing, and is even visible in standing
rds, since the base of the wingtip is often visible
st below the tertials. In Laughing Gull, this area
low the tertials is mainly black, while in
anding 'first summer' and adult Franklin's Gulls
is grey. Franklin's has a characteristic grey tail

with white sides, though in strong sunlight this
can be difficult to see.

Second-cycle Laughing Gulls show the same
characteristic features as adults, but may further
differ from Franklin's Gull in that some show grey
neck or flanks (mainly in winter).

# First cycle

With their very dark body, black legs, and black bill, first-cycle Laughing Gulls are distinctive. The plumage often gives a sooty, dirty impression.

The juvenile plumage looks brown and scaly. Juvenile Mediterranean Gull has been confused with Laughing Gull on occasion, but the latter shows darker head, dark brown greater coverts (obviously pale in Mediterranean), and pointed bill shape. In flight, it has a dark underwing (white in Mediterranean), dark inner primaries, and extensively dark tail. In addition, the juvenile

plumage is quickly moulted after fledging, and vagrants are unlikely to reach Europe in this plumage. After the post-juvenile moult, Laughing Gull acquires much darker, slaty grey upperparts than Mediterranean.

Differs from first-cycle Franklin's Gull in its grey breast and flanks, which are clean white in Franklin's, thin dark eye-mask instead of dark half hood in winter, and different size and structure. In flight, the dark underwing, dark inner primaries, and black tail are characteristic; first-cycle Franklin's has white underwing, grey inner primaries, and only a thin black tail band.

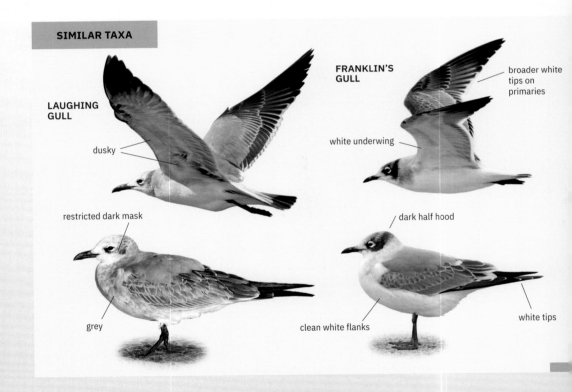

**SIMILAR TAXA**

LAUGHING GULL

dusky

restricted dark mask

grey

FRANKLIN'S GULL

broader white tips on primaries

white underwing

dark half hood

clean white flanks

white tips

**▶ RANGE**

An American species, breeding mainly along the Atlantic coast, from New Brunswick south to French Guiana. Also breeds on The Bahamas and along the Pacific coast in Mexico. Vagrant to Europe, with most records unsurprisingly in Britain and Ireland but has also reached Finland, Austria, Italy, and Greece.

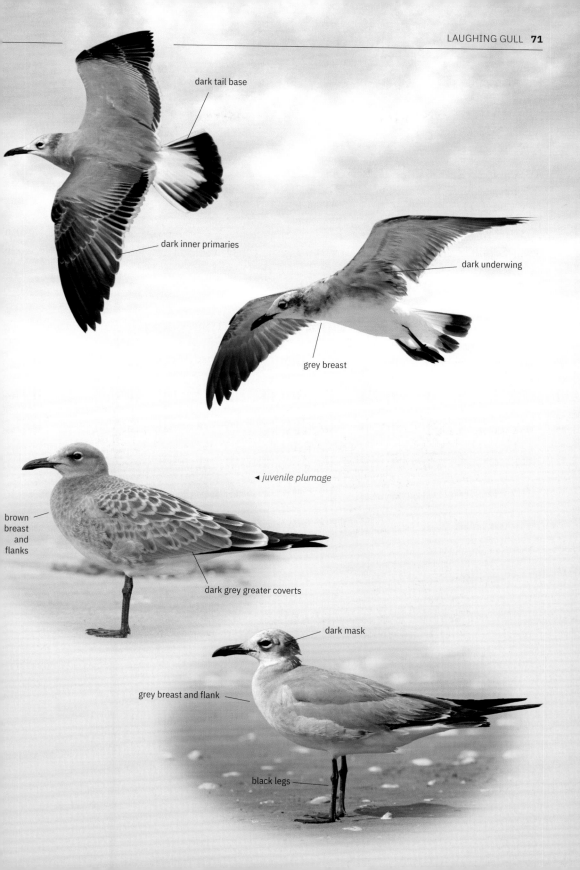

dark tail base

dark inner primaries

dark underwing

grey breast

◄ *juvenile plumage*

brown
breast
and
flanks

dark grey greater coverts

dark mask

grey breast and flank

black legs

# Franklin's Gull
## *Leucophaeus pipixcan*

### ▶ STRUCTURE
A small gull that looks slim and elegant in flight, with fairly rounded wings. Smaller than Black-headed Gull (and Laughing Gull). From its first cycle the species undergoes two complete moults per year, which render the plumage fresh at all times.

## Adult

The main confusion species is Laughing Gull (see p.68). Adult Franklin's Gull has a unique plumage, however, combining dark slaty-grey upperparts with a striking wing pattern characterised by a variable black subterminal band on the outer primaries bordered by white tips (variable in size, depending on plumage wear) and a white internal band separating it from the grey upperwing. In breeding plumage the head is covered by a black hood that descends down onto the middle of the nape, there are bold white crescents around the eye, the bill is dark red, and the legs are black. In nonbreeding the head shows a blackish-grey 'half hood' behind the eye, leaving the face white.

When perched, adult nonbreeding Sabine's Gull may be superficially similar, but its upperparts are slightly paler grey, the head is whiter, and white eye crescents are lacking. Often, a continuous white line is visible below the greater coverts (formed by the tips of the secondaries).

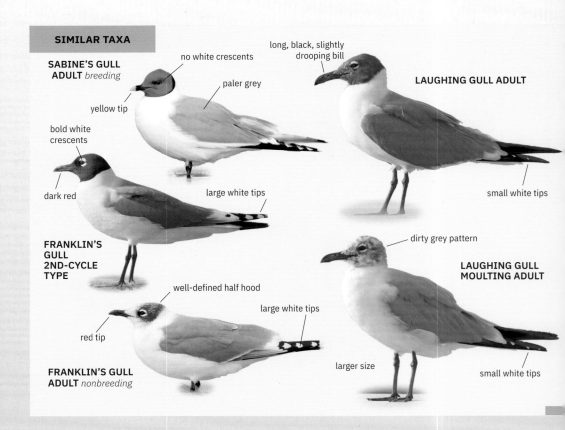

**SIMILAR TAXA**

**SABINE'S GULL ADULT** *breeding*
- no white crescents
- long, black, slightly drooping bill
- paler grey
- yellow tip

**LAUGHING GULL ADULT**
- small white tips

**FRANKLIN'S GULL 2ND-CYCLE TYPE**
- bold white crescents
- dark red
- large white tips

**FRANKLIN'S GULL ADULT** *nonbreeding*
- red tip
- well-defined half hood
- large white tips

**LAUGHING GULL MOULTING ADULT**
- dirty grey pattern
- larger size
- small white tips

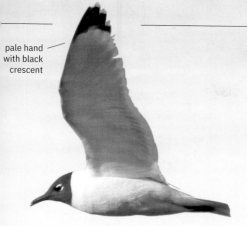

pale hand with black crescent

▲ *adult or 2nd cycle (in flight)*

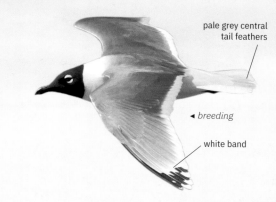

pale grey central tail feathers

◄ *breeding*

white band

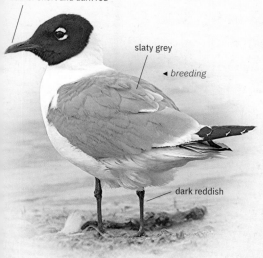

rather short and dark red

slaty grey

◄ *breeding*

dark reddish

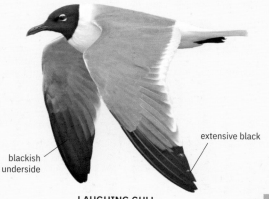

large dark half hood

◄ *nonbreeding*

large white tips

**SIMILAR TAXA**

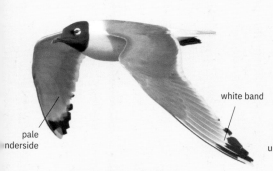

pale underside

white band

**FRANKLIN'S GULL**

blackish underside

extensive black

**LAUGHING GULL**

# First cycle

Juvenile birds quickly replace the scalloped brown pattern on their upperparts with a uniformly dark slaty-grey colour similar to adults during the post-juvenile moult. May be confused with Laughing Gull (see p.68), but the blackish head pattern is more extensive, the underwing is pale, the black tail band is narrow, and there is a broad white trailing edge on the secondaries and inner primaries.

After the very extensive prebreeding moult (which includes flight and tail feathers), the plumage resembles that of adult nonbreeding, but with more black on the outer primaries (reaching the primary coverts on the outermost two, and with a black subterminal mark on P5). A few birds retain a few juvenile outer primaries, which look brown and worn. Such an arrested moult is very different from Laughing Gull.

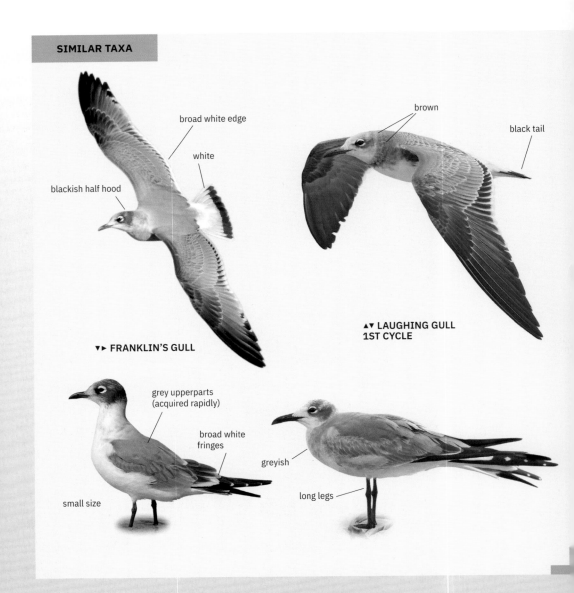

**SIMILAR TAXA**

broad white edge

white

blackish half hood

▾▸ **FRANKLIN'S GULL**

brown

black tail

▴▾ **LAUGHING GULL**
**1ST CYCLE**

grey upperparts
(acquired rapidly)

broad white
fringes

greyish

small size

long legs

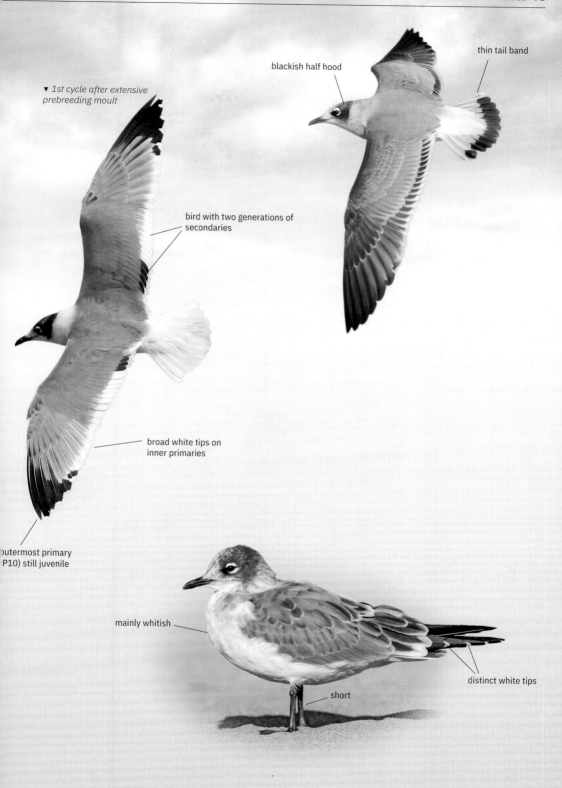

▼ *1st cycle after extensive prebreeding moult*

bird with two generations of secondaries

blackish half hood

thin tail band

broad white tips on inner primaries

outermost primary (P10) still juvenile

mainly whitish

short

distinct white tips

## Second cycle

———

After a complete moult between June and September/October, many birds of this age look very similar to adult nonbreeding, to the point of having an identical plumage. Some birds can nevertheless be aged by the slightly larger amount of black on the outer primaries, which lack the piebald pattern of adults (especially the white mirror on P10). Sometimes black marks are also present on the primary coverts or on the tail.

Surprisingly, second-cycle Mediterranean Gull ha[s] been mistaken for Franklin's, even though it always shows much paler upperparts, red bill and legs, and slightly larger size.

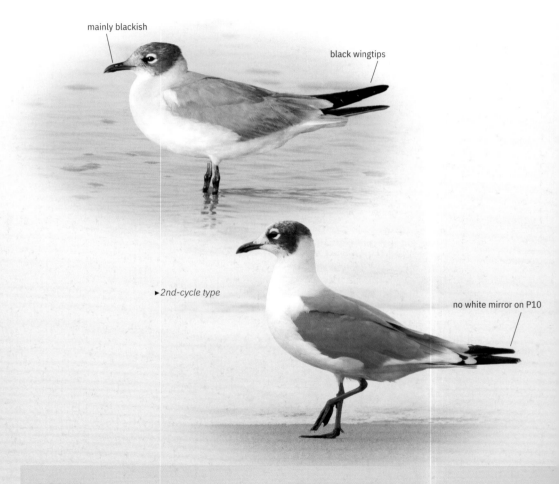

mainly blackish

black wingtips

▶2nd-cycle type

no white mirror on P10

**▶ RANGE**

A North American gull that essentially breeds in colonies on the Great Plains of Central and Western USA and Canada. It prefers freshwater marshes and lake shores on the American prairie. It migrates mainly through the centre of the North American continent, Mexico, and the Pacific coast of South America to winter along the coasts of Ecuador, Peru, and Chile. Vagrant to the East Coast of North America, as well as Western Europe and the coast of West Africa. There are also a few records from the Middle East, including from Oman and the United Arab Emirates.

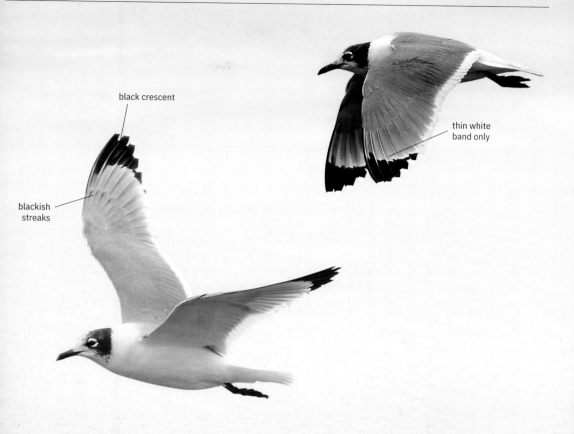

black crescent

blackish
streaks

thin white
band only

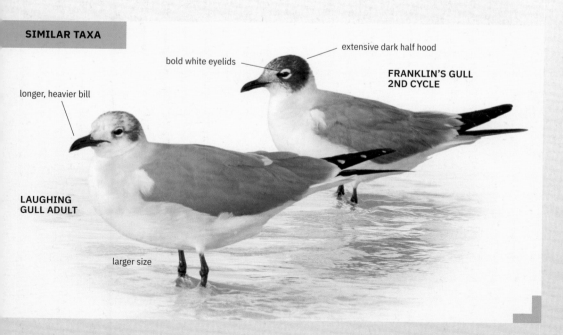

**SIMILAR TAXA**

bold white eyelids

extensive dark half hood

**FRANKLIN'S GULL
2ND CYCLE**

longer, heavier bill

**LAUGHING
GULL ADULT**

larger size

# Mediterranean Gull
## *Ichthyaetus melanocephalus*

> ▶ **STRUCTURE**
> In size this gull is between Black-headed and Common Gull; it has a rather square head and stout, parallel-sided bill, which looks stubbier than in either of these species. Looks slightly bulkier than Black-headed Gull, and the wings are broader and may look at little more rounded.

## Adult

Easily identified by its white wingtips, pale grey upperparts and bright, coral-red bill. In flight, adult Mediterranean Gulls show uniform pale wings, which from a distance look mainly white all over. There is no contrast between a grey wing and white leading edge of outer hand as in Black-headed Gull.

In breeding plumage shows a jet-black hood that reaches further down on the nape than in Black-headed Gull. The white eye crescents are also broader and more prominent than in that species.

In nonbreeding plumage the head is largely white with a dark eye-mask or a vague patch of dark streaks behind the eye. Nonbreeding birds do not show such a solid, well-defined dark spot behind the eye as Black-headed Gull.

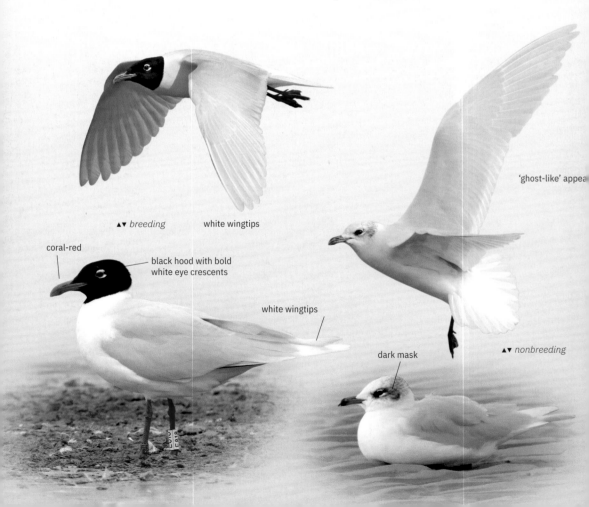

▲▼ *breeding*     white wingtips

coral-red

black hood with bold white eye crescents

white wingtips

'ghost-like' appea

dark mask

▲▼ *nonbreeding*

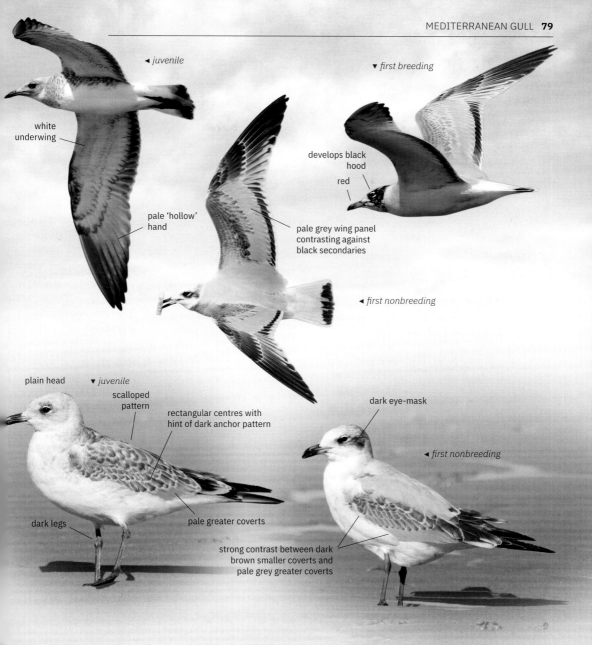

*◄ juvenile*

*▼ first breeding*

white underwing

pale 'hollow' hand

develops black hood

red

pale grey wing panel contrasting against black secondaries

*◄ first nonbreeding*

plain head

*▼ juvenile*

scalloped pattern

rectangular centres with hint of dark anchor pattern

dark eye-mask

*◄ first nonbreeding*

dark legs

pale greater coverts

strong contrast between dark brown smaller coverts and pale grey greater coverts

# First cycle

Birds of this age category show a dark outer wing, and dark median and lesser coverts that contrast with pale grey greater coverts. The wing pattern is therefore very different from Black-headed Gull, both in flight and at rest, and resembles that of first-cycle Common Gull. Mediterranean Gull differs from the latter by the blackish legs, whiter underwing (including most of the outer primaries), darker bill, and more contrasting pattern on the upperwing. In

first-cycle Common Gull, the greater coverts show a dull grey or brownish colour that barely contrasts with the rest of the wing coverts, and the inner primaries also look rather dull. When the upperwing is fully spread, the diagnostic white inner webs of the outer primaries become visible—making the underside of the hand look white. When perched, differs from Black-headed Gull by darker legs, dark, stubby bill, more solid dark median coverts, and different head pattern, lacking the isolated, solid dark ear spot.

In juvenile plumage, further differs from Common Gull by the more prominent white fringes to the scapulars and wing coverts, which may be notched at the sides and which create a scalloped look. Also, the brown centres on the lesser and median coverts have a more rectangular shape and often show a hint of a dark anchor pattern. The pattern on the wing coverts of juvenile Common Gull is simpler, consisting of plain, triangular centres and lacking any notches on the feather edges. The head of juvenile Mediterranean Gull looks very uniform whitish and contrasts with the blackish bill. Common Gull shows streaking on crown, ear coverts, and nape, and has a pinkish bill base.

The juvenile plumage is quickly lost (throughout August) and replaced by the first-winter plumage with uniform pale grey instead of scalloped, brown scapulars. The grey scapulars are about as pale as the greater coverts, another difference from Common Gull, in which the post-juvenile scapulars are clearly darker grey than the greater coverts. The head pattern, now with dark eye-mask, is also a useful feature. The dark tertials show thinner white tips than in most first-cycle Common Gulls. The pattern of the smaller wing coverts is still useful, but may become affected by wear as winter progresses. Still, these coverts are darker than in Common Gull and contrast more strongly with the pale grey greater coverts and scapulars.

In spring, wear and another partial moult produce a first-summer plumage in which the dark brown wing coverts fade to whitish and the head may become more extensively dark, with a few birds even developing a black hood. All other differences from Common Gull are still present, though.

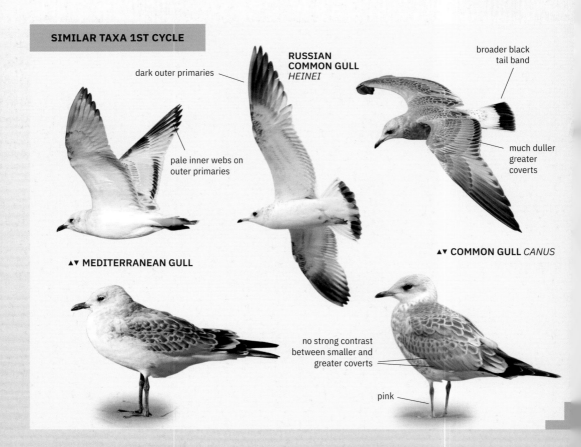

**SIMILAR TAXA 1ST CYCLE**

dark outer primaries

pale inner webs on outer primaries

▲▼ MEDITERRANEAN GULL

RUSSIAN COMMON GULL *HEINEI*

broader black tail band

much duller greater coverts

▲▼ **COMMON GULL** *CANUS*

no strong contrast between smaller and greater coverts

pink

► *nonbreeding*

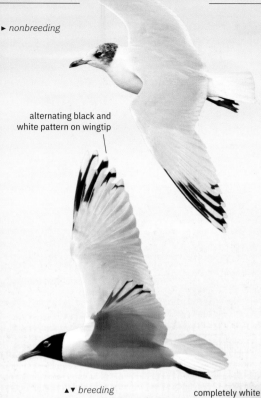

alternating black and
white pattern on wingtip

▲▼ *breeding*

completely white
underside of wingtip

# Second cycle

The plumage resembles adult, but with variable amount of black on outer primaries. Even in birds with maximum amount of black (i.e., on 6 primaries), the pattern is characteristic in showing alternating black outer and long white inner webs. When perched, second-cycle Mediterranean Gull might be mistaken for adult Black-headed Gull at a cursory glance, but it always shows clearly bigger white primary tips. In addition, the underside of the wingtip is white, whereas Black-headed Gull shows black underside with a long white wedge. Head pattern differs as in adults. Note also different shape, with stronger bill and flatter crown.

◄ *nonbreeding*

bold white primary tips

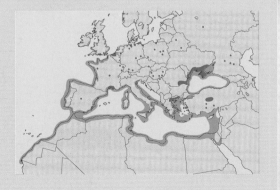

## ▶ RANGE

Breeds colonially at scattered localities across Western, Central and Southern Europe, and further east to the Black Sea (particularly Crimea) as well as the Russian provinces of Kalmykia and Stavropol between the Black and Caspian Seas. Winters on the southern shores of the Black Sea (as far east as the coast of Georgia), in the whole Mediterranean region, and along the Atlantic coast of France, the Iberian Peninsula, and West Africa south to the western Sahara. Small numbers winter in the North Sea area, Britain and Ireland. Vagrants have reached Iceland (3), Norway, Finland (58), Estonia (30), Latvia (20), Lithuania, Azores (41), Senegal, The Gambia, Kenya, Jordan, Iraq, Kuwait (7), and Kazakhstan.

# Small Hybrid Gulls

Mixed colonies, and even more so the presence of isolated individuals of one species in colonies of another at the edge of their breeding range or when colonising new places, may lead to mixed breeding and hybrid offspring. In this section we show a few examples of small gull hybrids or hybrids between small and medium-sized gulls. It is not an exhaustive overview but focuses on a few well-documented cases of the most frequent hybrid combinations.

First-cycle plumages are more difficult to identify than those of adults. Hybrids generally show structural and plumage characters from both parent species; they may look intermediate between the two or more similar to one or the other. To some extent, this depends on whether they are first-generation (the direct result of interbreeding between two different species) or next-generation hybrids (the offspring of a pure species and a hybrid).

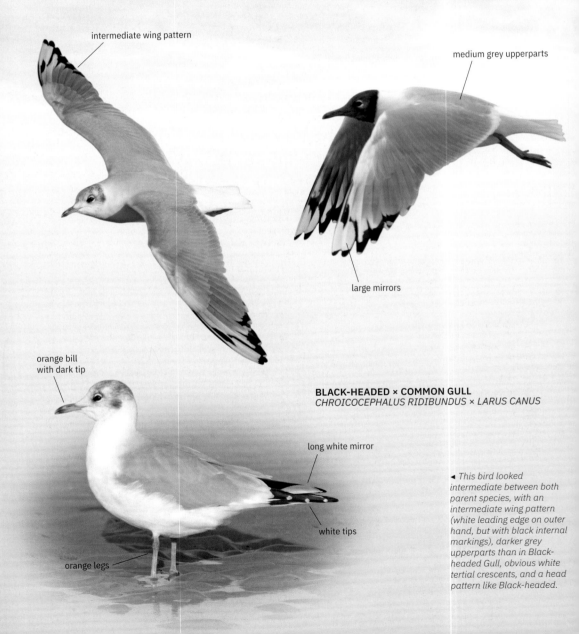

intermediate wing pattern

medium grey upperparts

large mirrors

orange bill with dark tip

**BLACK-HEADED × COMMON GULL**
*CHROICOCEPHALUS RIDIBUNDUS × LARUS CANUS*

long white mirror

white tips

orange legs

◄ This bird looked intermediate between both parent species, with an intermediate wing pattern (white leading edge on outer hand, but with black internal markings), darker grey upperparts than in Black-headed Gull, obvious white tertial crescents, and a head pattern like Black-headed.

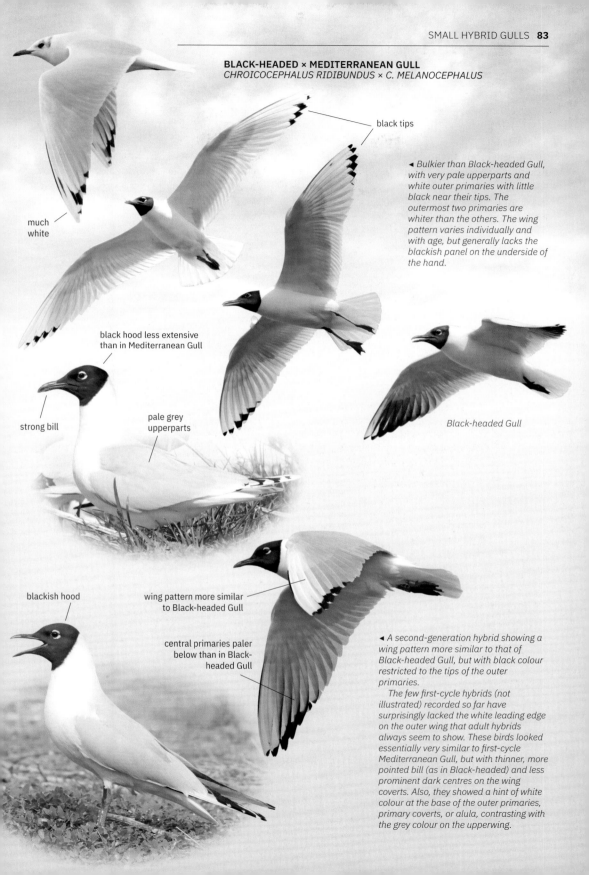

## BLACK-HEADED × MEDITERRANEAN GULL
### *CHROICOCEPHALUS RIDIBUNDUS × C. MELANOCEPHALUS*

black tips

much
white

◄ *Bulkier than Black-headed Gull, with very pale upperparts and white outer primaries with little black near their tips. The outermost two primaries are whiter than the others. The wing pattern varies individually and with age, but generally lacks the blackish panel on the underside of the hand.*

black hood less extensive
than in Mediterranean Gull

strong bill

pale grey
upperparts

*Black-headed Gull*

blackish hood

wing pattern more similar
to Black-headed Gull

central primaries paler
below than in Black-
headed Gull

◄ *A second-generation hybrid showing a wing pattern more similar to that of Black-headed Gull, but with black colour restricted to the tips of the outer primaries.*

*The few first-cycle hybrids (not illustrated) recorded so far have surprisingly lacked the white leading edge on the outer wing that adult hybrids always seem to show. These birds looked essentially very similar to first-cycle Mediterranean Gull, but with thinner, more pointed bill (as in Black-headed) and less prominent dark centres on the wing coverts. Also, they showed a hint of white colour at the base of the outer primaries, primary coverts, or alula, contrasting with the grey colour on the upperwing.*

# Relict Gull
## *Ichthyaetus relictus*

**▶ STRUCTURE**

This species is about the size of Ring-billed Gull, and therefore clearly bigger than Black-headed and Mediterranean Gulls. Its bill shows a strong gonydeal angle, which may create the impression of a slightly swollen bill tip.

At all ages shows dark bill and legs (dark grey to dark red) and lacks the white leading edge on outer wing of Black-headed and Brown-headed Gulls. In breeding plumage shows bold white eyelids, even more prominent than in Mediterranean Gull.

## Adult

Perhaps most similar to second-cycle Mediterranean Gull, but with darker bare parts and usually different primary pattern. Most birds show black markings on 6 primaries, while many second-cycle Mediterranean Gulls have only 5 primaries with black pattern. In addition, most adult Relict Gulls exhibit a complete black medial band on P10 or P9 (or both), which is exceptional in Mediterranean. Birds with less pigmented wingtip overlap with Mediterranean, although some still show at least a hint of a medial band. Note also size and bill shape.

In nonbreeding plumage, the head pattern consists of only a vague, dusky pattern behind the eye, often concentrated on the nape.

From a distance, perched adult Brown-headed Gull can look similar to Relict, but closer views will reveal a thinner bill, pale iris, red legs, and red bill. Unlike Relict, adult Brown-headed Gulls show hardly any white on the tertials. In flight, their outer primaries show a much more solid black pattern as well as a large white wing panel on the leading edge of the hand. The underwing looks duskier. In nonbreeding plumage, Brown-headed Gull shows a more distinct dark spot behind the eye.

**SIMILAR TAXA**

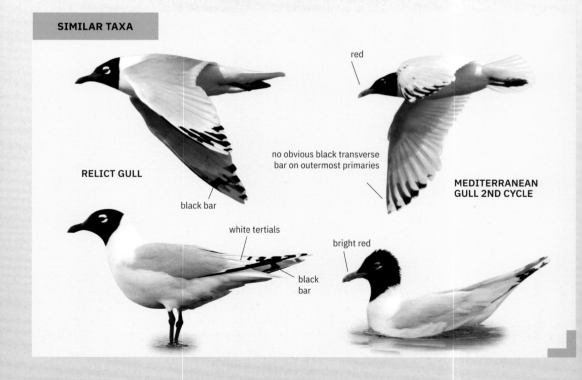

RELICT GULL

black bar

red

no obvious black transverse bar on outermost primaries

MEDITERRANEAN GULL 2ND CYCLE

white tertials

black bar

bright red

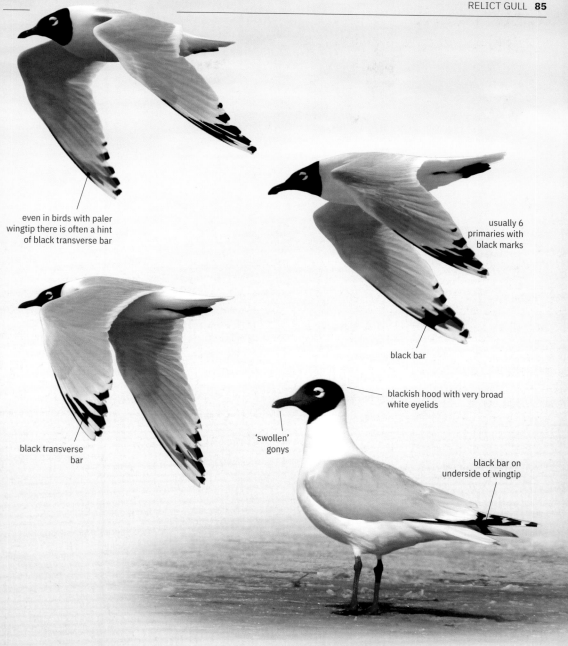

even in birds with paler wingtip there is often a hint of black transverse bar

usually 6 primaries with black marks

black bar

black transverse bar

blackish hood with very broad white eyelids

'swollen' gonys

black bar on underside of wingtip

In breeding plumage, the white eyelids are not as big as in Relict.

The differences from Black-headed Gull are even more pronounced, since that species shows an even more extensive white leading edge on the outer wing than Brown-headed, and has a characteristic blackish panel on the underside of the hand. Adult birds do not show white mirrors on the outermost primaries. At rest, they show clearly less white on the tertials than Relict, smaller white primary tips, paler bare parts, a distinct dark ear spot in nonbreeding plumage, and only thin white eyelids in breeding plumage. Note also size and bill shape.

◄ *plumage at start of 2nd cycle* ►

isolated black spots

dark bill contrasts with
white head

necklace of brown spots
and wavy bars

white underwing
with contrastingly
dark outer
primaries

dark outer
primaries

white mirror

dark legs

◄ *juvenile plumage*

## First cycle

At this age, Relict Gulls are only superficially similar to Mediterranean Gull. Juvenile birds show quite a unique plumage that looks spotted rather than scaled, because the scapulars show small dark centres only. After the post-juvenile moult, differs from Mediterranean by whiter head, a characteristic collar of brown spots and wavy bars around the neck, paler wing coverts, broad white fringes on tertials, and a white mirror on the outermost primary. In flight, shows characteristic isolated black spots on secondaries and inner primaries, and the outer primaries are more extensively dark than in Mediterranean.

In North America, first-cycle Ring-billed Gull with abnormally dark bare parts has been mistaken for Relict Gull; however, Ring-billed does not show the combination of white head and dark necklace. There may be a strongly spotted collar, but in that

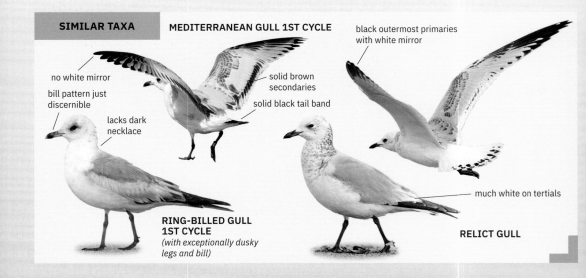

SIMILAR TAXA

**MEDITERRANEAN GULL 1ST CYCLE**

black outermost primaries
with white mirror

no white mirror

bill pattern just
discernible

solid brown
secondaries

solid black tail band

lacks dark
necklace

much white on tertials

**RING-BILLED GULL
1ST CYCLE**
*(with exceptionally dusky
legs and bill)*

**RELICT GULL**

case the head will also be dark spotted. In addition, Ring-billed lacks the broad white fringes to the tertials and does not normally show a white mirror on the underside of the wingtip. In flight, identification should be easy, based on the typical underwing pattern (white central panel contrasting with dark secondaries and brown lesser coverts), solid dark secondaries, more extensive dark pattern on inner primaries, and broader dark tail band.

First-cycle Russian Common Gull (*heinei*) might cause confusion due to its white head and streaked or spotted necklace, but this taxon can be told from Relict by its darker grey upperparts, darker wing coverts, pale legs, and pale bill base. In flight, the secondaries are mainly dark, the inner primaries show dark streaks, the outermost primaries lack a pale tongue, and the dark tail band is broader.

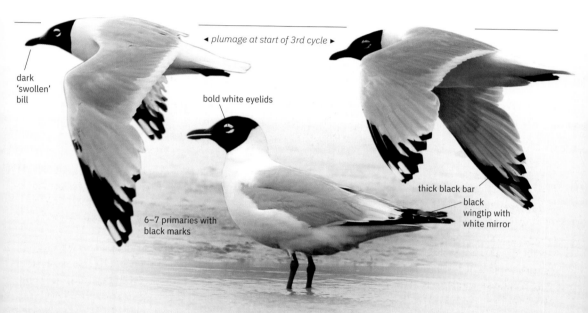

dark 'swollen' bill

◄ *plumage at start of 3rd cycle* ►

bold white eyelids

6–7 primaries with black marks

thick black bar

black wingtip with white mirror

## Second cycle

At this age, identification features are very much the same as for adults. Second-cycle birds have more extensive black pattern on their wingtips than adults, which makes it easier to tell them from second-cycle Mediterranean Gull. They show a broad black medial band on P9 and P10, as well as white mirrors divided by a black border on these feathers. In nonbreeding plumage, the head is more similar to first cycle, not as dusky as adult, and dark streaks or spots tend to be concentrated on the hindneck—another difference from Mediterranean Gull.

### ▶ RANGE

Relict Gull breeds mainly in Mongolia and northern China, with smaller numbers in eastern Kazakhstan and the Russian Far East. Its nonbreeding range is poorly understood, but it is thought that at least 90% of the population winters along the shores of the Yellow Sea, where it is concentrated at very few sites. The breeding grounds of this somewhat mysterious gull were not discovered until 1968, and the validity of the species was only confirmed in 1970. It is one of the most threatened gulls in the world.

Vagrants have been found in Hong Kong, Japan, Kyrgyzstan, and Vietnam. There has been one record in the Western Palearctic, a flock of 14 birds in the Saratov Oblast, Russia, at the border with Kazakhstan, in May 2000.

# White-eyed Gull
## *Ichthyaetus leucophthalmus*

**▶ STRUCTURE**
A medium-sized gull, almost as big as Common Gull, which has an exceptionally long, thin bill (appearing longer than the head) and elongated body. In flight, has long, narrow wings and agile flight with buoyant wingbeats.

At all ages, White-eyed Gull has a very dark plumage with entirely blackish underwings not shown by any other Western Palearctic gull species except for Sooty Gull. Unlike that species, it shows prominent white eyelids both above and below the eye. At long range, the long dark wings and agile flight may even suggest one of the smaller skuas, but in all plumages it shows clean white tail coverts and much longer bill, and lacks the pale 'flash' on the underside of the hand.

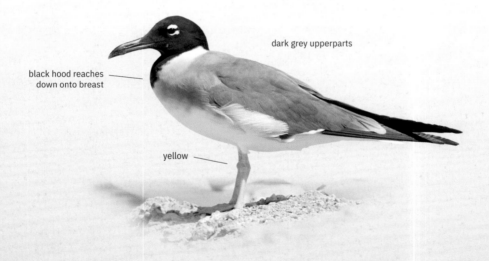

black hood reaches down onto breast

dark grey upperparts

yellow

## Adult

Can be confused only with Sooty Gull, but has clearly thinner, dark red bill (paler and greenish in Sooty), bold white crescents not only above but also below the eye, and dark grey rather than greyish-brown upperparts and breast. In breeding plumage, the head is jet black, while it is blackish-brown in Sooty. As in that species, the dark hood reaches down onto the breast, and there is a large white patch on the side of the neck. In nonbreeding plumage shows a degree of spotting or streaking on throat, unlike Sooty.

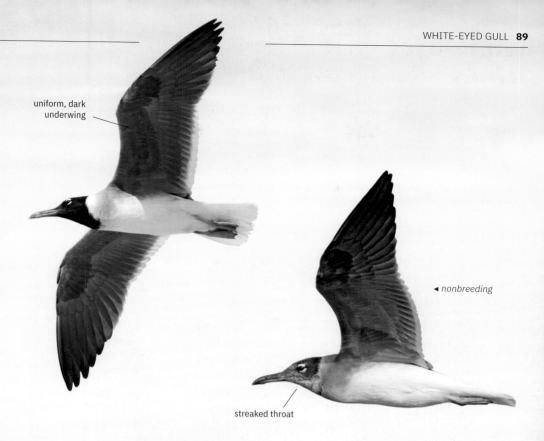

uniform, dark
underwing

◄ *nonbreeding*

streaked throat

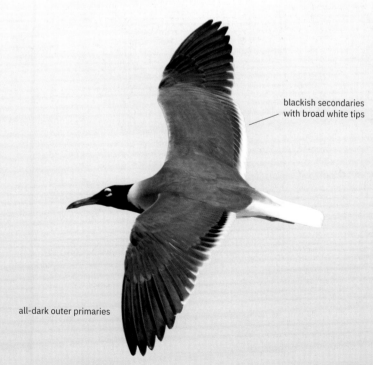

blackish secondaries
with broad white tips

all-dark outer primaries

# First cycle

The juvenile plumage looks darker than that of Sooty Gull because the fringes to the wing coverts, tertials, and scapulars are narrower and pale brown rather than whitish. The bill is all dark, whereas it is always distinctly two-tone in Sooty (pale greyish with black tip). The throat is streaked dark, unlike Sooty, in which it is uniformly dark brown.

After the post-juvenile moult the scapulars and a variable number of wing coverts become dark grey, less brownish than in first-winter Sooty Gull.

Melanistic gulls or gulls covered with soot could perhaps become vaguely similar to first-cycle White-eyed Gull, but can immediately be ruled out by their shorter bill. Note also the bold white eyelids of White-eyed, yellow legs, streaked throat pattern and broad white tips on the blackish secondaries.

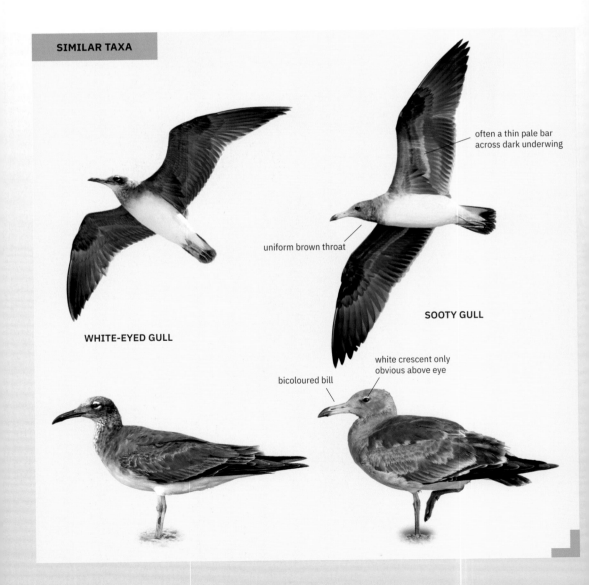

SIMILAR TAXA

often a thin pale bar across dark underwing

uniform brown throat

SOOTY GULL

WHITE-EYED GULL

white crescent only obvious above eye

bicoloured bill

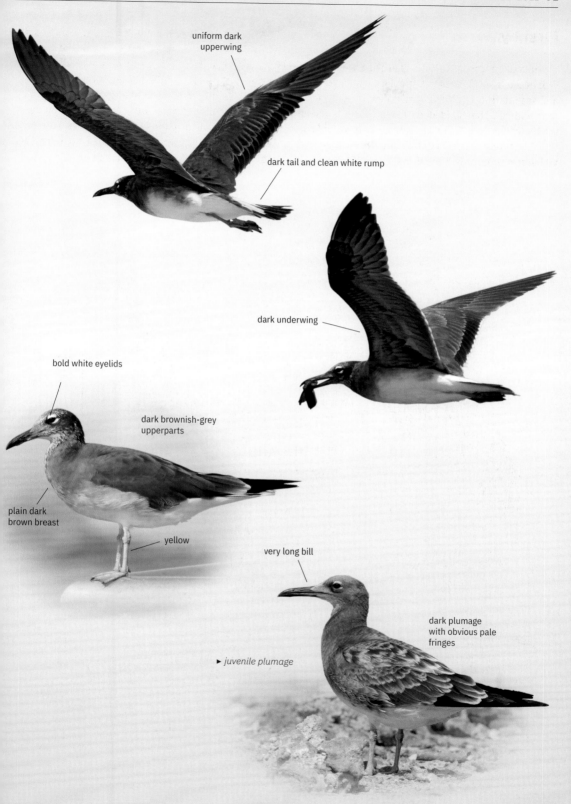

uniform dark
upperwing

dark tail and clean white rump

dark underwing

bold white eyelids

dark brownish-grey
upperparts

plain dark
brown breast

yellow

very long bill

dark plumage
with obvious pale
fringes

► *juvenile plumage*

# Second cycle

The plumage is basically similar to that of adults, but with a variable amount of black on the tail in most birds. Therefore, the same identification features are valid. Note also that in breeding as well as nonbreeding plumage the head is always distinctly darker than the breast and upperparts, whereas it is paler brown in second-cycle Sooty Gull, having more or less the same colour as the breast.

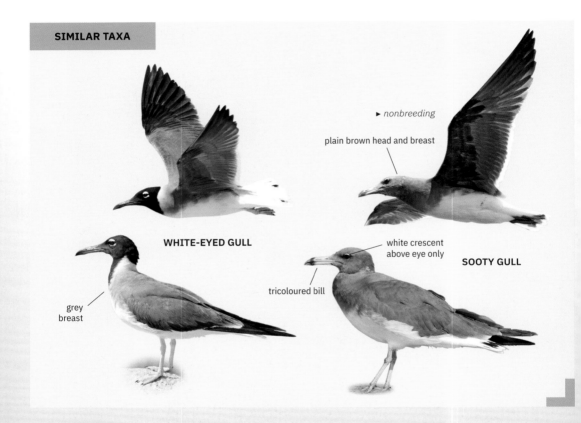

**SIMILAR TAXA**

▸ *nonbreeding*

plain brown head and breast

WHITE-EYED GULL

white crescent above eye only

SOOTY GULL

tricoloured bill

grey breast

## ▸ RANGE

The breeding range of White-eyed Gull is restricted to small islands in the Red Sea and the Gulf of Aden. The species is mainly resident all year, although outside of the breeding season it disperses along the coasts of Yemen and Somalia, and also through the Gulf of Suez and Gulf of Aqaba to the north. It is a regular nonbreeding visitor to Israel. Vagrants have reached Oman, United Arab Emirates, Kenya, Mozambique, South Africa, Iran, Turkey, Greece, and the Maldives. There are also recent records from East India (July 2016), Cyprus (June 2017), and Kuwait (June 2018).

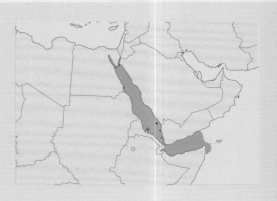

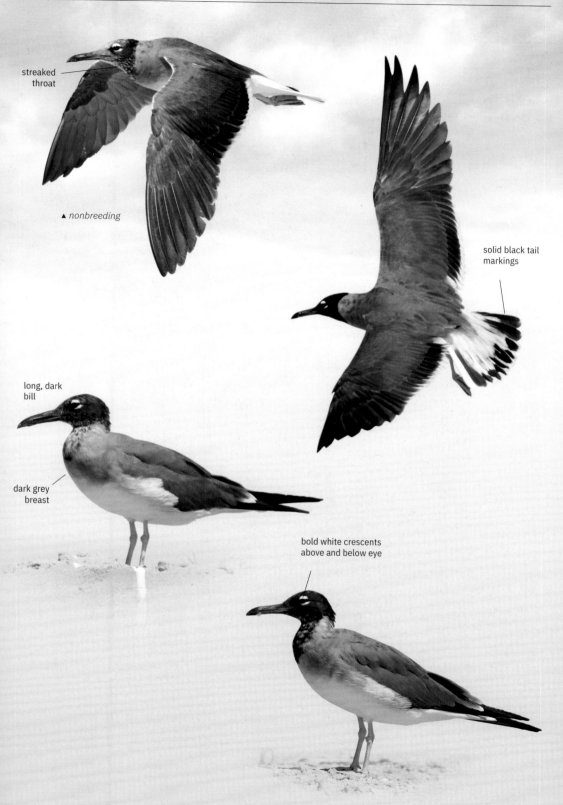

streaked throat

▲ *nonbreeding*

solid black tail markings

long, dark bill

dark grey breast

bold white crescents above and below eye

# Sooty Gull
## *Ichthyaetus hemprichii*

▶ **STRUCTURE**
Slightly bigger than White-eyed Gull, about the size of Common Gull. As in White-eyed, the bill is exceptionally long, but it is clearly stouter, with parallel sides. Identification is easy on bill shape alone and may be supported by the bulkier body with bulging breast, broader neck, and angular head shape.

The plumages can be confused only with White-eyed Gull; see that account on p.88 for the main differences.

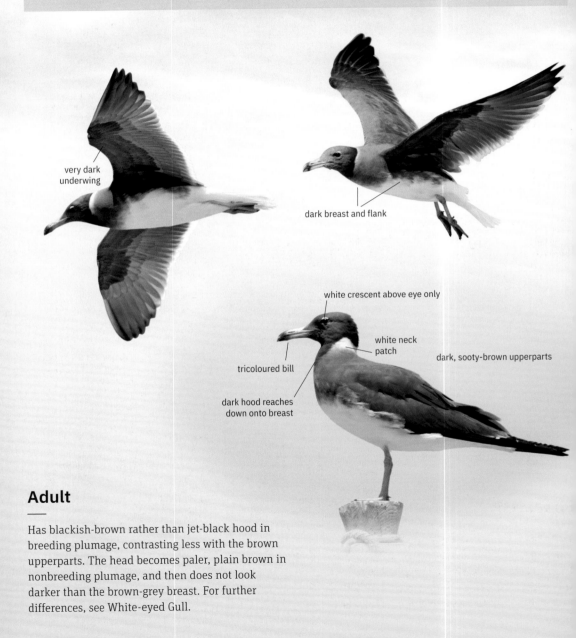

very dark underwing

dark breast and flank

white crescent above eye only

white neck patch

dark, sooty-brown upperparts

tricoloured bill

dark hood reaches down onto breast

## Adult

Has blackish-brown rather than jet-black hood in breeding plumage, contrasting less with the brown upperparts. The head becomes paler, plain brown in nonbreeding plumage, and then does not look darker than the brown-grey breast. For further differences, see White-eyed Gull.

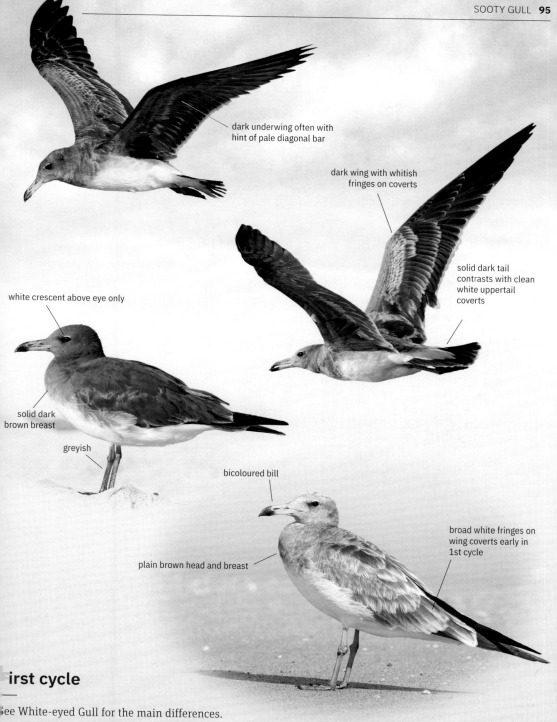

dark underwing often with hint of pale diagonal bar

dark wing with whitish fringes on coverts

solid dark tail contrasts with clean white uppertail coverts

white crescent above eye only

solid dark brown breast

greyish

bicoloured bill

broad white fringes on wing coverts early in 1st cycle

plain brown head and breast

# First cycle

See White-eyed Gull for the main differences.

In flight, many birds show a hint of a pale diagonal bar on the otherwise very dark brown underwing. This pale bar can be present in older birds too, and seems less frequent in White-eyed Gull.

# Second cycle

Looks mainly similar to adult, but with variable
black markings on the tail in many birds.
Identification can be based on the same features as
for adults; see White-eyed Gull for details.

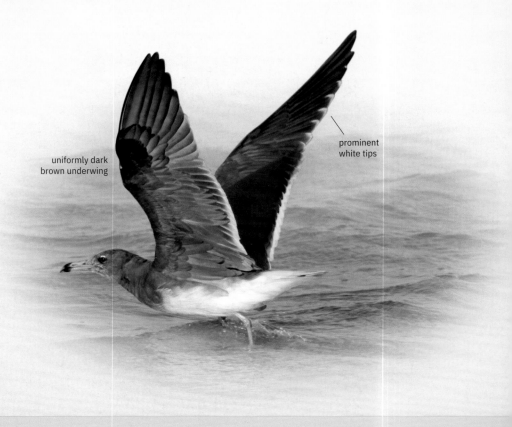

uniformly dark
brown underwing

prominent
white tips

## ❱ RANGE

Sooty Gull has a more extensive breeding range than
White-eyed Gull, nesting not only along the Red Sea and
Gulf of Aden but also further south along the East African
coast to Zanzibar (Tanzania), and further east to the
Persian Gulf and southeastern Pakistan. On the Red Sea,
it breeds mainly along the southern shores, and as far
north as the entrance to the Gulf of Suez (Ashrafi
islands). After the breeding season it disperses along the
coasts of the Indian Ocean and East Africa. Although the
species enters the Gulf of Aqaba in winter, it is only a
vagrant to Israel. Vagrants have also reached Bahrain,
India, Jordan, Lebanon, the Maldives, and Sri Lanka.

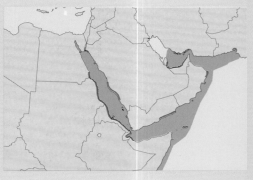

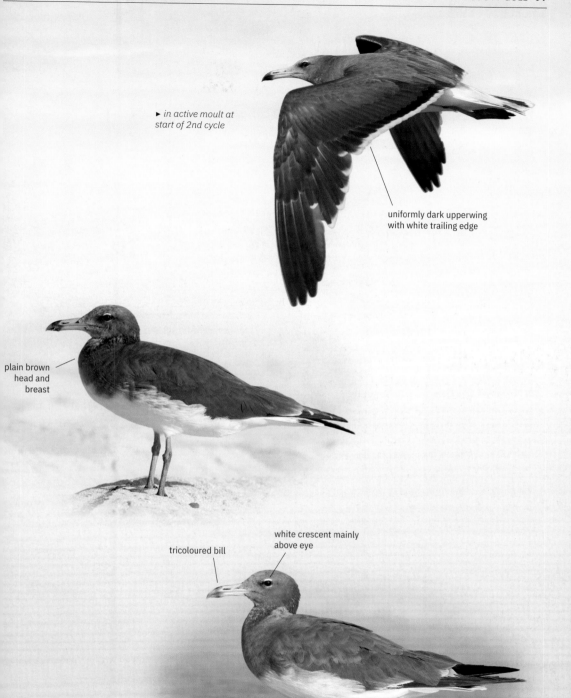

▸ *in active moult at start of 2nd cycle*

uniformly dark upperwing with white trailing edge

plain brown head and breast

tricoloured bill

white crescent mainly above eye

# Common Gull
## *Larus canus canus*

### ▶ STRUCTURE

In Europe, Common Gull is the reference species of the group of 'medium-sized gulls'. This is an elegant and agile gull with a dove-like, rounded head and slender bill, giving it a friendly facial expression, unlike the fierce large white-headed gull species. The buoyant flight makes it highly manoeuvrable, enabling it to chase equally swift Black-headed Gulls in aerial hunts for food.

In structure Common Gull is gentle and slim with a long rear end; it seems as if its legs are placed 'too far to the front'. The body is less stocky and much lighter than Herring Gull (weighing only one-half or one-third of a Herring Gull). From a distance, Common Gull may look vaguely similar to Caspian Gull in structure and wingtip pattern, but it is easily identified by its much smaller size when comparison is possible.

The subspecies *canus* closely resembles the other Common Gull taxa; see the chapters on *heinei* and *kamtschatschensis* for details.

## Adult

Adults have medium grey upperparts with a blue cast like Yellow-legged Gull, darker than *argenteus* Herring Gull. Common Gull has extensive black outer primaries, but with bold white pattern: there are large white mirrors on P9 and P10, the black band on P5 is often reduced, and an 'extra mirror' on P8 is not uncommon. None of the large gull species combine this much black with extensive white in the wingtips.

The tertials have broad white tips and the secondaries a broad white trailing edge, broader than in European large white-headed gulls.

Head streaking in winter is concentrated on the neck, rather delicate and fine, without bold spots. The greenish-yellow bill has a dark zigzag line in winter.

Birds in breeding condition have saturated clean yellow bills (without dark markings) and lack the red gonys spot of the larger species. Throughout the seasons, the iris remains dark at all ages.

The legs are greyish-green or yellowish, unlike the flesh-coloured legs of Herring Gull.

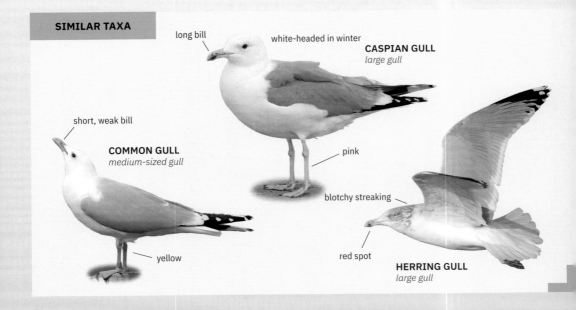

**SIMILAR TAXA**

long bill

white-headed in winter

**CASPIAN GULL**
*large gull*

short, weak bill

**COMMON GULL**
*medium-sized gull*

pink

blotchy streaking

yellow

red spot

**HERRING GULL**
*large gull*

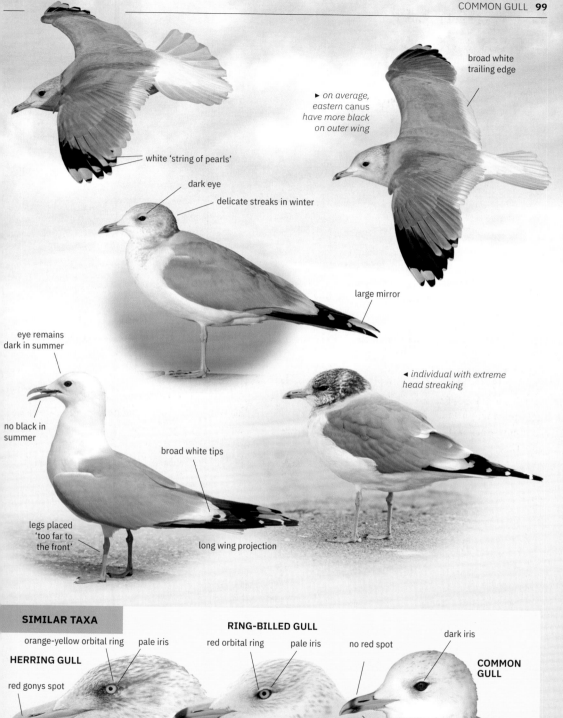

white 'string of pearls'

broad white trailing edge

► *on average, eastern* canus *have more black on outer wing*

dark eye

delicate streaks in winter

large mirror

eye remains dark in summer

no black in summer

broad white tips

◄ *individual with extreme head streaking*

legs placed 'too far to the front'

long wing projection

### SIMILAR TAXA

**RING-BILLED GULL**

orange-yellow orbital ring

pale iris

**HERRING GULL**

red orbital ring

pale iris

no red spot

dark iris

**COMMON GULL**

red gonys spot

clear bill-band

fine bill

heavy bill

# First cycle

The smaller size and elegant structure separate first-cycle Common Gull from larger species, but the simple pattern on the juvenile coverts and tertials is also different. The pattern consists of a dark triangular centre with straight pale fringes, unlike the notched or barred pattern of the larger gull species. Another clue is the blackish tail band, which is clearly cut off from the white, sparsely spotted tail base—a striking pattern even at a distance. Uppertail coverts and tail base are much more heavily marked in the larger species.

Superficially, first-cycle Mediterranean Gull is similar but has a silvery grey greater covert panel (brown or dull grey in Common Gull) as well as

extensive pale inner webs on the outer primaries. Also, it has unmarked white underwing coverts (often with dark brown scalloped feather tips in Common Gull, creating narrow lines on a white background).

The post-juvenile moult is usually limited to the mantle and scapulars; new feathers are rather plain grey, sometimes with a darker wedge-shaped centre (these feathers lack the bold anchor patterns of the large gull species). In winter, the grey scapulars reveal the medium grey tone of the adult plumage and form a 'grey saddle' that contrasts with the brown wing coverts. Birds from northern populations have limited moult and may retain the juvenile plumage throughout winter, thus lacking the grey saddle.

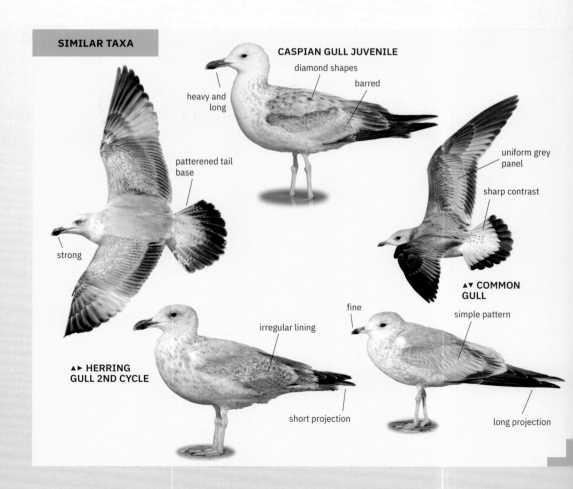

SIMILAR TAXA

CASPIAN GULL JUVENILE
diamond shapes
barred
heavy and long
patterened tail base
uniform grey panel
sharp contrast
strong
▲▼ COMMON GULL
fine
simple pattern
irregular lining
▲► HERRING GULL 2ND CYCLE
short projection
long projection

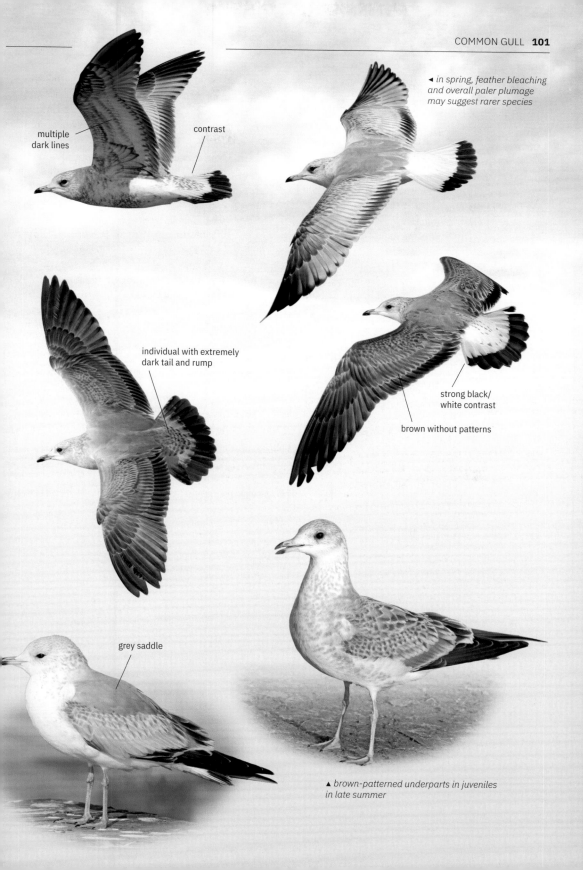

multiple dark lines

contrast

◄ *in spring, feather bleaching and overall paler plumage may suggest rarer species*

individual with extremely dark tail and rump

strong black/ white contrast

brown without patterns

grey saddle

▲ *brown-patterned underparts in juveniles in late summer*

# Second cycle

At rest, second-cycle birds look much like adults but show some remnants of immaturity as well as smaller white spots on the outermost primaries. For separation from similar species, see under 'adult plumage'.

Since the white primary tips are rather small (or may even be absent), some birds could be mistaken for Kittiwake or Ring-billed Gull.

Second-cycle Ring-billed Gull normally has more extensive immature markings, including dark marks on the tail or on the secondaries. Common Gull subspecies *canus* may show some spots on the tertials or on the tail as well (in a minority of birds) but only rarely has dark centres on secondaries. For more details, see under Ring-billed Gull.

Kittiwake, with its small black wingtips, only superficially resembles Common Gull. Its inner primaries are much paler than the grey upperparts (equally grey in Common Gull), its head is white with grey hindneck in winter, and the legs are obviously shorter and blackish. Also, Kittiwake is a different bird structurally.

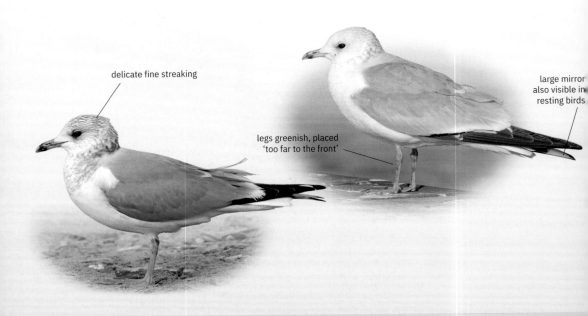

delicate fine streaking

legs greenish, placed 'too far to the front'

large mirror also visible in resting birds

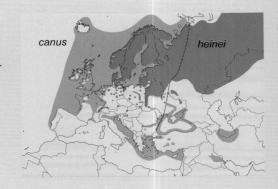

## ▶ RANGE

Common Gull has a breeding range from Atlantic Europe (ssp. *canus*) eastwards through interior northern Asia (ssp. *heinei*) reaching the Pacific (ssp. *kamtschatschensis*). The breeding population of *canus* is resident in areas with mild winters, like Western Europe. Populations breeding in Russia (east to Moscow) and Northern Europe are migratory and join the Western European birds in winter. Vagrants have reached The Gambia, Greenland, Libya, Malta, Mauritania, and Senegal. Very small numbers regularly winter in Newfoundland, Canada.

canus

heinei

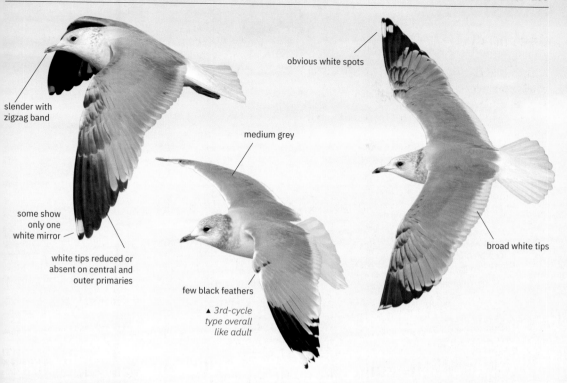

obvious white spots

medium grey

slender with zigzag band

some show only one white mirror

white tips reduced or absent on central and outer primaries

few black feathers

▲ *3rd-cycle type overall like adult*

broad white tips

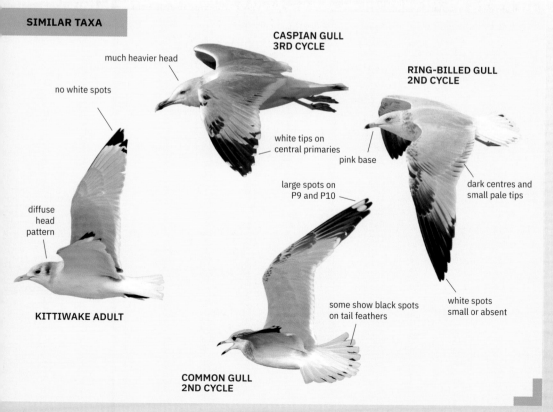

**SIMILAR TAXA**

**CASPIAN GULL 3RD CYCLE**

much heavier head

no white spots

white tips on central primaries

pink base

**RING-BILLED GULL 2ND CYCLE**

large spots on P9 and P10

dark centres and small pale tips

diffuse head pattern

some show black spots on tail feathers

white spots small or absent

**KITTIWAKE ADULT**

**COMMON GULL 2ND CYCLE**

# Russian Common Gull
## *Larus canus heinei*

▶ **STRUCTURE**
Many *heinei* (though far from all) stand out due to their noticeably long wings, at rest but also in flight, when the wings may look slender with a very pointed hand. The crown may look very flat, and the forehead rather more sloping than in *canus*. Note that there is some clinal variation in *canus*, with birds becoming larger and longer-winged towards the east of the breeding range (Baltic states, western Russia), and the extent of overlap in measurements for the two subspecies may be incompletely known.

## Adder

## Adult

Recent field studies in the wintering range have shown that many *heinei* give a different impression from *canus*. This is especially true for those birds with a clean white head, which is sharply set off by a 'boa' of dark, pencil-like streaks or neat, rounded, and often rufous spots on the lower hindneck. Some are also distinctive due to their stronger yellow bill colour (even with a hint of orange). In addition, the iris is pale yellow in nearly 20% of adult birds, and the upperparts are often slightly darker grey (even as dark as *graellsii* Lesser Black-backed Gull in a few). *Heinei* show on average more black and less white on their wingtips than *canus,* and the precise pattern may allow positive identification. Due to extensive overlap with *canus*, none of the features are diagnostic on their own, but when used in combination they become significant. Adult birds matching any of the following three combinations of features are very likely *heinei*:

1. There is no white tongue-tip on P7, and head and bill also look good for *heinei*.
2. If a white tongue-tip is present, it should be clearly thin and crescent-shaped, like the tip of a fingernail. In addition, at least one of the following features should also be present:
   - black on P8 reaches the primary coverts across the full width of the outer web, or
   - the black wedge on outer web of P6 covers more than half the length of the feather;
3. Some birds with less black on P8 and P6 (but still with little white on P7) may still be identifiable if they show the following combination of features:

- The white mirror on P9 is smaller than the black subterminal band, or at most equal in size, and
- P5 shows a complete black band (across both webs), and
- The pale tongue on P8 is shorter than half the feather length.

It should be noted that adult *canus* shows some clinal variation in its wing pattern, with eastern birds (e.g., from Estonia) showing a little more black than those in Western Europe. In eastern *canus*, a complete black band on P5 is regularly seen, as well as a black spot on P4.

staring pale iris

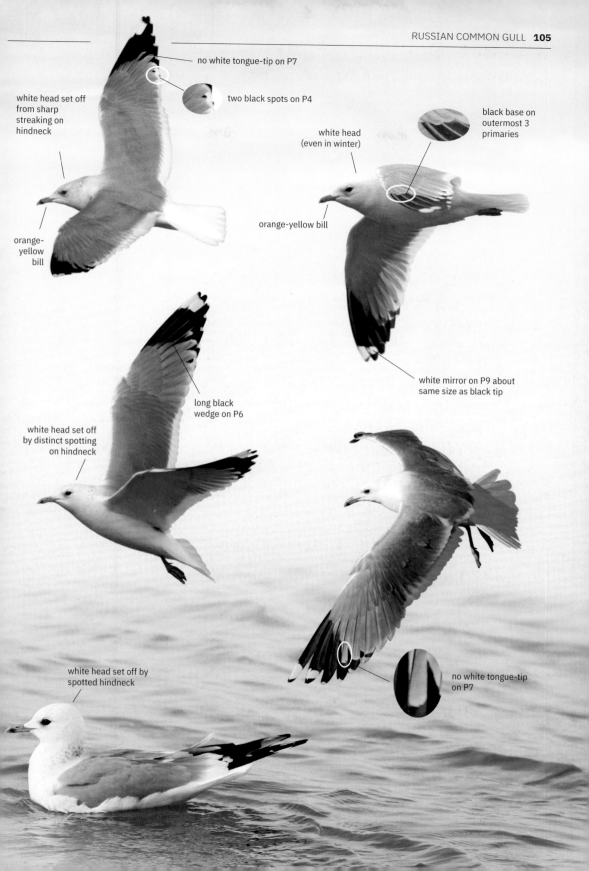

no white tongue-tip on P7

two black spots on P4

white head set off from sharp streaking on hindneck

orange-yellow bill

white head (even in winter)

orange-yellow bill

black base on outermost 3 primaries

white mirror on P9 about same size as black tip

long black wedge on P6

white head set off by distinct spotting on hindneck

no white tongue-tip on P7

white head set off by spotted hindneck

**SIMILAR TAXA**

*HEINEI*

long, narrow wings

*CANUS*

extensive grey base

both white mirrors clearly bigger than black tips

*HEINEI*

white mirror P9 clearly smaller than on P10

*CANUS*

broad white tongue-tip on P7

both white mirrors very big

*HEINEI*

bill often greenish

streaked head

*CANUS*

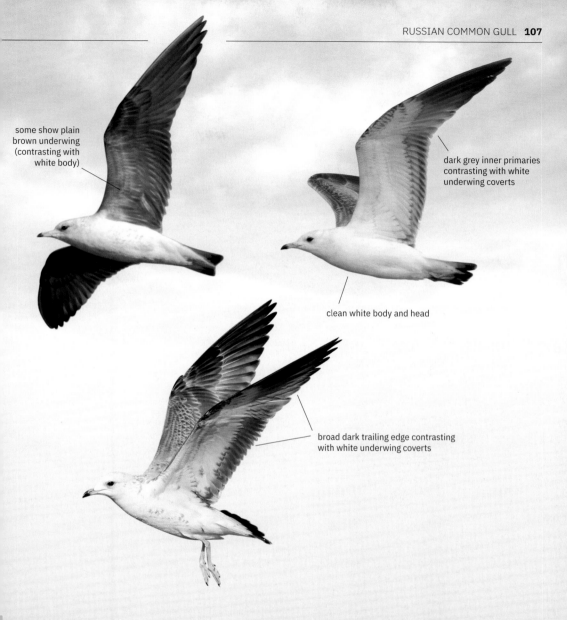

some show plain brown underwing (contrasting with white body)

dark grey inner primaries contrasting with white underwing coverts

clean white body and head

broad dark trailing edge contrasting with white underwing coverts

## First cycle

To birders familiar with *canus*, first-cycle *heinei* may stand out because of their unmarked white head and bright bill colour. As in adults, the white head is set off by a 'boa' of fine brown streaks or spots on hindneck. The underparts may also be clean white, and the tertials may completely lack white fringes. Some birds show solid dark brown greater coverts that contrast against the gleaming white underparts, whereas *canus* with such dark wing coverts normally also show dark pattern on flank or belly. Many first-cycle *canus* show brown spots on the

uppertail coverts or rump, while *heinei* is usually clean white there.

However, the most important feature is probably the pattern of the underwing. Many *heinei* show unmarked, gleaming white underwing with a contrasting dark trailing edge formed by the dark secondaries and primaries. First-cycle *canus* can have clean white underwing coverts, but in such birds the secondaries and, especially, the inner primaries tend to be paler than in *heinei*. At the other extreme, some *heinei* show completely uniform brown underwing, which is quite unexpected in a taxon with such a white body, and which is never

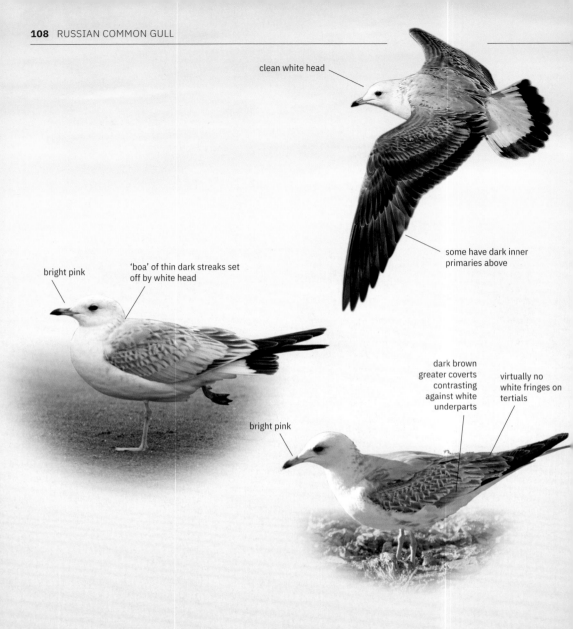

clean white head

some have dark inner primaries above

bright pink

'boa' of thin dark streaks set off by white head

dark brown greater coverts contrasting against white underparts

virtually no white fringes on tertials

bright pink

shown by *canus*. Other birds show an alternating pattern of thin, dark bars across the white underwing, bordered by a wide blackish trailing edge. The pattern often looks more contrasting than in *canus* but the difference is subtle, and identifying such birds down to subspecies level is probably not 'safe'. The axillaries can be (partly) barred in *canus*, a pattern that is very rare in *heinei*.

Because most of the identification criteria are a matter of degree rather than clearly delineated, it may be difficult to recognise first-cycle *heinei* outside of its usual range. Birds with completely chocolate brown underwings are easily told from *canus*, though, and those with clean white underwings bordered by a complete dark trailing edge including dark inner primaries should also prove to be *heinei*, although identification should be supported by as many other features as possible.

**SIMILAR TAXA**

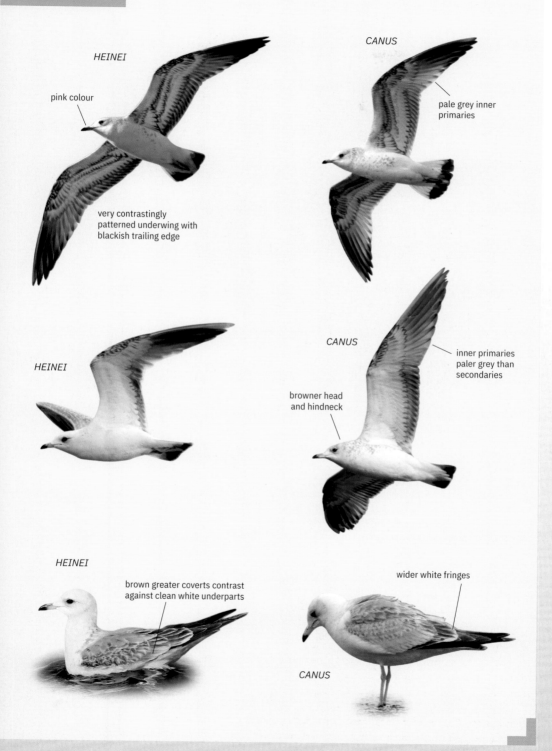

*HEINEI*

pink colour

very contrastingly
patterned underwing with
blackish trailing edge

*CANUS*

pale grey inner
primaries

*HEINEI*

*CANUS*

browner head
and hindneck

inner primaries
paler grey than
secondaries

*HEINEI*

brown greater coverts contrast
against clean white underparts

wider white fringes

*CANUS*

## Second cycle

Most birds of this age category show the same features as adults, although they have even more black on their wingtips, and they more frequently show dark spotting on the head. Some birds show a 'retarded' plumage with dark brown centres on many wing coverts, darker and more extensive than in most *canus*. If such birds show a clean white head they look distinctive. Black spots or streaks on the tail feathers or, especially, secondaries are more frequent in second-cycle *heinei* than in *canus*. The outer wing shows on average more black and less white than *canus*. P9 regularly lacks a white mirror, unlike most *canus*, and black on P4 is more extensive. The following two combinations of features in the primary pattern are diagnostic:

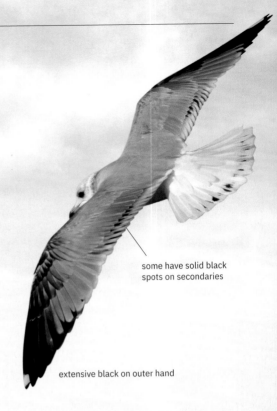

some have solid black spots on secondaries

extensive black on outer hand

- A bird with black marks on both the outer and inner webs of P4 (either as isolated spots or as a complete black band), the mirror on P9 absent or confined to the inner web, no white tongue-tip on P7, and a blunt tip on the black wedge on outer web of P7 can be identified as *heinei* if head pattern and bill colour also indicate this taxon.
- If the white mirror on P9 extends onto outer web, second-cycle birds can still be identified as *heinei* if they show a complete black band across both webs of P4 and no white tongue-tip on P7, and their head pattern and bill colour also indicate this taxon.

▶ **RANGE**

This subspecies of Common Gull breeds in Russia, from the Moscow region all the way east to the Lena river, and also in the north of Kazakhstan and Mongolia. The exact western boundary of the range seems to be poorly known, since nominate *canus* also appears to breed near Moscow and there is probably an intergradation zone (interbreeding between two subspecies). Winters mainly around the Black Sea and on the southern shores of the Caspian Sea, though apparently nowhere in big numbers. May also winter in Eastern Mediterranean region (though it is very scarce in Egypt and Israel) and on inland lakes in Iraq. (Very) scarce in Persian Gulf. Eastern populations are said to winter in Eastern China, but numbers seem to be very low, and the subspecies *kamtschatschensis* appears to be dominant there.

Regularly occurs in Western Europe in winter as indicated by ringing data. Field characters have only recently become known but have led to a number of records in this region already.

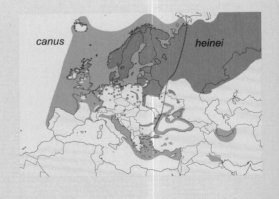

canus

heinei

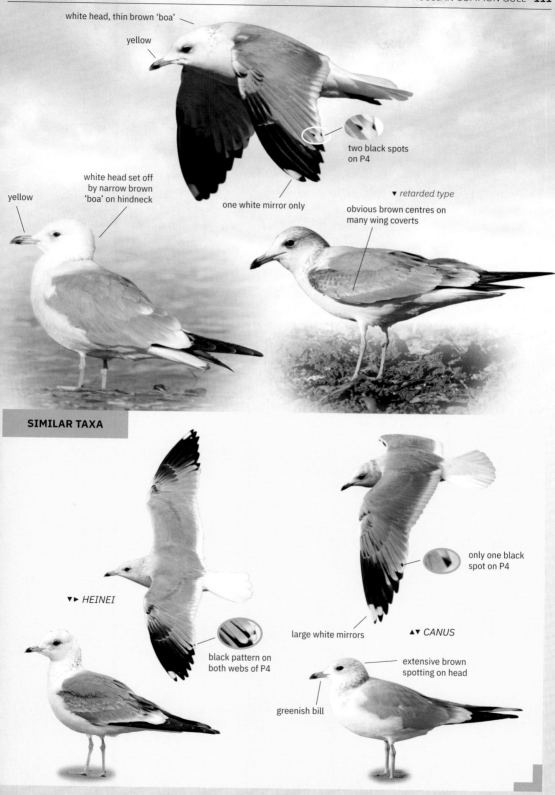

white head, thin brown 'boa'

yellow

two black spots
on P4

white head set off
by narrow brown
'boa' on hindneck

yellow

one white mirror only

▼ *retarded type*

obvious brown centres on
many wing coverts

**SIMILAR TAXA**

▼► *HEINEI*

only one black
spot on P4

large white mirrors

▲▼ *CANUS*

black pattern on
both webs of P4

extensive brown
spotting on head

greenish bill

# Kamchatka Gull
## *Larus (canus) kamtschatschensis*

▶ **STRUCTURE**
Most Kamchatka Gulls are quite big, being similar in size to Ring-billed Gull *L. delawarensis*. The body may look oval shaped and inflated, almost recalling a rugby ball. Many birds have an obviously long, sloping forehead and a long, stout bill, which combined may give a rather 'snouty' impression. Variation in structure is not to be underestimated, though, and a few birds look surprisingly small, slim, or thin-billed.

A rather distinct taxon in the 'Common Gull complex'. More research, especially on DNA, is needed to establish whether Kamchatka Gull is a subspecies of *Larus canus* or a separate species. However, its plumages are fairly distinctive, and some of its calls may be different from the other Common Gull taxa.

## Adult
———

Many adult Kamchatka Gulls look distinctive due to their dark slaty grey upperparts and strong, 'banana yellow' bill. In winter they often show an extensive, heavily blotched, brown 'shawl' across the neck, which may continue far down onto the breast and even onto flanks in some (which is rare in *canus*). Head streaking can be stronger and more extensive than in *canus*, and heavy streaking may be present on the chin and throat (again, only rarely so in *canus*). There is usually no dark bill band, but a small dark or even slightly orange spot may be present on the gonys. The iris is usually pale.

The primary pattern is also helpful, though it is variable and can be identical to that of *canus* in some. Many birds, however, show prominent white tongue-tips ('pearls') on P7–P8, which makes the white trailing edge on the secondaries and inner primaries appear to continue across the outer primaries. At the same time, they show more black on P4 and P5, and the white mirror on P9 is often smaller than in *canus* (roughly half the size of the mirror on P10). Also, the tongues on the outermost primaries average slightly longer and wider than in *canus* and, especially, *heinei*. Identification of vagrants should be supported by good photographs of the primary pattern. A detailed identification key can be found in Adriaens & Gibbins (2016).

For separation from Short-billed Gull, see that species.

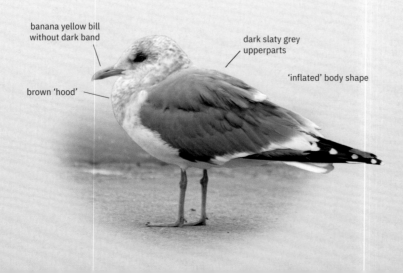

banana yellow bill without dark band

dark slaty grey upperparts

'inflated' body shape

brown 'hood'

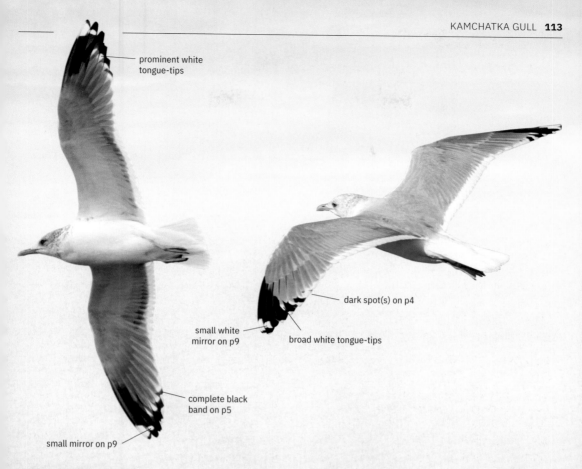

prominent white
tongue-tips

dark spot(s) on p4

small white
mirror on p9

broad white tongue-tips

complete black
band on p5

small mirror on p9

**SIMILAR TAXA**

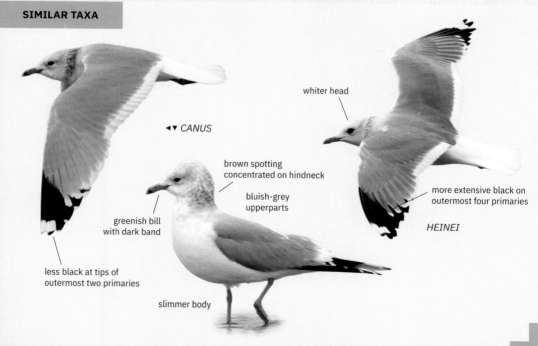

◀▼ *CANUS*

brown spotting
concentrated on hindneck

bluish-grey
upperparts

whiter head

greenish bill
with dark band

more extensive black on
outermost four primaries

*HEINEI*

less black at tips of
outermost two primaries

slimmer body

# First cycle

Compared with *canus*, the plumage of first-cycle Kamchatka Gull often looks browner overall, lacking a clean grey 'saddle'. The body is often covered extensively in brown blotches, extending across the head, breast, and belly, reaching between the legs and meeting the dark bars of the undertail coverts. In some dark birds the head streaking extends obviously around to the malar region and chin. Those birds that are not so extensively marked often retain a patch of streaking or barring on the belly—a 'Dunlin patch'. This will help separate them from *canus*. In winter the upperparts usually show a mixture of dark grey,

brown (juvenile), and partly white scapulars. The wing coverts show pale sandy or white fringes, which often create the impression of a white wing panel on the greater coverts. The bill often has a strong pink colour that may recall first-cycle Ring-billed Gull. In flight, the tail often shows a dark base, as well as extensive brown spotting on the uppertail coverts. The underwing looks predominantly brown, except for pale greater coverts. Many birds show some barring or stippling on the axillaries.

A few *canus* can have very dark tail, and such birds may also show rather dark underparts and underwing. However, such birds show dull brown wing coverts lacking prominent white fringes, and

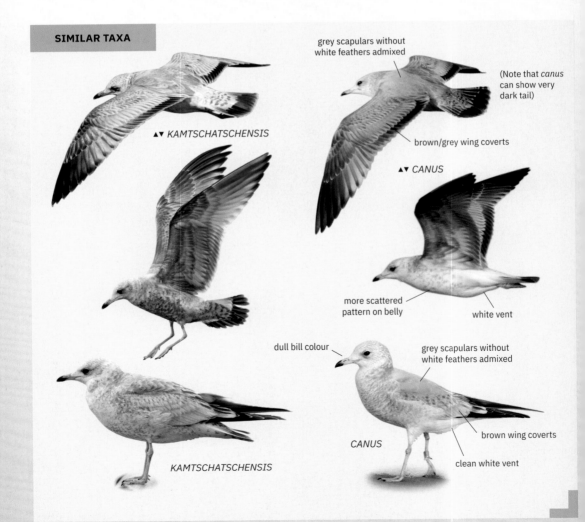

SIMILAR TAXA

▲▼ *KAMTSCHATSCHENSIS*

grey scapulars without white feathers admixed

(Note that *canus* can show very dark tail)

brown/grey wing coverts

▲▼ *CANUS*

more scattered pattern on belly

white vent

dull bill colour

grey scapulars without white feathers admixed

*CANUS*

brown wing coverts

clean white vent

*KAMTSCHATSCHENSIS*

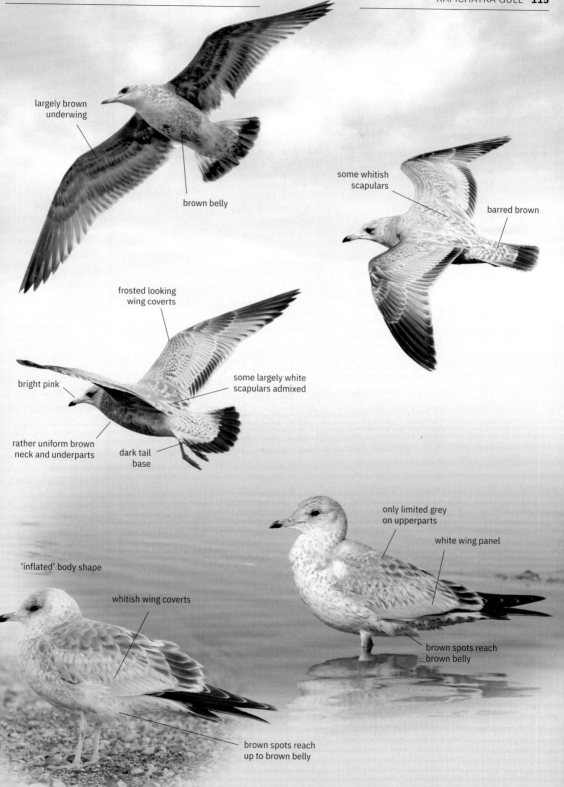

largely brown underwing

brown belly

some whitish scapulars

barred brown

frosted looking wing coverts

bright pink

some largely white scapulars admixed

rather uniform brown neck and underparts

dark tail base

only limited grey on upperparts

white wing panel

brown spots reach brown belly

'inflated' body shape

whitish wing coverts

brown spots reach up to brown belly

they lack broad white fringes on moulted scapulars. There are usually no or very few brown spots on the vent, and the pattern on the belly and neck is less dense.

First-cycle *heinei* are rather different from *kamtschatschensis*, with typically whiter head and body, clean white tail base, browner wing coverts, and more extensive grey colour on moulted scapulars. Most birds also have paler underwing, lacking any barred pattern on the axillaries. Some birds show very brown underwing, but in that case the brown colour is more extensive and more uniform than in Kamchatka Gull.

For differences from Short-billed Gull, see that species.

## Second cycle
——

Most birds of this age category look quite different from *canus* due to their different size and shape as well as more immature plumage. The wing coverts show an extensive brown wash, and often also prominent white fringes on the feathers. This may create a variegated appearance, as the dark grey saddle then contrasts with a whitish-looking wing. Unlike *canus*, there are nearly always blackish spots on the tertials. Many birds show a typical dark shawl on the hindneck consisting of heavy brown blotches, which can be so extensive that it creates the impression of an 'executioner's hood'. The bill colour is often bright, with some already having vivid yellow or even pale orange bills. The iris can already be pale (in nearly one in five birds).

In flight, most second-cycle Kamchatka Gulls show some black patterning on the tail, and they regularly show a complete black tail band. Some show a limited amount of brown barring on the uppertail coverts, which is absent in *canus/heinei*. The underwing coverts often show prominent brown fringes, unlike *canus*. Approximately half of all second-cycle Kamchatka Gulls show blackish markings on the secondaries, and, in more well-marked birds, the pattern may consist of rectangular, solid black patches ('piano keys') contrasting against a pale ground colour, thus giving a distinct piebald impression. A white mirror on P9 is often absent or is very small (i.e., confined to the inner web), and there is often a complete black band across both webs of P4. The pale tongues on P7–P8 average longer and wider than in *canus* and, especially, *heinei*. Note, however, that the primary pattern is not as developed as in adult birds and therefore overlaps even more widely with that of *canus*.

For differences from Short-billed Gull, see that species.

> **▶ RANGE**
> Breeds in eastern Siberia, more precisely in southern Chukotka, Kamchatka, around the Sea of Okhotsk and into Yakutia. The breeding range of *kamtschatschensis* may extend further west than generally thought, into central and perhaps even western Yakutia, and there may be an intergradation zone (see definition on p.110) with *heinei*. Intergradation may also be happening around Lake Baikal, where some birds appear to show mixed characters of both taxa.
>
> Winters mainly in Japan, Korea and eastern China. Vagrant to North America outside of Alaska, with multiple records on the Atlantic coast, as far east as Nova Scotia and Newfoundland. Records on the Atlantic coast seem to have become annual since 2014. There is one record in the Western Palearctic of an adult bird in County Kerry, Ireland, in March 2014, though at the time of writing it was still being reviewed by the Irish rarities committee.

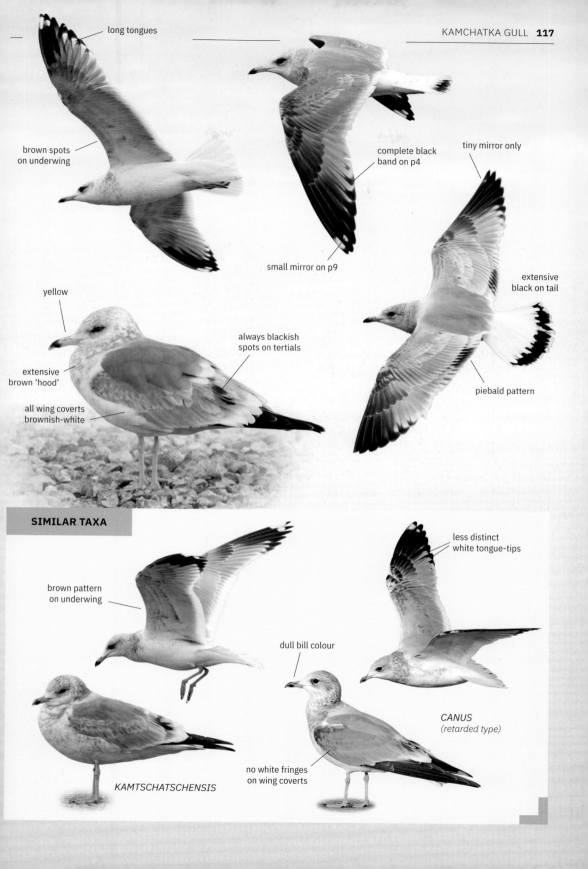

long tongues

brown spots
on underwing

complete black
band on p4

tiny mirror only

small mirror on p9

extensive
black on tail

yellow

always blackish
spots on tertials

extensive
brown 'hood'

all wing coverts
brownish-white

piebald pattern

## SIMILAR TAXA

brown pattern
on underwing

less distinct
white tongue-tips

dull bill colour

*CANUS*
(retarded type)

*KAMTSCHATSCHENSIS*

no white fringes
on wing coverts

# Short-billed Gull
## *Larus brachyrhynchus*

▶ **STRUCTURE**

Short-billed Gull is a trifle smaller than *canus,* with slightly smaller, thinner bill and an even more rounded head with steep forehead. The neck can look rather long at times. Quite a few birds show a slim body with flat back, no tertial step, and curiously upturned wingtips at rest, creating a slight 'banana shape' that is quite unique among gulls. The species is clearly smaller than Kamchatka Gull (which is about the size of Ring-billed Gull) and lacks the oval body shape and sloping forehead of that taxon. The thin bill is also an important difference.

This American taxon has generally been considered part of the Common Gull complex, but it has distinctive plumage at all ages, different size and shape, and different display call. It is separated from the three Common Gull taxa by the Bering Sea and the Pacific Ocean, and its DNA is different from all three (see also Taxonomy on p.6 in the Introduction of this book). We therefore treat it as a distinct species.

## Adult

In winter plumage, the head pattern is distinctive, with an extensive brown wash across the neck, which unlike *kamtschatschensis* tends to be smoothly textured rather than heavily blotched. The brown wash often extends onto the flanks. Head markings are often rather smudgy, and many birds show brown ear coverts or ear patch. Perched birds may attract attention because of their extensive grey base to the wingtips, which may even extend beyond the tertials. The bill colour is usually dull as in *canus*, but a dark bill band is normally absent. A few birds show a complete band but it is rather greyish and does not contrast much with the rest of the bill. The iris averages slightly paler than in *canus*.

The primary pattern is distinctive. Compared with the Common Gull taxa, adult Short-billed Gull tends to have longer pale tongues on the outermost three primaries (P8–P10), larger, more rounded white tongue-tips ('pearls') on P7–P8, and shorter black wedges on the outer webs of P6–P9 combined with more extensive black on P4–P5. The white tips on the inner primaries are typically almost as wide as those on the secondaries, while they are usually much narrower in the Common Gull taxa. These broad white tips on the flight feathers, together with the white 'pearls' on P7–P8 create the impression of a white trailing edge that continues across the outer primaries. Nearly half of all adult Short-billed Gulls show some black on P4, while this is less frequently seen in *canus* (in fewer than 10%). The following features are sometimes shown by adult Short-billed Gull, but never by the Common Gull taxa:

- A white tongue-tip on P9.
- A long tongue on P10, covering more than half the length of the feather (especially in combination with a complete black band on P5).
- A very long tongue on P9, cutting into the white mirror.
- An extensive grey base on the outer web of P9 (covering more than one-third the length of the feather) or P8 (covering more than half the length of the feather).

Unlike the Common Gull taxa, Short-billed Gull only exceptionally shows an isolated white mirror on p8. Especially when used in combination, the subtle features in the primary pattern allow positive identification of nearly all adult Short-billed Gulls even outside their normal range. A detailed identification key can be found in Adriaens and Gibbins (2016). A few *canus* can show the 'string of pearls' up to and including P8, but such birds invariably lack black on P4 and often also on P5; they also show larger white mirrors on P9–P10. The biggest challenge is formed by some

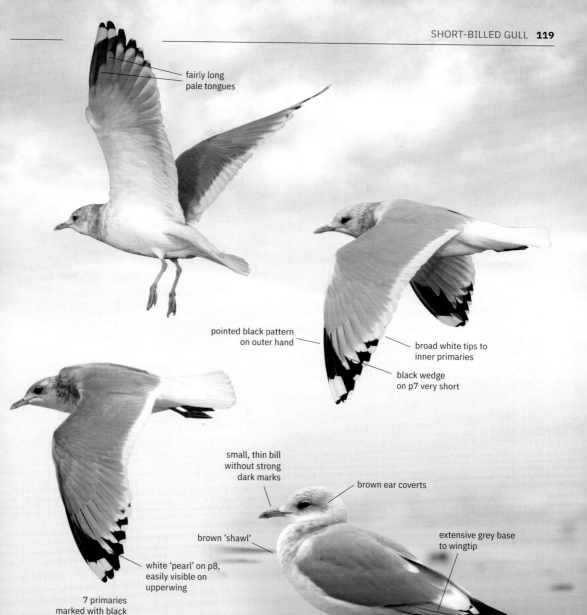

fairly long
pale tongues

pointed black pattern
on outer hand

broad white tips to
inner primaries

black wedge
on p7 very short

small, thin bill
without strong
dark marks

brown ear coverts

brown 'shawl'

extensive grey base
to wingtip

white 'pearl' on p8,
easily visible on
upperwing

7 primaries
marked with black

Kamchatka Gulls, which may combine a string of
pearls with a complete black band on P5. Still, such
birds normally show a complete black base on P9,
and the pattern on P5 is often not symmetrical,
unlike Short-billed.

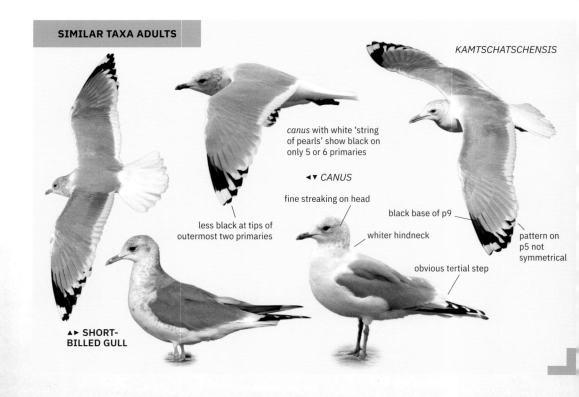

SIMILAR TAXA ADULTS

*KAMTSCHATSCHENSIS*

*canus* with white 'string of pearls' show black on only 5 or 6 primaries

◄▼ *CANUS*

fine streaking on head

black base of p9

less black at tips of outermost two primaries

whiter hindneck

pattern on p5 not symmetrical

obvious tertial step

▲► SHORT-BILLED GULL

# First cycle

At this age, Short-billed Gulls are at their most distinctive, due to their uniform brown neck and underparts, largely dark tail, and pale brown wing coverts. There may be a brown smudge on the ear coverts. The upper- and undertail coverts of Short-billed Gull are typically darker than in the Common Gull taxa, frequently with dark dominating over pale, although there is some variation and paler birds can show a pattern of scattered spots only, overlapping with well-marked *canus*. The tertials often show very thin white fringes only, which unlike *canus* and *kamtschatschensis* do not broaden at the tip. The underwing looks mainly brown. Even paler birds retain a rather sullied greyish ground colour on the underwing coverts so the contrasts are less marked than in the Common Gull taxa. The pattern on the inner primaries is often quite unique; the

dark tips are often well demarcated and extensive, spreading equally across both the outer and inner web of each feather, which may create the impression of a dark trailing edge on the inner hand. In addition, quite a few Short-billed Gulls (though far from all) have a distinctive, wholly pale innermost primary (except for the dark tip). This is very rare in the Common Gull taxa, which nearly always have a thin dark outer edge on this feather.

The main identification problem is with small, dark individuals of Kamchatka Gull. However, these often show stouter bill, barred pattern on the axillaries (unlike Short-billed Gull), more coarsely mottled underparts, and wider, more prominent white fringes on the wing coverts. The scapulars are often more of a mixture of dark grey, brown, and whitish feathers. Note also tertial pattern (showing broad white fringes) and the pattern of the innermost primary (always with dark outer edge).

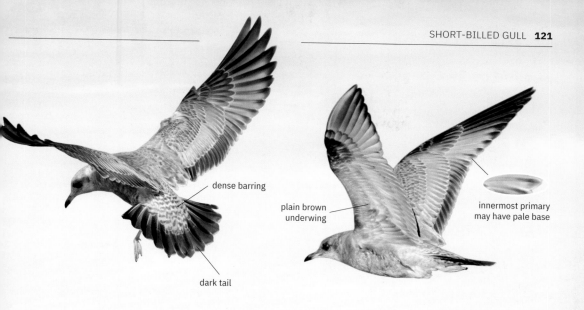

dense barring

plain brown
underwing

innermost primary
may have pale base

dark tail

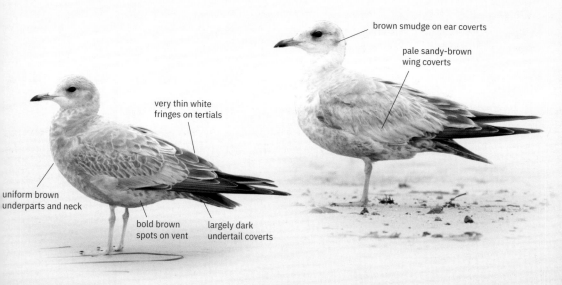

brown smudge on ear coverts

pale sandy-brown
wing coverts

very thin white
fringes on tertials

uniform brown
underparts and neck

bold brown
spots on vent

largely dark
undertail coverts

**SIMILAR TAXA**

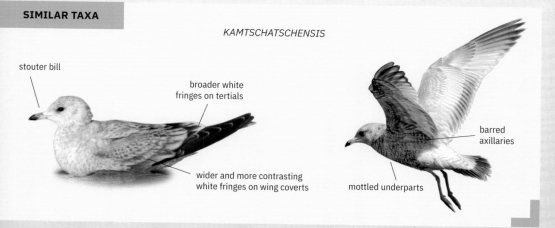

*KAMTSCHATSCHENSIS*

stouter bill

broader white
fringes on tertials

barred
axillaries

wider and more contrasting
white fringes on wing coverts

mottled underparts

# Second cycle

At least in winter, birds of this age category show smooth brown neck pattern that is more extensive than in adults, and some show extensive brown flanks or even a brown belly. There is often a brown patch on the ear coverts. The pattern is more uniform than in the Common Gull taxa, which tend to show coarse spots or fine streaks. The wing coverts may show a brown wash, but usually no prominent white fringes (unlike many Kamchatka Gulls). In flight, the outer greater coverts look mainly plain greyish, except for a thin dark outer edge on the outermost feather in some birds. In Kamchatka Gull, there are usually several outer greater coverts that show such a blackish outer edge. Another useful feature is the pattern of the secondaries: second-cycle Short-billed Gulls only rarely show black centres on the secondaries (unlike many Kamchatka Gulls). These feathers are either adult-like or show just a few thin dark streaks. The greater primary coverts may show a quite unique pattern of thick, drop-shaped black tips contrasting against an extensive, unmarked grey base. In the Common Gull taxa, any thick blackish markings are normally connected to the median primary coverts through a blackish outer edge on some of the feathers, even though this can be very thin. However, Short-billed Gull can also show a pattern very similar to that of the Common Gull taxa, so this feature works in one direction only. Most second-cycle Short-billed Gulls show black tail markings, and some show a complete black tail band (which seems very rare in *canus* at this age). Short-billed further differs from *canus* in showing distinct brown pattern on the underwing coverts.

The primary pattern may also be helpful in distinguishing it from the Common Gull taxa, especially if any of the following features are present:

- Some distinct grey colour at the base of the outer web of P9 (absent in the Common Gull taxa at this age).
- A grey base on the outer web of P8 (rare in second-cycle birds of the Common Gull taxa, in which black usually reaches the primary coverts).
- A long tongue on P9 (covering more than half the length of the feather).
- A very long tongue on P8 (ending level with the white mirrors on P9–P10).
- A white tongue-tip on P8.
- A very symmetrical black pattern on both P5 and P6.

Note also that many birds show a complete black band on P4 (unlike most *canus*), and that most show a broad white tongue-tip ('pearl') on P7 (which is less frequently seen in the Common Gull taxa of this age category).

▶ **RANGE**
Short-billed Gull breeds in Alaska and northwest Canada. It winters along the American west coast south to Southern California, with small numbers reaching Baja California, Mexico. Vagrant in the interior and Atlantic states of North America. There has been one accepted record in the Western Palearctic: an adult bird on the Azores in February–March 2003.

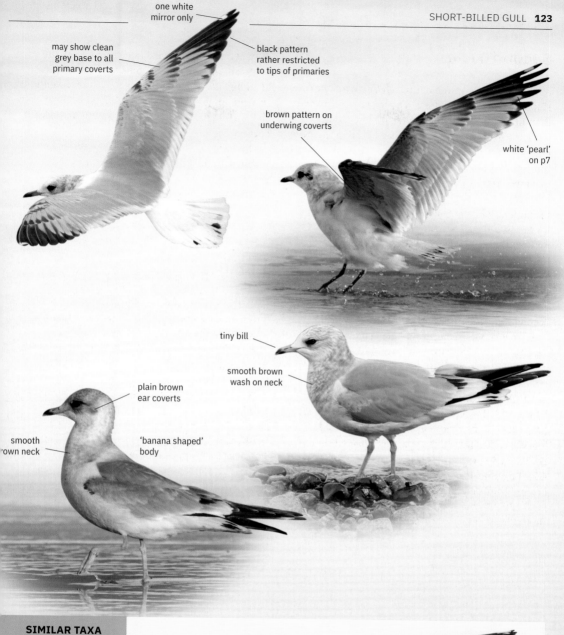

one white mirror only

may show clean grey base to all primary coverts

black pattern rather restricted to tips of primaries

brown pattern on underwing coverts

white 'pearl' on p7

tiny bill

smooth brown wash on neck

plain brown ear coverts

smooth own neck

'banana shaped' body

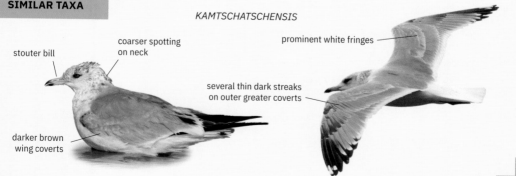

## SIMILAR TAXA

### KAMTSCHATSCHENSIS

stouter bill

coarser spotting on neck

prominent white fringes

several thin dark streaks on outer greater coverts

darker brown wing coverts

# Ring-billed Gull
## *Larus delawarensis*

### ▶ STRUCTURE

Ring-billed Gull sits between Herring Gull and Common Gull in size but is closer to the latter. Large male Ring-billed Gulls recall the former, while small females are very like Common Gull.

Ring-billed is a well-proportioned species, bulkier and broader-winged than Common Gull, and with noticeably stouter, less pointed bill, though not as fierce looking and compact as Herring Gull. When standing or floating, it has a flatter back than Common Gull, making the body look more 'shoebox-shaped'. In direct comparison, Common Gull is more elegant than Ring-billed, often showing a more rounded, dove-like head (but beware that head shape can change with mood). In flight, Ring-billed Gull recalls Herring rather than Common Gull, but at rest, Herring Gull is always appreciably larger and stockier with shorter primary projection and heavier bill.

## Adult

Adults recall Common Gull, but have yellow iris (speckled or all-dark in Common Gull) and pale silvery grey upperparts (similar to Black-headed Gull, while Common Gull is darker, medium grey). Adults combine a staring pale yellow eye, yellow legs, and red orbital ring, and, as the name suggests, a clear-cut black bill band. There is no red gonys spot. Common Gull has a greenish-yellow bill in winter without the bold black ring, sporting a narrow dark zigzag band with diffuse edges instead.

Some Common Gulls have vivid yellow legs, but always show darker grey upperparts with bold and more contrasting white scapular and tertial crescents. Common Gull has much larger white mirrors on the outermost two primaries, particularly obvious in flight. Also, Common Gull has larger and more contrasting white tongue-tips on P5–P7 (or P8), and the white trailing edge on the secondaries and inner primaries is more obvious and better defined. The grey colour of the upperwings of Ring-billed Gull looks so pale in flight that it seems to merge into the white trailing edge, while in adult Common Gull there is a clear-cut contrast between the trailing edge and the rest of the wing.

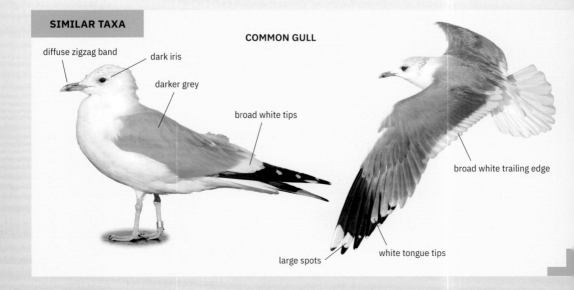

**SIMILAR TAXA**

COMMON GULL

diffuse zigzag band

dark iris

darker grey

broad white tips

broad white trailing edge

large spots

white tongue tips

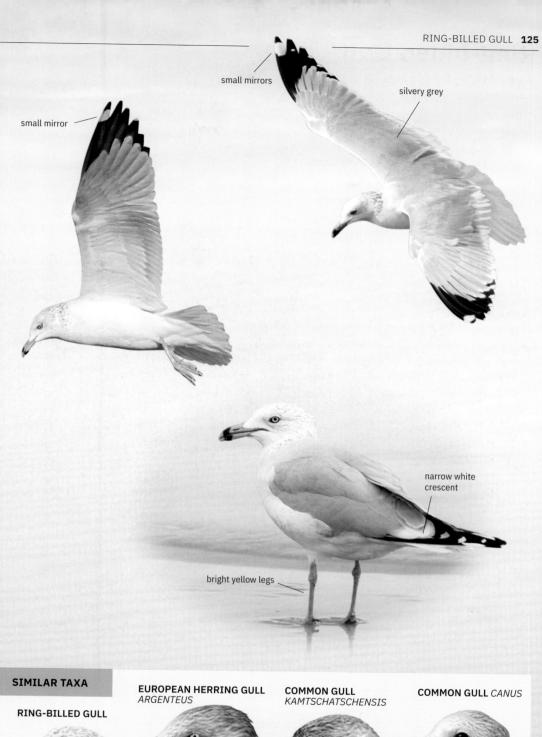

small mirrors

silvery grey

small mirror

narrow white crescent

bright yellow legs

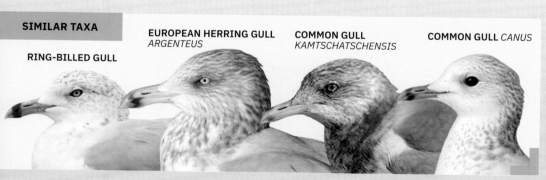

**SIMILAR TAXA**

**EUROPEAN HERRING GULL** *ARGENTEUS*

**COMMON GULL** *KAMTSCHATSCHENSIS*

**COMMON GULL** *CANUS*

**RING-BILLED GULL**

# First cycle

At this age, identification should be based on a combination of characters, including the structural features mentioned above. First-cycle Ring-billed has pink legs and a pink bill with clear-cut black tip or distal black band, recalling Glaucous Gull. In Common Gull the dark tip of the bill is diffuse, showing less contrast to a duller overall bill colour, and the legs often have a green hue instead of pale pink, but note that birds gain more vivid bare parts in late spring.

The plumage in first-cycle Ring-billed shows a lot of contrast, a result of pale grey and bold dark patterns (Common Gull has an overall dull plumage aspect). Ring-billed Gull often shows bold chevron patterns on the flank, while such markings on underparts are less extensive in Common Gull. Replaced scapulars (from early autumn) are silvery grey in Ring-billed Gull, obviously paler than the medium grey feathers in Common Gull. Also, these grey scapulars in Ring-billed Gull commonly show

thin dark anchor patterns and obvious white fringes; such bold patterns are not found in the clean grey scapulars of Common Gull, which at most have a faded darker centre.

The white tail has a dark distal band, normally with dark marbling and spotting at the base, and the dark colour runs up along the shafts (i.e., the tail band appears to 'dissolve'). Typically, Common Gulls have a striking clear-cut black tail band against a clean white tail base.

The underwing of first-cycle Ring-billed Gull shows a characteristic clean white central panel contrasting with dark secondaries and brown lesser underwing coverts.

Ring-billed Gull often shows a silvery grey background on the greater coverts, different from the dull grey or brown coverts in Common Gull. Furthermore, the greater coverts can show a barred pattern, especially on the inner feathers, which differs from the plain coverts of Common Gull.

The tertials show less white at their tips than in Common Gull.

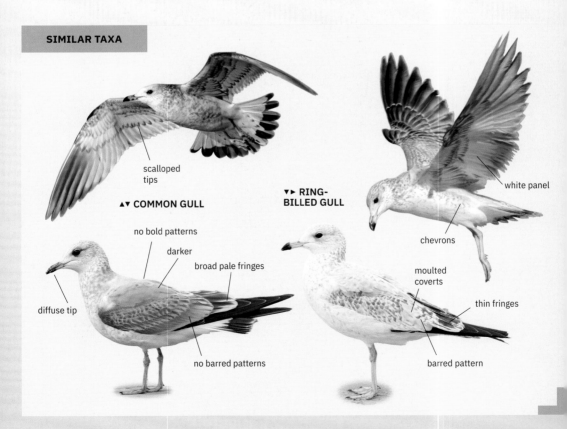

SIMILAR TAXA

scalloped tips

▲▼ COMMON GULL

▼▶ RING-BILLED GULL

white panel

chevrons

no bold patterns

darker

broad pale fringes

diffuse tip

moulted coverts

thin fringes

no barred patterns

barred pattern

If any coverts or tertials are included in the post-juvenile moult, this is a good indication of Ring-billed Gull, since wing coverts and tertials are usually not replaced before March in first-cycle Common Gull (though accidental loss of feathers may happen; check both wings for symmetry).

First-cycle Ring-billed Gulls are variable. Pale birds are sometimes referred to as 'ghost-type' Ring-billed Gull. They show limited brown pattern on underparts, head, and neck, and they lack heavy markings on flanks. The other extreme of the spectrum includes dark, chocolate brown birds with extensive dark markings on the underparts, head, and neck, and solid dark centres on the longer scapulars.

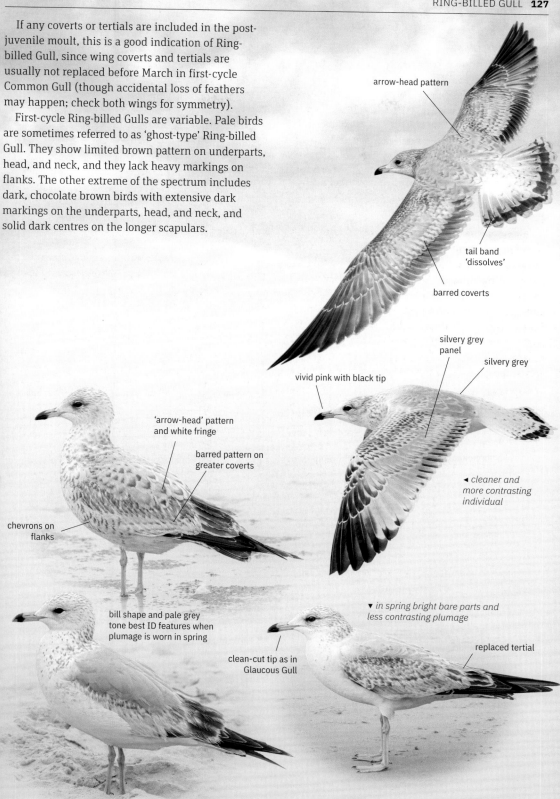

arrow-head pattern

tail band 'dissolves'

barred coverts

silvery grey panel

silvery grey

vivid pink with black tip

'arrow-head' pattern and white fringe

barred pattern on greater coverts

chevrons on flanks

◄ *cleaner and more contrasting individual*

▼ *in spring bright bare parts and less contrasting plumage*

replaced tertial

bill shape and pale grey tone best ID features when plumage is worn in spring

clean-cut tip as in Glaucous Gull

# Second cycle

Resembles Common Gull at rest, but the plumage generally matures more slowly and shows more subadult markings. It has small mirrors on the outermost primaries (the mirror on P9 may even be absent), while Common Gull (especially ssp. *canus*) tends to have large mirrors, especially on P10. Many second-cycle Ring-billed Gulls start to show a yellow iris from midwinter onwards, while Common Gulls retain dark eyes (even as adults). The grey tone of the upperparts is always darker on Common Gull.

Plumage-wise this age-class may be mistaken for one year older Herring Gull, which shares the pale eye and the smaller mirrors, and which often has a black band on the bill. Herring Gull is much heavier, however, and its immature markings are a pale diffuse or faded brown, while in Ring-billed they are sharply demarcated and almost blackish. Unlike second-cycle Ring-billed, third-cycle Herring Gull shows barred pattern on greater coverts or tertials.

Second-cycle Ring-billed Gull often shows blackish spots on the tail, secondaries, or tertials. Although dark marks on tail feathers are not unusual in Common Gull, black markings on the secondaries are rare (although more common in the races *heinei* and *kamtschatschensis*).

The bare parts and iris coloration in second-cycle Ring-billed Gull recall adults, while second-cycle Common has less saturated bare parts in autumn and early winter. The legs are often greenish or greyish-yellow in the latter species and the bill base often appears bluish.

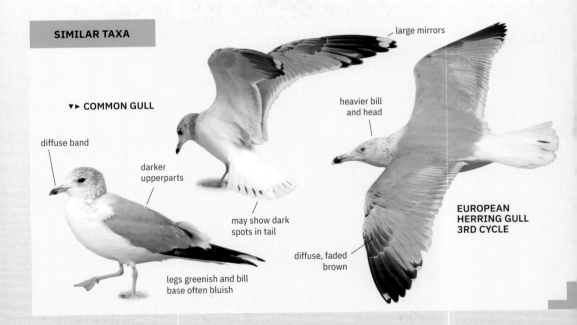

SIMILAR TAXA

large mirrors

▾► COMMON GULL

heavier bill and head

diffuse band

darker upperparts

may show dark spots in tail

EUROPEAN HERRING GULL 3RD CYCLE

diffuse, faded brown

legs greenish and bill base often bluish

**▶ RANGE**

An annual transatlantic vagrant in small numbers, with most records in Iceland, Ireland, and Britain. May turn up anywhere as a vagrant (there is even a record from the Caspian Sea, Kazakhstan) and can be very confiding, feeding at the local mall's parking lot. Vagrant birds often associate with other species, notably Black-headed and Common Gulls.

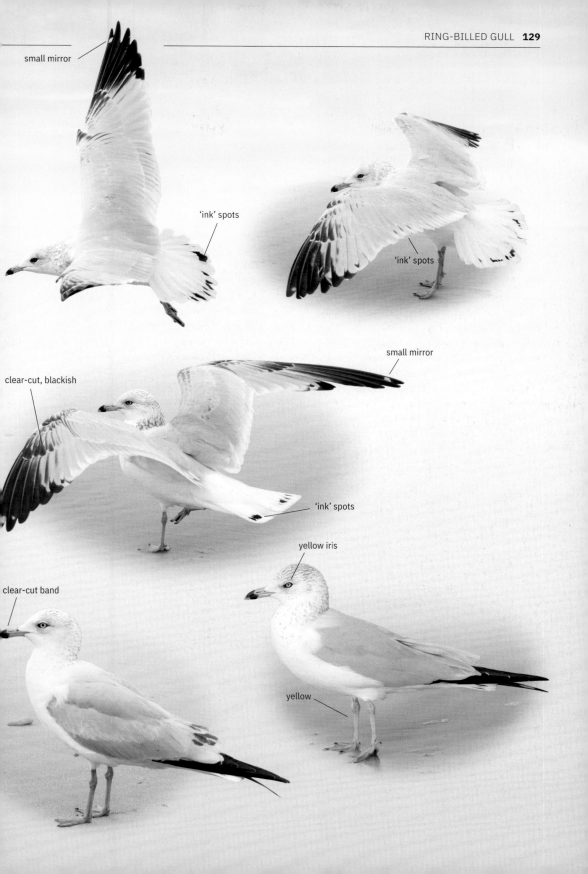

small mirror

'ink' spots

'ink' spots

clear-cut, blackish

small mirror

'ink' spots

yellow iris

clear-cut band

yellow

# Audouin's Gull
## *Ichthyaetus audouinii*

**▶ STRUCTURE**
Slightly smaller than Lesser Black-backed Gull, although the wing span is approximately equal. Has a rather characteristic shape due to the long, flat forehead, pointed, slightly drooping bill, and slim body with long primary projection. At all ages has dark grey legs and dark iris.

## Adult

Easily recognised by its red bill, pale grey upperparts (slightly paler than European Herring Gull race *argenteus*), dark eye, and dark legs. The white tertial crescent is only thin and indistinct. The underparts have a pale grey wash, which even from a distance adds to the impression of a rather grey gull with white head, unlike other adult large gulls, which show more contrast between the upperparts and white underparts. In flight, the white trailing edge on the wings is less distinct than in the other large gulls. The outermost two or three primaries show more extensive black than in European Herring Gull, and there is at most a small white mirror on P10 only.

In Herring Gulls feeding on organic waste or carrion, the bill might become soiled red, but closer scrutiny should reveal clear differences from Audouin's in size, shape, leg colour, and iris colour. Even from a distance, the broader white tertial crescent and, in flight, prominent white trailing edge on the wings should be obvious.

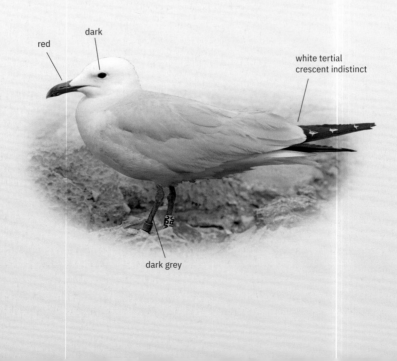

red

dark

white tertial
crescent indistinct

dark grey

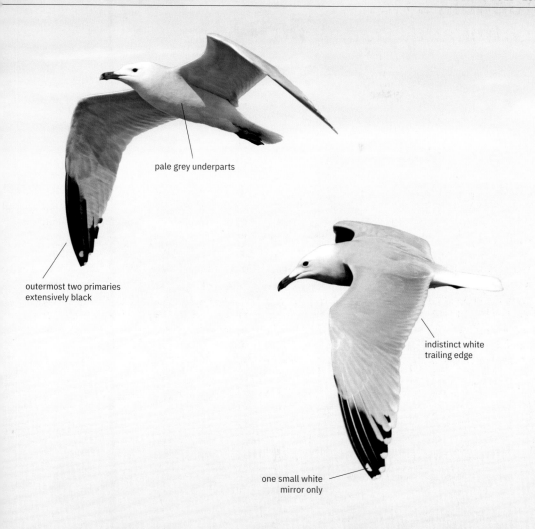

pale grey underparts

outermost two primaries
extensively black

indistinct white
trailing edge

one small white
mirror only

## First cycle

Juvenile Audouin's Gulls show a brown, scalloped plumage that is quite similar to that of the larger gulls, especially dark individuals of Lesser Black-backed Gull, which also have dark inner primaries, dark greater coverts, and rather dark tail. However, Audouin's shows more uniform brown head, neck, and underparts, whereas juvenile Lesser Black-backed Gull shows a streaked pattern on head and neck, as well as a coarser, more barred pattern on flanks. In fresh plumage, the wing coverts show neat pale edges, while Lesser Black-backed shows notched edges and often a barred pattern on the greater coverts. The undertail coverts show isolated dark spots, whereas Lesser Black-backed usually shows more of a barred pattern. Note also leg colour, and that many Audouin's show a pale face and chin, contrasting with the brown neck and breast. In flight, the underwing is immediately diagnostic, as it shows a clean white central panel that contrasts strongly against otherwise dark brown feathers. The uppertail coverts show a few scattered, bold, dark spots on the outer feathers but are otherwise clean white; the pattern may create a white U-shape not seen in Lesser Black-backed Gull. The tail is solid dark, whereas Lesser Black-backed usually shows some fine barring at the base.

After the post-juvenile moult, the upperparts are largely pale grey, and the wing coverts are often of

two types: clean grey feathers and old brown, juvenile ones. Such a combination of clean grey feathers and worn juvenile, plain brown feathers is quite unique among large gulls. First-winter Herring Gulls do not show clean grey feathers on upperparts or wing coverts, and second-cycle birds (after the complete moult) do not show juvenile primaries (brown and pointed, versus blackish and rounded in second-cycle Herring). Second-cycle Herring Gulls also differ in their pale inner primaries, far less contrasting underwing pattern, and pink legs.

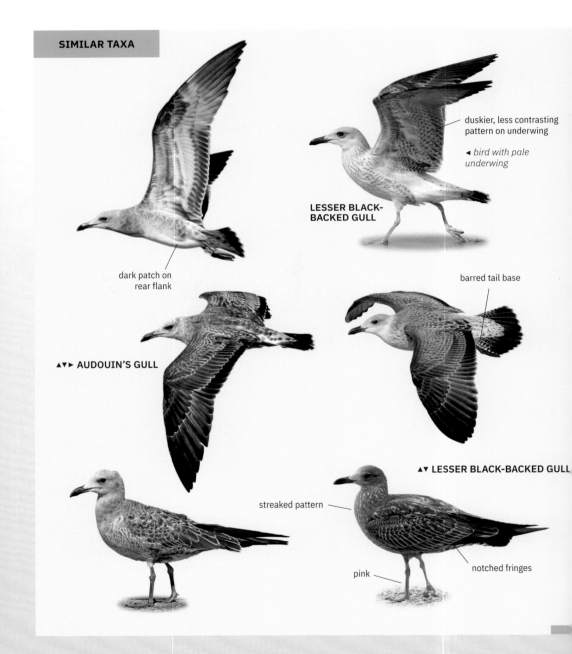

SIMILAR TAXA

duskier, less contrasting pattern on underwing

◄ *bird with pale underwing*

LESSER BLACK-BACKED GULL

dark patch on rear flank

barred tail base

▲▼► AUDOUIN'S GULL

▲▼ LESSER BLACK-BACKED GULL

streaked pattern

notched fringes

pink

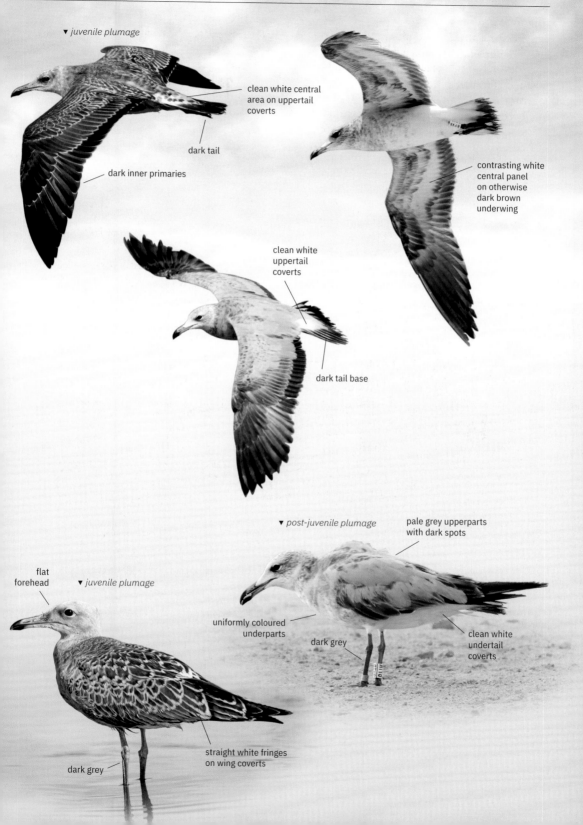

▼ *juvenile plumage*

clean white central area on uppertail coverts

dark tail

dark inner primaries

contrasting white central panel on otherwise dark brown underwing

clean white uppertail coverts

dark tail base

▼ *post-juvenile plumage*

pale grey upperparts with dark spots

flat forehead

▼ *juvenile plumage*

uniformly coloured underparts

dark grey

clean white undertail coverts

straight white fringes on wing coverts

dark grey

# Second cycle

The upperparts and most wing coverts are clean grey and adult-like at this age. Thus, the plumage looks more advanced than in larger gulls of the same age, and is more similar to that of third-cycle rather than second-cycle Herring, but the former often has pale iris and brown pattern on the greater coverts. Second-cycle Audouin's shows a more solid, clear-cut black band on the tail, and the inner primaries often look darker (although some birds show quite adult-like pattern on up to four inner primaries). The white tertial crescent is faint or absent. The underparts assume a grey wash and the bill becomes orange or reddish towards spring. Note also leg colour.

With their pale grey upperparts, dark legs, brown eye-mask, similar bill colour, and clean black and white tail pattern, second-winter Audouin's may bear a slight resemblance to first-winter Mediterranean Gulls with advanced moult in their wing coverts. It is much bigger, however, and shows grey instead of white underparts. Its outer greater coverts are dark and so are the outer primaries, whereas in first-cycle Mediterranean Gull the outer primaries, when viewed from below, are mainly white.

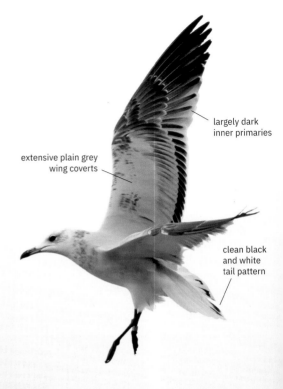

largely dark inner primaries

extensive plain grey wing coverts

clean black and white tail pattern

## ▶ RANGE

Breeds around the Mediterranean Sea, from Ceuta in the west to Cyprus in the east. Has recently also colonised southwest Spain (Huelva) and southeast Portugal, and also breeds in northern Morocco (Tangiers). The largest breeding colonies are found in the Ebro delta and on the Chafarinas Islands (Spain).

Winters in the Mediterranean basin but large numbers also move south along the West African coast, south to Senegambia. Also spreads along the southern coast of Portugal in winter, and now occurs regularly further north along the Atlantic coast up to Basque Country, Spain. Rare in Israel. Vagrant to Western, Central, and Northern Europe, with among others 9 records in Britain, 2 in Finland, and 1 in Sweden up to 2020. Has also reached Georgia (August 2015), Guinea (October 2016), and the Azores (4 records), and there is even a recent record from South America (Trinidad, December 2016).

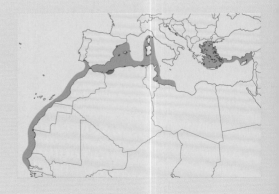

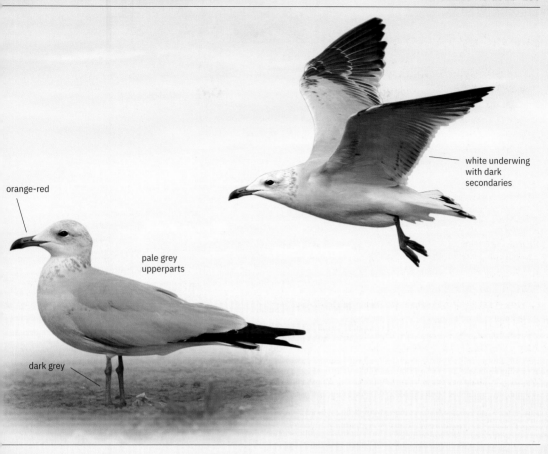

white underwing with dark secondaries

orange-red

pale grey upperparts

dark grey

## Third cycle

Resembles adult, and can be easily identified on the basis of the same criteria for that age category. There is usually no white mirror on the outermost primary.

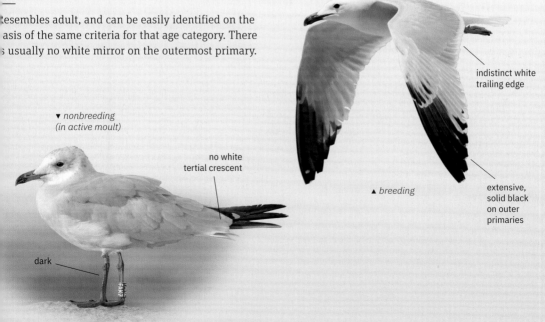

▼ *nonbreeding (in active moult)*

no white tertial crescent

▲ *breeding*

indistinct white trailing edge

extensive, solid black on outer primaries

dark

# Pallas's Gull
## *Ichthyaetus ichthyaetus*

▶ **STRUCTURE**

Even though it belongs to the same genus as Mediterranean Gull (*Ichthyaetus*), Pallas's Gull is a very large gull with bulky structure. It has a sloping forehead, strong bill, and angular nape. The overall impression is that of a slightly triangular head shape. Compared with the body, the head looks proportionally small; the overall shape may recall that of Glaucous Gull to some extent, with rather short primary projection. The legs are long. Flies with fairly slow wingbeats, often with arched wings. The species appears to sit high on the water, more obviously so than most other large gulls.

## Adult

Unmistakable in breeding plumage since it is the only large gull with a black hood. Easily identified by its large size, grey upperparts, and large white leading edge on the outer hand (and black subterminal markings on P5/6–P10), and a black hood (in breeding plumage). In nonbreeding plumage shows a prominent blackish mask around the eye with contrasting white eyelids, unlike other large gulls.

Confusion is possible with second-cycle Mediterranean Gull if size cannot be judged accurately, but the darker grey upperparts, contrasting white panel on outer hand, yellow bill base, and yellow legs should make identification easy.

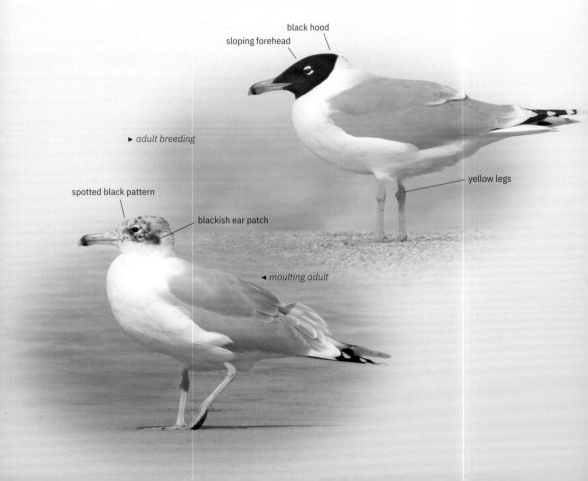

black hood

sloping forehead

▶ *adult breeding*

yellow legs

spotted black pattern

blackish ear patch

◀ *moulting adult*

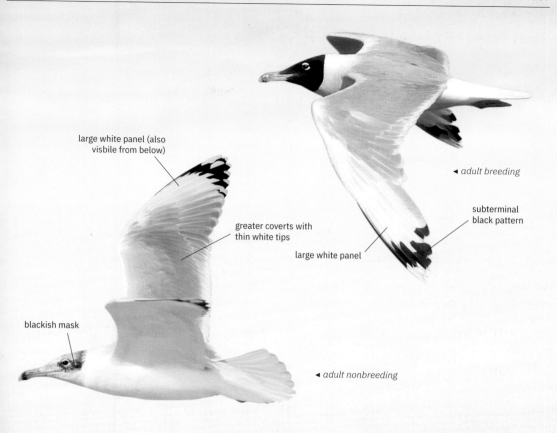

large white panel (also visbile from below)

greater coverts with thin white tips

◄ *adult breeding*

subterminal black pattern

large white panel

blackish mask

◄ *adult nonbreeding*

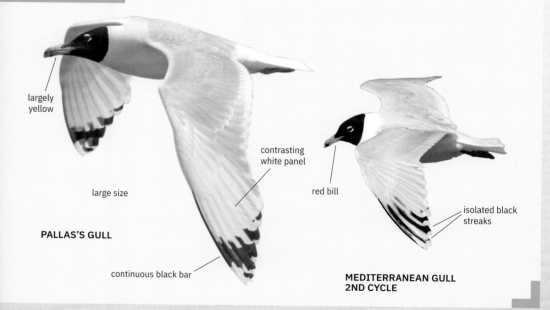

largely yellow

contrasting white panel

red bill

isolated black streaks

large size

**PALLAS'S GULL**

continuous black bar

**MEDITERRANEAN GULL 2ND CYCLE**

## First cycle

At this age the plumage recalls that of the medium-sized gulls, like Common Gull. It may also be confused with immature Caspian or Yellow-legged Gulls, but its underparts are much cleaner white, and its white eyelids stand out clearly in the dark mask around the eye.

After the post-juvenile moult, Pallas's Gulls show characteristic rounded black spots on the upper mantle, while the rest of the upperparts are uniformly grey. As in juvenile birds, the tail is clean white with a well-defined black band, and the greater coverts often look grey rather than brown. The upperwing coverts show a very simple pattern without any barring or notching. The underwing looks much whiter than in first-cycle Yellow-legged and Caspian Gull. Also typical at this age are the black V-shaped spots on the outer undertail coverts.

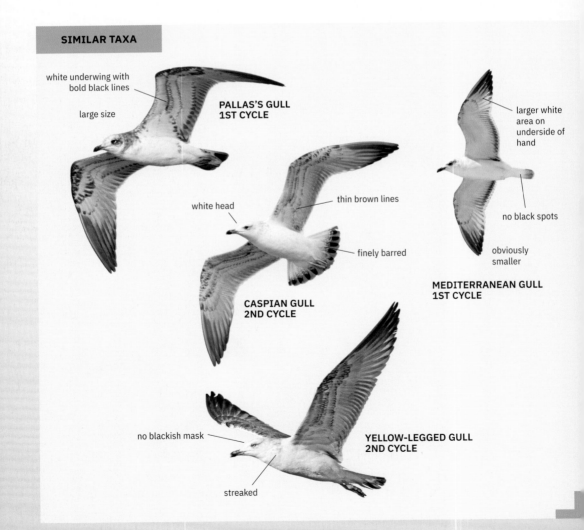

**SIMILAR TAXA**

white underwing with bold black lines

large size

**PALLAS'S GULL 1ST CYCLE**

larger white area on underside of hand

white head

thin brown lines

no black spots

finely barred

obviously smaller

**MEDITERRANEAN GULL 1ST CYCLE**

**CASPIAN GULL 2ND CYCLE**

no blackish mask

**YELLOW-LEGGED GULL 2ND CYCLE**

streaked

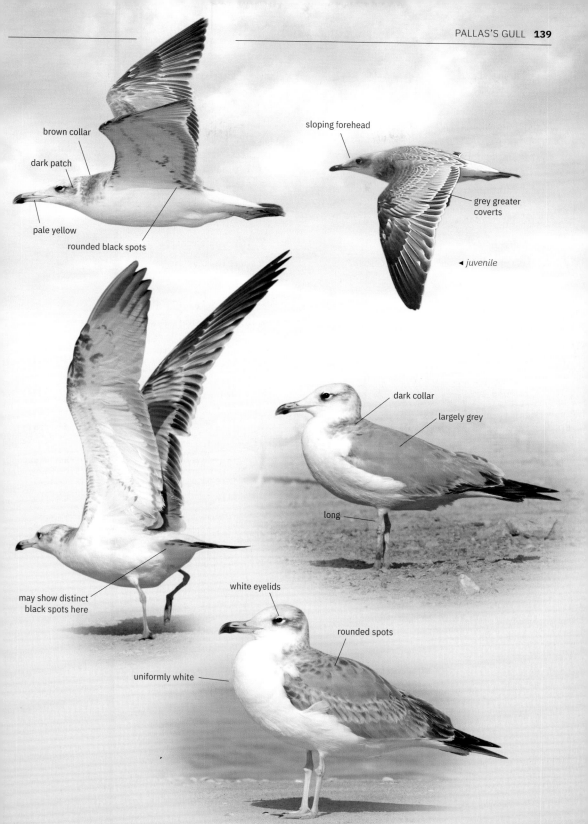

brown collar

dark patch

pale yellow

rounded black spots

sloping forehead

grey greater coverts

◄ *juvenile*

dark collar

largely grey

long

may show distinct black spots here

white eyelids

rounded spots

uniformly white

# Second cycle

Like adults, easily recognised by the white leading edge on the outer hand, blackish mask through the eye, and largely yellow bill. In second-cycle birds, the white wing panel is combined with largely black outer primaries, which show just small white mirrors on P9–P10.

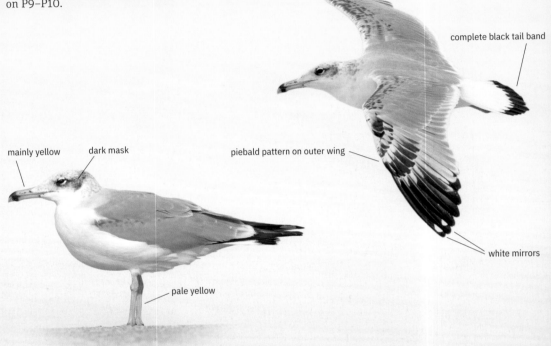

complete black tail band

mainly yellow    dark mask

piebald pattern on outer wing

white mirrors

pale yellow

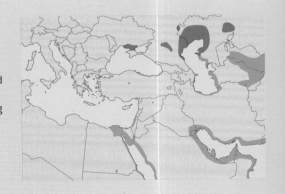

**▶ RANGE**

Pallas's Gull breeds from the Danube delta in Romania (where a few tens of pairs have started breeding in recent years) through Crimea, the shores of the Caspian Sea, and Kazakhstan east to northwestern Mongolia, and the northwesternmost part of China. It winters mainly from the Red Sea (in Egypt) to Myanmar, especially along the northern shores of the Indian Ocean. Winters on several lakes in Armenia and Azerbeijan, along the southern and eastern shores of the Caspian Sea, and in Central Asia. It is rare along the eastern shores of the Mediterranean Sea and the western coast of the Black Sea (Bulgaria, Romania), as well as from Ethiopia to Tanzania and in Thailand. It is a regular vagrant to Central Europe, and a very rare vagrant to Western and Northern Europe, Northwest Africa, and Madeira.

# Third cycle

At this age, the plumage is very similar to that of
adults, with a slightly larger amount of black on the
outer primaries (black pattern covering more than
half the feather on P9–P10).

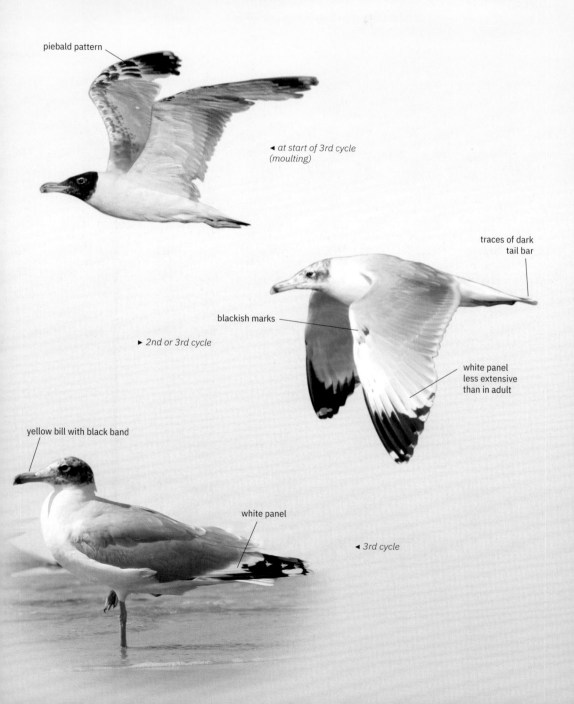

piebald pattern

◄ *at start of 3rd cycle
(moulting)*

traces of dark
tail bar

blackish marks

► *2nd or 3rd cycle*

white panel
less extensive
than in adult

yellow bill with black band

white panel

◄ *3rd cycle*

# Great Black-backed Gull
## *Larus marinus*

**▶ STRUCTURE**

This species is the largest of all gulls in the world. It is stocky, brutal, and powerful with heavy bill, robust pink legs, short primary projection, and a heavy 'bull neck'. Males are easily identified on size and structure; females are smaller, though equally impressive, and stronger than, for example, Herring Gull. It has relatively small, beady eyes set high in the flat head. The iris is rather dark at all ages.

## Adult

Adults are unmistakable due to their blackish upperparts, strong pink legs, and fierce-looking head. They have a relatively small, speckled eye and powerful yellow bill.

Its smaller cousin the Lesser Black-backed Gull has slate grey upperparts, yellow legs, and a longer wing projection. It also has more black and less white in the wingtip. In Great Black-backed Gull, P10 has a large mirror that merges with the white tip, and a large mirror on P9. An 'extra mirror' on P8 is fairly common. The black band on P5 is reduced or absent, unlike in Lesser Black-backed Gull.

Adults in winter appear white-headed with only delicate streaking, not creating a hooded or blotchy effect.

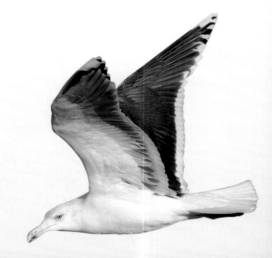

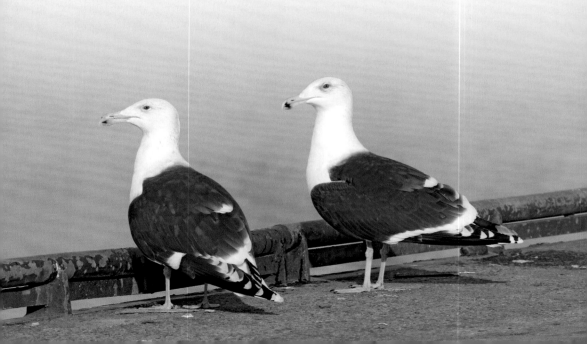

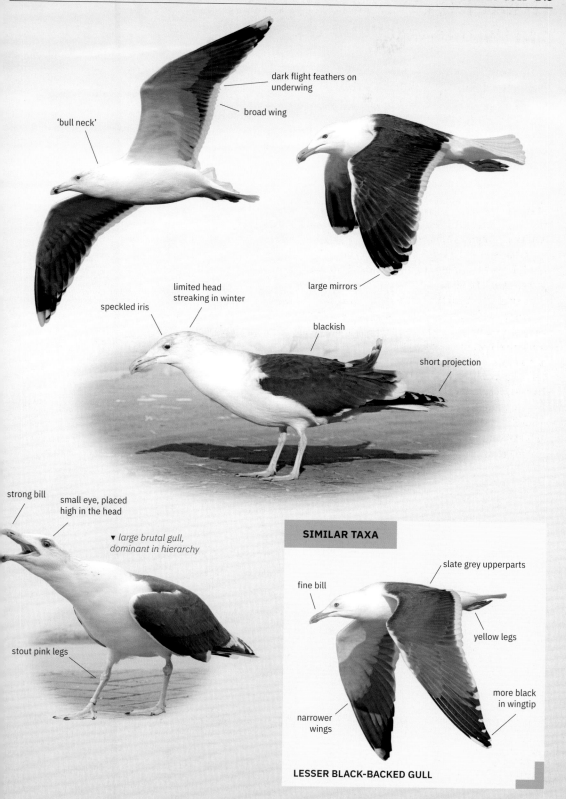

dark flight feathers on
underwing

broad wing

'bull neck'

large mirrors

limited head
streaking in winter

speckled iris

blackish

short projection

strong bill

small eye, placed
high in the head

▼ *large brutal gull,
dominant in hierarchy*

stout pink legs

**SIMILAR TAXA**

slate grey upperparts

fine bill

yellow legs

more black
in wingtip

narrower
wings

**LESSER BLACK-BACKED GULL**

# First cycle

Easily identified on structure and size, but also relevant in this age-class is the contrasting plumage with broad white spacing on the greater covert row, and obvious white notching on the tertial fringes, two features also found in Herring Gull. Unlike that species, the tail shows limited black, normally reduced to a thin band that contrasts strongly with the white tail base. In flight, shows only a weak pale window on the inner primaries, not as obvious as in first-cycle Herring Gull. The inner primaries are a dull, muddy brown, with less contrast to the outer primaries, and they often show a pale spot near the tip.

Some first cycles may recall Yellow-legged Gull, which also has a rather narrow tail band. However,

being a southern European species, Yellow-legged typically shows bleached and worn wing coverts already by November. Hence, feather wear can be a useful feature, since Great Black-backed Gulls from northern latitudes remain remarkably 'fresh' in autumn. Also, Yellow-legged Gull develops a warm reddish brown cast on the coverts, while Great Black-backed Gull is rather cold brown, with a contrasting silvery white background to the feather pattern. From late September onwards, many first-cycle Yellow-legged Gulls show new wing coverts or tertials. Great Black-backed Gull does not replace these feathers in the post-juvenile moult (and in this respect is similar to Herring Gull).

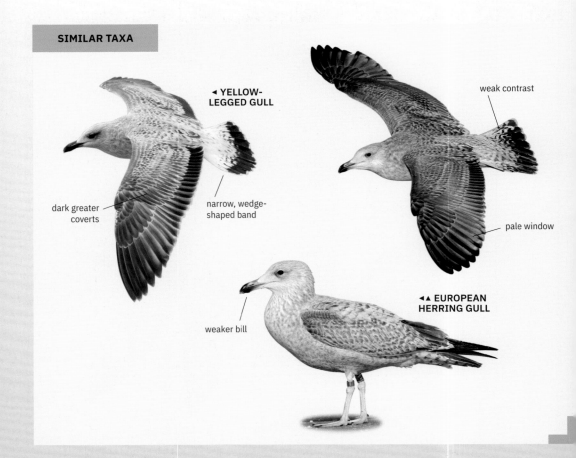

**SIMILAR TAXA**

◄ YELLOW-LEGGED GULL

dark greater coverts

narrow, wedge-shaped band

weak contrast

pale window

weaker bill

◄▲ EUROPEAN HERRING GULL

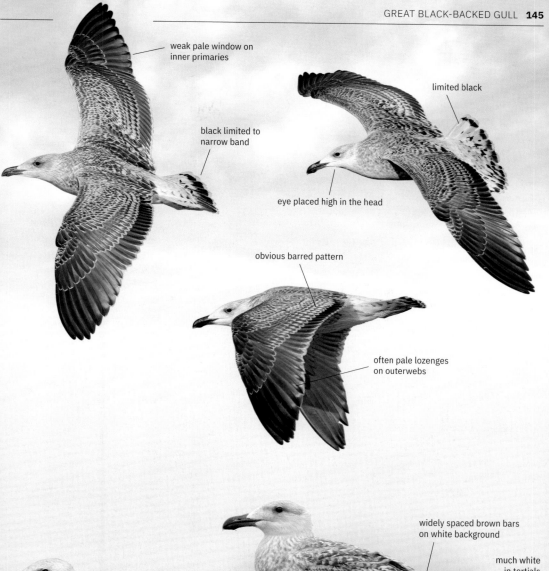

weak pale window on
inner primaries

limited black

black limited to
narrow band

eye placed high in the head

obvious barred pattern

often pale lozenges
on outerwebs

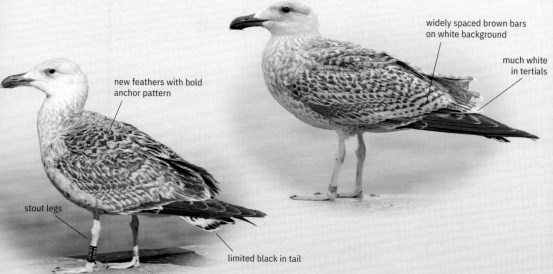

widely spaced brown bars
on white background

much white
in tertials

new feathers with bold
anchor pattern

stout legs

limited black in tail

## Second cycle

—

Unmistakable. Potential confusion is limited to Scandinavian Herring Gulls that have not yet acquired adult-like grey feathers on upperparts. In Great Black-backed Gull the head is pale with delicate streaking, concentrated around the dark eye and on the side of the breast. Same-age Herring Gull often has bold blotchy markings, especially on hindneck. Most of the underparts are whitish, while Herring Gull is heavily patterned on flanks and on the side of the breast in autumn and winter.

Great Black-backed Gull has a contrasting plumage with very dark brown patterns set off against a silvery white background. Overall, Herring Gull looks more 'muddy brown'. Identification becomes straightforward when fresh because replaced feathers reveal a blackish tone similar to adult upperparts.

Great Black-backed Gull has much white in the primaries as an adult, and a small mirror is commonly found already in second-generation P10, a feature shared with Caspian and Scandinavian Herring Gulls, but not found in Yellow-legged and Lesser Black-backed Gull. The inner primaries are a 'cold' grey-brown, darker than in Herring Gull.

The tail has a narrow band with fine barring and spotting, showing a strong contrast to the white base. Most Herring Gulls show densely patterned tail base and thus lack such strong contrast.

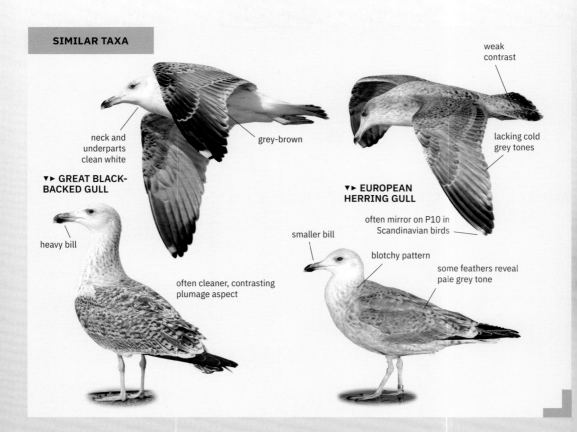

**SIMILAR TAXA**

weak contrast

neck and underparts clean white

grey-brown

lacking cold grey tones

▼▶ GREAT BLACK-BACKED GULL

▼▶ EUROPEAN HERRING GULL

heavy bill

often mirror on P10 in Scandinavian birds

smaller bill

blotchy pattern

some feathers reveal pale grey tone

often cleaner, contrasting plumage aspect

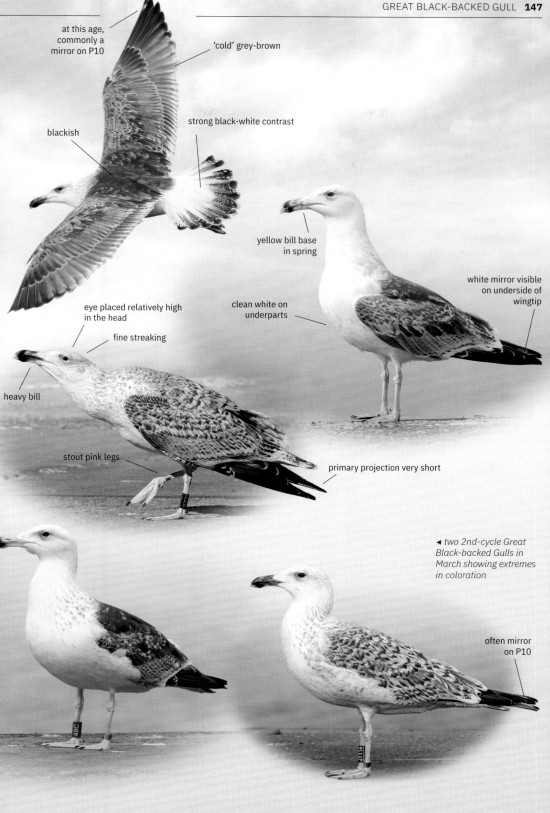

at this age, commonly a mirror on P10

'cold' grey-brown

strong black-white contrast

blackish

yellow bill base in spring

eye placed relatively high in the head

clean white on underparts

white mirror visible on underside of wingtip

fine streaking

heavy bill

stout pink legs

primary projection very short

◄ *two 2nd-cycle Great Black-backed Gulls in March showing extremes in coloration*

often mirror on P10

# Third cycle

Unmistakable. Identification is straightforward as in adults, based on size, structure, and blackish upperparts. The only potential pitfall is immature Lesser Black-backed Gull, which may show pink legs but is always appreciably smaller. The mirror on P10 is small or absent in immature Lesser Black-backed, while large and sharply defined in Great Black-backed Gull. Like many adults, some third-cycle birds have the mirror merged with the white tip, which is never the case in immature Lesser Black-backed.

Also, third-cycle Lesser Black-backed Gull commonly shows an adult-like plumage (i.e., few immature features, and often a completely white tail), while Great Black-backed is slow in maturation, often retaining brown wing coverts and barring on the tertials, much black in the tail, and much black on the bill.

Other features to check are the eye colour (notably paler iris in Lesser Black-backed) and the size of the white primary tips (tiny tips in Lesser Black-backed, large white tips in Great Black-backed Gull).

---

**SIMILAR TAXA**

heavy bill

**GREAT BLACK-BACKED GULL**

dark eye

**LESSER BLACK-BACKED GULL**

smaller white tips

---

▶ **RANGE**

Great Black-backed Gull is a particularly marine species from Northern Europe with expanding breeding range along the Atlantic coast in France. There are few inland records, most often along rivers, and there is a small breeding population along the river Rhine.

Many birds follow trawlers on open sea for prolonged periods, coming to land only to rest and preen. Other birds choose fishing ports and beaches to spend the winter, where they feed on fish discards and leftovers. It is a dominant species, highest in the gull hierarchy when fighting over food resources.

Some records may involve birds from the American population, as proven by a ringed bird in Portugal. The species is a vagrant to Central and most of Southern Europe, although small numbers breed in northern Spain and southern Morocco.

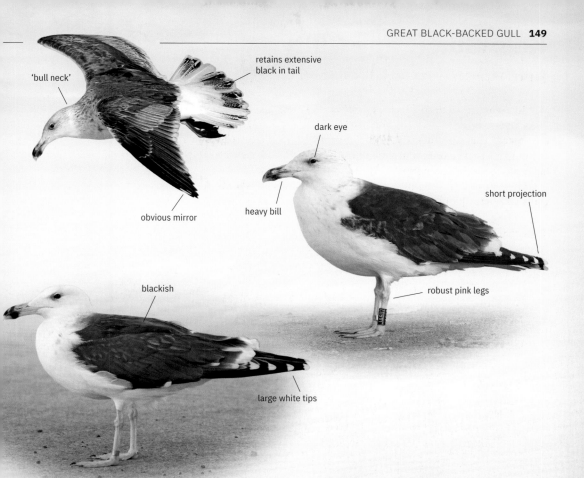

'bull neck'

retains extensive
black in tail

dark eye

short projection

obvious mirror

heavy bill

robust pink legs

blackish

large white tips

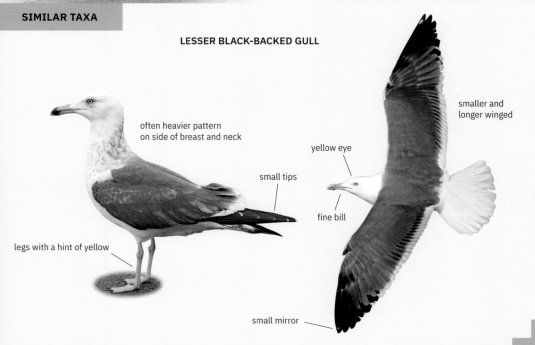

**SIMILAR TAXA**

**LESSER BLACK-BACKED GULL**

often heavier pattern
on side of breast and neck

smaller and
longer winged

yellow eye

small tips

fine bill

legs with a hint of yellow

small mirror

# Kelp Gull (Cape Gull)
## *Larus dominicanus vetula*

▶ **STRUCTURE**

Kelp Gull is a big, bulky species that recalls Great Black-backed Gull in structure and coloration. African birds have long legs, long wings, and bulky body with heavy chest, but the most characteristic part of their structure is the shape of the bill and head. The bill is huge, with a distinct gonydeal angle which gives it a drooping impression, as if the tip is too heavy—an effect reinforced by the extensive red gonys spot in adults. The head is big, more angular, and less rounded than in Great Black-backed, with a small eye placed high and to the front. At all ages the secondaries are clearly visible below the greater coverts in perched birds.

As Cape Gull is a Southern Hemisphere species, its moult cycle is theoretically the opposite of that of the other large gulls in this book, which means that it replaces its primaries during the boreal winter and spring (November–May). However, in birds breeding in Senegambia, moult timing can be similar to that of Northern Hemisphere gulls. Indeed, most of the birds observed in Europe and Morocco have exhibited 'normal' moult timing, although sometimes delayed by two or three months and not yet complete in January–February.

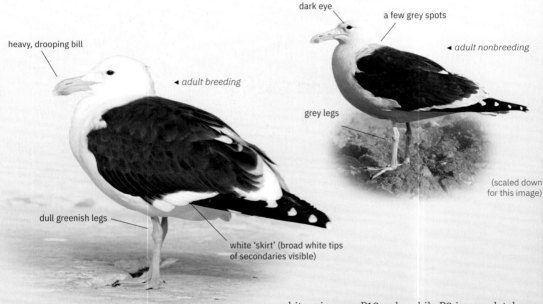

dark eye

a few grey spots

◀ *adult nonbreeding*

heavy, drooping bill

◀ *adult breeding*

grey legs

dull greenish legs

white 'skirt' (broad white tips of secondaries visible)

(scaled down for this image)

## Adult

The white trailing edge on the wing is very wide and obvious even on perched birds, in which it forms a continuous and wide white line below the greater coverts—a notable difference from Great and Lesser Black-backed Gulls. In flight, the white trailing edge is wide not only on the secondaries but also on the inner primaries, where it is wider than in the other gull taxa discussed here. There is usually a small white mirror on P10 only, while P9 is completely black, although a very small, rounded, white mirror may rarely be present on the inner web of the latter feather. There is never a large white area at the tip of the outermost primary in *vetula*, unlike in adult Great Black-backed Gull. Thin, indistinct white tongue-tips are present on the central primaries, most visible on P5 but sometimes extending to P7. Black subterminal pattern can be present inwards to P4. In adult Great Black-backed Gull, black is usually present only to P5, and the white tongue-tips are

broad white trailing edge

white tongue-tips
sometimes lacking

dark eye with orange
orbital ring

sometimes a little
black on bill

one small
white mirror

◄ *adult breeding*

▼ *adult breeding*

iris rarely dull yellow

broad white crescent

yellowish-green legs

leg colour
rarely yellow

streaked hindneck

heavy, drooping bill with a
little black on gonys

► *adult nonbreeding*

greyish-green legs

## SIMILAR TAXA

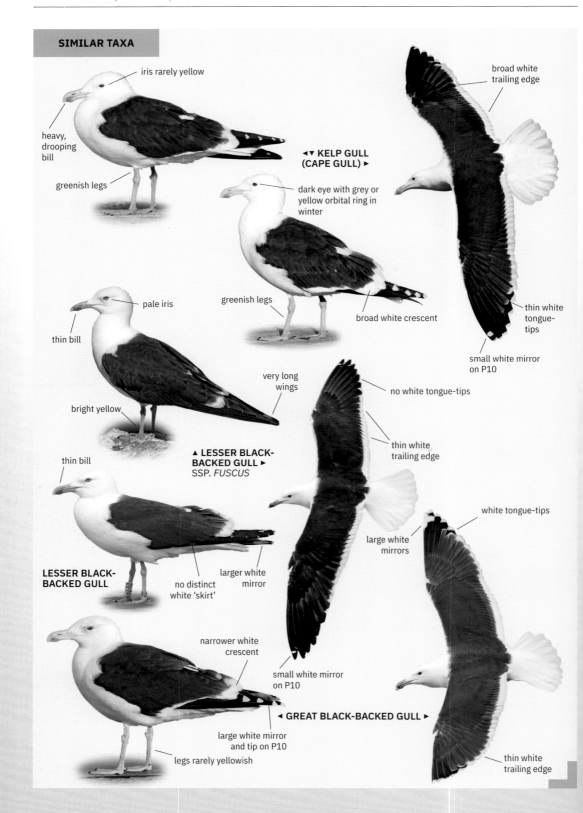

iris rarely yellow

heavy, drooping bill

greenish legs

◄▼ KELP GULL (CAPE GULL) ►

dark eye with grey or yellow orbital ring in winter

greenish legs

broad white crescent

broad white trailing edge

thin white tongue-tips

small white mirror on P10

pale iris

thin bill

bright yellow

very long wings

no white tongue-tips

thin white trailing edge

▲ LESSER BLACK-BACKED GULL ►
SSP. *FUSCUS*

thin bill

LESSER BLACK-BACKED GULL

no distinct white 'skirt'

larger white mirror

large white mirrors

white tongue-tips

narrower white crescent

small white mirror on P10

◄ GREAT BLACK-BACKED GULL ►

large white mirror and tip on P10

legs rarely yellowish

thin white trailing edge

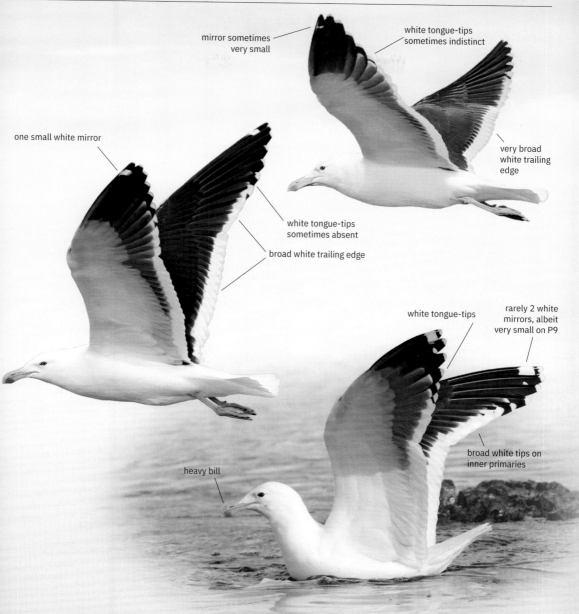

mirror sometimes
very small

white tongue-tips
sometimes indistinct

one small white mirror

very broad
white trailing
edge

white tongue-tips
sometimes absent

broad white trailing edge

white tongue-tips

rarely 2 white
mirrors, albeit
very small on P9

heavy bill

broad white tips on
inner primaries

more obvious on P6–P7. Lesser Black-backed Gulls with the darkest, blackish upperparts do not show white tongue-tips, but the pattern of P9–P10 resembles that of *vetula* (small white mirror on P10). Of course, Lesser Black-backed Gulls show thinner and more elongated structure with slightly longer wings, longer neck, and a small head.

The upperparts of Cape Gull are jet black, lacking the greyish hue shown by some Great Black-backed Gulls. The head is white with just a few grey streaks in nonbreeding plumage, which become generally more concentrated and more diffuse on the nape and hindneck, as in, for example, Caspian Gull. The legs are greenish or dull yellowish during breeding, rarely bright yellow, and become grey or greenish-grey outside of the breeding season. The colour is therefore quite different from Lesser (yellow) and Great Black-backed Gull (pink). The iris is typically dark, looking black from a distance. The primary pattern and the wider white trailing edge on the wing are important differences from those rare Great Black-backed Gulls with yellowish legs.

# First cycle

Kelp Gulls of this age resemble mostly Lesser Black-backed Gull but can be told by a combination of subtle structural and plumage features:

- Most birds (not all) show a heavy, drooping bill, and their secondaries are well visible below the greater coverts when the wing is folded.
- The plumage looks more uniform, less patterned; the juvenile plumage is very dark, with sooty body and brown scapulars, wing coverts and tertials with just a white fringe—no pale notches or bars, unlike most other large gulls. Post-juvenile scapulars often also lack strong pattern, being plain dark grey with just a thin dark streak or

diamond-shaped spot along the shaft, or a dark anchor mark in some.

- In flight, the wings appear very dark, with the inner primaries as dark as the outer, and with plain dark greater coverts lacking internal bars (except occasionally on the innermost feathers). The thin pale fringes on the wing coverts wear quickly and the wings then look uniformly brown.
- The tail usually looks completely dark and contrasts strongly with the largely white uppertail coverts. First-cycle Lesser Black-backed Gulls can show an all-dark tail too, but in that case the uppertail coverts nearly always show strong dark spotting or barring.
- The underwing coverts are very dark, the lesser coverts uniformly dark brown.

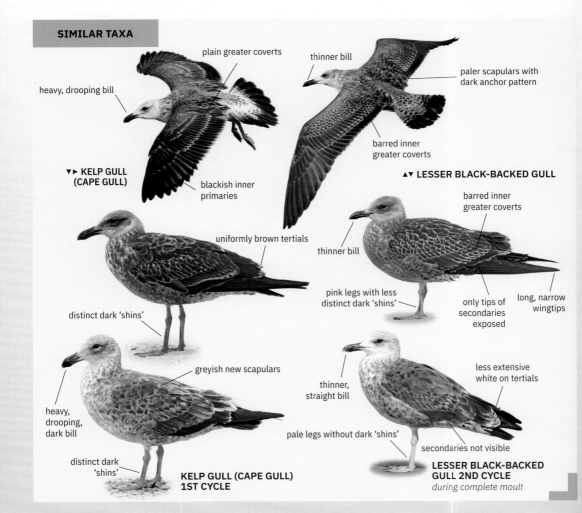

**SIMILAR TAXA**

plain greater coverts

heavy, drooping bill

thinner bill

paler scapulars with dark anchor pattern

▼▶ KELP GULL (CAPE GULL)

blackish inner primaries

barred inner greater coverts

▲▼ LESSER BLACK-BACKED GULL

uniformly brown tertials

thinner bill

barred inner greater coverts

distinct dark 'shins'

pink legs with less distinct dark 'shins'

only tips of secondaries exposed

long, narrow wingtips

greyish new scapulars

thinner, straight bill

less extensive white on tertials

heavy, drooping, dark bill

pale legs without dark 'shins'

secondaries not visible

distinct dark 'shins'

**KELP GULL (CAPE GULL) 1ST CYCLE**

**LESSER BLACK-BACKED GULL 2ND CYCLE**
*during complete moult*

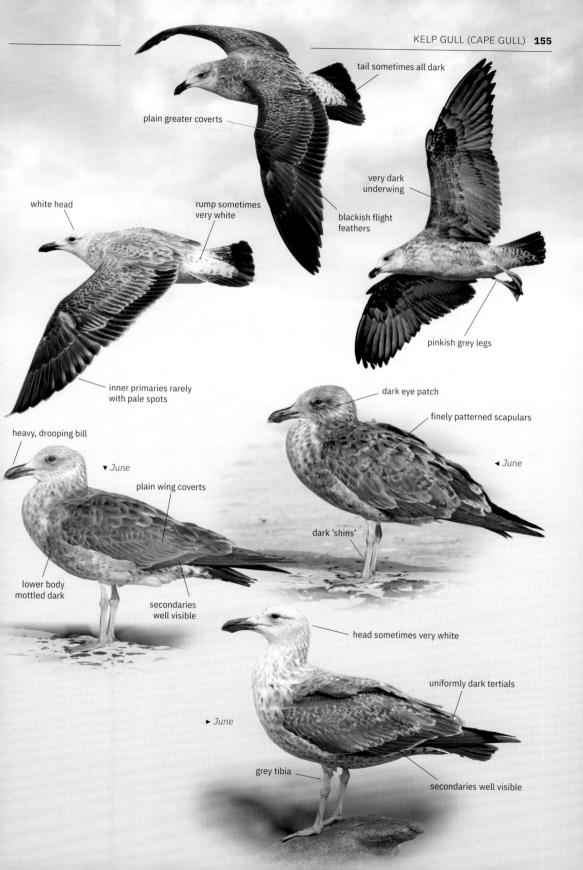

tail sometimes all dark

plain greater coverts

very dark
underwing

white head

rump sometimes
very white

blackish flight
feathers

inner primaries rarely
with pale spots

pinkish grey legs

dark eye patch

finely patterned scapulars

heavy, drooping bill

▼ *June*

◄ *June*

plain wing coverts

dark 'shins'

lower body
mottled dark

secondaries
well visible

head sometimes very white

uniformly dark tertials

► *June*

grey tibia

secondaries well visible

- The pink legs show dark 'shins' on the front of the tarsus and often already a grey tinge on the tibia, while they are usually more uniformly pink in other large gulls.

If born in the Southern Hemisphere, a typical immature Cape Gull will show fresh plumage during the boreal spring/summer and worn feathers in autumn/winter, when it will also start to moult its primaries. Even though the post-juvenile moult is partial, it may include wing coverts, tertials, tail feathers, and, rarely, a number of secondaries. New tertials tend to show wider white tips than in Lesser Black-backed Gull. However, the moult of those first-cycle Cape Gulls observed in the Western Palearctic has not differed much from that of Northern Hemisphere gulls.

## Second cycle

Differs from Lesser Black-backed Gull by its structure (especially the wide panel of visible secondaries at rest), leg colour (greenish, grey, or brownish-pink, with dark 'shins' on tarsus), often wider white tips on the tertials, and darker underwing. Told from Great Black-backed Gull by the more uniformly coloured upperwings, darker underwings, bill and leg colour, and a largely or completely black tail. Unlike many second-cycle Great Black-backed Gulls, Cape Gull does not show a white mirror on P10 at this age. The complete moult produces a really variable pattern on the new wing coverts, but these tend to look more uniform than in second-cycle Great and Lesser Black-backed Gulls. The tail feathers are generally black with some white at the base and no dark bars. The flight feathers are very dark and uniform, lacking a pale window on the inner primaries. The upperparts look very uniform overall. The head is quite heavily streaked, with larger and more diffuse brown blotches on the neck and breast.

The partial moult can be even more extensive than in the first cycle and may include not just tail feathers and secondaries but also a number of primaries. The most advanced birds can still be aged by the lack of white tips on the outer primaries (unlike third cycle) and sometimes also by a few retained brown secondaries that show only thin whitish tips or lack these altogether. Such an extensive prebreeding moult recalls that of *intermedius* Lesser Black-backed Gull and is very different from Great Black-backed Gull. It has not been published before for Kelp Gull.

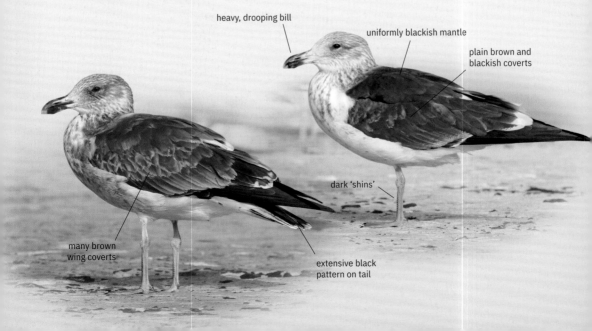

heavy, drooping bill

uniformly blackish mantle

plain brown and blackish coverts

dark 'shins'

many brown wing coverts

extensive black pattern on tail

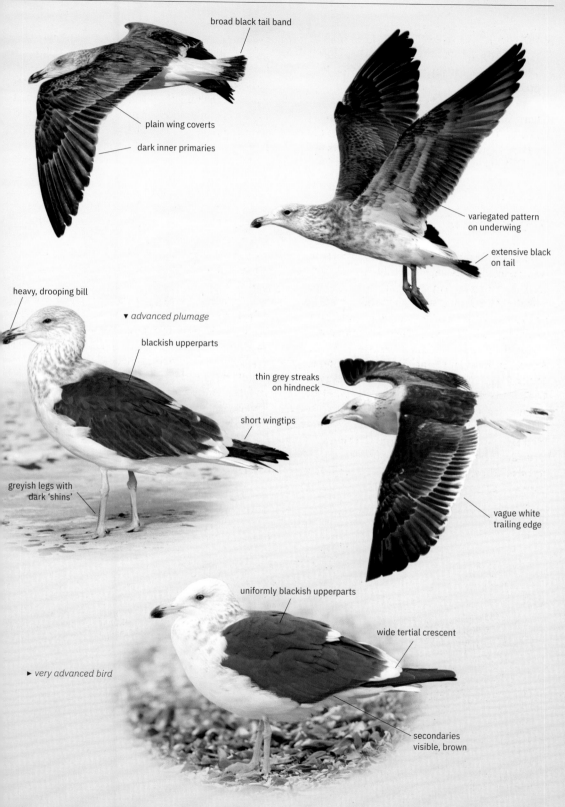

broad black tail band

plain wing coverts

dark inner primaries

variegated pattern on underwing

extensive black on tail

heavy, drooping bill

▼ *advanced plumage*

blackish upperparts

thin grey streaks on hindneck

short wingtips

greyish legs with dark 'shins'

vague white trailing edge

uniformly blackish upperparts

wide tertial crescent

► *very advanced bird*

secondaries visible, brown

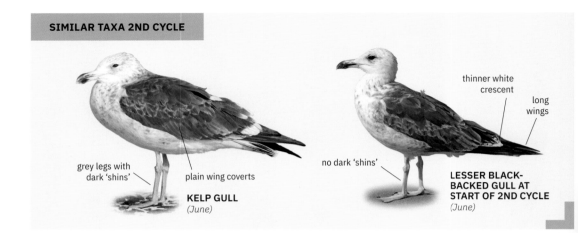

**SIMILAR TAXA 2ND CYCLE**

grey legs with dark 'shins'

plain wing coverts

**KELP GULL**
(June)

thinner white crescent

long wings

no dark 'shins'

**LESSER BLACK-BACKED GULL AT START OF 2ND CYCLE**
(June)

# Third cycle

After the complete postbreeding moult most birds look similar to adult, but with greenish-grey legs that still show brown 'shins' on the tarsi and that are quite different from the uniformly yellow or yellowish-pink legs of Lesser Black-backed Gull at this age. Note also the wide white tertial and scapular crescents, as well as bill shape. Great Black-backed Gulls of this age category already show an extensive white pattern on the outer primaries that clearly differs from the mainly black outer primaries

of third-cycle Cape Gull, as well as uniformly pink legs and often pink bill base.

There is usually no white mirror on P10 in third-cycle Cape Gulls (rarely just a small, triangular, and indistinct mirror), while a few central primaries already show a thin white tongue-tip (P4–P5). The outer primaries show white tips, though. In nonbreeding plumage the head is streaked and the neck and breast show heavy brown blotching; in breeding plumage the pattern is reduced to a spotted or streaked 'shawl' on hindneck, recalling Caspian Gull.

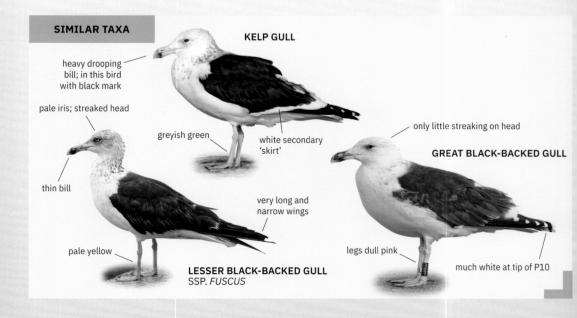

**SIMILAR TAXA**

**KELP GULL**

heavy drooping bill; in this bird with black mark

pale iris; streaked head

greyish green

white secondary 'skirt'

only little streaking on head

**GREAT BLACK-BACKED GULL**

thin bill

pale yellow

very long and narrow wings

**LESSER BLACK-BACKED GULL SSP. *FUSCUS***

legs dull pink

much white at tip of P10

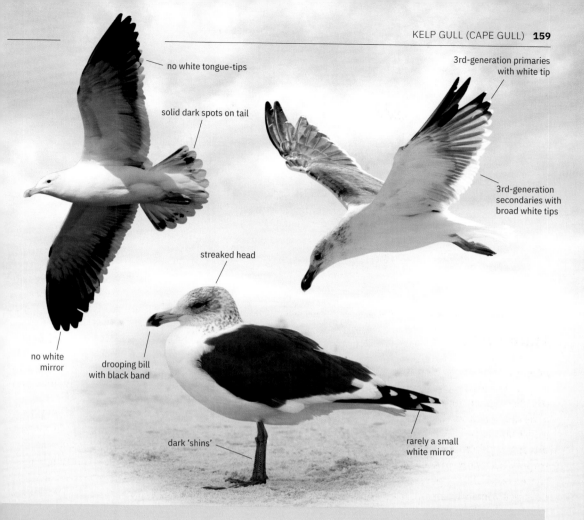

no white tongue-tips

3rd-generation primaries with white tip

solid dark spots on tail

3rd-generation secondaries with broad white tips

streaked head

no white mirror

drooping bill with black band

dark 'shins'

rarely a small white mirror

▶ **RANGE**

Kelp Gull is a widespread species of the Southern Hemisphere. It breeds from the Antarctic Peninsula to the subantarctic Atlantic and Pacific islands, in New Zealand, and also along the South American coasts up to the equator (nominate *dominicanus*). It also nests on the subantarctic islands in the Indian Ocean (ssp. *judithae*) and on the west coast of Madagascar (ssp. *melisandae*). In South Africa and Namibia, the subspecies *vetula* is found ('Cape Gull'), which spreads up to Angola in winter, but has bred in Senegal since the 1980s. A few adult birds have also been present in a mixed colony of Yellow-legged and Great Black-backed Gulls at Khnifiss Lagoon, western Sahara, since 2009. Since then, several birds have been observed in Morocco and in Europe, more specifically in France (2 records, in 1995 and 2018), Portugal (6 records), and Spain (6 records, including 3 on the Canary Islands: 1 in 2001 and 2 in 2020).

The Khnifiss birds have been suspected of hybridising with the local Yellow-legged Gulls in some years. Even though hybrids are very rare, the identification of Cape Gull can be problematic, particularly in Morocco, and all the field marks presented here are important.

# Glaucous-winged Gull
## *Larus glaucescens*

**▶ STRUCTURE**

Typical Glaucous-winged Gulls are rather large and bulky, with a heavy bill, marked gonydeal angle, bulky head, fat body, and short primary projection. In a perched bird, the wings extend only slightly beyond the tail, and the secondaries often project below the greater coverts (referred to as a 'skirt'). The large, heavy head, small dark eye, and thick bill often combine to give the bird a rather 'primitive' look; the small eye is positioned 'high on the head', especially in males. There is variation in size and structure, however, with some birds smaller with more rounded head and smaller bill, although the typical bill structure with marked gonys angle is usually still discernible.

## Adult

A large, grey-winged gull. Characterised by medium grey upperparts, grey wingtips, broad white tertial crescents, and strong pink leg colour. The iris is usually dark, and the red gonys spot is very small. The wingtips range from medium to dark grey, slightly darker than the upperparts, although it is unknown just how dark they can get since this has not been studied on ringed birds. However, even when dark grey, the outer primaries are darkest at their tips, and then gradually fade to neutral grey towards the base of the feathers. In hybrids, there is a clearer demarcation between the dark grey (or blackish) pattern and the grey bases.

Differs from Kumlien's Gull most notably in size and structure, especially bill size and wing projection. The plumage is more similar, but the upperparts and upperwings are slightly darker grey and the white primary tips are smaller. In flight,

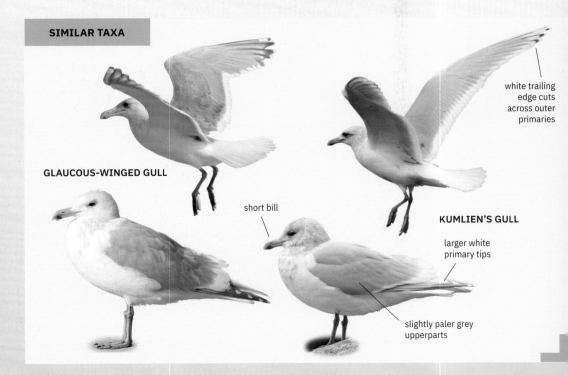

SIMILAR TAXA

GLAUCOUS-WINGED GULL

short bill

KUMLIEN'S GULL

white trailing edge cuts across outer primaries

larger white primary tips

slightly paler grey upperparts

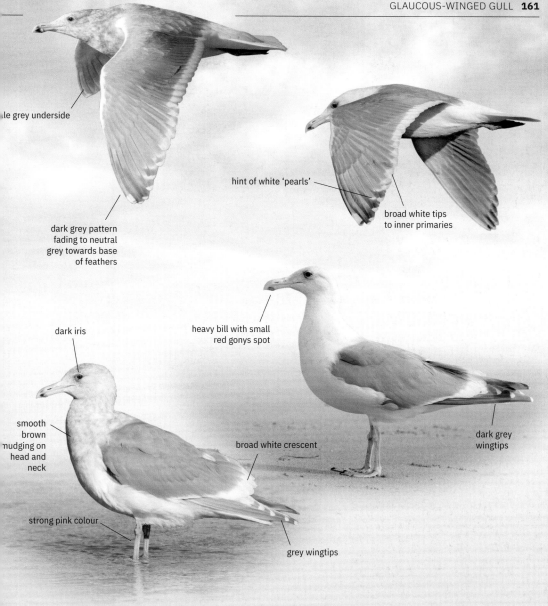

le grey underside

hint of white 'pearls'

broad white tips
to inner primaries

dark grey pattern
fading to neutral
grey towards base
of feathers

dark iris

heavy bill with small
red gonys spot

smooth
brown
nudging on
head and
neck

broad white crescent

dark grey
wingtips

strong pink colour

grey wingtips

here is more contrast between the grey upperwing nd the white trailing edge. The outer primaries are nainly grey, usually with no more than a hint of hite 'pearls', while in adult Kumlien's the white ailing edge continues across the outermost rimaries. In addition, usually 6 primaries are narked with dark grey, as opposed to only 5 in dult Kumlien's.

Leucistic adult European Herring Gulls (and 'Viking Gulls') may have grey wingtips, but such birds will show a different shape, pale iris, narrow white tertial crescent, streaked pattern on head and neck rather than uniform brown smudging, and larger white mirrors on outermost primaries. The leg colour, colour of upperparts, and exact wing pattern are variable, but will rarely (if ever) add up to perfectly match Glaucous-winged Gull.

densely spotted

pale
underside

dark tail

upperwing looks
uniform in colour

black bill

densely barred
undertail coverts

▼ *darker type*
*(Japan)*

new scapulars
very plain

densely patterned
greater coverts

brown wingtip
(same colour
as tertials)

distinct
gonys angle

smooth velvety
brown underparts

dark pink

# First cycle

Immature Glaucous-winged Gulls show a more uniform plumage than most European large gulls, except for the white-winged gulls, which show a similar, washed-out texture on the underparts. In addition, the juvenile plumage is retained well into the winter, which means the upperparts look mainly brown and scaled, due to white fringes on the feathers. New scapulars acquired in the post-

juvenile moult look uniformly grey, sometimes even adult-like. Otherwise first-cycle birds are characterised by their uniform brown-grey body, brown wingtips, dark tail, dark pink legs, and blackish bill.

Pale European Herring Gulls (and 'Viking Gulls') can show pale brown wingtips but differ in their more coarsely marked plumage with barred new

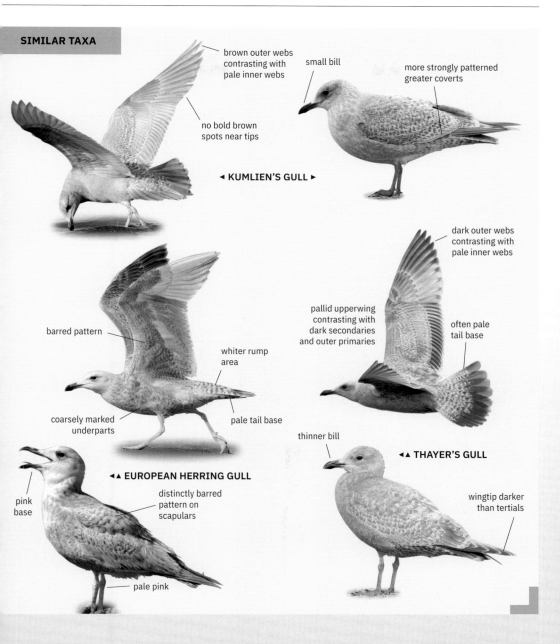

**SIMILAR TAXA**

brown outer webs contrasting with pale inner webs

small bill

more strongly patterned greater coverts

no bold brown spots near tips

◄ KUMLIEN'S GULL ►

dark outer webs contrasting with pale inner webs

barred pattern

pallid upperwing contrasting with dark secondaries and outer primaries

often pale tail base

whiter rump area

coarsely marked underparts

pale tail base

thinner bill

◄▲ THAYER'S GULL

pink base

◄▲ EUROPEAN HERRING GULL

distinctly barred pattern on scapulars

wingtip darker than tertials

pale pink

capulars (rather than plain grey), spotted or barred ing coverts, pale flesh-coloured legs, pinkish bill ase (on both mandibles), and different shape. urthermore, they will usually show a pale tail base ith some dark spotting or barring, whiter, less ensely marked undertail and uppertail coverts, arred axillaries, and more spotted or streaked nderparts and neck, and they lack the plain brown ce of many Glaucous-winged.

Kumlien's Gull may show rather similar plumage, but it has a different bill shape, longer wing projection, and more strongly patterned wing coverts and tertials. In flight, the tail is often not entirely dark and shows some pattern at the base, and the inner primaries look plain, showing either no pattern at the tips or just thin, brown arrowheads (while many Glaucous-winged show rounded dark spots there).

Thayer's Gull shows a thinner bill, more rounded head, longer wing projection, darker brown wingtips (generally darker than tertials), bright pink legs, and more strongly marked wing coverts, and the juvenile scapulars often show a paler brown centre and thin, dark, subterminal bar. In flight, the upperwing looks pale silvery, with contrasting dark secondaries and dark outer primaries, unlike the uniform brown upperwings of Glaucous-winged.

Towards the end of the first cycle, wear and bleaching may result in (almost) white wingtips in Glaucous-winged Gull, thus resembling Glaucous Gull. However, the bill remains mainly dark and looks more swollen around the gonys area. The legs are often still rather dark. Any incoming, recently moulted feathers are darker than in Glaucous.

For differences from first-cycle Slaty-backed Gull, see that species.

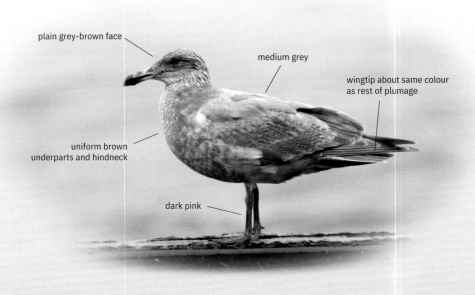

plain grey-brown face

medium grey

wingtip about same colour
as rest of plumage

uniform brown
underparts and hindneck

dark pink

## Second cycle

Birds of this age category show even more washed-out plumage texture than first-cycle birds. In flight, the outer primaries typically look darkest at their tips, gradually becoming paler towards the base of the feathers. Identification is made easier by the adult-like grey 'saddle' of many birds. As with many other Nearctic species, the rump and upper- and undertail coverts show strikingly dense barring.

Some European Herring Gulls (especially subspecies *argentatus*) and 'Viking Gulls' can show pale brown wingtips. However, they generally differ from second-cycle Glaucous-winged in their more contrastingly patterned wing coverts with, for example, wavy barring on the greater coverts, streaked rather than smudged head, whiter rump area, and paler undertail coverts with widely spaced barring. The wingtips are usually still darker than the tertials. In flight, the outer primaries do not

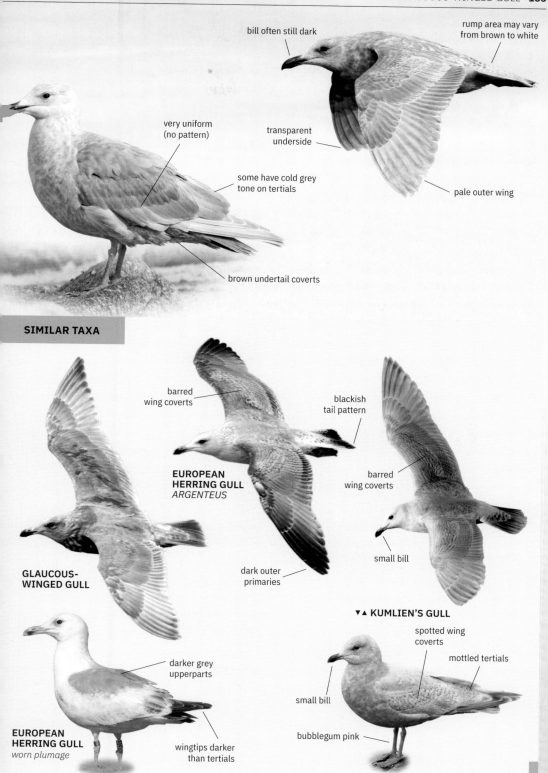

bill often still dark

rump area may vary from brown to white

very uniform (no pattern)

transparent underside

some have cold grey tone on tertials

pale outer wing

brown undertail coverts

**SIMILAR TAXA**

barred wing coverts

blackish tail pattern

**EUROPEAN HERRING GULL** *ARGENTEUS*

barred wing coverts

**GLAUCOUS- WINGED GULL**

dark outer primaries

small bill

**▾▴ KUMLIEN'S GULL**

spotted wing coverts

mottled tertials

darker grey upperparts

small bill

**EUROPEAN HERRING GULL** *worn plumage*

wingtips darker than tertials

bubblegum pink

normally show a gradual darkening towards the tips of the feathers. The colour of the bill, legs, and upperparts may vary, but these will rarely (if ever) combine to perfectly match those of Glaucous-winged.

Second-cycle Kumlien's Gull shows less uniform plumage, with finely spotted wing coverts and mottled tertials. If any adult-like grey scapulars are present, these are paler than in Glaucous-winged, with longer wing projection, smaller bill, and bubblegum pink leg colour. The iris may become pale. In flight, the tail often looks paler grey and shows some pale mottling at the base.

## Third cycle

The plumage in this cycle is rather variable, ranging from similar to second cycle to much like adult. Retarded birds are characterised by their uniformly coloured plumage, extensive brown smudging on neck and underparts, and pale brown wingtips. A broad white trailing edge is present on the inner primaries and may also be visible on the secondaries, even at rest. Advanced birds look similar to adults but often show dark tail markings, which can look surprisingly blackish. The leg colour is now bright pink. Note that the outer primaries can be a little darker grey than in adults at this age.

Kumlien's Gull has similar plumage and differs mainly in size and shape; however, its upperparts are slightly paler grey, and in flight the white trailing edge on the secondaries and inner primaries looks less contrasting. The tail markings (if present) are paler and less solid, that is, they may show a finely marbled pattern. Bill colour is often greenish, while it is largely pink or yellowish in third-cycle Glaucous-winged.

### Range

Breeds around the northern Pacific, from northern Oregon and Washington, USA, in the east, via Alaska (including the Aleutian and Pribilof Islands), USA, to the Komandorskie Islands and Kamchatka, northeastern Russia, in the west. Has occasionally bred in Hokkaido, Japan (e.g., one bird paired with Slaty-backed Gull in 2011). The species winters around the northern Pacific, southeast to Baja California, Mexico, and southwest to Japan.

Vagrant to the Western Palearctic, with accepted records in Canary Islands, Morocco, Great Britain (3), Denmark, Norway (2), Ireland, and Iceland.

Glaucous-winged Gull is perhaps the gull species most prone to hybridising. Mixed breeding with Western Gull Larus occidentalis has been described extensively on the American west coast, and hybridisation with American Herring Gull has been documented in British Columbia, Canada, as well as in the Cook Inlet region, Alaska. Hybridisation with Glaucous Gull has been described from southwestern Alaska, and with Slaty-backed Gull from the east coast of the Kamchatka peninsula (Russia), the Commander Islands (Russia), and Hokkaido (Japan; see above).

A few skins in the Zoological Museum of Moscow suggest that hybridisation between Glaucous-winged and Slaty-backed Gull also takes place in the Kuril Islands, Russia. In addition, interbreeding between Glaucous-winged and Vega Gull Larus vegae was reported from St. Matthew Island, Alaska, in 2018, although the published photograph of that Vega does not allow separation from a hybrid Slaty-backed × Vega Gull. In any case, hybrid gulls are notoriously common on the US west coast in winter, where they may even outnumber pure gull species in certain spots at times. No Pacific hybrids have been recorded in Europe yet (and these are therefore not discussed further here), but it is clear that any candidate vagrant Glaucous-winged Gull showing more than one anomalous feature should be very critically examined.

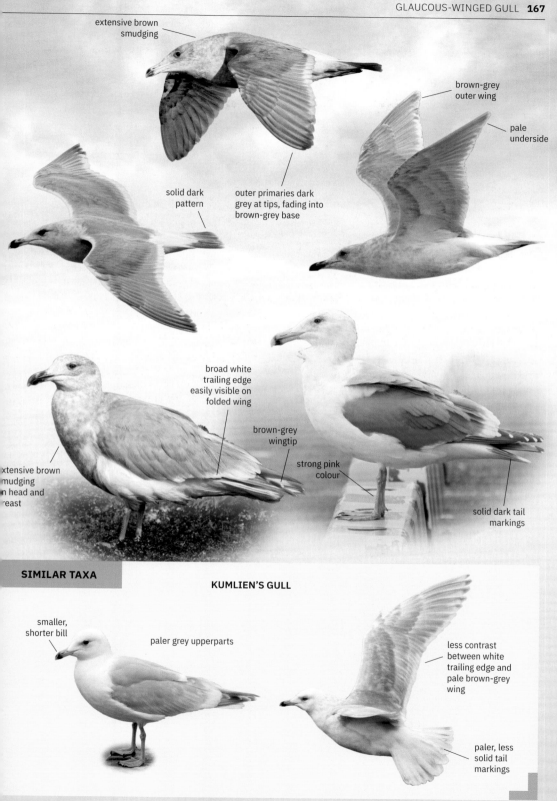

extensive brown smudging

brown-grey outer wing

pale underside

solid dark pattern

outer primaries dark grey at tips, fading into brown-grey base

broad white trailing edge easily visible on folded wing

brown-grey wingtip

strong pink colour

extensive brown smudging on head and breast

solid dark tail markings

**SIMILAR TAXA**

**KUMLIEN'S GULL**

smaller, shorter bill

paler grey upperparts

less contrast between white trailing edge and pale brown-grey wing

paler, less solid tail markings

# Glaucous Gull
## *Larus hyperboreus*

▶ **STRUCTURE**
Glaucous Gull is slightly bigger and bulkier than European Herring Gull, with a heavy chest, broader neck, and shorter wings giving it an overall more robust look. The big head is more oval-shaped, less angular than in Herring. In immature birds the dark eye looks small and placed high on the head, creating a peculiar facial expression. The bill is long, stout, and parallel-sided; it looks stronger than in Iceland Gull, from which the species also differs by its bigger, less rounded head with sloping, almost convex forehead and shorter wings. Unlike Iceland Gull, the bill is longer than the wing projection.

## Adult

Differs from European Herring Gull in its white wingtips, paler grey upperparts (even when compared with the subspecies *argenteus*), and more extensive, smudgier brown markings on head and neck in winter. The bill is bright yellow in summer, duller in winter, when it shows a pinkish base and yellow tip. The bare parts differ from Herring in that the bill tends to look more pinkish in winter, and the orbital ring is yellow or orange rather than pink or red. The head is usually quite heavily streaked in winter, with a particularly dark area just in front of the eye and often with a dark 'shawl' on hindneck and breast. Some birds show only a little head streaking in winter, though. The outer primaries show white tips without any hint of black, as in Iceland Gull. A big, heavy gull with the structure and colour of a Glaucous Gull but with even the slightest extent of black on the primaries should be considered a hybrid with either European or American Herring Gull. Care should also be taken with adult Scandinavian Herring Gulls actively moulting their outer primaries in late summer to autumn, when the wingtip may seem to lack black pigmentation, especially when viewed from below. Closer examination will reveal the different structure of the latter, darker grey upperparts, and at least a little dark pattern on the primaries. See also hybrid Glaucous × Herring Gull ('Viking Gull').

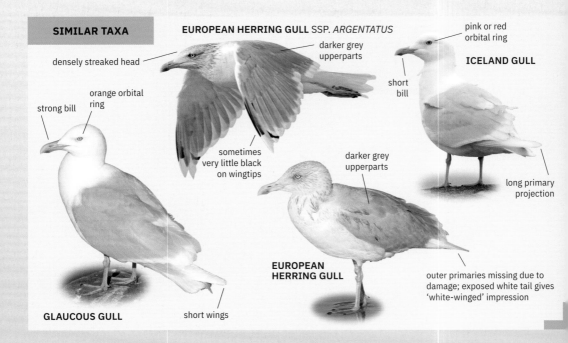

**SIMILAR TAXA**

**EUROPEAN HERRING GULL** SSP. *ARGENTATUS*

darker grey upperparts

densely streaked head

pink or red orbital ring

**ICELAND GULL**

short bill

orange orbital ring

strong bill

sometimes very little black on wingtips

darker grey upperparts

long primary projection

**EUROPEAN HERRING GULL**

outer primaries missing due to damage; exposed white tail gives 'white-winged' impression

**GLAUCOUS GULL**

short wings

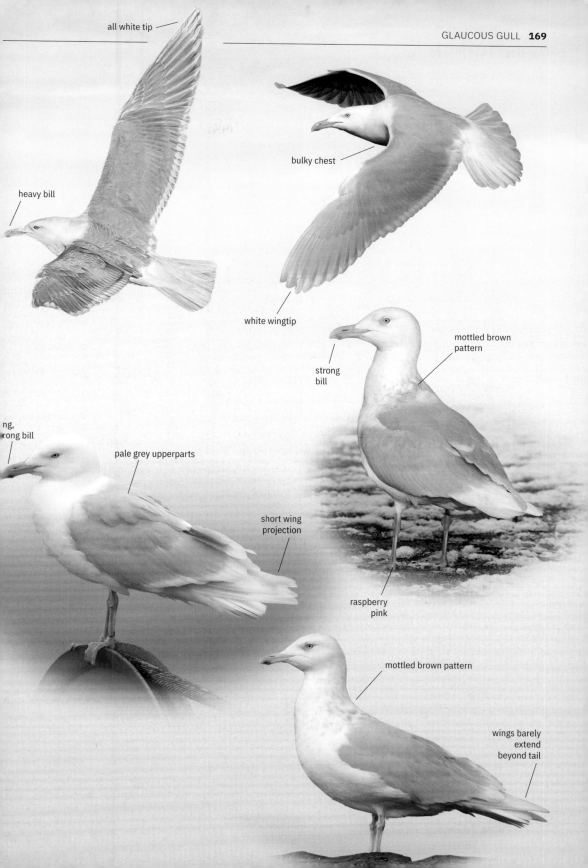

all white tip

heavy bill

bulky chest

white wingtip

strong bill

mottled brown pattern

ng, rong bill

pale grey upperparts

short wing projection

raspberry pink

mottled brown pattern

wings barely extend beyond tail

# First cycle

The plumage of first-cycle Glaucous Gull is variable; it can be rather dark, with delicately marbled, sooty brown body, or it can be white, especially in worn and bleached birds. All shades between these two extremes are possible. The colour of the outer primaries is a key feature; these feathers are the palest part of the wing, even if some birds show a washed brown colour at the tips or dark subterminal chevrons as in the darkest first-cycle Iceland Gulls. If the dark colour gradually increases towards the outermost primaries, genetic influence of Herring Gull should be considered, no matter how remote. Dark Glaucous Gulls may show a broad, uniformly brown tail band as well as rather dark tertials with solid brown base, white tips, and thin dark subterminal marks. In typical birds the tail feathers and tertials are finely vermiculated brown on a white base colour, and the scapulars and median coverts typically show brown chevrons. The bare parts are diagnostic at this age, especially the bill, which is bright pink with sharply demarcated black tip. The legs are pink, with no dark marks.

Most first-cycle Iceland Gulls show a dark bill gradually becoming more pinkish towards the base; advanced birds with bicoloured bill pattern can be told from Glaucous by size and shape, especially bill shape and wing projection. In addition, the bill pattern is not as clear-cut in the former species, and the inner edge of the black tip is often S-shaped rather than perfectly vertical and straight. Bleached or leucistic Herring Gulls show a different structure than Glaucous; their bill usually lacks the clear-cut bicoloured pattern, and their legs are paler pink.

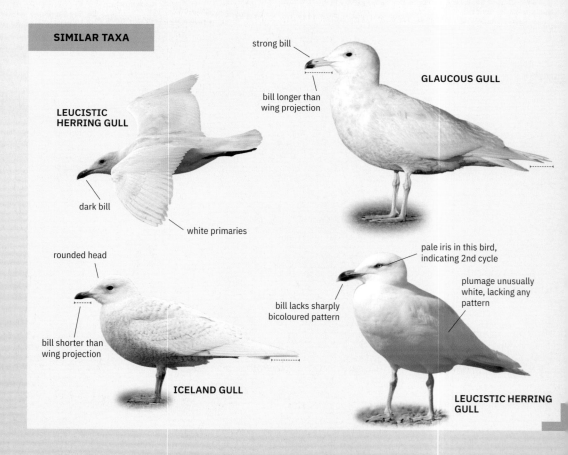

SIMILAR TAXA

strong bill

bill longer than wing projection

GLAUCOUS GULL

LEUCISTIC HERRING GULL

dark bill

white primaries

rounded head

bill shorter than wing projection

ICELAND GULL

bill lacks sharply bicoloured pattern

pale iris in this bird, indicating 2nd cycle

plumage unusually white, lacking any pattern

LEUCISTIC HERRING GULL

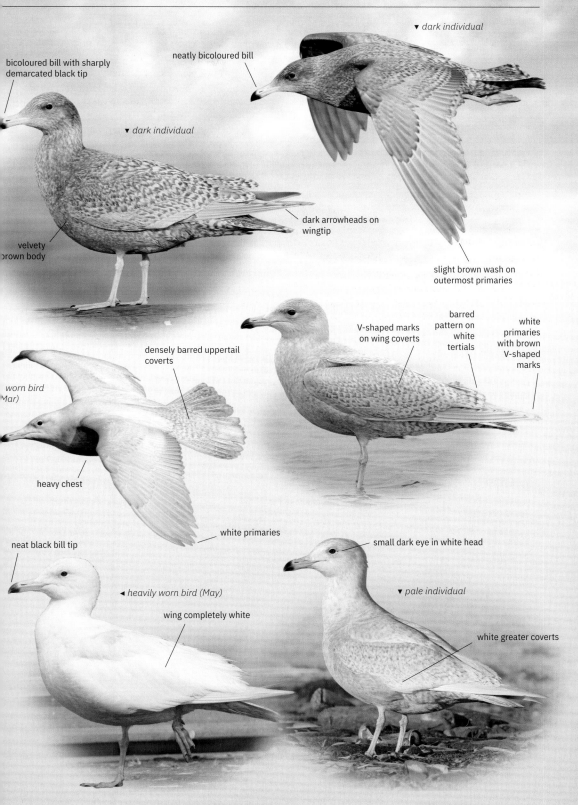

▼ *dark individual*

bicoloured bill with sharply demarcated black tip

neatly bicoloured bill

▼ *dark individual*

dark arrowheads on wingtip

velvety brown body

slight brown wash on outermost primaries

barred pattern on white tertials

V-shaped marks on wing coverts

white primaries with brown V-shaped marks

densely barred uppertail coverts

*worn bird (Mar)*

heavy chest

white primaries

neat black bill tip

◄ *heavily worn bird (May)*

wing completely white

small dark eye in white head

▼ *pale individual*

white greater coverts

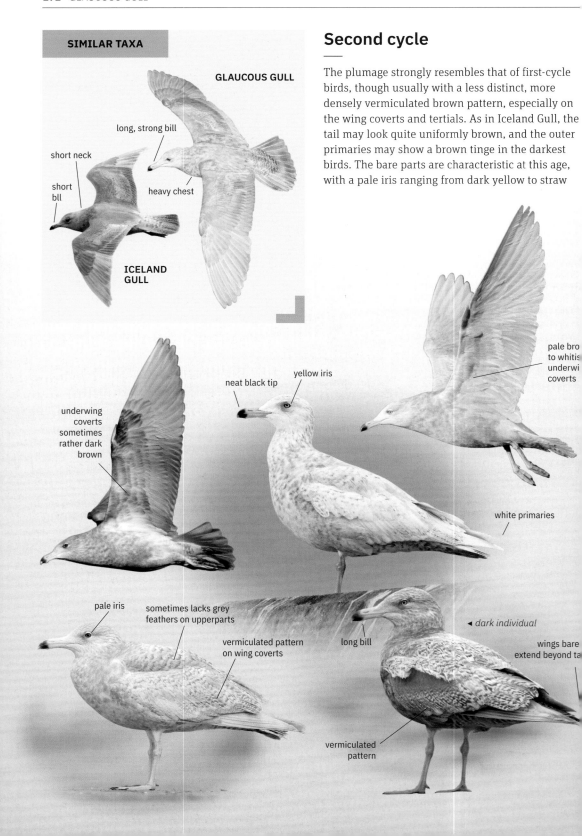

**SIMILAR TAXA**

GLAUCOUS GULL

long, strong bill

short neck

short bll

heavy chest

ICELAND GULL

# Second cycle

The plumage strongly resembles that of first-cycle birds, though usually with a less distinct, more densely vermiculated brown pattern, especially on the wing coverts and tertials. As in Iceland Gull, the tail may look quite uniformly brown, and the outer primaries may show a brown tinge in the darkest birds. The bare parts are characteristic at this age, with a pale iris ranging from dark yellow to straw

pale bro
to whitis
underwi
coverts

neat black tip

yellow iris

underwing coverts sometimes rather dark brown

white primaries

pale iris

sometimes lacks grey feathers on upperparts

vermiculated pattern on wing coverts

long bill

*◀ dark individual*

wings bare
extend beyond ta

vermiculated pattern

yellow and a pink bill with a small pink tip and a black subterminal band. The body and wings often consist of a mixture of white and brown feathers. Iceland Gulls of this age category show similar bill and iris colour but different structure (short, fine bill, small, rounded head on short neck, long wings). Leucistic or bleached Herring Gulls do not show the same bill pattern nor the same robust structure.

# Third cycle
—

From their third cycle on, Glaucous Gulls differ from Iceland Gulls, apart from their structure, in the colour of their bare parts, with pinkish-yellow bill—not greenish-yellow—and yellow—not pink—orbital ring. In winter the head is streaked brown, with a more uniform dark patch in front of the eye, and the breast is often blotched brown. The outer primaries show large white tips, as in adult birds and as in Iceland Gull.

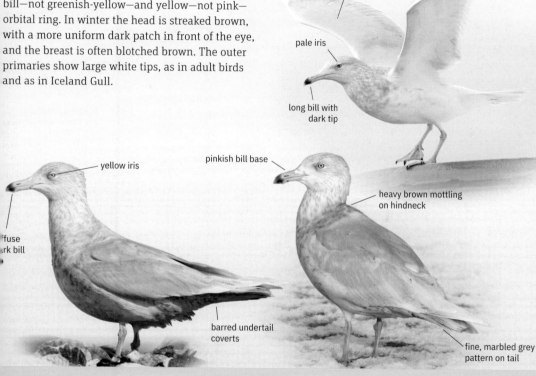

wing coverts mainly grey

pale iris

long bill with dark tip

yellow iris

pinkish bill base

heavy brown mottling on hindneck

fuse rk bill

barred undertail coverts

fine, marbled grey pattern on tail

▶ **RANGE**

Glaucous Gull is an Arctic species that breeds along the northern coasts of the American and Eurasian continents, and winters along the coasts of Northwest Europe, Northeast Asia, and North America, including the Great Lakes. It is a coastal species, often present in large fishing harbours but never in big numbers except in, for instance, Iceland in winter. It is rarer inland.

Vagrants are sometimes recorded in Central and Eastern Europe and the Mediterranean region, and have also reached the Red Sea, Black Sea, and Caspian Sea.

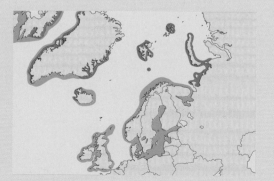

# Iceland Gull
## *Larus glaucoides glaucoides*

**▶ STRUCTURE**
Compared with European Herring Gull, the structure is more delicate and elongated, with very long wings, a rounded, small head, and a shorter bill that often gives the bird a somewhat pigeon-like look. The species is clearly smaller than Glaucous Gull, with longer primary projection, shorter bill, lighter structure, and smaller body. Unlike Glaucous, the bill is shorter than the wing projection. Even from a distance the small, rounded head, short bill, and long wings allow separation from leucistic or strongly bleached individuals of other large gull species.

## Adult

Adult birds show pale grey upperparts, paler than *argenteus* Herring Gull in most birds. They show clean white wingtips with no hint of dark grey or blackish colour. The presence of darker grey markings should be considered an indication of (pale) Kumlien's Gull, although it should be noted that the outer web of P10 can be slightly darker grey than the rest of the wing in adult Iceland Gull (nominate *glaucoides*). The bill may show duller colour than in other large gulls in winter, when it may look greenish or greyish-yellow. The head shows variable brown streaking in winter, ranging from indistinct spots concentrated on the hindneck to a complete hood of brown blotches reaching down on neck and upper breast. The iris is whitish or pale yellow; a darker iris may perhaps be considered a sign of Kumlien's Gull. The legs are pink, often brighter coloured than in *argenteus* Herring Gull, as in Thayer's Gull.

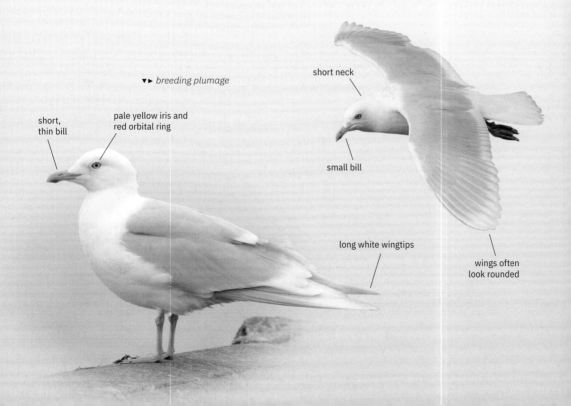

short, thin bill

pale yellow iris and red orbital ring

▼▶ *breeding plumage*

short neck

small bill

long white wingtips

wings often look rounded

heavily marked head

pale grey upperparts

rounded headed and 'neckless' impression

small, short bill

white wingtip

white wingtip

iris sometimes speckled dark

mottled brown pattern

long white wingtips

bill paler in winter

vague brown collar

thin bill

white wingtip

bright pink

# First cycle

The plumage is typically white or whitish with delicate, pale brown markings and white wingtips. The lower scapulars and the tertials show thin, neat, brown bars on a clean white background, lacking the uniformly grey-brown colour sometimes seen in Kumlien's. The tail feathers are also white with fine brown barring, sometimes with a broader subterminal bar when the feathers are more uniformly coloured or show densely vermiculated pattern. The primaries may show a brown wash at their tips, but these become gradually paler and white towards the outermost. Strongly marked first-cycle birds may exhibit a denser dark pattern and sootier background colour, but their primaries still become whiter outwards. Some birds show well-defined dark chevrons near the tip of their primaries, as in some pale Kumlien's Gulls. The bill is dark with a pinkish base that grows more extensive during the year, to the point where a few birds even show a distinct contrast between the pink colour and relatively demarcated black tip, inviting confusion with first-cycle Glaucous Gull. That species always has a bulkier body, however, and a shorter primary projection.

The separation from pale Kumlien's Gull can be problematic, and some birds cannot be identified with certainty. A few pale birds with finely barred plumage and clean white primaries are present in the wintering range of Kumlien's Gull. It is not clear what these birds are; they could very well be pale Kumlien's Gulls that look exactly like nominate Iceland Gull. See the Kumlien's Gull account (p.180).

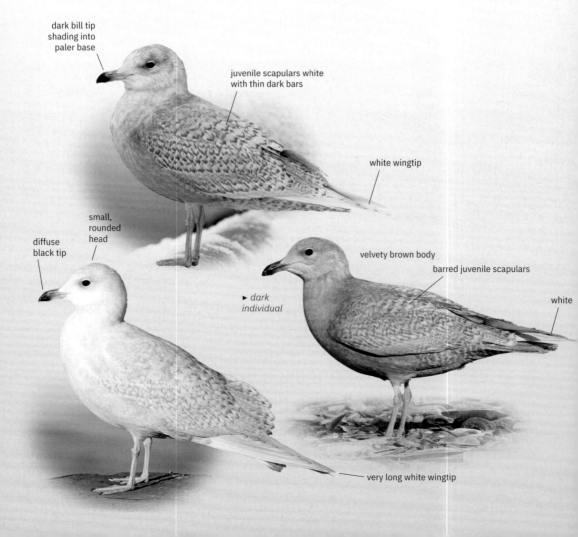

dark bill tip shading into paler base

juvenile scapulars white with thin dark bars

white wingtip

small, rounded head

diffuse black tip

▶ *dark individual*

velvety brown body

barred juvenile scapulars

white

very long white wingtip

irregularly shaped
dark bill tip

finely marbled
tail pattern

small head and
short neck

tail pattern
sometimes
uniform

very white flight feathers

round head

pale
secondaries

short, thin bill with
diffuse dark tip

primaries becoming
whiter outwards

▶ *worn plumage*

long primary projection

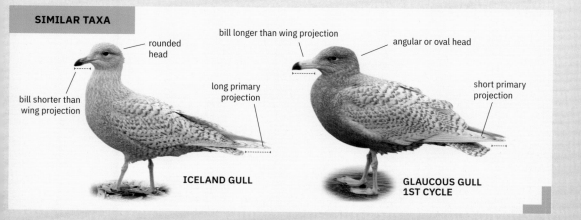

**SIMILAR TAXA**

rounded
head

bill longer than wing projection

angular or oval head

bill shorter than
wing projection

long primary
projection

short primary
projection

**ICELAND GULL**

**GLAUCOUS GULL
1ST CYCLE**

# Second cycle

Most birds of this age class show brown chevrons on the scapulars that contrast little with the brown wing coverts, as well as an extensive brown wash or vermiculated pattern on the tail. The greater coverts show dense vermiculations rather than parallel barring. A few birds already acquire a uniformly grey mantle during the prebreeding moult. The bill is dull pinkish or greyish with a more or less sharply separated black tip, and the iris colour ranges from dark brown to dark yellow. The bill pattern may recall that of younger, first-cycle Glaucous Gull, but the structure and the long wings enable identification.

grey 'saddle'

tail sometimes uniformly grey

secondaries paler than wing coverts

white primaries

vermiculated tail band

grey bill with black tip

white win[g]

bill with greyish base

iris may be dark

finely vermiculated coverts

bill can be pink with black tip

dull yellow iris

mottled plumage

long primary projection

**SIMILAR TAXA**

rounded head

**ICELAND GULL 2ND CYCLE**

short bill, often with greyish base

long primary projection

long, strong bill with pink base

angular or oval head

small eye

short primary projection

**GLAUCOUS GULL 2ND CYCLE**

# Third cycle

The plumage resembles that of adults, but the upperparts often consist of a mixture of adult-like grey feathers and a few brown or finely marbled immature feathers. The tail feathers often show a brown wash or fine brown barring. The inner primaries show the same pattern and colour as in adults, but the outer primaries may be washed brown. The brown head and neck streaking can be more extensive than in adults and may reach further down on underparts. The bill looks grey or greenish, becoming greenish-yellow towards spring, with an indistinct dark subterminal band. The iris is pale yellow at this age.

Separation from Glaucous Gull should be based on structural features (see Structure on p.168).

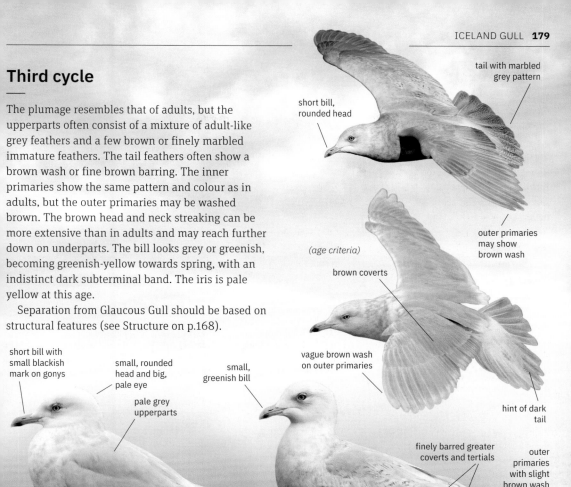

tail with marbled grey pattern

short bill, rounded head

outer primaries may show brown wash

*(age criteria)*

brown coverts

vague brown wash on outer primaries

hint of dark tail

short bill with small blackish mark on gonys

small, rounded head and big, pale eye

pale grey upperparts

small, greenish bill

finely barred greater coverts and tertials

outer primaries with slight brown wash

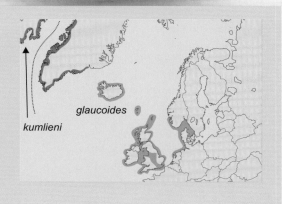

▶ **RANGE**
Iceland Gull breeds along the coasts of Greenland, where most birds also winter, although variable numbers migrate southeast to spend the winter in Iceland, the British Isles, and off the coasts of Northern and Western Europe. Iceland Gulls are coastal birds and regularly visit fishing harbours. The species is common in Iceland in winter, where flocks of more than 100 birds can be seen. Severe winter conditions, especially strong storms, may displace birds inland or south of their usual wintering range.

Vagrants occasionally reach Finland, Central Europe, the Mediterranean region, and Morocco. There are also accepted records from the Azores, Canary Islands, and Madeira.

glaucoides

kumlieni

# Kumlien's Gull
## *Larus glaucoides kumlieni*

> ▶ **STRUCTURE**
> Size and shape are identical to those of Iceland Gull, although young birds may sometimes appear a little bulkier, with slightly stronger bill (but these are variable features).

## Adult

The main identification feature of adult Kumlien's Gull is the pattern of the outer primaries. Within the group that it forms with Iceland and Thayer's Gulls, its primary pattern is generally intermediate. Compared with the former, the slightest pigmentation on the primaries may already indicate Kumlien's. Note, however, that adult *glaucoides* can show a subtle dark grey outer web on P10. A more contrasting pattern on this primary or a more extensive dark pattern is therefore required (such as dark grey not only on P10 but also on P9, with dark subterminal bands) before the bird can be considered a 'good' *kumlieni*. The markings on the primaries are generally quite variable: sometimes covering P6–P10, sometimes fewer primaries. A dark mark on P5 is rare. The colour of the primary pattern ranges from pale grey to blackish grey (in which case separation from Thayer's Gull can be very difficult; see that species on p.188). The pattern is present mainly on the outer webs of the feathers, but often subterminal bands are visible too (on P6–P9). Many birds show white mirrors on P9–P10. Lastly, birds with unmarked white wingtips are also occasionally seen in the breeding or wintering ranges of Kumlien's Gull. It is not clear whether such birds are extralimital *glaucoides* or variants of *kumlieni*.

The upperparts are pale grey, similar to Iceland Gull but just slightly darker (and a little paler than in Thayer's Gull, but the difference is subtle and variable). The iris ranges from (dark) yellow to brownish; it is yellow in adult Iceland and brown in most Thayer's Gulls. The legs are bright pink. The bill colour is identical to that of Iceland Gull.

A few adult European Herring Gulls with worn or leucistic plumage may show a plumage that resembles Kumlien's, but they are bigger (with bulkier structure), their bill is heavier, their legs

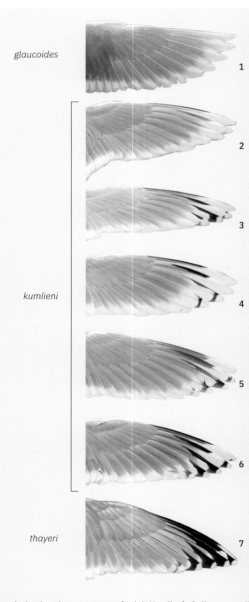

*glaucoides* 1

*kumlieni* 2 3 4 5 6

*thayeri* 7

*variation in primary pattern of adult Kumlien's Gull (numbers 2–6)*

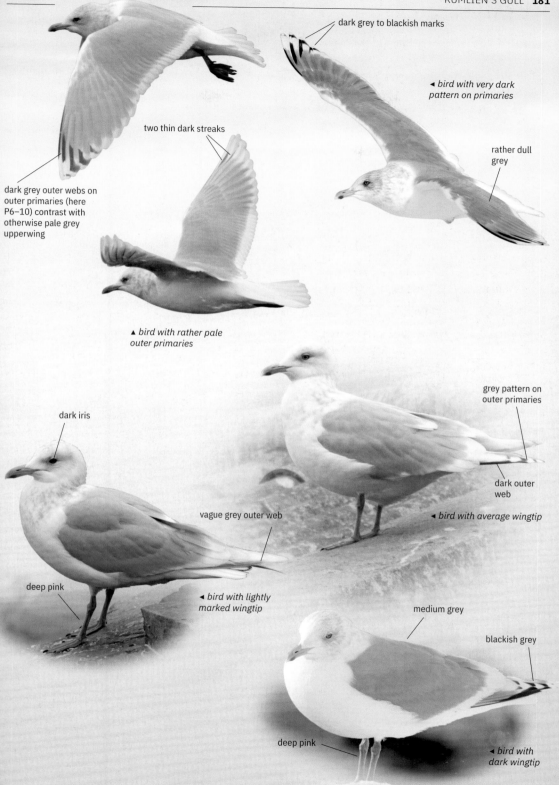

dark grey to blackish marks

◄ *bird with very dark pattern on primaries*

rather dull grey

two thin dark streaks

dark grey outer webs on outer primaries (here P6–10) contrast with otherwise pale grey upperwing

▲ *bird with rather pale outer primaries*

dark iris

grey pattern on outer primaries

dark outer web

◄ *bird with average wingtip*

vague grey outer web

deep pink

◄ *bird with lightly marked wingtip*

medium grey

blackish grey

deep pink

◄ *bird with dark wingtip*

paler pink, and the pattern of their outer primaries often differs (e.g., in showing extensive dark inner webs). The same features should also help to distinguish from hybrid Glaucous × European Herring Gulls ('Viking Gulls'), which can show variable grey marks on the outer primaries. Confusion is most likely with Iceland and, especially, Thayer's Gull (see pp.174 and 188), and some birds cannot be identified with certainty.

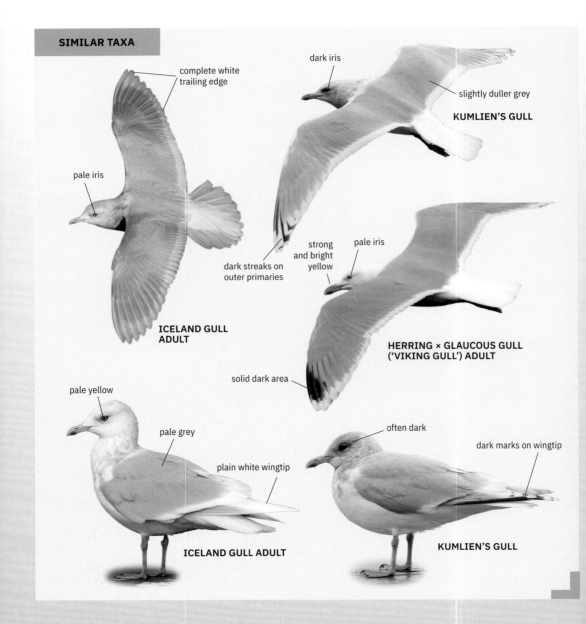

**SIMILAR TAXA**

complete white trailing edge

dark iris

slightly duller grey

**KUMLIEN'S GULL**

pale iris

strong and bright yellow

pale iris

dark streaks on outer primaries

**ICELAND GULL ADULT**

**HERRING × GLAUCOUS GULL ('VIKING GULL') ADULT**

solid dark area

pale yellow

pale grey

plain white wingtip

often dark

dark marks on wingtip

**ICELAND GULL ADULT**

**KUMLIEN'S GULL**

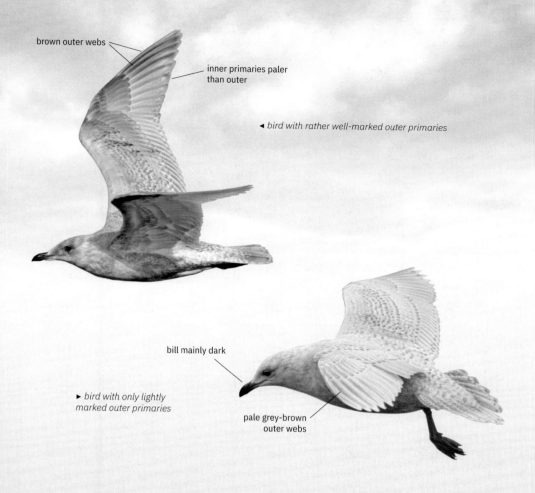

brown outer webs

inner primaries paler
than outer

◄ *bird with rather well-marked outer primaries*

bill mainly dark

► *bird with only lightly
marked outer primaries*

pale grey-brown
outer webs

# First cycle

At this age the primaries are again the main feature. Outside their normal range, only those first-cycle Kumlien's Gulls can be identified that show dark outer webs on the outer primaries (whitish or pale brown in Iceland Gull). In flight, the outer primaries of such Kumlien's Gulls appear darker than the inner ones. In first-cycle Iceland Gull, all primaries usually show the same colour, although, conversely, the inner ones may look slightly darker than the outers.

The folded wingtip of first-cycle Kumlien's Gull often shows a brown centre and paler tip on the primaries (whereas these feathers are uniformly pale in Iceland, sometimes with thin brown chevrons near the tips, which may cause confusion). A few first-cycle birds in the wintering range of Kumlien's Gull nevertheless show completely pale wingtips and cannot be separated from Iceland Gull. Also, note that the plumage of first-cycle birds bleaches during winter, which may also affect the colour of the outer primaries.

The overall plumage is very similar to that of Iceland Gull; however, it may be a bit more densely patterned, creating a darker brown impression. This is particularly true for the tail pattern but may also be the case on the wing coverts and scapulars. The

bill is usually entirely black; the base may become greyish-pink during the first winter, but less extensively so than in Iceland Gull (although this is variable).

Can be confused with 'Viking Gull' or European Herring Gull with worn or bleached plumage (see above under Adult). For differences from Thayer's and Glaucous Gulls, see pp.188 and 168.

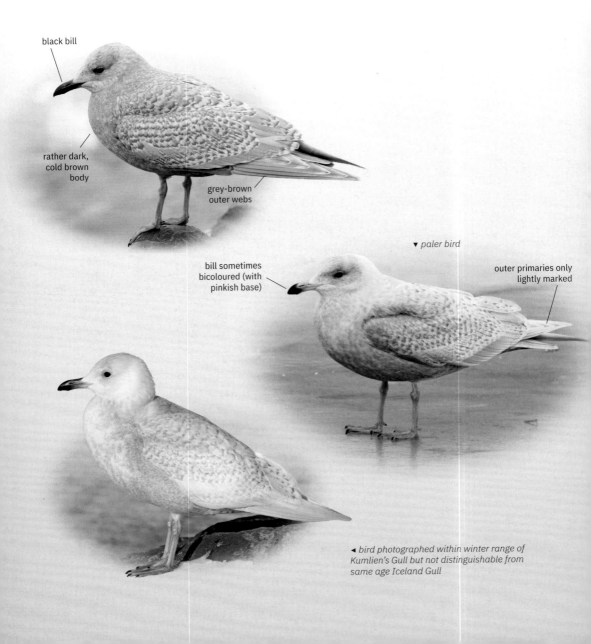

black bill

rather dark, cold brown body

grey-brown outer webs

bill sometimes bicoloured (with pinkish base)

▼ *paler bird*

outer primaries only lightly marked

◄ *bird photographed within winter range of Kumlien's Gull but not distinguishable from same age Iceland Gull*

## SIMILAR TAXA

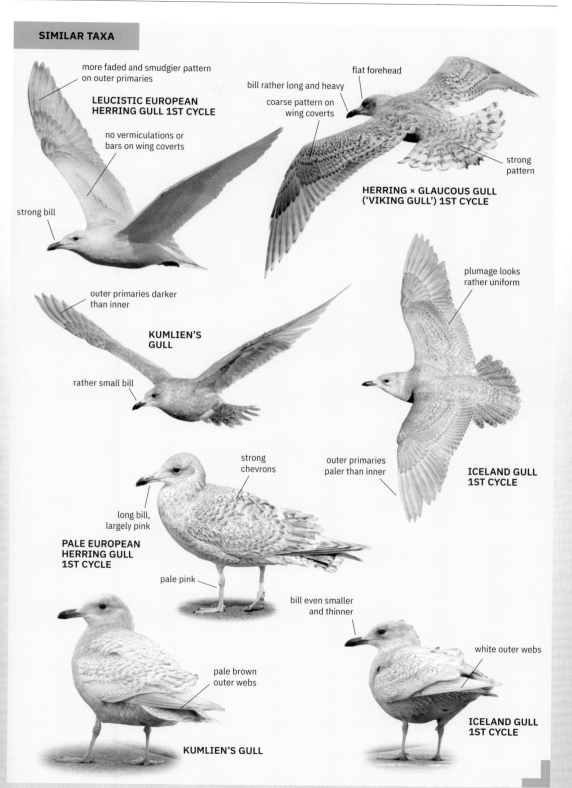

more faded and smudgier pattern on outer primaries

**LEUCISTIC EUROPEAN HERRING GULL 1ST CYCLE**

no vermiculations or bars on wing coverts

strong bill

flat forehead

bill rather long and heavy

coarse pattern on wing coverts

strong pattern

**HERRING × GLAUCOUS GULL ('VIKING GULL') 1ST CYCLE**

outer primaries darker than inner

**KUMLIEN'S GULL**

rather small bill

plumage looks rather uniform

outer primaries paler than inner

**ICELAND GULL 1ST CYCLE**

strong chevrons

long bill, largely pink

**PALE EUROPEAN HERRING GULL 1ST CYCLE**

pale pink

bill even smaller and thinner

white outer webs

pale brown outer webs

**ICELAND GULL 1ST CYCLE**

**KUMLIEN'S GULL**

# Second cycle

Most birds of this age-class differ from Iceland Gull by the brown outer webs of the outer primaries contrasting with pale inner webs, and by the white mirror frequently present on P10. Second-cycle Iceland Gull lacks this dark pattern on the outer primaries, although it can show some degree of contrast, but this is due to the inner and central primaries that are darker than the outer feathers.

The tail pattern is not a reliable feature at this age, but a strong contrast between the white tail base and brown tail band is more typical of Kumlien's. The bill shows a bicoloured pattern with pink base and black tip, and the iris ranges from amber to brown. A few birds with pale plumage and pale iris cannot be distinguished from Iceland Gull.

For differences from Thayer's and Glaucous Gulls, see those species (pp.188 and 168).

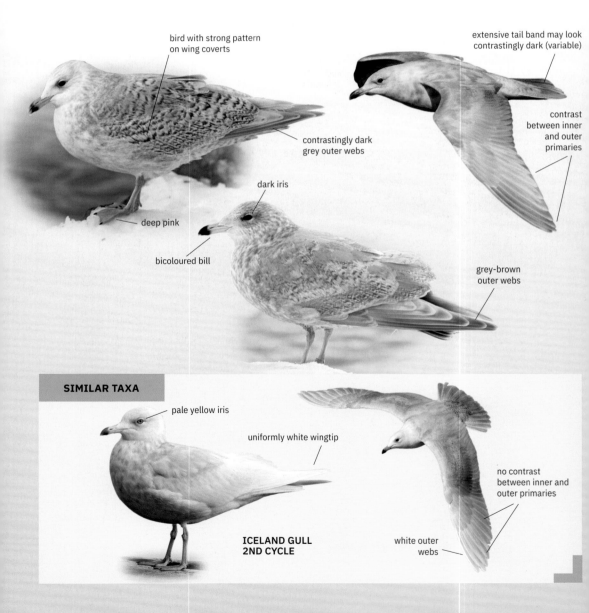

bird with strong pattern on wing coverts

extensive tail band may look contrastingly dark (variable)

contrast between inner and outer primaries

contrastingly dark grey outer webs

dark iris

grey-brown outer webs

deep pink

bicoloured bill

**SIMILAR TAXA**

pale yellow iris

uniformly white wingtip

no contrast between inner and outer primaries

**ICELAND GULL 2ND CYCLE**

white outer webs

# Third cycle

Birds of this age-class differ from Iceland Gull in that the outer webs of the outer primaries are darker than the primary coverts and greater coverts. In addition, they often show a white mirror on P10.

A few birds with very pale outer primaries cannot be distinguished from Iceland Gull (which may show pale brown outer primaries at this age). The latter may show a distinct grey tail band, rendering the tail pattern rather useless for identification, although a completely dark grey tail seems to occur only in Kumlien's Gull. At this age, Iceland Gulls show a yellow iris, while it is dark in some Kumlien's.

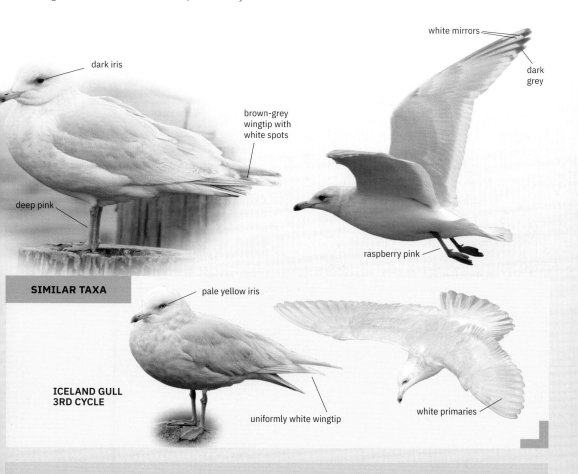

dark iris

brown-grey wingtip with white spots

deep pink

white mirrors

dark grey

raspberry pink

**SIMILAR TAXA**

pale yellow iris

**ICELAND GULL 3RD CYCLE**

uniformly white wingtip

white primaries

▶ **RANGE**

The taxonomic position of Kumlien's Gull is uncertain and controversial. It could be a hybrid form or an incipient species, but it is treated here as a subspecies of Iceland Gull *Larus g. glaucoides*, following the IOC list (Gill et al 2020).

The breeding range of Kumlien's Gull is located in the northeast of the Canadian Arctic and includes southern Baffin Island, Southampton Island, and the northern part of the Hudson Bay. The subspecies winters mainly in Newfoundland and Nova Scotia, Canada, but also around the Great Lakes and along the Atlantic Coast of the United States south to North Carolina (rarely further south). Smaller numbers winter off the coast of Greenland (especially the southwestern coast). The taxon regularly occurs in Iceland in winter, and it is rare but also regular in the north of the British Isles and the Faroes. It is very rare elsewhere in Northwest Europe but has occurred as far south as the Iberian Peninsula.

# Thayer's Gull
## *Larus thayeri*

▶ **STRUCTURE**
A fairly elegant taxon, with rounded head, thin, straight bill, short legs, and long primary projection. Smaller birds may even recall Ring-billed Gull in shape. Shows slightly longer bill and longer primary projection than Kumlien's Gull on average, and thinner bill, more rounded head and smaller size compared with American Herring Gull.

Thayer's Gull is a controversial, much debated taxon. For almost half a century it was generally considered a full species, but American authorities recently downgraded it to a subspecies of Iceland Gull. We remain critical of this decision, though, since we find it hard to believe that a gull with black wingtips can be the same species as one from another continent with white wingtips. We have seen no evidence that Thayer's and Iceland Gulls behave as subspecies and believe that there are clear morphological and acoustic differences between the two (see also Taxonomy in the Introduction of this book, p.6). More research is certainly needed, but in this book we maintain Thayer's Gull as a full species.

Birds with intermediate plumage between Thayer's and Kumlien's Gulls occur regularly, and are probably best left unidentified. Also, on the Pacific coast, some hybrid gulls can strongly resemble Thayer's Gull—but these birds are outside the geographic scope of this book.

## Adult
—

Most Thayer's Gulls show dark iris, deep pink leg colour, and pink or purple orbital ring. In winter, the bill is often greenish rather than yellow, and it shows no or very little dark pattern. They further differ from American Herring Gull in their slightly darker grey upperparts and different wing pattern. The outer primaries are greyish-black rather than truly ink black. The outer webs of the outer primaries are blackish, while the colour is more greyish on the inside of the shaft, creating a two-tone pattern ('venetian blind'). From below, the wingtip looks mainly pale (with thin blackish trailing edge). On the folded wingtip, the pale inner webs are often still visible as a white 'hook' running from one or two primary tips back to the tertials. Extensive white is also visible on the underside of the wingtip. A few American Herring Gulls (especially in northeastern Canada) and northern European Herring Gulls can show extensive pale inner webs like Thayer's, but the outer webs are still ink-black in such birds. Also, such European Herring Gulls usually show large white mirrors, with no black pattern at the tip of the outermost primary (unlike Thayer's), and they have darker grey upperparts than Thayer's, a pale iris, and less extensive brown smudging on neck and breast in winter. They are also larger, with bulkier head, heavier bill, and slightly longer legs. See also 'Viking Gull'.

Kumlien's Gulls at the dark end of the variation can show extensive dark wingtips, though the colour is usually dark grey or dark brown on close inspection. Aside from its longer, less stubby bill, Thayer's Gull usually differs from such birds in its wing pattern, showing:

- a complete dark outer edge on P9 (since the white mirror on that feather is either absent or confined to the inner web);
- a blackish medial band on P10 or P9;
- a dark pattern usually on 6 primaries (mainly 5 or fewer in Kumlien's).

In addition, the blackish pattern on P9 usually reaches the primary coverts.

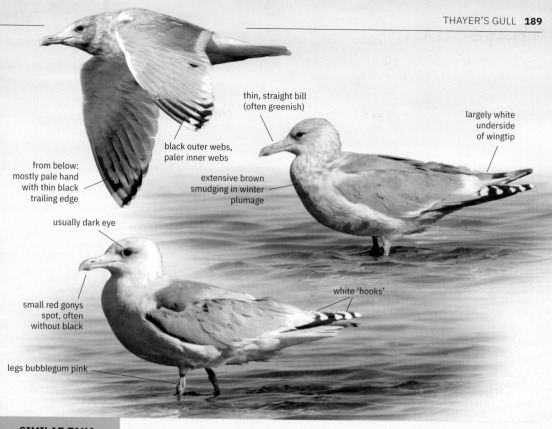

thin, straight bill
(often greenish)

largely white
underside
of wingtip

black outer webs,
paler inner webs

from below:
mostly pale hand
with thin black
trailing edge

extensive brown
smudging in winter
plumage

usually dark eye

white 'hooks'

small red gonys
spot, often
without black

legs bubblegum pink

## SIMILAR TAXA

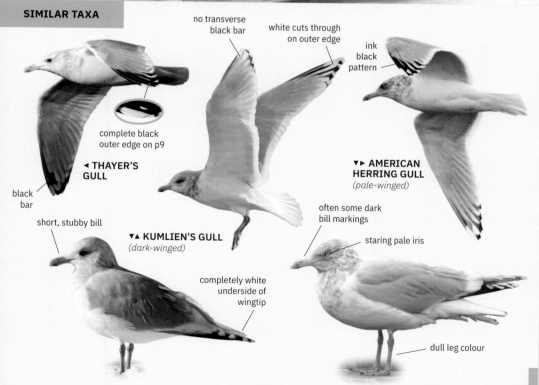

no transverse
black bar

white cuts through
on outer edge

ink
black
pattern

complete black
outer edge on p9

◄ **THAYER'S
GULL**

black
bar

**▼► AMERICAN
HERRING GULL**
*(pale-winged)*

short, stubby bill

often some dark
bill markings

staring pale iris

**▼▲ KUMLIEN'S GULL**
*(dark-winged)*

completely white
underside of
wingtip

dull leg colour

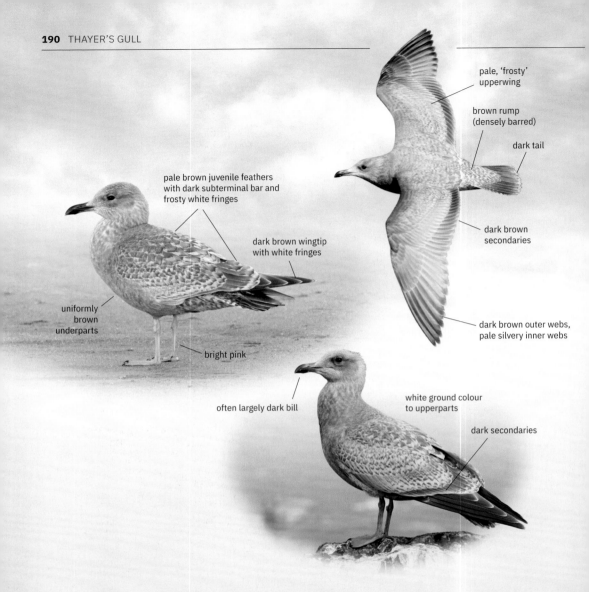

pale, 'frosty' upperwing

brown rump (densely barred)

dark tail

dark brown secondaries

dark brown outer webs, pale silvery inner webs

pale brown juvenile feathers with dark subterminal bar and frosty white fringes

dark brown wingtip with white fringes

uniformly brown underparts

bright pink

often largely dark bill

white ground colour to upperparts

dark secondaries

# First cycle

Perhaps most similar to American Herring Gull, but with paler brown plumage and pale underside of wingtip. While first-cycle Thayer's Gulls at rest look rather brown overall, they characteristically appear paler in flight due to a silvery or frosty bloom on the upperwings. The folded wingtip typically shows neat, thin, white fringes. In flight, the outer primaries show a two-tone pattern of dark outer webs and pale inner webs. In American Herring Gull, the underside of the outermost primaries shows a brown rather than pale silvery hue, the outer primaries do not show a two-tone pattern from

above, and pale fringes on the folded wingtip are either absent or barely visible. Many Thayer's Gulls retain their juvenile plumage well into winter, unlike most (but certainly not all) American Herring Gulls. The juvenile scapulars often show a typical pattern of pale brown centres, dark brown subterminal bars, and white fringes. Unlike that of many American Herring Gulls, the bill usually remains dark throughout winter.

Some first-cycle European Herring Gulls can show pale grey-brown plumage with white fringes on the folded wingtip, but in such birds the fringes tend to be wide and not sharply defined. Note also the rather spotted or streaked underparts in

**SIMILAR TAXA**

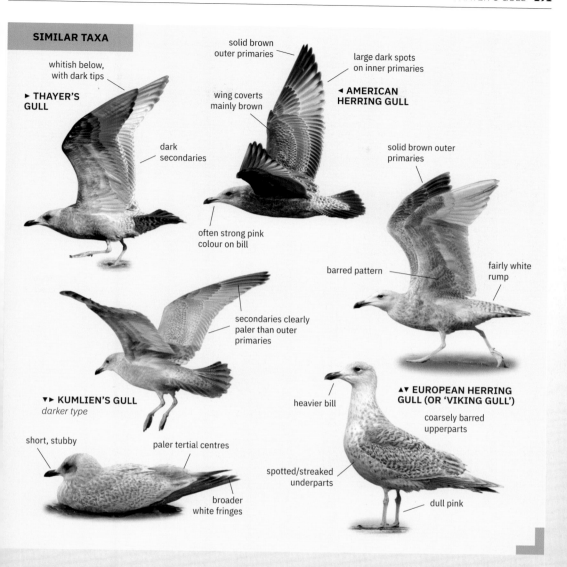

solid brown
outer primaries

large dark spots
on inner primaries

whitish below,
with dark tips

► **THAYER'S GULL**

wing coverts
mainly brown

◄ **AMERICAN HERRING GULL**

dark
secondaries

solid brown outer
primaries

often strong pink
colour on bill

barred pattern

fairly white
rump

secondaries clearly
paler than outer
primaries

heavier bill

▾► **KUMLIEN'S GULL**
*darker type*

▲▾ **EUROPEAN HERRING GULL (OR 'VIKING GULL')**

coarsely barred
upperparts

short, stubby

paler tertial centres

spotted/streaked
underparts

dull pink

broader
white fringes

European birds, coarsely barred wing coverts, moulted scapulars with dark anchors or bars, heavier bicoloured bill, and duller leg colour. In flight, further differences from Thayer's Gull are the whiter rump, pale tail base with coarse markings, more solid brown outer primaries when seen from above, and barred pattern on axillaries. First-cycle Thayer's Gulls show a classic 'Nearctic look' due to their dark tail and densely barred uppertail and undertail coverts.

Kumlien's Gulls at the dark end of the variation can look very similar to Thayer's but generally show wider white fringes on the folded wingtip, spotted or marbled rather than solid brown tertials, and shorter, stubbier bill. The juvenile scapulars usually show broader white fringes and smaller brown centres than in Thayer's Gull, but there is some overlap between the two taxa. In flight, the secondaries are pale—clearly paler than the outer primaries. Most birds lack a dark trailing edge on the underside of the outer primaries.

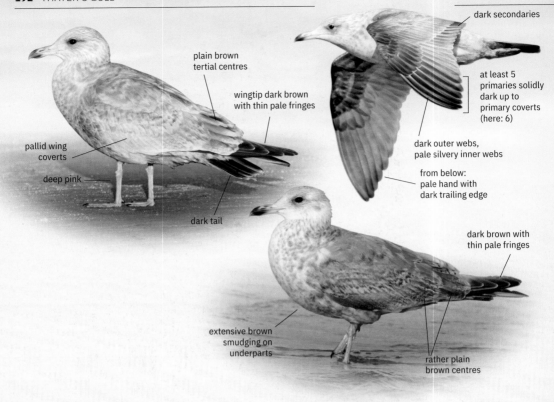

plain brown tertial centres

wingtip dark brown with thin pale fringes

pallid wing coverts

deep pink

dark tail

dark secondaries

at least 5 primaries solidly dark up to primary coverts (here: 6)

dark outer webs, pale silvery inner webs

from below: pale hand with dark trailing edge

dark brown with thin pale fringes

extensive brown smudging on underparts

rather plain brown centres

## Second cycle

The plumage looks somewhat intermediate between American Herring Gull and Iceland Gull. Unlike the former species, the folded wingtip is dark brown, not blackish, and shows well-defined, thin white fringes. In American Herring, any fringes are small and confined to the tips of the primaries. In second-cycle Thayer's, the wing coverts may look pale, rather washed out, and less strongly patterned than in American Herring. In flight, note the pale hand from below (with dark trailing edge), and the two-tone pattern of the outermost primaries from above (dark outer webs, pale silvery inner webs).

Some European Herring Gulls of this age category can show rather whitish wing coverts and brown wingtip with pale fringes. These fringes are not sharply defined, though. In addition to their larger size and bulkier structure, such birds often also differ from Thayer's in their more strongly patterned wing coverts and less extensive but coarser brown pattern on underparts. In flight, they show mainly white rump area, coarsely marked tail, and often solid brown outermost primaries both above and below.

Dark individuals of Kumlien's Gull still tend to show paler folded wingtip (dark grey to medium brown) with broader white fringes. In flight, the outer primaries become darker towards their tips, a gradient not seen in Thayer's. The tertials show a washed-out, vermiculated pattern rather than solid dark centres as in Thayer's. Difficult birds can best be identified from good flight photographs, which will reveal pale secondaries and a primary pattern that differs from Thayer's in the following ways:

- Broad whitish inner webs on outermost primaries (thinner, and pale brown or silvery in Thayer's).
- At most, 4 outer primaries with solid dark outer web that reaches the primary coverts (5 or more in Thayer's, creating a more extensive dark base on outer hand).
- Large white mirror on outermost primary (smaller or absent in Thayer's).

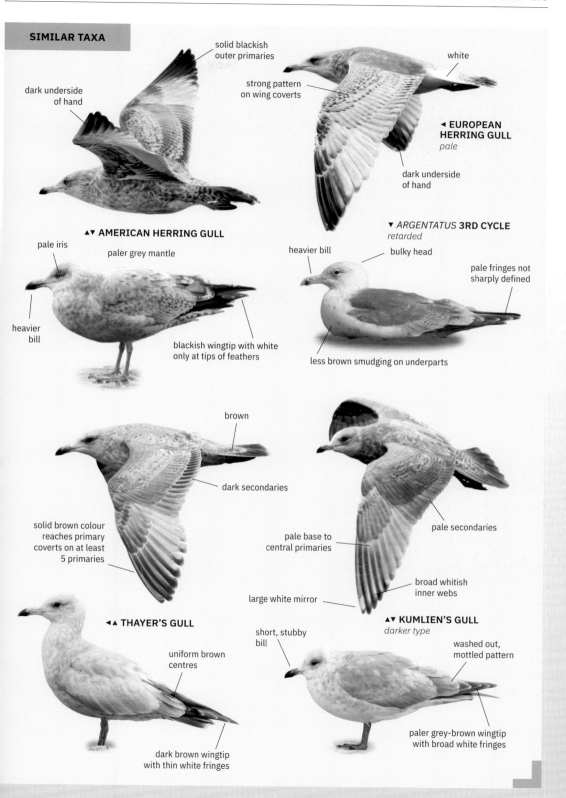

**SIMILAR TAXA**

solid blackish
outer primaries

dark underside
of hand

strong pattern
on wing coverts

white

◄ **EUROPEAN
HERRING GULL**
*pale*

dark underside
of hand

▲▼ **AMERICAN HERRING GULL**

▼ *ARGENTATUS* **3RD CYCLE**
*retarded*

pale iris

paler grey mantle

heavier
bill

blackish wingtip with white
only at tips of feathers

heavier bill

bulky head

pale fringes not
sharply defined

less brown smudging on underparts

brown

dark secondaries

solid brown colour
reaches primary
coverts on at least
5 primaries

pale base to
central primaries

pale secondaries

broad whitish
inner webs

large white mirror

◄▲ **THAYER'S GULL**

uniform brown
centres

dark brown wingtip
with thin white fringes

▲▼ **KUMLIEN'S GULL**
*darker type*

short, stubby
bill

washed out,
mottled pattern

paler grey-brown wingtip
with broad white fringes

# Third cycle

—

When perched, mostly resembles American Herring Gull, but with large extent of white on the underside of the folded wingtip. Also note that the wingtip is greyish black rather than truly black. The upperparts are slightly darker grey than in American Herring, the iris is darker, and the legs are a deep purple-pink. In flight, the outermost primaries show black outer webs but paler, blackish-grey colour on the inside of the shaft, creating a two-tone pattern (sometimes visible only when the wing is fully outstretched). From below, the primaries look pale and transparent, with a dark trailing edge.

Differs from European Herring Gull in its thinner bill, slightly smaller size, longer primary projection, deep pink leg colour, darker iris, and pale, translucent underside of outer primaries. Also, most third-cycle Herring Gulls show some coarse dark barring on tertials or greater coverts.

In dark Kumlien's Gulls, the wingtips often look dark grey rather than truly blackish, and the white primary tips are often bigger than in Thayer's Gulls of the same age. The underside of the folded wingtip is completely white, and there are no distinct dark centres on the tertials. In flight, the primary pattern differs as follows:

- Kumlien's Gull usually shows dark pattern on 5 primaries (usually 6 in third-cycle Thayer's).
- Kumlien's shows broader and paler inner webs on outer primaries.
- Except for vague dark trailing edge, Kumlien's Gull shows entirely pale underside on outermost primaries (whereas third-cycle Thayer's shows blackish hue on inner web of P10).

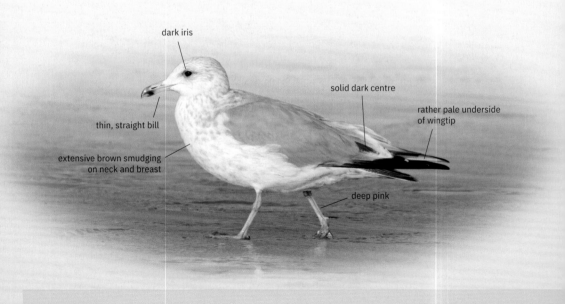

dark iris

thin, straight bill

extensive brown smudging
on neck and breast

solid dark centre

rather pale underside
of wingtip

deep pink

▶ **RANGE**
Breeds in Arctic Canada. In addition, a pair was found in southwestern Greenland in 2012, which could indicate that a (very) small population might still exist there. Winters mainly along the Pacific coast of North America; much lower numbers winter in the Great Lakes area, and very small numbers even reach Japan. Vagrant to Europe, with accepted records in Ireland, Britain, Iceland, Denmark, Norway, Spain, and the Netherlands.

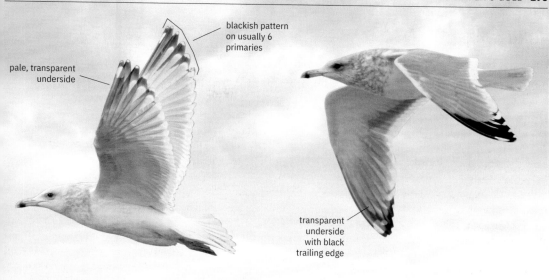

blackish pattern
on usually 6
primaries

pale, transparent
underside

transparent
underside
with black
trailing edge

## SIMILAR TAXA

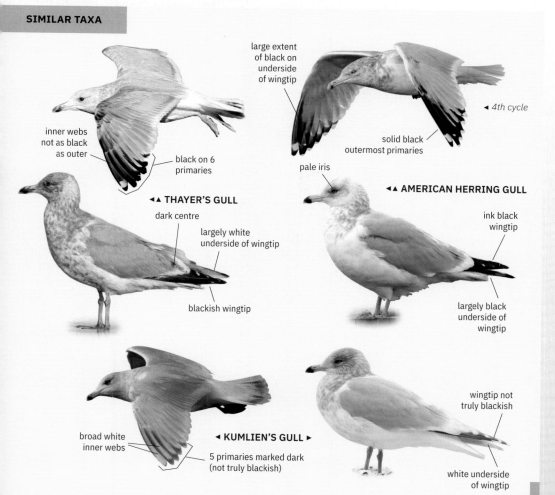

large extent
of black on
underside
of wingtip

◄ *4th cycle*

inner webs
not as black
as outer

black on 6
primaries

solid black
outermost primaries

pale iris

◄◄ THAYER'S GULL

◄◄ AMERICAN HERRING GULL

dark centre

largely white
underside of wingtip

ink black
wingtip

blackish wingtip

largely black
underside of
wingtip

broad white
inner webs

◄ KUMLIEN'S GULL ►

5 primaries marked dark
(not truly blackish)

wingtip not
truly blackish

white underside
of wingtip

# European Herring Gull
## *Larus argentatus argentatus* and *argenteus*

▶ **STRUCTURE**

Herring Gull is a stocky and powerful large gull with a fierce expression (in adults emphasised by the staring yellow iris) and angular head. It has a compact body with relatively short primary projection, short exposed tibia in resting birds, and an obvious tertial step. The stubby bill has an obvious gonys angle, most distinct in males.

Scandinavian *argentatus* is a strong bird, with slightly longer wings than British *argenteus*, and sloping forehead, giving it a 'snouty look'. Studying the structure, behaviour, and plumage of Herring Gulls in depth is a first step in gull identification, as this is often 'the reference species' to compare with.

## Adult

European Herring Gull has pink or 'flesh coloured' stocky legs in most of its range. Some show a straw yellow cast, though, and in the Baltic population birds may show saturated yellow legs, thus resembling Yellow-legged Gull *michahellis*. However, the latter is darker bluish-grey on the upperparts, and has more black and less white in the wingtip. Many birds can be separated by looking at the underside of the folded wingtip: Yellow-legged Gulls have a black underside with a small white mirror, while Baltic *argentatus* often show a long, pale tongue and large white mirror.

Adult European Herring Gulls have a fierce yellow eye with yellow-orange orbital ring, unlike, for example, Caspian Gull. Red on the bill is restricted to the lower mandible, unlike the large red gonys spot in Yellow-legged Gull.

The upperparts are pale silvery grey in *argenteus* and a shade darker in nominate *argentatus* from Scandinavia. The black-white distribution in the wingtip of adults is a variable but important feature for separating adult Herring, Caspian, and Yellow-legged Gulls. The typical black pattern in *argenteus* includes a black subterminal band on P10, a small mirror on P9, and some black on P5. On average, *argentatus* has less black on P9 and P10, and no black on P5. The primary pattern of Yellow-legged Gull is rather similar to *argenteus*, but the black band on P5 is more often complete and broader, and the grey tongues on P7–P8 are slightly shorter and darker.

In autumn/winter, adult European Herring Gulls show obvious streaking on the head with blotchy pattern in the neck, sometimes running down on the sides of the breast, while Caspian and Yellow-legged Gulls remain rather white-headed. *Argenteus* may become white-headed by late December, while *argentatus* is often still streaked on the head in March.

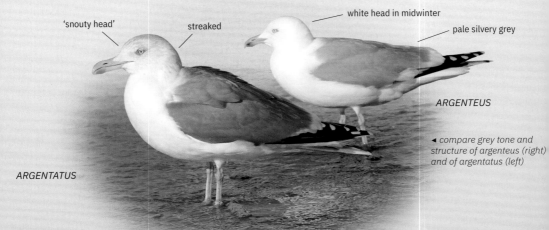

'snouty head'     streaked     white head in midwinter     pale silvery grey

ARGENTEUS

ARGENTATUS

◄ *compare grey tone and structure of argenteus (right) and of argentatus (left)*

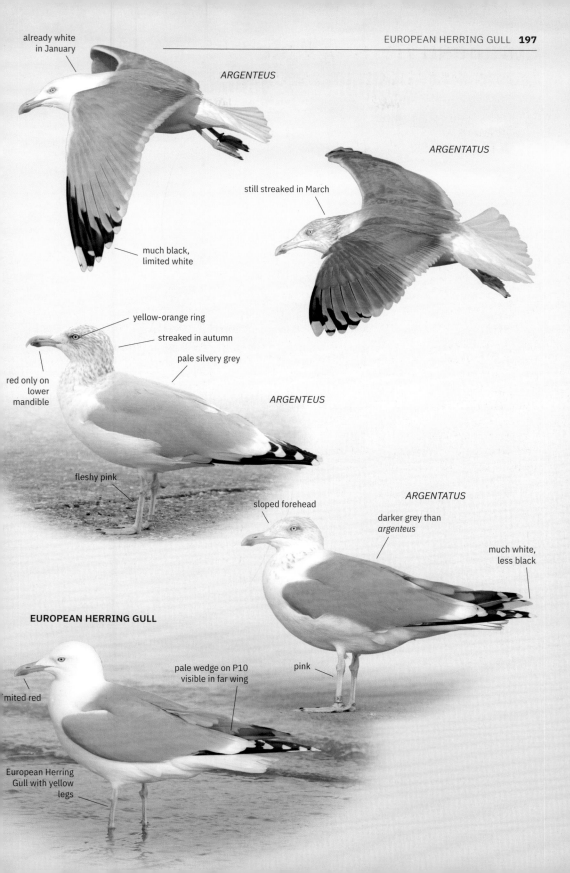

already white
in January

*ARGENTEUS*

*ARGENTATUS*

still streaked in March

much black,
limited white

yellow-orange ring

streaked in autumn

pale silvery grey

*ARGENTEUS*

red only on
lower
mandible

fleshy pink

*ARGENTATUS*

sloped forehead

darker grey than
*argenteus*

much white,
less black

**EUROPEAN HERRING GULL**

pale wedge on P10
visible in far wing

pink

limited red

European Herring
Gull with yellow
legs

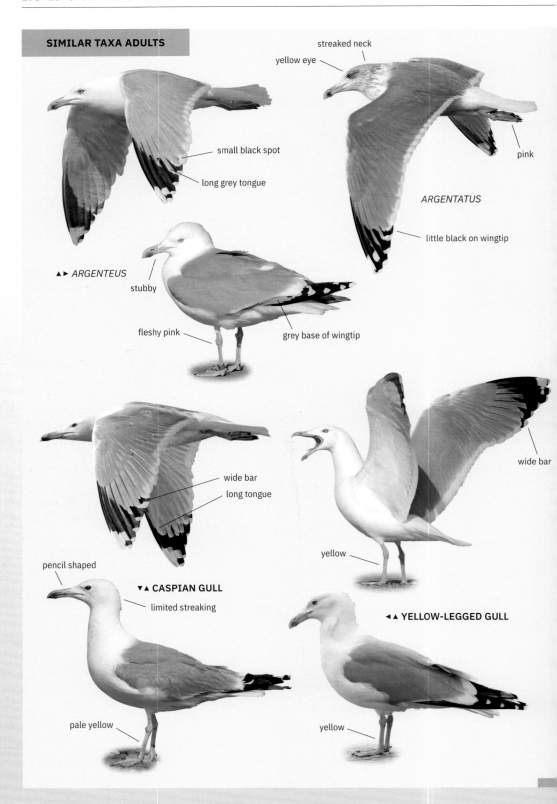

**SIMILAR TAXA ADULTS**

streaked neck

yellow eye

pink

small black spot

long grey tongue

*ARGENTATUS*

little black on wingtip

▲► *ARGENTEUS*

stubby

fleshy pink

grey base of wingtip

wide bar

wide bar

long tongue

yellow

pencil shaped

▼▲ CASPIAN GULL

limited streaking

◄▲ YELLOW-LEGGED GULL

pale yellow

yellow

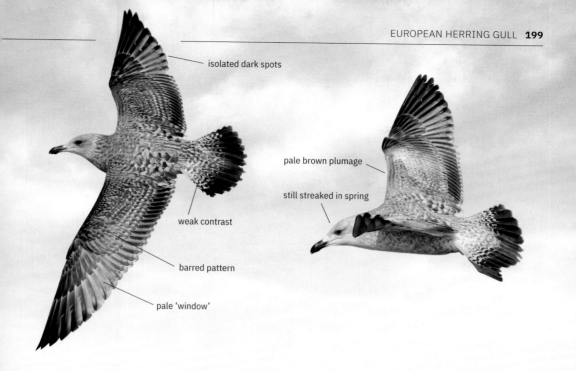

isolated dark spots

weak contrast

barred pattern

pale 'window'

pale brown plumage

still streaked in spring

# First cycle

The key feature for identifying first-cycle European Herring Gull is found in the inner primaries. In flight, Herring Gull has a large pale patch on the inner hand, called a 'window'. Both inner and outer webs of the inner primaries are pale; this pale window breaks the dark row of secondaries and outer primaries. In addition, there are characteristic, isolated dark spots near the tip of these pale feathers. Such an obvious window is not found in the other European large gulls, which may have pale inner webs, but combine these with dark outer webs, creating a 'venetian blind' effect, and which lack the isolated dark spots (except for Great Black-backed Gull).

Juvenile plumage in Herring Gull is overall rather pale or 'faded' brown, paler than chocolate brown *graellsii* Lesser Black-backed Gull, and also different from reddish-brown Yellow-legged Gull. The outer primaries are often dark brown with a paler fringe (not uniformly blackish as in Lesser Black-backed

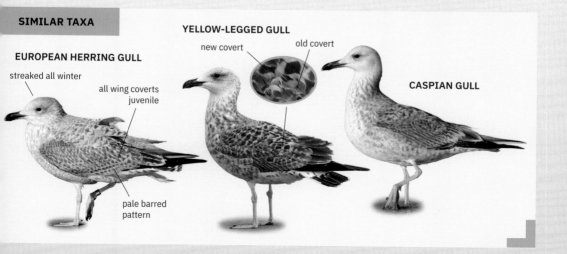

**SIMILAR TAXA**

**EUROPEAN HERRING GULL**

streaked all winter

all wing coverts juvenile

pale barred pattern

**YELLOW-LEGGED GULL**

new covert

old covert

**CASPIAN GULL**

Gull). In flight, Herring Gull has an overall barred plumage, including most of the tail, rump, and wing coverts, leaving no strong contrast between tail base and dark tail band. Both Caspian and Yellow-legged Gull have a more contrasting tail pattern.

Flight feathers, tertials, and wing coverts will remain juvenile throughout the first cycle. Yellow-legged and Caspian Gulls have an early and advanced post-juvenile moult in autumn, often including tertials and some wing coverts. Lesser Black-backed Gull, unlike Herring Gull, commonly replaces wing coverts and tertials as well, but in winter. Hence, any first-cycle bird with replaced wing coverts or tertials is almost certainly

not a Herring Gull. Replaced feathers show a bold anchor pattern clearly different from the brown juvenile coverts.

In Herring Gull, the juvenile tertials and wing coverts show a barred or notched pattern. Yellow-legged, Caspian, and Lesser Black-backed Gull have dark (outer) greater coverts.

First-cycle Herring Gulls remain streaked on the head throughout winter, while both Caspian and Yellow-legged Gulls quickly appear rather white-headed.

Distinguishing first-cycle *argentatus* from *argenteus* is not possible on plumage characteristic only the structural extremes or ringed birds can be separated.

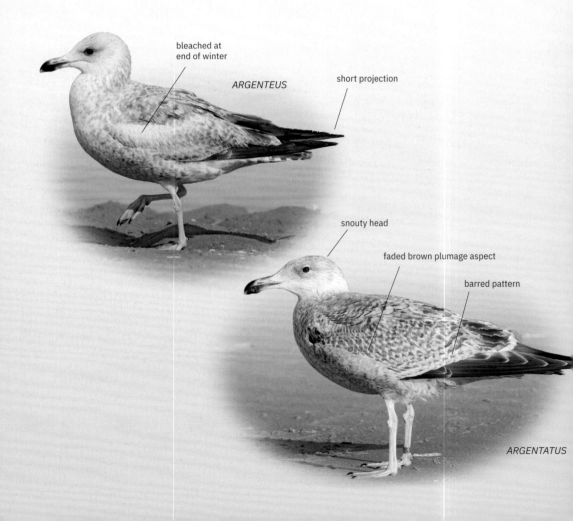

bleached at end of winter

*ARGENTEUS*

short projection

snouty head

faded brown plumage aspect

barred pattern

*ARGENTATUS*

**SIMILAR TAXA**

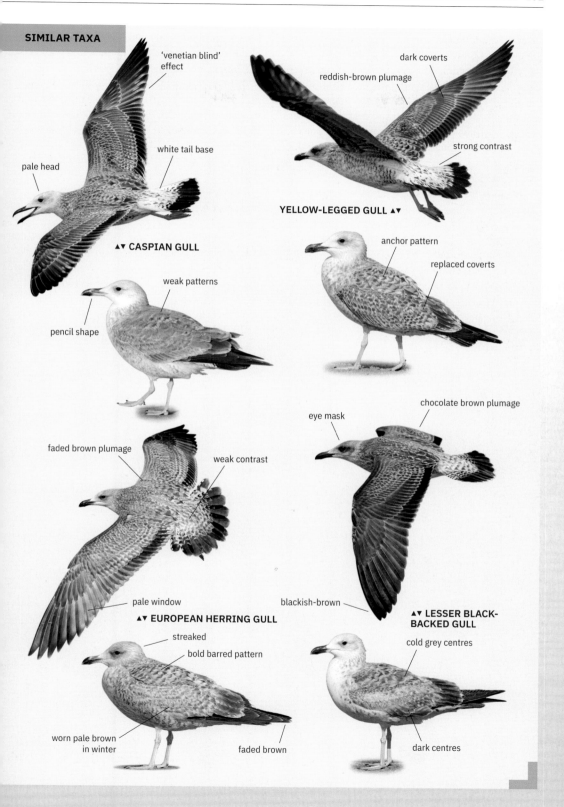

'venetian blind' effect

dark coverts

reddish-brown plumage

white tail base

strong contrast

pale head

**YELLOW-LEGGED GULL ▲▼**

▲▼ **CASPIAN GULL**

anchor pattern

replaced coverts

weak patterns

pencil shape

chocolate brown plumage

eye mask

faded brown plumage

weak contrast

pale window

blackish-brown

▲▼ **EUROPEAN HERRING GULL**

▲▼ **LESSER BLACK-BACKED GULL**

streaked

cold grey centres

bold barred pattern

worn pale brown in winter

faded brown

dark centres

# Second cycle

As in first-cycle birds, the inner primaries are much paler than the outer primaries, not only in Herring but also in Caspian and Yellow-legged Gulls. Still, in Herring Gull the pattern is slightly different and less contrasting: the inner primaries show some fine streaks and arrowhead patterns near the tips, unlike the much cleaner greyish-brown inner primaries on Caspian and Yellow-legged Gulls.

Second-generation secondaries have pale brown centres, contrasting only weakly with the wing coverts. Both Yellow-legged and Caspian Gulls have contrasting blackish secondary centres.

Many birds acquire a few adult-like feathers on upperparts in winter, which reveal the upperpart grey tone of adults. Such feathers are pale grey in *argenteus* Herring Gull but a darker shade of grey in Yellow-legged Gull. Many Scandinavian *argentatus* remain overall barred brown or muddy brown-grey throughout the second cycle, while grey scapulars often create a 'grey saddle' in *argenteus* (also found in Caspian and Yellow-legged Gulls).

Head, breast, and flanks retain brown streaking in autumn and most of the winter, with dark patches concentrated around the eye and blotchy streaking in the neck. However, underparts and head turn paler in spring. Any blotchy patterns on the head are rare in second-cycle Yellow-legged and Caspian Gulls.

The iris becomes paler at the end of winter, whereas Caspian Gull remains dark-eyed in this age class.

The broad dark tail band disintegrates into thin dark bars towards the base, often leaving a weak contrast to the tail base. In Yellow-legged and Caspian Gulls the blackish tail band contrasts strongly with the whitish base. The underwing remains largely brown in Herring Gull, while it is usually whitish in Caspian Gull.

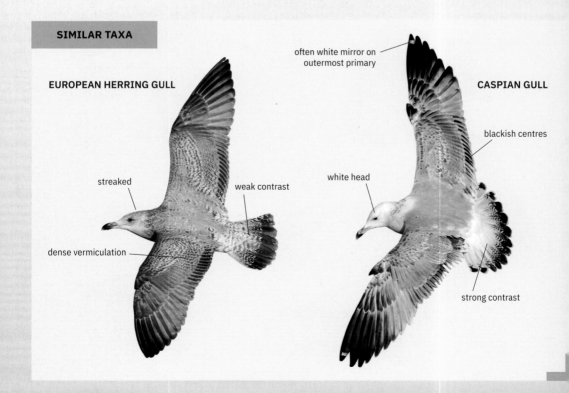

**SIMILAR TAXA**

**EUROPEAN HERRING GULL**

**CASPIAN GULL**

often white mirror on outermost primary

blackish centres

streaked

weak contrast

white head

dense vermiculation

strong contrast

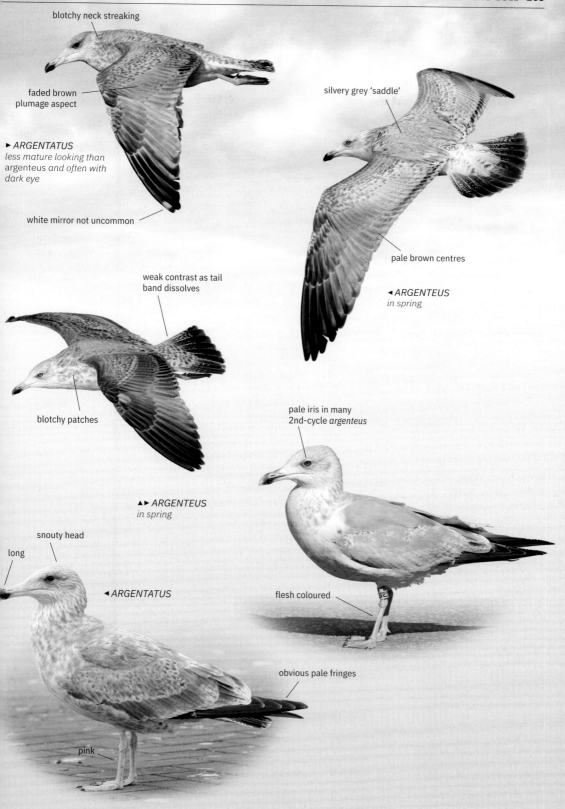

blotchy neck streaking

faded brown plumage aspect

► *ARGENTATUS*
*less mature looking than
argenteus and often with
dark eye*

white mirror not uncommon

silvery grey 'saddle'

pale brown centres

◄ *ARGENTEUS*
*in spring*

weak contrast as tail band dissolves

blotchy patches

pale iris in many 2nd-cycle *argenteus*

▲► *ARGENTEUS*
*in spring*

snouty head

long

◄ *ARGENTATUS*

flesh coloured

obvious pale fringes

pink

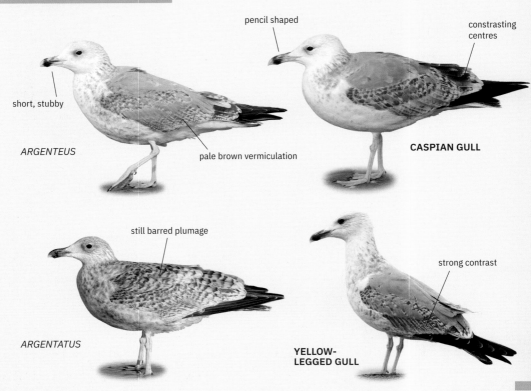

SIMILAR TAXA 2ND CYCLE

pencil shaped

constrasting centres

short, stubby

*ARGENTEUS*

pale brown vermiculation

**CASPIAN GULL**

still barred plumage

*ARGENTATUS*

strong contrast

**YELLOW-LEGGED GULL**

## Range

A widespread species in Western and Northwest Europe, with the nominate taxon *argentatus* breeding in Scandinavia, Poland, the Baltic states, Belarus, and Russia, the paler *argenteus* breeding in Iceland, Britain, Belgium, and the continental coast of France, and with a large zone of intergradation between the two taxa from the Netherlands to northern Germany. It is an opportunistic species, feeding at beaches and open sea following fishing vessels, and it can also be found on landfills, in towns, meadows, fields, and in harbours. *Argenteus* is mainly resident or a short-distance migrant; some reach the Iberian Peninsula. In winter, northern *argentatus* join *argenteus* in Britain, the Low Countries, and northern France.

European Herring Gull is probably a regular migrant to the Black Sea area. Vagrants have reached the Middle East, the southern Mediterranean region, Kazakhstan, and the east coast of North America.

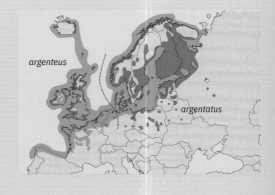

*argenteus*

*argentatus*

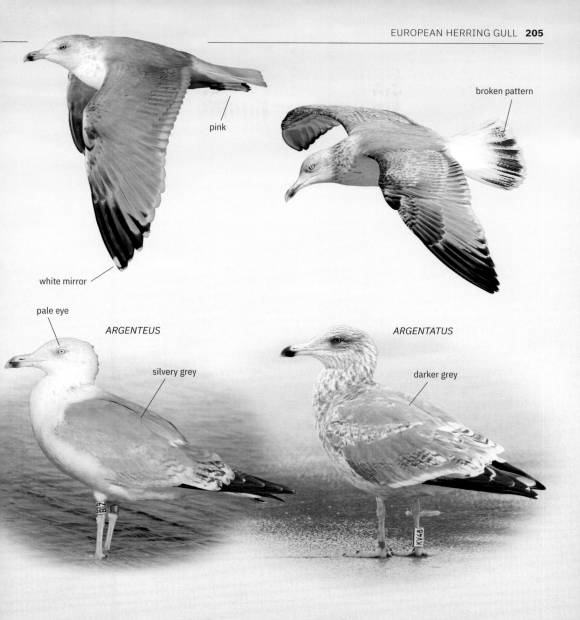

pink

broken pattern

white mirror

pale eye

*ARGENTEUS*

silvery grey

*ARGENTATUS*

darker grey

# Third cycle

Grey feathers on the back indicate the grey tone of adult upperparts and can be used for identification (see adults). In third cycle, the plumage of *argenteus* resembles adult, with just a few remnants of immaturity (check, e.g., tail and primary coverts for dark centres). Yellow-legged and Caspian Gulls have similar plumage (quite adult-like), but Yellow-legged Gull is darker than *argenteus* and acquires yellow legs, while Caspian Gull differs in head and bill

shape, darker eye, clean white head in autumn, lack of strong pink colour in the legs, and slightly different primary pattern (see p.226).

Northern *argentatus* may still look surprisingly immature, and a check for adult-like pattern on inner primaries may be necessary to confirm age. Once correctly aged, such third cycles with retarded plumage are hard to misidentify. Also, such birds show extensive brown spotting on head and neck in this age class (more than in adults), unlike Caspian and Yellow-legged Gulls.

# American Herring Gull
## *Larus smithsonianus*

▶ **STRUCTURE**

Size and structure are very similar to Scandinavian Herring Gull (*Larus argentatus argentatus*), hence larger and stronger than average *argenteus* Herring Gull. *Smithsonianus* shows a rather bulky body on short legs with snouty head profile. They are slightly different in other features as well (e.g., bill structure is longer, more parallel-sided, and with less obvious gonydeal angle than European Herring), but there is much overlap due to individual and sex-related variation. Structure can be a first hint or a supporting trait, but identification should be based on detailed plumage features.

## Adult

Adults have pale grey upperparts (matching *argenteus*, paler than *argentatus*) and, in winter, show extensive streaking and mottling on head and neck. The legs are pink (in all plumages), and the eyes are pale yellow with a yellow-orange orbital ring. The red gonys spot averages smaller than in European Herring Gull. The primary pattern is variable in adult birds, but it is an essential identification feature for any out-of-range candidate and requires detailed observation. In general, adult American Herring Gull combines much white on the inner webs with extensive black on outer webs of the outer primaries. In a Western Palearctic context, vagrants can be identified by the following combination of features:

- P10 should have a long pale tongue (covering more than 50% of the length of the inner web, which is most easily determined on the underwing) that curves steeply at the end.

**SIMILAR TAXA**

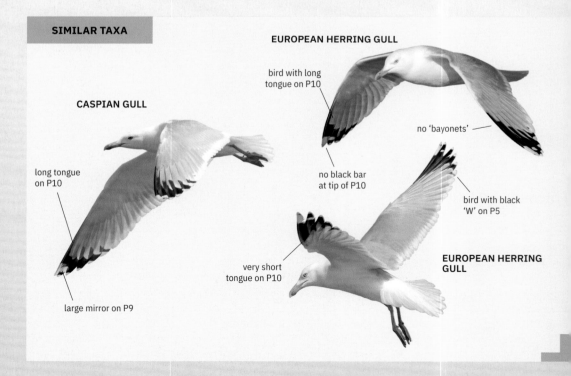

EUROPEAN HERRING GULL

bird with long tongue on P10

CASPIAN GULL

no 'bayonets'

long tongue on P10

no black bar at tip of P10

bird with black 'W' on P5

large mirror on P9

very short tongue on P10

EUROPEAN HERRING GULL

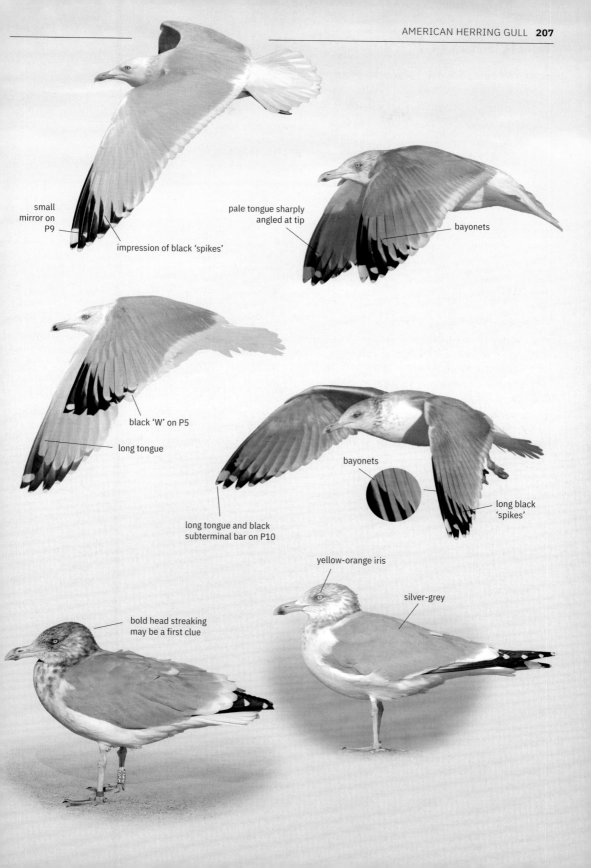

small mirror on P9

impression of black 'spikes'

pale tongue sharply angled at tip

bayonets

black 'W' on P5

long tongue

long tongue and black subterminal bar on P10

bayonets

long black 'spikes'

yellow-orange iris

silver-grey

bold head streaking may be a first clue

Ideally, there should be a complete black subterminal band. The presence of an isolated grey spot in the black colour on the underside of P10 is a supporting feature. The long pale tongue may recall Caspian Gull, but European species combine this with little or no subterminal black.

Similarly, a full black subterminal band is quite common in, for example, *argenteus* Herring Gull, but correlates with a short P10 tongue (covering less than 50% of the length of the feather). Most *argenteus* show a serrated or diagonal division between the short pale tongue and the dark outer web.

- On P9 as well, the pale tongue on the inner web is long (and may cut through the medial band to join the white mirror). Classic *smithsonianus* combine this long tongue with only a small white mirror restricted to the inner web. If European Herring Gulls show a long tongue on P9, they combine this with a large mirror, covering both webs. Similarly, European birds with only a small mirror on P9 have much black on the inner web. Thus, on the underside of P9 and P10 the shape of the pigmentation is important: in *smithsonianus* it is like a black 'hockey stick' that runs down on the outer web and curves inwards at the tip.

- P7 and P8, again, have very long, pale tongues (covering more than 75% of the inner web) and a white (ideally rounded) tongue-tip. The black pattern on the outer web has a thin, very pointed, almost needle-shaped black wedge on the outer edge, known as the 'bayonet pattern'. The common pattern in European birds is a blunt or straight black-grey division on the outer webs.

- On P5 and P6, *smithsonianus* has a black band showing three pointed wedges, creating a symmetrical 'W' pattern. In birds with the band on P5 confined to the outer web, two very pointed wedges remain present, creating a forked or U-shaped pattern.

In European Herring Gull, the corners of the black band are often rounded or straight, lacking the forked pattern. Also, many European birds have a bold black spot on the outer web and little or no black on the inner web.

Any Herring Gull showing the combination of P10, P9, and P5 patterns described here, and additionally showing the bayonet pattern on P7 and P8 should be an American Herring Gull. Still, more research is needed, for instance to estimate what proportion of adult American Herring Gulls show this combination to its full extent.

## First cycle
—

The plumage is similar to European Herring Gull, and about 40% of birds would be inseparable in flocks of this species due to overlap. Still, east coast American first cycles are often distinct with their overall dark brown, uniform texture on underparts and dark tail. European Herring Gulls may occasionally show such features too, however, and a combination of multiple features should therefore be used for positive identification of American Herring Gull:

- A mainly dark tail without white, except for the pale shafts. European Herring Gull typically shows a distinct tail band with extensive white base.
- Densely barred undertail coverts and vent. The dark pattern can be extensive, in which case the white bars are reduced to paired spots, and the longest undertail coverts may be almost entirely dark. In European Herring Gulls the dark bars are much thinner than the pale bars, leaving an overall pale vent.
- Densely patterned rump and uppertail coverts with dark brown bars, in tone close to the rest of the upperparts. In European Herring Gull the rump area is much paler than the dark tail band, and coarsely patterned with brown chevrons.
- Extensive dark brown 'smooth texture' on the underparts, lacking delicate fine lining. In European Herring, the underparts are more coarsely marked.
- Uniform brown lower hindneck and upper mantle, merging with the uniform brownish underparts.

largely dark
greater coverts

looking brown

dark from a distance

solid dark neck

(nearly) all dark tail

◄ *individual
similar to
European
Herring Gull*

These are the five main characteristics. Also relevant are these features:

- The tertials show less deeply notched fringes than European Herring Gull.
- The dark centres of the greater coverts form a dark band.
- The scapulars replaced during the post-juvenile moult often show dark and messy patterns. They do not show the regular, parallel barring of European Herring.

- The inner primaries show a weaker pale window than in European birds.

A bird showing this complete set of characteristics should be an American Herring Gull.

In late winter, many first-cycle *smithsonianus* acquire a pale head as a result of wear, which contrasts with the dark body. Another feature is the clear-cut pale base on the bill, which may recall first-cycle Glaucous Gull.

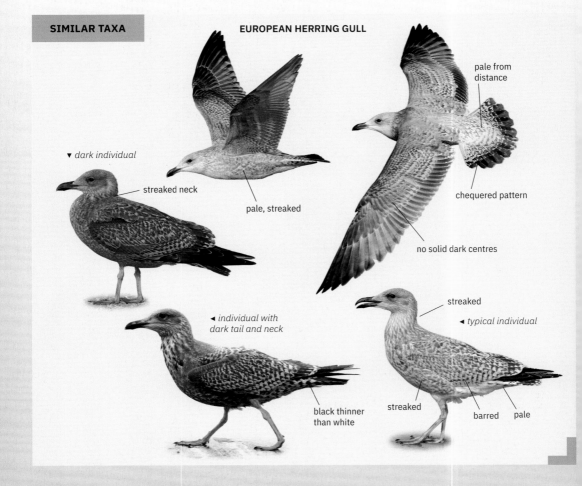

SIMILAR TAXA

EUROPEAN HERRING GULL

pale from distance

▼ dark individual

streaked neck

pale, streaked

chequered pattern

no solid dark centres

streaked

◄ individual with dark tail and neck

◄ typical individual

black thinner than white

streaked

barred    pale

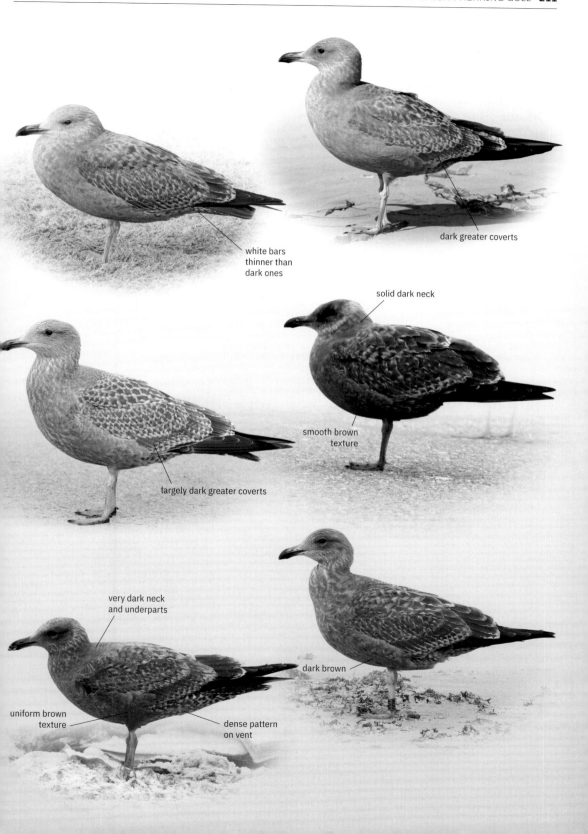

white bars
thinner than
dark ones

dark greater coverts

solid dark neck

largely dark greater coverts

smooth brown
texture

very dark neck
and underparts

dark brown

uniform brown
texture

dense pattern
on vent

# Second cycle

—

Second-cycle *smithsonianus* show a lot of seasonal and individual variation, and positive identification of vagrant birds should be based on the strict combination of the following features:

- A dense solid brown 'shawl' on the lower hindneck, which continues onto the upper mantle and underparts. European Herring Gull is more coarsely marked.
- Solid dark tertial centres with narrow pale tips, somewhat like Lesser Black-backed Gull. Hardly any notching at the fringes.
- Undertail coverts and vent with solidly dark-centred feathers or a pattern of closely spaced bars; the pale bars may even be reduced to pale spots. European birds have narrow dark bars or sparsely patterned undertail coverts.
- Densely barred rump and uppertail coverts.
- All-dark tail, ideally lacking any white along the edges.
- Darker and more uniform greater coverts than in European Herring Gull; coarse barring is generally absent.

These are the main characteristics. Also helpful are the following features:

- An extensively pale-based bill, the pattern typically resembling that of immature Glaucous Gull.
- Solid brown underwing coverts, lacking a barred pattern.

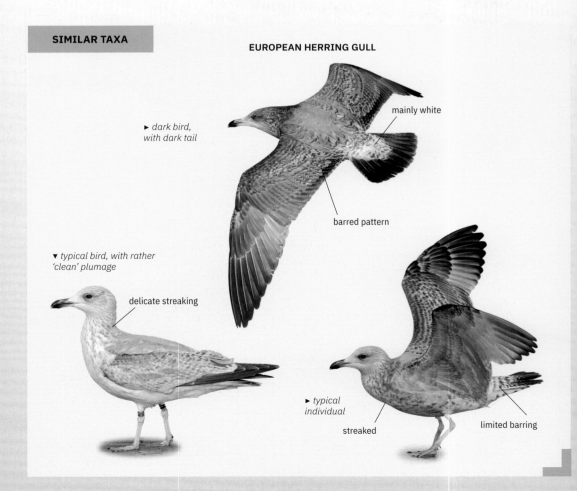

SIMILAR TAXA

EUROPEAN HERRING GULL

► *dark bird, with dark tail*

mainly white

barred pattern

▼ *typical bird, with rather 'clean' plumage*

delicate streaking

► *typical individual*

streaked

limited barring

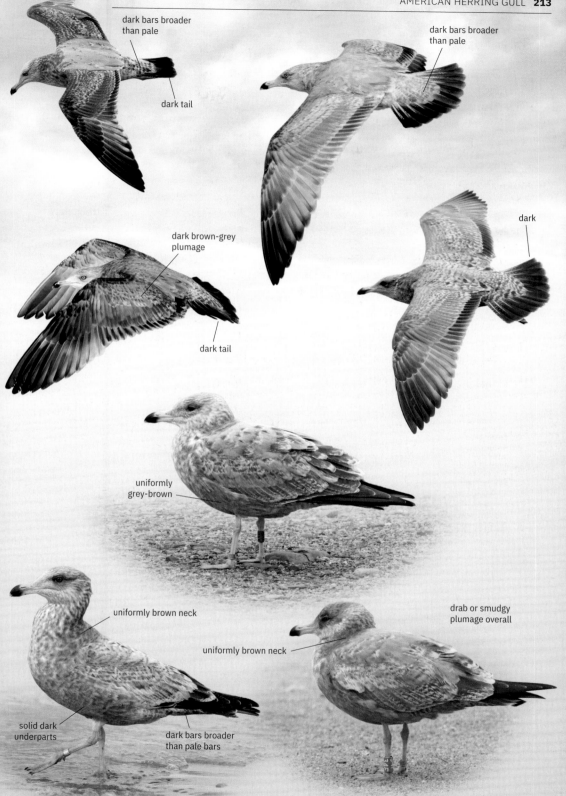

dark bars broader than pale

dark tail

dark bars broader than pale

dark

dark brown-grey plumage

dark tail

uniformly grey-brown

uniformly brown neck

drab or smudgy plumage overall

uniformly brown neck

solid dark underparts

dark bars broader than pale bars

# Third cycle

With increasing age, the proportion of identifiable birds decreases sharply, particularly because third-cycle European Herring Gull is highly variable. Still, birds showing more than one of the following characters deserve a detailed look:

- Obvious, clear-cut, solid black markings on the centres of (some) tertials (sharply defined spots, lacking vermiculation).
- Large, well-defined, rectangular black markings on otherwise adult-like secondaries; in some birds virtually every feather is marked with such a black centre, creating an impression of 'piano keys'.

- Extensive black in the tail. The black pattern is solid and contrasting, while it is diffuse or vermiculated in European Herring Gull.
- Long grey tongues on the outermost two primaries (P9 and P10), as in adult birds (see p. 206).
- Thin and pointed black wedges on the outer web of P5 and P6, which are often wider and blunt or rectangular in European Herring Gull.

European Herring Gulls do not show solid black, neatly demarcated 'ink spots' on the secondaries, but often have faded brown and vermiculated secondary centres instead. If the centres are largely dark, they have diffuse edges and do not usually give the 'piano keys' impression.

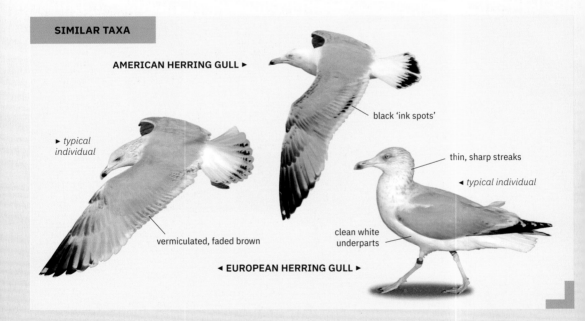

**SIMILAR TAXA**

AMERICAN HERRING GULL ▶

▶ *typical individual*

black 'ink spots'

thin, sharp streaks

◀ *typical individual*

vermiculated, faded brown

clean white underparts

◀ **EUROPEAN HERRING GULL** ▶

**▶ RANGE**

Nearctic vagrant of the 'Herring Gull complex'. A widespread species found along coastlines and lakes in the US and Canada, often in vast flocks. In the Western Palearctic, most records have been from the Azores, Ireland, Britain, and Iceland, but there are also several records from France, Spain, and Portugal, and a few records from Poland, Germany, and Norway. The true number of Western Palearctic records is likely obscured by difficulties in identification, due to large overlap with European Herring Gull. In this book we focus on traits in the American east coast population, which is most likely to stray into the Western Palearctic and, fortunately, is also more easily told from European birds.

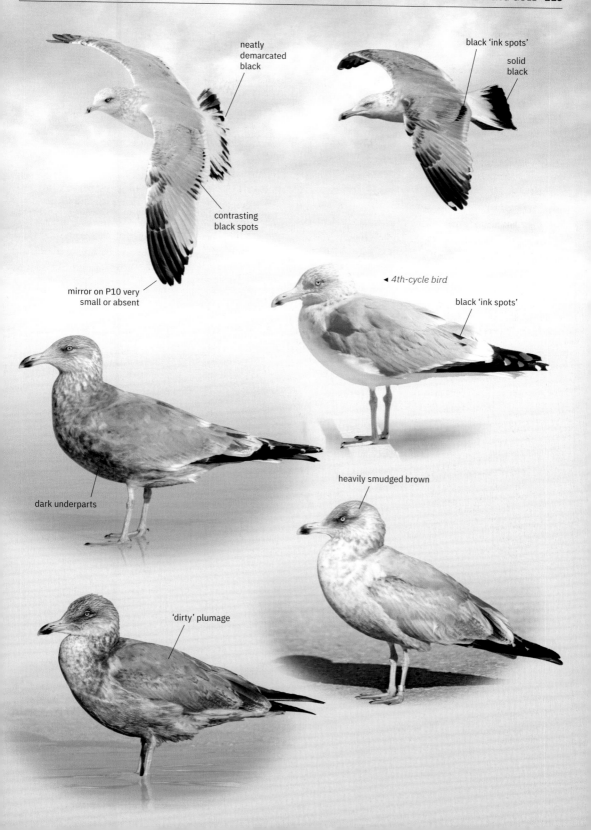

neatly demarcated black

black 'ink spots'

solid black

contrasting black spots

mirror on P10 very small or absent

◄ 4th-cycle bird

black 'ink spots'

heavily smudged brown

dark underparts

'dirty' plumage

# Vega Gull
## *Larus vegae*

▶ **STRUCTURE**
Similar in size and shape to European Herring Gull *L. argentatus* but with more pear-shaped head and higher crown as well as fuller forehead, which together often create a peculiar facial expression. The overall structure is variable, some showing rather bulky breast but others a more elongated shape. In early winter, adult birds are still growing their outermost primaries, and on resting birds the wingtips therefore appear short, which adds to the stocky outline.

## Adult

Compared with most of the other 'Herring Gull types', the upperparts of Vega Gull are a darker, concentrated lead grey with a bluish tinge similar to dark Scandinavian Herring Gulls (*L. a. argentatus*). The species differs from other large gulls with grey upperparts in its wingtip pattern, broader white tertial and scapular crescents, and the colour of its bare parts: bright, raspberry legs, dark iris (rarely dirty yellowish), a dark red orbital ring, and—in nonbreeding plumage—a dull greenish bill with yellow tip without blackish marks and with just a small red spot on the gonys, as in American Herring Gull. There are black markings on 6, sometimes 7 primaries, with a distinctive pattern: a fairly large white mirror on P10 with a thin black subterminal band and a small, rounded white mirror on P9 (rarely absent). Many Vega Gulls can be identified by a combination of criteria. All features of the primary pattern can be shown by other gulls, but not in combination:

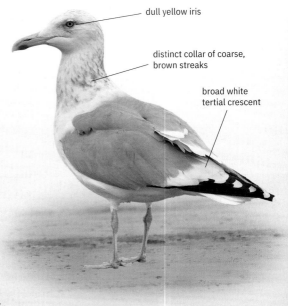

dull yellow iris

distinct collar of coarse, brown streaks

broad white tertial crescent

- White tongue-tips on at least P5–P7, as in Slaty-backed Gull *L. schistisagus* (but also a few *argentatus*).
- Complete black band on P5 and sometimes also a black mark on P4. Some birds combine a white tongue-tip on P8 with a black mark on P4—a combination not shown by *argentatus*.
- The black bands on P5–P6 form short black wedges not only on the edges of the feather but also on the shaft, creating a 'W' pattern reminiscent of American Herring Gull.
- The outer primaries show a lot more black on the outer than on the inner webs, but the resulting grey tongues are not as long as in Caspian Gull

*L. cachinnans* or the palest-winged American Herring Gulls.

In nonbreeding plumage, head and breast show dark streaks, which become more extensive, wider, and blotchier on the hindneck. There is often a dark patch around the eye.

Due to their greenish bill, dark iris, and purple-pink legs, some birds may recall Thayer's Gull, especially if they show less black on their primaries than average. Thayer's, however, shows only a little black on the inner web of P10 (seen from below) and does not show black at the base of the inner webs of P9–P10 (seen from above).

Some birds with whiter head than average, a collar of dense streaking on the hindneck, and dark eyes may recall Caspian Gull, but Vega differs in wing pattern, deep pink leg colour, and darker upperparts.

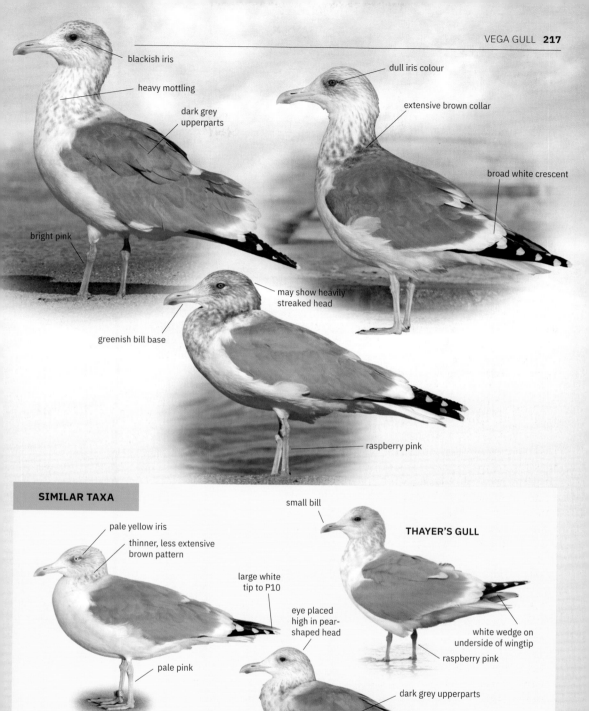

blackish iris

heavy mottling

dark grey
upperparts

bright pink

dull iris colour

extensive brown collar

broad white crescent

may show heavily
streaked head

greenish bill base

raspberry pink

**SIMILAR TAXA**

pale yellow iris

thinner, less extensive
brown pattern

large white
tip to P10

eye placed
high in pear-
shaped head

pale pink

**EUROPEAN HERRING
GULL** *ARGENTATUS*

small bill

**THAYER'S GULL**

white wedge on
underside of wingtip

raspberry pink

dark grey upperparts

**VEGA GULL**

raspberry pink

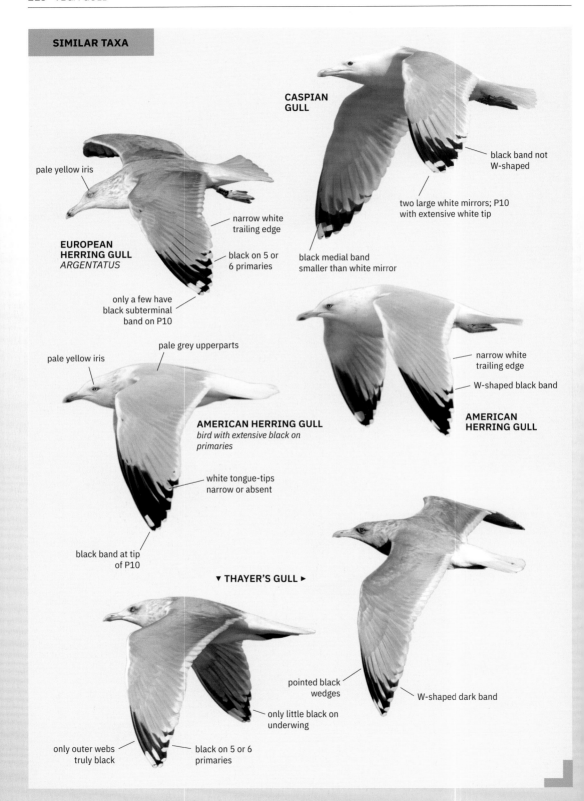

**SIMILAR TAXA**

**CASPIAN GULL**

black band not W-shaped

two large white mirrors; P10 with extensive white tip

black medial band smaller than white mirror

pale yellow iris

narrow white trailing edge

**EUROPEAN HERRING GULL** *ARGENTATUS*

black on 5 or 6 primaries

only a few have black subterminal band on P10

pale grey upperparts

pale yellow iris

narrow white trailing edge

W-shaped black band

**AMERICAN HERRING GULL** *bird with extensive black on primaries*

**AMERICAN HERRING GULL**

white tongue-tips narrow or absent

black band at tip of P10

▼ THAYER'S GULL ►

pointed black wedges

W-shaped dark band

only little black on underwing

only outer webs truly black

black on 5 or 6 primaries

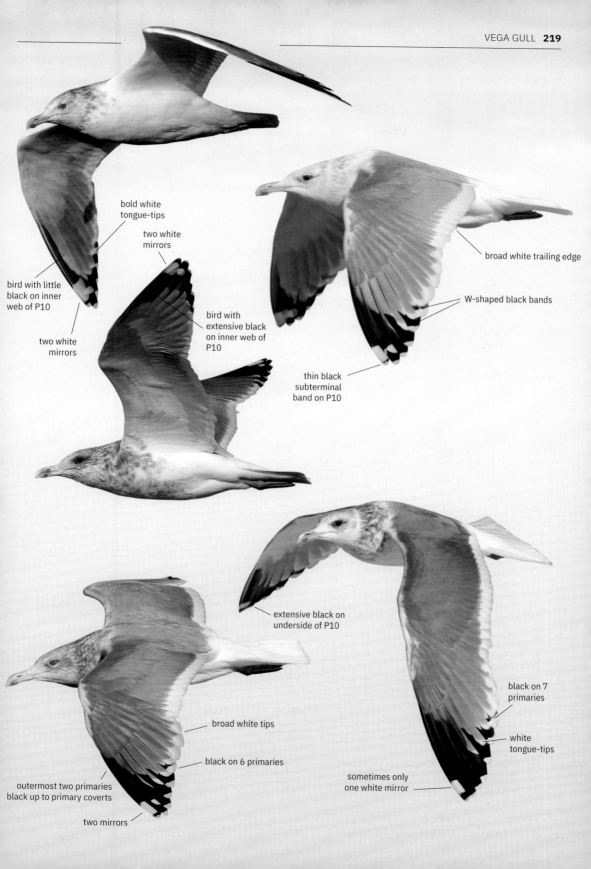

bold white
tongue-tips

two white
mirrors

broad white trailing edge

bird with little
black on inner
web of P10

bird with
extensive black
on inner web of
P10

W-shaped black bands

two white
mirrors

thin black
subterminal
band on P10

extensive black on
underside of P10

black on 7
primaries

broad white tips

white
tongue-tips

black on 6 primaries

outermost two primaries
black up to primary coverts

sometimes only
one white mirror

two mirrors

# First cycle

In a vagrant context, identification of first-cycle Vega Gull seems fraught with difficulty, even though several features in combination could possibly indicate this species. It is very similar to European Herring Gull, but the dark tail band averages broader (though it is variable) with fine dark barring at the bases of the tail feathers, recalling Caspian Gull. Differs from Mongolian Gull (*L. vegae mongolicus*) in its tail pattern, since in the latter taxon it is more similar to Yellow-legged Gull, showing a well-demarcated subterminal bar, and very few fine bars on the extensive white tail base. The tertial pattern is similar to that of European Herring, with white notches and often a pale 'thumbprint' near the tips. The greater coverts are very white, with widely spaced, thin brown bars, although the outermost coverts show a more uniform pattern. The palest birds may strongly recall Mongolian Gull. The majority of first-cycle birds retain their juvenile rear scapulars during winter, whereas newly moulted scapulars show a very thin, grey subterminal bar, as in the palest European Herring Gulls. Further average differences from European Herring Gull are the more pear-shaped head with fuller forehead, a uniform dark patch around the eye, deep pink leg colour, and stronger contrast between the very dark underwing and whitish upperwing.

The tertials, with their pale, subterminal 'thumbprints' are often different from the plain brown tertials of American Herring Gull. Most Vega Gulls show paler plumage than this species, with fewer markings on the undertail coverts and with duller bill colour. Their greater coverts are whiter on average.

First-cycle Thayer's Gulls usually retain more juvenile scapulars throughout winter (sometimes all) and show a more extensive brown tail as well as pale fringes on the brown folded wingtip. In flight, the upperwing looks silvery pale in Thayer's, with obvious pale inner webs on the outer primaries.

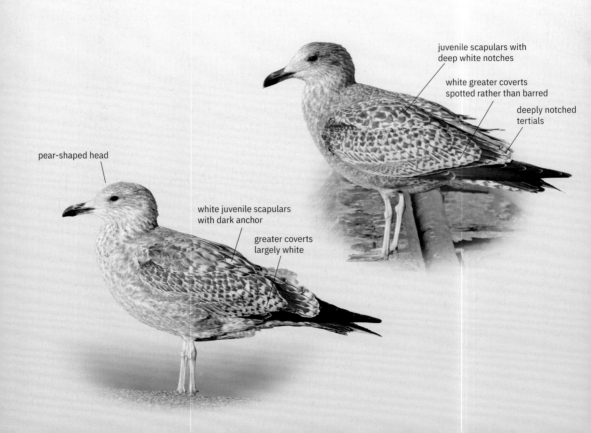

juvenile scapulars with deep white notches

white greater coverts spotted rather than barred

deeply notched tertials

pear-shaped head

white juvenile scapulars with dark anchor

greater coverts largely white

barred outer tail feathers

finely barred black
and white pattern

pale silvery window

retained juvenile
scapulars

▶ *bird with
pale tail*

barred greater
coverts

contrasting black
tail band

large pale spot on inner webs

uniformly dark
underwing

moulted scapulars with
thin dark anchor

white greater coverts
with vague dark bars

tertials with white
internal markings

dark barring reaches belly

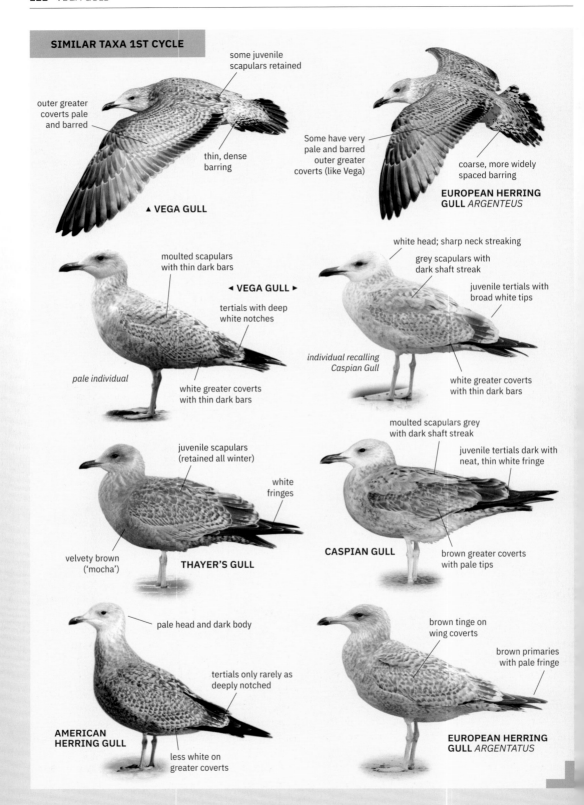

**SIMILAR TAXA 1ST CYCLE**

some juvenile scapulars retained

outer greater coverts pale and barred

thin, dense barring

▲ VEGA GULL

Some have very pale and barred outer greater coverts (like Vega)

coarse, more widely spaced barring

**EUROPEAN HERRING GULL** *ARGENTEUS*

moulted scapulars with thin dark bars

◄ VEGA GULL ►

tertials with deep white notches

*pale individual*

white greater coverts with thin dark bars

white head; sharp neck streaking

grey scapulars with dark shaft streak

juvenile tertials with broad white tips

*individual recalling Caspian Gull*

white greater coverts with thin dark bars

juvenile scapulars (retained all winter)

white fringes

velvety brown ('mocha')

**THAYER'S GULL**

moulted scapulars grey with dark shaft streak

juvenile tertials dark with neat, thin white fringe

**CASPIAN GULL**

brown greater coverts with pale tips

**AMERICAN HERRING GULL**

pale head and dark body

tertials only rarely as deeply notched

less white on greater coverts

brown tinge on wing coverts

brown primaries with pale fringe

**EUROPEAN HERRING GULL** *ARGENTATUS*

dark grey 'saddle'

whitish panel

distinct black tail band

underwing still
very dark

dark brown collar

tail may be
fully black

pale wing coverts

heavily streaked
head with dark eye

uniformly
brown
hindneck

barred tertials

very pale greater coverts
with vermiculated pattern

extensive white colour
on wing coverts

dark tertials with
broad white tips

# Second cycle

Very similar to European Herring Gull, but the
overall structure is a little bulkier with heavier
breast, the head and breast tend to show stronger
streaking in winter with a blotched pattern on the
hindneck, and the greater coverts are very pale,
whitish. These feathers contrast with the grey
upperparts ('saddle'); they mostly lack dark barring
(unlike European Herring) and form a pale wing
panel, which in flight is enhanced by the pale
window on the inner primaries. The tertials show
broad white tips but also a more uniform, blackish

centre than in European Herring. The dark tail band
is very broad in most birds of this age category,
strongly contrasting with the white uppertail coverts
and recalling American rather than European
Herring. The bill base is pink or greenish.

At this age, Thayer's Gulls can also show pale
(though usually brown) greater coverts and lead grey
upperparts, but the inner webs on their outer
primaries are very pale, creating a bicoloured
pattern on upperwing and entirely pale underside of
the hand. In addition, the tail is entirely dark and
structure is different (slimmer, more elongated, with
thinner bill).

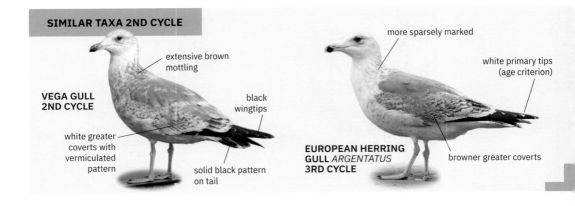

SIMILAR TAXA 2ND CYCLE

more sparsely marked

extensive brown
mottling

white primary tips
(age criterion)

**VEGA GULL
2ND CYCLE**

black
wingtips

white greater
coverts with
vermiculated
pattern

solid black pattern
on tail

**EUROPEAN HERRING
GULL** *ARGENTATUS*
**3RD CYCLE**

browner greater coverts

# Third cycle

Difficult to tell from Scandinavian Herring Gull at this age, which may also have dark grey upperparts and a hint of a white 'string of pearls' on the primaries. Classic third-cycle Vega Gulls have dark iris, their orbital ring is already turning red, their hindneck is heavily marked with brown blotches in winter, and they show black pattern on 6 or 7 primaries (often only 5 in Scandinavian Herring). Unlike in American Herring Gull, there is no solid black panel on the tertials, but there may be a few oval black spots.

Some birds may be identifiable outside their normal range if they show the following combination of features: a broad white trailing edge on the inner primaries, not being narrower than on the secondaries; solid blackish spots on the primary coverts; only small white mirrors on P9–P10 (sometimes absent); sometimes a black 'W' on P4; a collar of brown blotches on hindneck; sometimes

solid black spots on the tail; deep pink legs; and dark iris.

Thayer's Gulls of this age-class show a blackish-grey rather than jet black primary pattern. The inner webs of the outer primaries are largely pale and the underside of the hand is therefore mainly pale too.

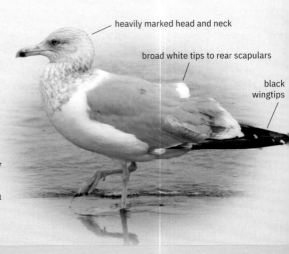

heavily marked head and neck

broad white tips to rear scapulars

black
wingtips

> **DISTRIBUTION**
> Vega Gull is treated as a full species here because it is phenotypically distinct from American Herring Gull *Larus smithsonianus*, the species to which it is closest genetically. Vega Gull has a wide distribution range throughout Asia: it breeds in the Siberian Arctic, from east of the Taimyr Peninsula to the Bering Strait, and winters along the Asian Pacific coast, from Kamchatka to eastern China including Japan and the Korean Peninsula. In western breeding birds the leg colour may
>
> vary from pink to yellow, and this population is sometimes considered a different subspecies, named *birulai*.
> The species is a recent addition to the list of Western Palearctic birds. There have been two records: an adult bird in Ireland in January 2016 (accepted by the Irish rarities committee) and a subadult bird in France in November of the same year.

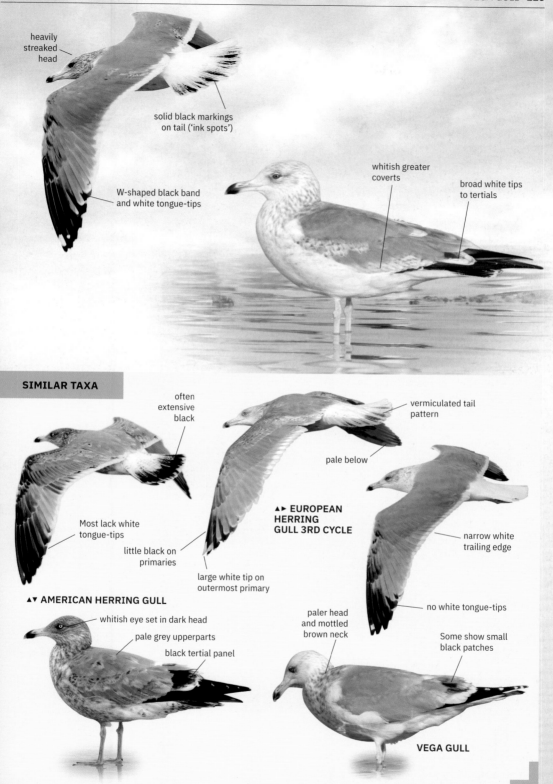

heavily streaked head

solid black markings on tail ('ink spots')

W-shaped black band and white tongue-tips

whitish greater coverts

broad white tips to tertials

## SIMILAR TAXA

often extensive black

vermiculated tail pattern

pale below

Most lack white tongue-tips

little black on primaries

large white tip on outermost primary

**▲► EUROPEAN HERRING GULL 3RD CYCLE**

narrow white trailing edge

no white tongue-tips

**▲▼ AMERICAN HERRING GULL**

whitish eye set in dark head

pale grey upperparts

black tertial panel

paler head and mottled brown neck

Some show small black patches

**VEGA GULL**

# Caspian Gull
## *Larus cachinnans*

> ▶ **STRUCTURE**
> Similar in size to European Herring Gull, but compared with that species and Yellow-legged Gull, its overall structure is more more elongated. Its bill is thinner with less distinct gonydeal angle, the head is pear-shaped with flat forehead, the highest point of the crown often lies behind the eye, and the legs are thin with well-visible tibia. The bill may look disproportionally long. The primary projection is longer than in European Herring Gull. Some birds look very elongated, others bulkier. Unlike European Herring, which holds its wings closed, Caspian Gull raises its wings when it utters its display call ('albatross posture').

## Adult

The upperparts have more or less the same grey tone as *argenteus* Herring Gull or are slightly darker, which means they are slightly paler than in Yellow-legged Gull. Differs from the former in its structure, its greyish or flesh-coloured legs in winter, pale yellowish in summer, blackish or brown-yellow iris (rarely paler yellow), orange or red orbital ring (never pink), and its wing pattern. In nonbreeding plumage, dense dark streaks form a characteristic 'shawl' on the hindneck, contrasting with an often very white head. The primary pattern is a key feature for separating adult birds from other large gulls with grey upperparts (Herring, Yellow-legged, and taxa from the Asian steppes): black pattern is present on 6 primaries, and long grey tongues cover most of the inner webs of the outer primaries, creating a largely grey underside of the hand with black crescent along the tips. There is a large white area at the tip of P10, sometimes broken by a thin black subterminal bar, a fairly large, rounded white mirror on P9, and prominent white tongue-tips on P5–P7. On the inner web of P10, the white area at the tip is often longer than the black medial band, and the rest of the inner web is pale grey with little or no black (unlike European Herring and Vega Gull, which often show a substantial amount of black on the inside of the shaft). Eastern birds may show less black, as well as white tongue-tips on all outer primaries, including P10.

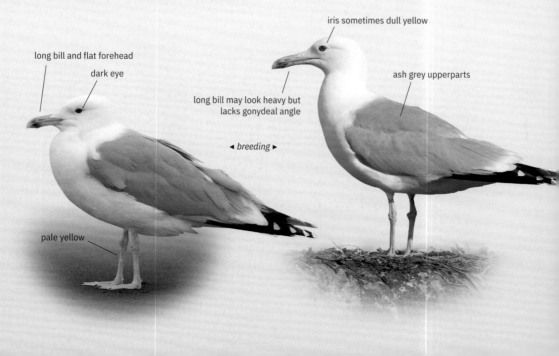

long bill and flat forehead

dark eye

pale yellow

iris sometimes dull yellow

ash grey upperparts

long bill may look heavy but lacks gonydeal angle

◄ *breeding* ►

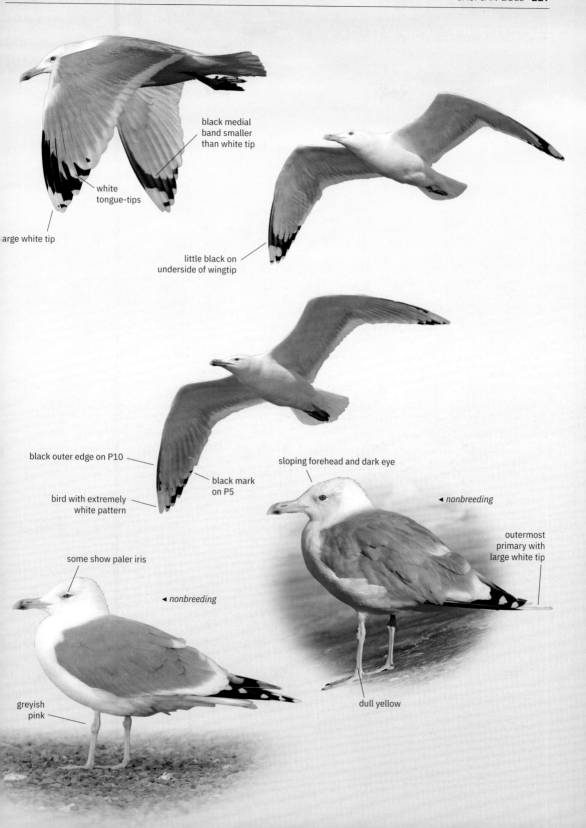

black medial band smaller than white tip

white tongue-tips

arge white tip

little black on underside of wingtip

black outer edge on P10

bird with extremely white pattern

black mark on P5

sloping forehead and dark eye

◄ *nonbreeding*

outermost primary with large white tip

some show paler iris

◄ *nonbreeding*

greyish pink

dull yellow

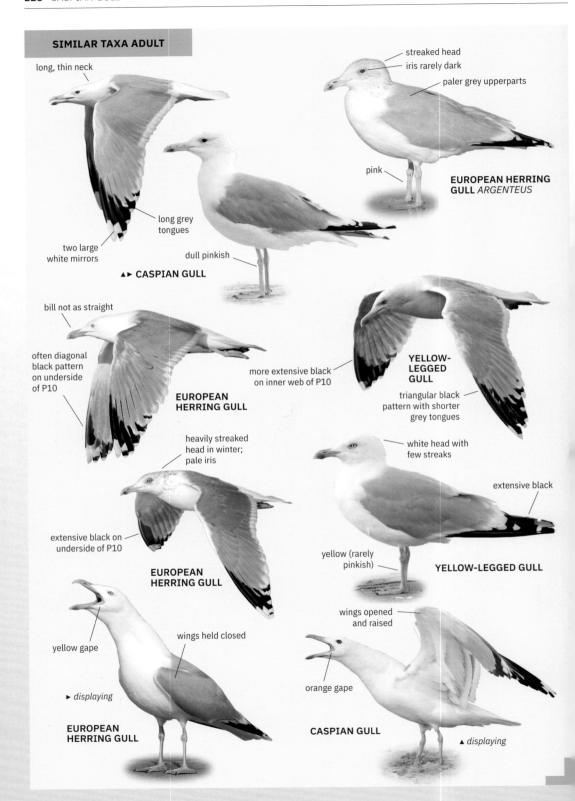

**SIMILAR TAXA ADULT**

long, thin neck

streaked head
iris rarely dark
paler grey upperparts

pink

**EUROPEAN HERRING GULL** *ARGENTEUS*

long grey tongues

two large white mirrors

dull pinkish

▲▶ **CASPIAN GULL**

bill not as straight

often diagonal black pattern on underside of P10

more extensive black on inner web of P10

**EUROPEAN HERRING GULL**

**YELLOW-LEGGED GULL**

triangular black pattern with shorter grey tongues

heavily streaked head in winter; pale iris

white head with few streaks

extensive black

extensive black on underside of P10

**EUROPEAN HERRING GULL**

yellow (rarely pinkish)

**YELLOW-LEGGED GULL**

yellow gape

wings held closed

wings opened and raised

▶ *displaying*

**EUROPEAN HERRING GULL**

orange gape

**CASPIAN GULL**

▲ *displaying*

# First cycle

In addition to differences in shape, the plumage averages more grey and white than in Yellow-legged Gull, without the tawny colours often present in that species. The following five typical features are key field marks to distinguish first-cycle Caspian from Yellow-legged and European Herring Gull:

- A very white head with a 'shawl' of dense brown streaks or spots on hindneck in autumn/winter.

- Plain greater coverts with white fringes only, no coarse pale bars.
- Tertials without pale notches, showing just a neat white edge at the tips (wearing off during winter).
- Largely white underwing coverts and axillaries.
- A characteristic tail pattern, with a broad dark tail band that gradually merges into the clean white base through a series of intricate, 'Chinese' marks, whereas in Yellow-legged the tail band is clear-cut and in European Herring the tail pattern looks browner and more barred overall.

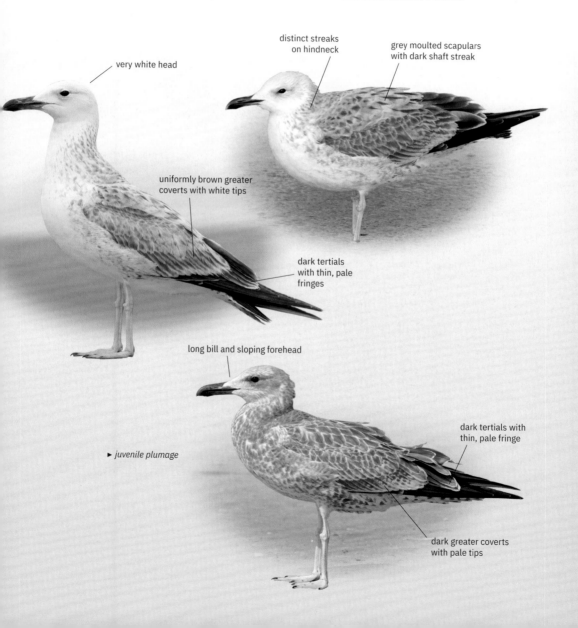

very white head

distinct streaks on hindneck

grey moulted scapulars with dark shaft streak

uniformly brown greater coverts with white tips

dark tertials with thin, pale fringes

long bill and sloping forehead

▶ *juvenile plumage*

dark tertials with thin, pale fringe

dark greater coverts with pale tips

The grey inner primaries create a pale window that is less distinct than in Herring, because the outer webs are largely dark. The post-juvenile scapulars are often plain grey with thin dark shaft streak, although they may also show a dark anchor pattern, particularly in birds with more strongly patterned greater coverts.

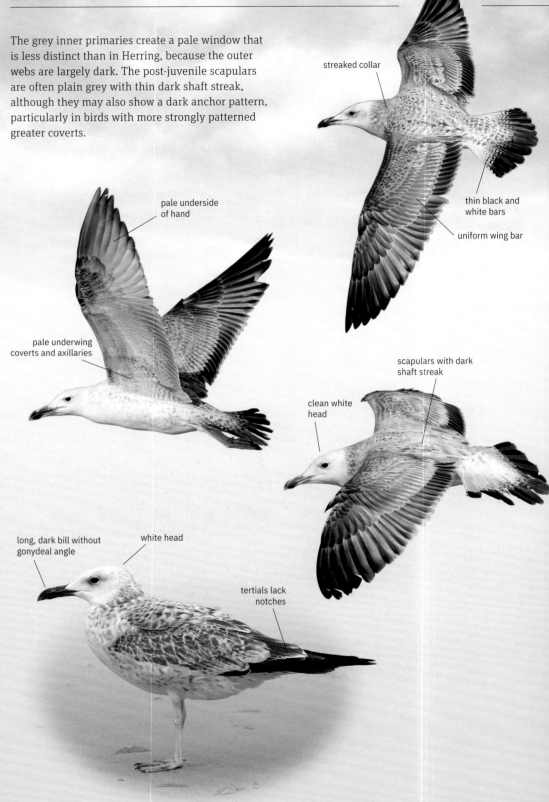

streaked collar

pale underside of hand

thin black and white bars

uniform wing bar

pale underwing coverts and axillaries

scapulars with dark shaft streak

clean white head

long, dark bill without gonydeal angle

white head

tertials lack notches

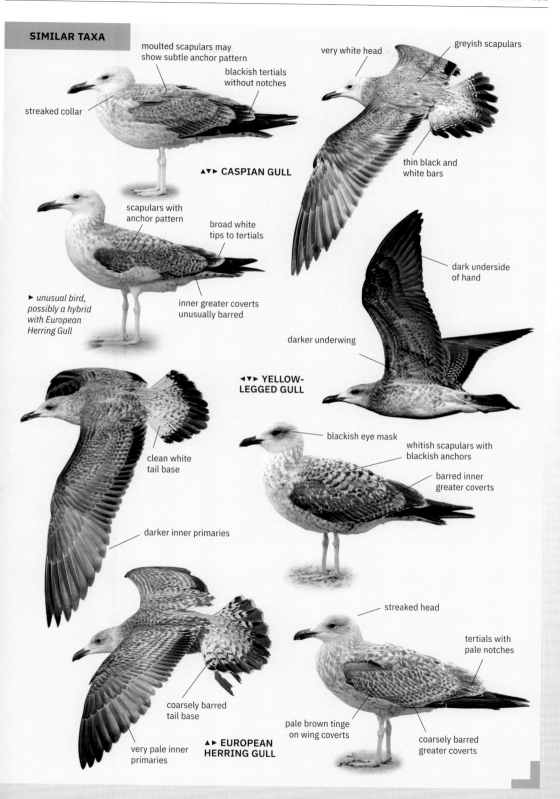

**SIMILAR TAXA**

moulted scapulars may show subtle anchor pattern

blackish tertials without notches

streaked collar

greyish scapulars

very white head

thin black and white bars

▲▼► CASPIAN GULL

scapulars with anchor pattern

broad white tips to tertials

► *unusual bird, possibly a hybrid with European Herring Gull*

inner greater coverts unusually barred

dark underside of hand

darker underwing

◄▼► YELLOW-LEGGED GULL

clean white tail base

blackish eye mask

whitish scapulars with blackish anchors

barred inner greater coverts

darker inner primaries

streaked head

tertials with pale notches

coarsely barred tail base

pale brown tinge on wing coverts

very pale inner primaries

▲► EUROPEAN HERRING GULL

coarsely barred greater coverts

## Second cycle

Resembles first-cycle birds, but the greater coverts
look even plainer with finer vermiculated pattern on
the inners, the tertials are black with a wide white
tip and vermiculated edges, the scapulars are often a
mixture of plain grey feathers and paler feathers
with dark shaft streak, and the tail band is black
with vermiculated upper edge. The underwing looks
whiter than in European Herring and Yellow-legged
Gull, and the grey inner primaries form a more
distinct pale window than in the latter species.
About half of all birds show a small white mirror on
P10, unlike Yellow-legged and *argenteus* Herring
Gull (but not nominate *argentatus*). The iris is
typically still dark, the legs are flesh-coloured,
and a grey 'shawl' on the hindneck contrasts
with a very white head.

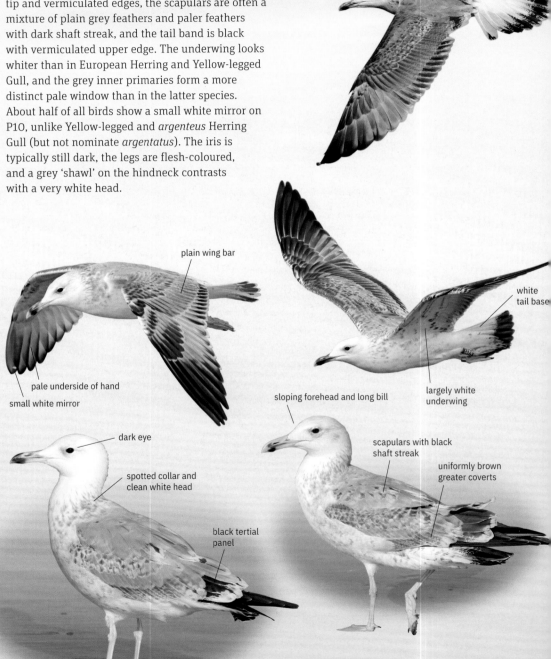

streaked collar

thin tail band
with slightly
vermiculated
upper edge

plain wing bar

white
tail base

pale underside of hand

small white mirror

sloping forehead and long bill

largely white
underwing

dark eye

spotted collar and
clean white head

black tertial
panel

scapulars with black
shaft streak

uniformly brown
greater coverts

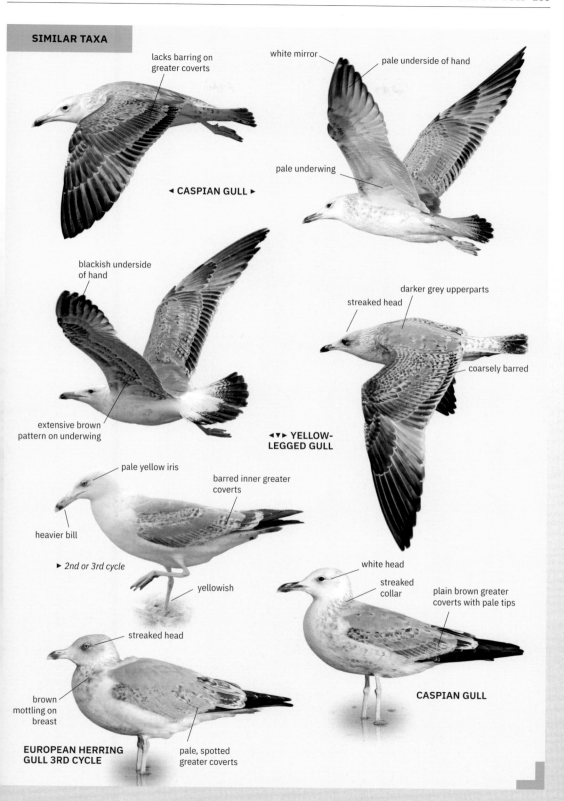

**SIMILAR TAXA**

lacks barring on greater coverts

◄ **CASPIAN GULL** ►

white mirror

pale underside of hand

pale underwing

blackish underside of hand

darker grey upperparts

streaked head

extensive brown pattern on underwing

coarsely barred

◄▼► **YELLOW-LEGGED GULL**

pale yellow iris

barred inner greater coverts

heavier bill

► *2nd or 3rd cycle*

yellowish

white head

streaked collar

plain brown greater coverts with pale tips

streaked head

brown mottling on breast

**CASPIAN GULL**

**EUROPEAN HERRING GULL 3RD CYCLE**

pale, spotted greater coverts

# Third cycle

The wing pattern recalls that of adults but with more extensive black on the inner webs of the outer primaries. Still, the grey tongues on the primaries are often longer than in Yellow-legged Gulls of the same age. There is already a large white area at the tip of P10, and P9 usually shows a small, rounded white mirror. If the pale tongues on P9–P10 cover more than half the length of the feather or if there are prominent white tongue-tips on P7–P8 (P9), these features indicate Caspian rather than Yellow-legged Gull. The tail shows little or no black. The bare parts are distinctive, with flesh-coloured legs, dark iris, and dull bill colour. There is a characteristic grey 'shawl' on the hindneck in winter, unlike in Yellow-legged Gull.

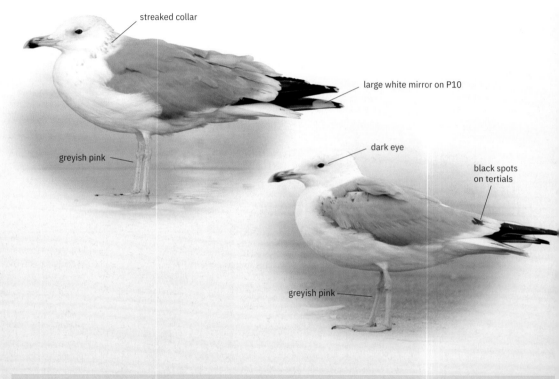

streaked collar

large white mirror on P10

greyish pink

dark eye

black spots on tertials

greyish pink

## ▶ RANGE

Caspian Gull breeds in the steppes of Western and Central Asia, from the Black Sea, Caspian Sea, and Aral Sea to the great lakes in eastern Kazakhstan. Small breeding populations have established in Poland, Germany, and (recently) the Netherlands. In winter, the species spreads to the coasts of Western and Central Europe, the eastern part of the Mediterranean Sea, and the Arabian Peninsula, where Steppe Gull *L. (fuscus) barabensis* also winters. Whereas Caspian Gulls used to be rare along the Atlantic coast, they are now regular visitors there.

The species is (very) rare in Iceland, Ireland, Luxembourg, Malta, Norway, Portugal, Slovenia, and Tunisia.

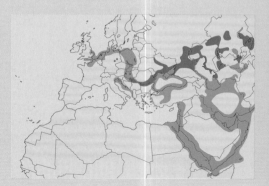

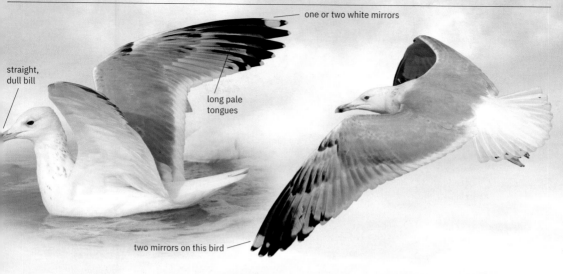

one or two white mirrors

straight, dull bill

long pale tongues

two mirrors on this bird

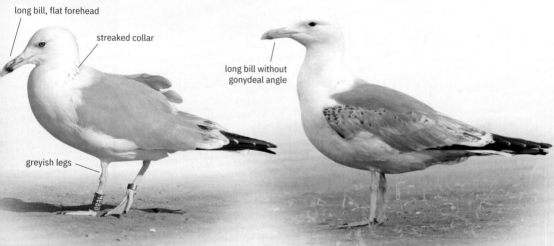

long bill, flat forehead

streaked collar

long bill without gonydeal angle

greyish legs

## SIMILAR TAXA

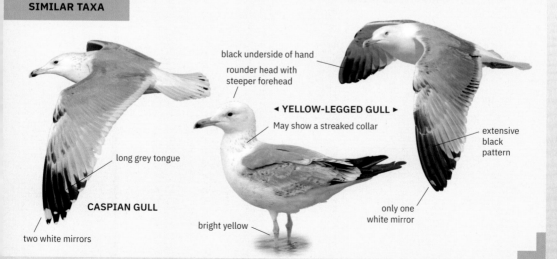

black underside of hand

rounder head with steeper forehead

◄ YELLOW-LEGGED GULL ►

May show a streaked collar

long grey tongue

extensive black pattern

CASPIAN GULL

bright yellow

only one white mirror

two white mirrors

# 'Azores Gull'
## *Larus michahellis atlantis*

▶ **STRUCTURE**
Size and structure are of no real help in the identification process, particularly not in lone or vagrant birds, but Macaronesian, Moroccan, and Atlantic Iberian Yellow-legged Gulls average a little smaller than the nominate subspecies, with slightly shorter legs and wings.

## Adult

In a vagrant context, only about one in three adult 'Azores Gulls' can be identified with confidence. Separation from other Yellow-legged Gulls requires a characteristic combination of features in the primary pattern, careful assessment of the colour of the upperparts, and preferably a classic head pattern. 'Azores Gulls' have the darkest bluish-grey upperparts of all Yellow-legged Gulls, and they show the most extensive black on their primaries. The following combination of four features can be considered diagnostic:

1. No grey tongue or just a short one on P10 (shorter than one-third the length of the feather);
2. No white mirror on P9;
3. Fully black outer web on P8 up to primary coverts (i.e., no grey visible at base of outer web), adding to a completely black base on outermost 3 primaries;
4. Black spot or band on P4.

A few birds even show a black mark on P3, which is apparently unique among adult Yellow-legged Gulls. In autumn (August–October), the head pattern may be eye-catching, with strong streaking creating a restricted 'hood' and with clean white neck. Importantly, the lore and forehead often show dark markings, and the malar area is streaked.

The combination of features 1–4 listed above, supported by head pattern and exact colour of upperparts, also helps to separate adult Azores Gull from hybrids like Lesser Black-backed × Yellow-legged Gull, which usually also differ in their broader white tertial and scapular crescents.

The combination of features 2–4 mentioned above also helps to identify a handful of Yellow-legged Gulls from the Canary Islands, Madeira, and Portugal (birds from the latter country belonging to the subspecies *lusitanius*), but most adult birds from populations other than the Azores cannot safely be told from nominate *michahellis* in a vagrant context.

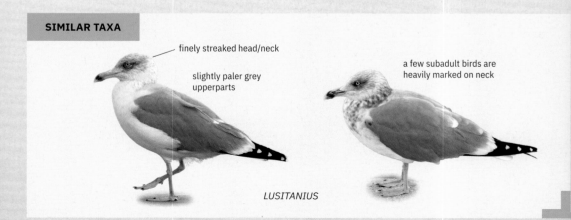

SIMILAR TAXA

finely streaked head/neck

slightly paler grey upperparts

a few subadult birds are heavily marked on neck

*LUSITANIUS*

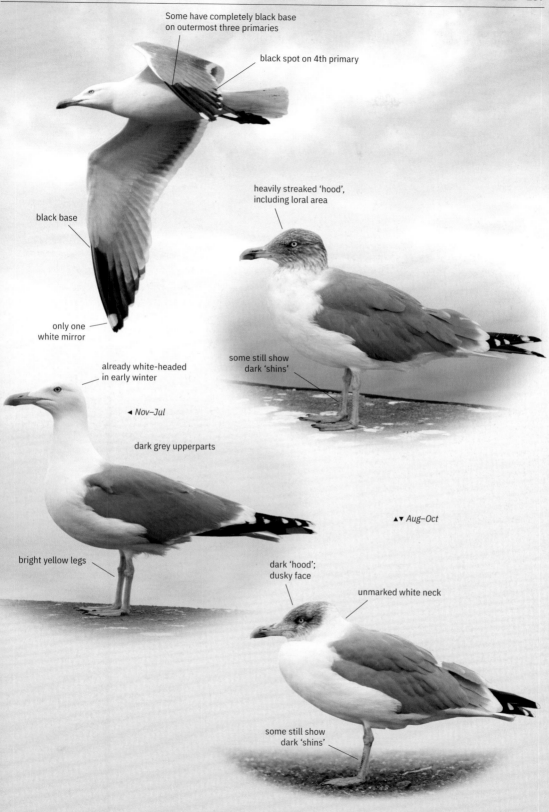

Some have completely black base on outermost three primaries

black spot on 4th primary

heavily streaked 'hood', including loral area

black base

only one white mirror

some still show dark 'shins'

already white-headed in early winter

◄ *Nov–Jul*

dark grey upperparts

▲▼ *Aug–Oct*

bright yellow legs

dark 'hood'; dusky face

unmarked white neck

some still show dark 'shins'

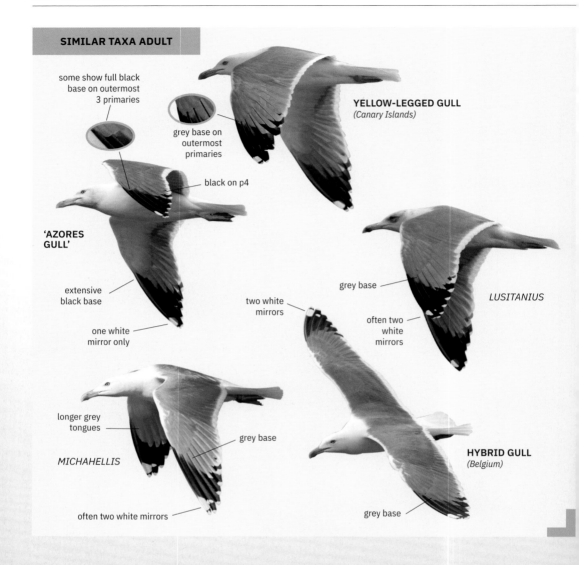

**SIMILAR TAXA ADULT**

some show full black base on outermost 3 primaries

grey base on outermost primaries

black on p4

YELLOW-LEGGED GULL
*(Canary Islands)*

'AZORES GULL'

extensive black base

one white mirror only

two white mirrors

grey base

often two white mirrors

*LUSITANIUS*

longer grey tongues

grey base

*MICHAHELLIS*

HYBRID GULL
*(Belgium)*

often two white mirrors

grey base

grey base

# First cycle

In their first year, 'Azores Gulls' are characterised by their dark brown, almost sooty plumage. It should be noted, however, that some Canarian, Madeiran, Portuguese, Galician, and probably Moroccan birds too can show very dark brown plumage, as do some Lesser Black-backed Gulls. Therefore, only typical birds can be identified with confidence, and mainly after the post-juvenile moult, when the pattern of the new scapulars adds to the differences. We estimate that, after the post-juvenile moult, about 50% of all first-cycle 'Azores Gulls' show the following unique combination of features that renders them distinctive:

- Plain brown wing coverts, lacking pale fringes or barred pattern (except for moulted feathers) , and looking 'oil-stained'.
- Dark, sooty face.
- Streaked pattern on chin and throat.
- Dark brown breast (often densely patterned).
- Bold, dense, vertical dark bars on the white flank, just above the legs, creating a kind of 'zebra pattern'.
- Dark and messy pattern on replaced scapulars.

dark inner primaries

very dark underwing coverts

broad black tailband

'zebra barring' above legs

messy, mixed pattern

plain, tawny brown wing coverts and tertials, looking 'oiled'

dark brown face

dark, mottled underparts

▼ *Aug–Oct*

► *Oct–Apr*

dark lore

uniformly dark ear coverts

very similar to dark Lesser Black-backed Gull

bold barring above legs

- Very dark underwing.
- Plain dark inner primaries.

In flight, first-cycle 'Azores' generally show a broader black tail band than nominate *michahellis*, and some birds even show dark barring or spotting at the base of the outermost tail-feather (unlike *michahellis*, which usually has a clean white base). Rump and uppertail coverts can look barred (versus spotted in *michahellis*).

Differs from American Herring Gull in its more coarsely marked underparts, bolder and more widely spaced pattern on undertail coverts, dark inner primaries, and obvious white colour at tail base. Also, the bill is blackish in first-cycle 'Azores Gull' (as in other Yellow-legged Gull populations), with any pink colour usually confined to the base of the lower mandible.

First-cycle Yellow-legged Gulls from populations other than the Azores are more similar to nominate *michahellis* and their identification is probably not safe, even though many birds show a broader tail band, as well as darker head and underparts than *michahellis*.

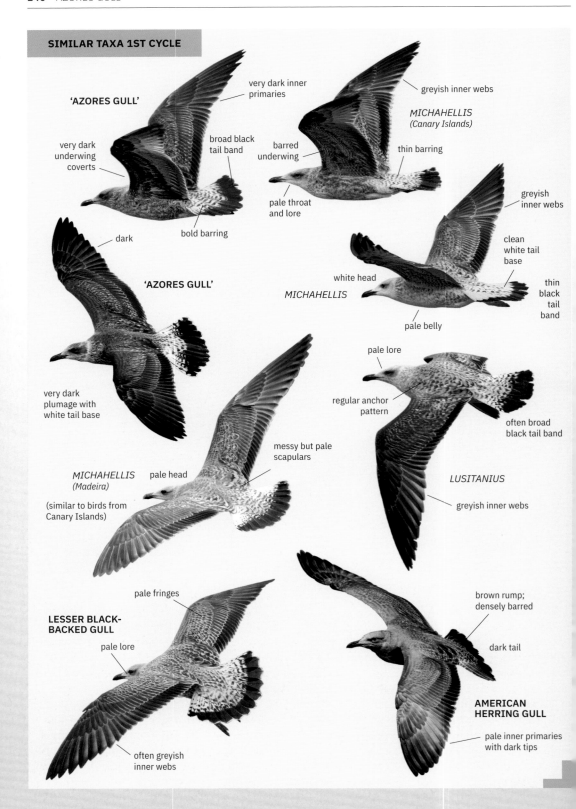

**SIMILAR TAXA 1ST CYCLE**

**'AZORES GULL'**

very dark inner primaries

very dark underwing coverts

broad black tail band

bold barring

dark

**'AZORES GULL'**

very dark plumage with white tail base

*MICHAHELLIS* (Madeira)

(similar to birds from Canary Islands)

pale head

messy but pale scapulars

*MICHAHELLIS* (Canary Islands)

greyish inner webs

thin barring

barred underwing

pale throat and lore

white head

*MICHAHELLIS*

pale belly

greyish inner webs

clean white tail base

thin black tail band

pale lore

regular anchor pattern

often broad black tail band

*LUSITANIUS*

greyish inner webs

**LESSER BLACK-BACKED GULL**

pale fringes

pale lore

often greyish inner webs

brown rump; densely barred

dark tail

**AMERICAN HERRING GULL**

pale inner primaries with dark tips

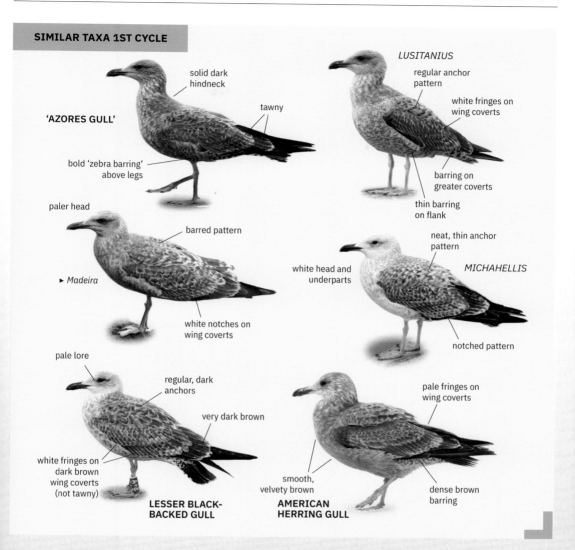

**SIMILAR TAXA 1ST CYCLE**

'AZORES GULL'

solid dark hindneck

tawny

bold 'zebra barring' above legs

paler head

▶ Madeira

barred pattern

white notches on wing coverts

pale lore

regular, dark anchors

very dark brown

white fringes on dark brown wing coverts (not tawny)

**LESSER BLACK-BACKED GULL**

*LUSITANIUS*

regular anchor pattern

white fringes on wing coverts

barring on greater coverts

thin barring on flank

neat, thin anchor pattern

white head and underparts

*MICHAHELLIS*

notched pattern

pale fringes on wing coverts

smooth, velvety brown

dense brown barring

**AMERICAN HERRING GULL**

# Second cycle

'Azores Gulls' of this age class show variable plumage, but about 30% show a unique combination of the following features:

1. A strong 'hood' of streaks covering the whole head (including forehead, chin, and throat) but not the neck;
2. An isolated, solid brown belly patch (vaguely reminiscent of summer-plumaged Dunlin);
3. Uniformly dark greater coverts, creating a solid dark wing panel.

A few second-cycle Yellow-legged Gulls from the Canary Islands and Madeira look very similar, but their greater coverts tend to show a coarsely barred pattern, especially on the inner feathers. The 'classic' 30% of second-cycle 'Azores Gulls' lack such a pattern, showing all-dark greater coverts with at most a bit of pale stippling instead.

It is likely that birds showing strong hood and isolated 'Dunlin patch' (features 1 and 2) can all be identified as Macaronesian, though more research into the plumage variation in *lusitanius* is needed to confirm this.

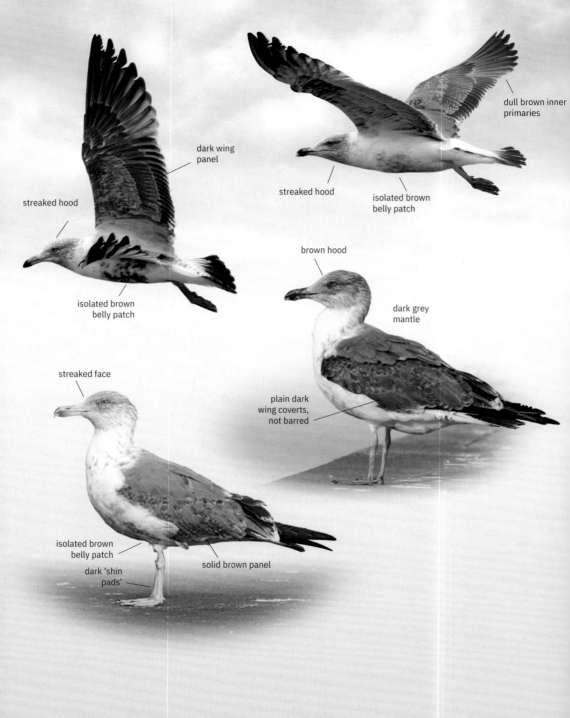

dull brown inner primaries

dark wing panel

streaked hood

streaked hood

isolated brown belly patch

brown hood

dark grey mantle

isolated brown belly patch

plain dark wing coverts, not barred

streaked face

isolated brown belly patch

dark 'shin pads'

solid brown panel

Second-cycle nominate *michahellis* show whiter head with dark streaking around the eye or all over the head and neck, and they have either clean white belly or mottled brown underparts throughout. Most show coarsely barred pattern on greater coverts and lack the dark horizontal bars on the front of the legs that 'Azores' often show (the so-called shin pads).

## SIMILAR TAXA

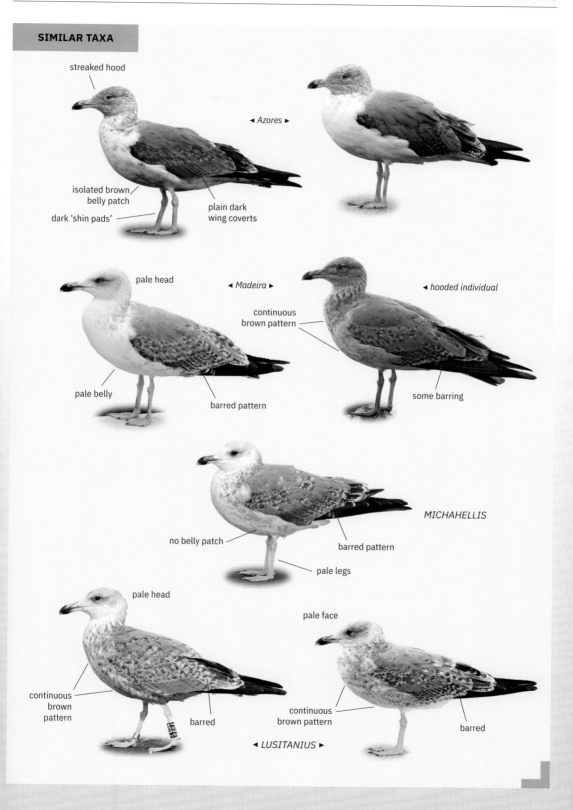

streaked hood

◄ *Azores* ►

isolated brown belly patch

dark 'shin pads'

plain dark wing coverts

pale head

◄ *Madeira* ►

◄ *hooded individual*

continuous brown pattern

pale belly

barred pattern

some barring

no belly patch

*MICHAHELLIS*

barred pattern

pale legs

pale head

pale face

continuous brown pattern

barred

continuous brown pattern

barred

◄ *LUSITANIUS* ►

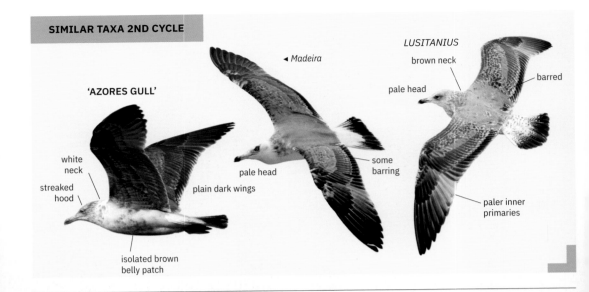

**SIMILAR TAXA 2ND CYCLE**

*LUSITANIUS*

brown neck

◄ *Madeira*

pale head

barred

'AZORES GULL'

white neck

streaked hood

pale head

plain dark wings

some barring

isolated brown belly patch

paler inner primaries

## Third cycle

On current knowledge, most 'Azores Gulls' of this age class cannot be identified safely. However, a small minority (about 5%–9%) of Yellow-legged Gulls from all of the Macaronesian islands appear sufficiently distinct from the mainland populations as they show an eye-catching combination of features, namely:

- Dark streaking on head, including forehead, lores, and chin, well demarcated from the white neck.
- Dark grey upperparts (slightly darker than nominate *michahellis*).

- Blackish bill.
- Dark 'shin pads'.

This combination of features is not unique to the Azores but is found throughout all of the Macaronesian Islands.

Third-cycle nominate *michahellis* can show blackish bill but has white head, with any dark streaking concentrated around the eye, and lacks dark 'shin pads'. Also, the black pattern on the outer hand is generally less extensive than in 'Azores Gulls' of same age.

▶ **RANGE**

We consider this taxon to be restricted to the Azores, and to be a subspecies of Yellow-legged Gull rather than a full species. It is mainly resident, but birds have been observed following vessels for more than 1,000 km, and there are accepted records of vagrants from Ireland, Great Britain, Spain, and even Iceland. Records of Yellow-legged Gull in North America may pertain to the Azorean subspecies, but this has not been proven yet. Yellow-legged Gulls in Portugal and Atlantic Spain belong to a different subspecies, *L. m. lusitanius,* characterised mainly by its relatively small measurements and its high-pitched display calls (similar to European Herring Gull). Birds from the Canary Islands, Madeira, and

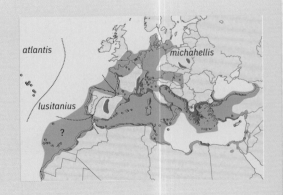

*atlantis*

*michahellis*

*lusitanius*

?

Morocco are difficult to assign to any subspecies and may be intergrades.

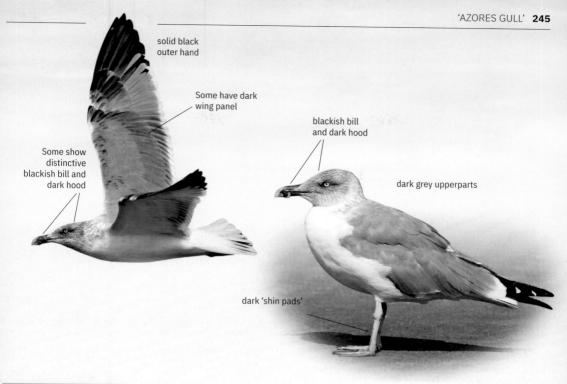

solid black outer hand

Some have dark wing panel

blackish bill and dark hood

dark grey upperparts

Some show distinctive blackish bill and dark hood

dark 'shin pads'

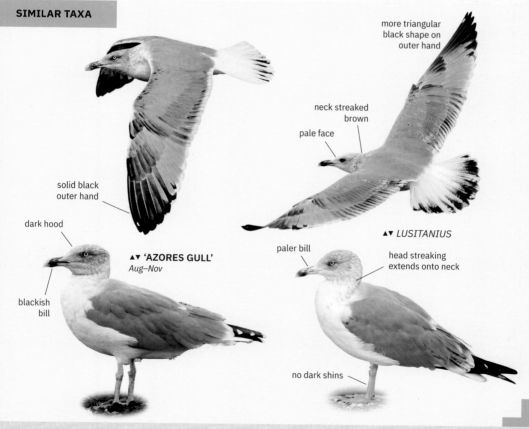

**SIMILAR TAXA**

more triangular black shape on outer hand

neck streaked brown

pale face

solid black outer hand

▲▼ *LUSITANIUS*

dark hood

▲▼ **'AZORES GULL'**
*Aug–Nov*

paler bill

head streaking extends onto neck

blackish bill

no dark shins

# Yellow-legged Gull
## *Larus michahellis*

▶ **STRUCTURE**
In size and structure, Yellow-legged Gull is close to those European Herring Gulls with angular head and strong bill, but slightly better proportioned with longer wings. Females are somewhat like Lesser Black-backed Gull, but in direct comparison Yellow-legged is stronger and heavier.

## Adult

As the name suggests, the legs are saturated yellow. Adults have medium grey upperparts, paler than slate grey *graellsii* Lesser Black-backed Gull, and obviously darker than silvery grey *argenteus* Herring Gull. Scandinavian Herring Gulls (*L. argentatus argentatus*) show similarly dark upperpart tone, but they lack the distinct bluish hue of Yellow-legged Gull.

Some Herring Gulls, in particular of the Baltic population, commonly share Yellow-legged Gull traits: yellow legs, red orbital ring and gape, red on the bill that 'bleeds' onto the upper mandible, and similar grey tone on the upperparts. Such birds are a known pitfall, and details of the wingtip pattern are important for identification. Yellow-legged Gull has much black in the wingtip: both P7 and P8 have shorter grey tongues on the inner webs and often more extensive black on the outer webs, creating a solid dark triangle on the stretched outer wing. In addition, the mirror on P10 is often separated from the white tip by a black band, and P5 has a broad black subterminal band. In Herring and Caspian Gulls, P7 and P8 show long grey tongues eating into the black outer hand, often creating a 'spiked' black pattern. In many Scandinavian Herring Gulls the white mirror on P10 merges completely with the white primary tip, and the black band on P5 is often reduced or absent. Note that Yellow-legged Gulls from the Eastern Mediterranean populations have slightly less black in the wingtip.

In winter, Yellow-legged Gull has limited fine and delicate streaking on the head, while Herring and Lesser Black-backed Gulls show more spotted, blurred markings, often running down onto the breast.

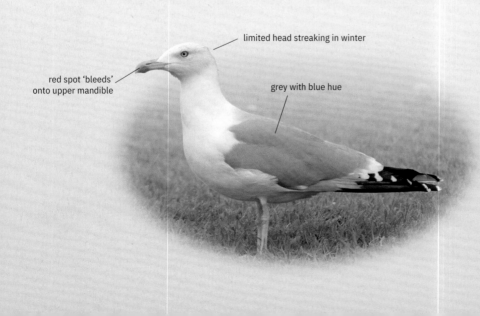

limited head streaking in winter

red spot 'bleeds' onto upper mandible

grey with blue hue

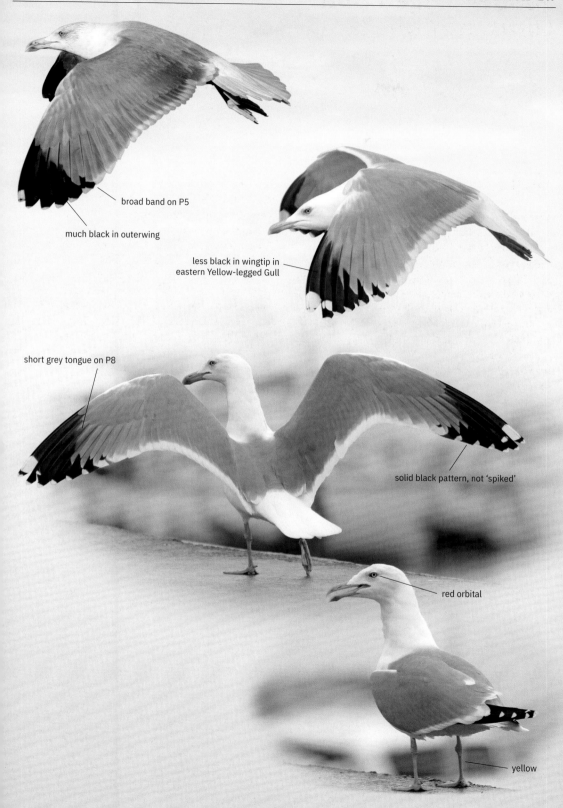

broad band on P5

much black in outerwing

less black in wingtip in
eastern Yellow-legged Gull

short grey tongue on P8

solid black pattern, not 'spiked'

red orbital

yellow

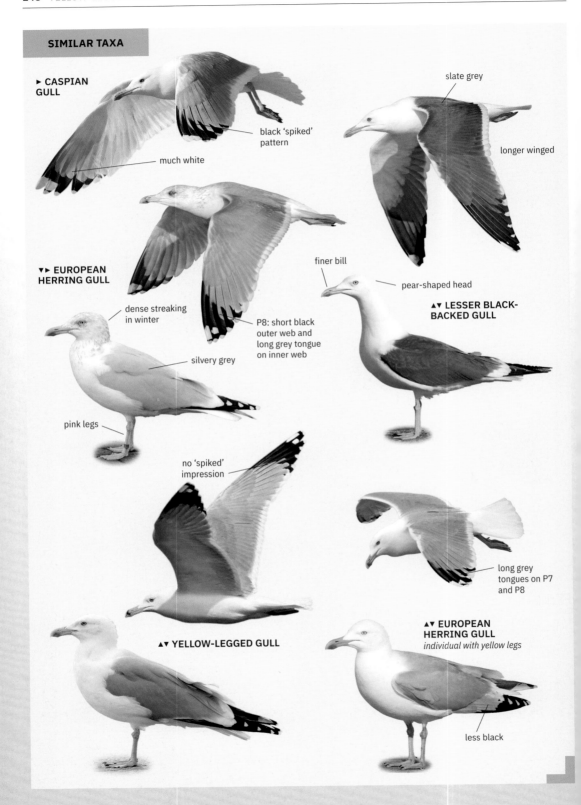

**SIMILAR TAXA**

► CASPIAN GULL

black 'spiked' pattern

much white

slate grey

longer winged

finer bill

pear-shaped head

▼► EUROPEAN HERRING GULL

▲▼ LESSER BLACK-BACKED GULL

dense streaking in winter

silvery grey

P8: short black outer web and long grey tongue on inner web

pink legs

no 'spiked' impression

▲▼ YELLOW-LEGGED GULL

long grey tongues on P7 and P8

▲▼ EUROPEAN HERRING GULL
*individual with yellow legs*

less black

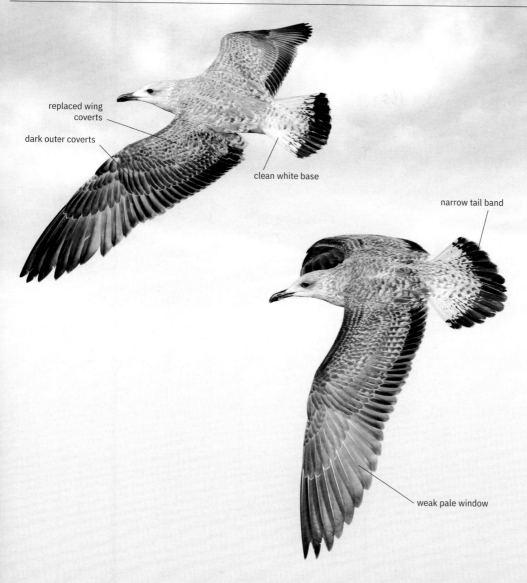

replaced wing coverts

dark outer coverts

clean white base

narrow tail band

weak pale window

# First cycle

Closely resembles other members of the 'Herring Gull group'. Yellow-legged Gull has a rufous brown plumage aspect, while Herring Gull is more greyish brown. Also, Herring Gull has an obvious pale window on the inner primaries and a notched pattern on coverts and tertials. Yellow-legged Gull shows a weak primary window and has dark tertials and dark outer greater coverts, reminiscent of Lesser Black-backed Gull.

Separating Yellow-legged Gull from Lesser Black-backed Gull can be problematic, but a combination of features should clinch the identification. Overall, Lesser Black-backed Gull has a darker, more chocolate brown aspect. Yellow-legged Gull has limited spotting on the tail base, leaving a contrasting clear-cut black band, which narrows on the outer tail feathers (i.e. the tail band is wedge-shaped). Furthermore, Lesser Black-backed Gull remains quite streaked on the head all winter, while Yellow-legged Gull becomes white-headed with pronounced eye-mask. Yellow-legged Gull, being stronger and larger than Lesser Black-backed Gull, also has stouter legs, which often appear salmon pink and lack dark shins.

New, post-juvenile scapulars often have a paler background colour than in Lesser Black-backed, and a more contrasting pattern.

Apart from the structural and plumage characteristics, moult timing is important as well. Yellow-legged Gull is an early moulting species; its post-juvenile moult starts in late summer (when Lesser Black-backed Gull still has fresh juvenile plumage), and it often replaces wing coverts and tertials in autumn. In Lesser Black-backed Gull, moult of wing coverts and tertials usually starts a few months later, in midwinter.

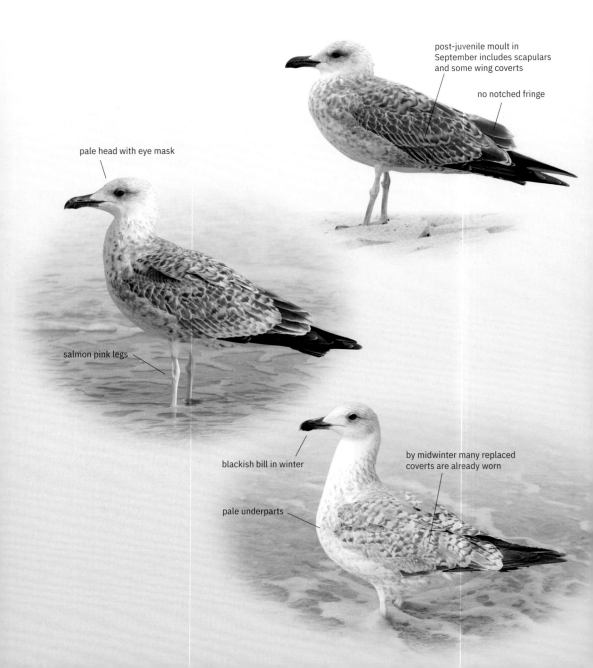

post-juvenile moult in September includes scapulars and some wing coverts

no notched fringe

pale head with eye mask

salmon pink legs

blackish bill in winter

by midwinter many replaced coverts are already worn

pale underparts

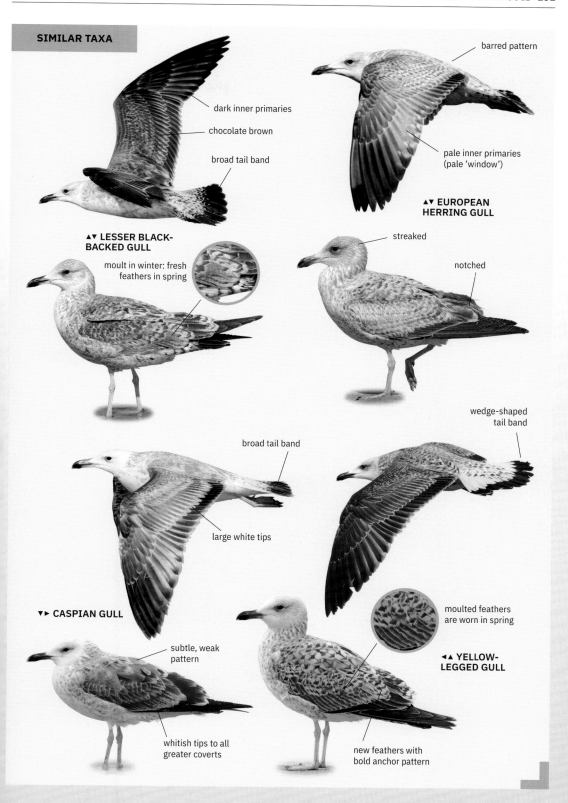

## SIMILAR TAXA

dark inner primaries

chocolate brown

broad tail band

barred pattern

pale inner primaries (pale 'window')

▲▼ EUROPEAN HERRING GULL

▲▼ LESSER BLACK-BACKED GULL

moult in winter: fresh feathers in spring

streaked

notched

wedge-shaped tail band

broad tail band

large white tips

moulted feathers are worn in spring

◄▲ YELLOW-LEGGED GULL

▼► CASPIAN GULL

subtle, weak pattern

whitish tips to all greater coverts

new feathers with bold anchor pattern

## Second cycle

Yellow-legged Gull quickly develops an 'advanced-looking' plumage, with most second-cycle birds showing a grey scapular area (referred to as 'grey saddle') already in autumn. Commonly, at least a few wing coverts and tertials are replaced in autumn too and appear adult-like grey. From midwinter on, the mature appearance is reinforced by the neat white underparts. The grey tone on the back is subtly different from Herring, Lesser Black-backed, and Caspian Gulls.

Herring Gulls with similar grey tone are Scandinavian, but these populations do not mature quickly. Advanced birds are more likely British Herring Gulls (*L. a. argenteus*), which have paler grey upperparts. Also, in Herring Gull the pattern on the greater coverts is often faded brown and vermiculated, unlike the contrasting, darker and bolder barred or spade pattern of Yellow-legged Gull. In addition, the latter often shows neat, rounded black spots ('spades') on the lesser coverts.

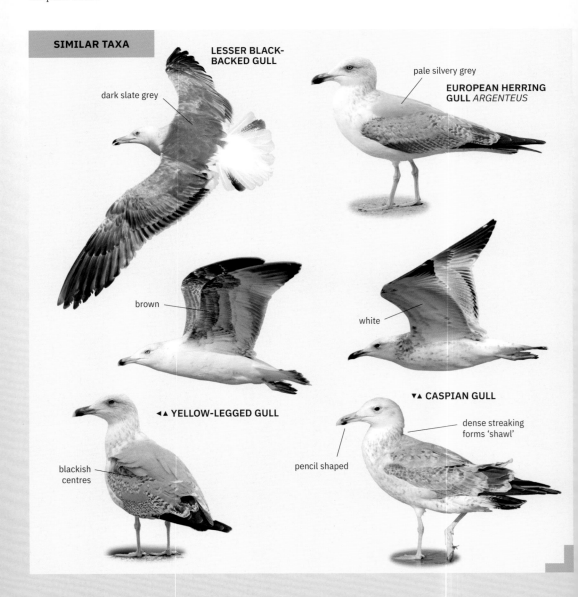

SIMILAR TAXA

LESSER BLACK-BACKED GULL

dark slate grey

pale silvery grey

EUROPEAN HERRING GULL *ARGENTEUS*

brown

white

◄▲ YELLOW-LEGGED GULL

▼▲ CASPIAN GULL

dense streaking forms 'shawl'

blackish centres

pencil shaped

fresh feathers reveal grey tone of adults

blackish brown centres

clean inner primaries

contrasting pattern in coverts

delicate, fine streaking in autumn

contrasting black and white

pink-yellow in autumn

◄ *breeding plumage by late winter*

# Third cycle

The upperparts and upperwings show the adult-like grey colour with a blue hue, the legs are yellowish (some may show dull pink-yellow legs in autumn), and the bill remains largely black in the first half of winter. Therefore, identification is often straightforward: third-cycle Yellow-legged Gulls resemble adults, while the biggest pitfall, Scandinavian Herring Gulls with similar grey tone on upperparts, often show a retarded immature plumage at this age.

Lesser Black-backed Gull is darker slate grey on the upperparts, but it shares the yellow legs. Also, like Yellow-legged Gull, it tends to show much black on the bill in autumn. However, third-cycle Lesser Black-backed Gulls usually show extensive brown head and neck streaking in autumn/winter.

The black pigmentation in the wing becomes an important feature at this age. Yellow-legged Gull has more or less 'solid dark' outer primaries. Same-aged Herring and Caspian Gulls often show long pale inner webs that create a 'spiked effect' on the outer wing.

Subadult Yellow-legged Gull has limited winter head streaking compared with Lesser Black-backed Gull or Herring Gull. Still, the streaking is more extensive than in adults, and many show a dark mask around the eye, giving them a grumpy demeanour.

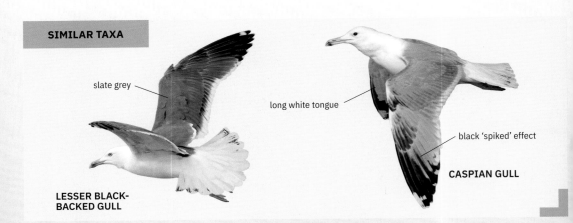

**SIMILAR TAXA**

slate grey

**LESSER BLACK-BACKED GULL**

long white tongue

black 'spiked' effect

**CASPIAN GULL**

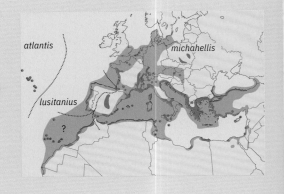

## ▶ RANGE

The nominate race *michahellis* breeds in Mediterranean and Black Sea basins on cliffs and rocky islands and in salinas, and small breeding colonies can also be found at inland lakes and along rivers in Europe. Yellow-legged Gull extended its range substantially in the 1980s and 1990s along the French Atlantic coast and into interior Europe, but the expansion was halted at the turn of the century.

In late summer it disperses from the Mediterranean into Northwest Europe and subsequently moves southwards again along the Atlantic coast in autumn. Vagrants have reached Iceland, Estonia, Latvia, Finland, Norway, and Saudi Arabia, as well as North America.

*atlantis*

*michahellis*

*lusitanius*

?

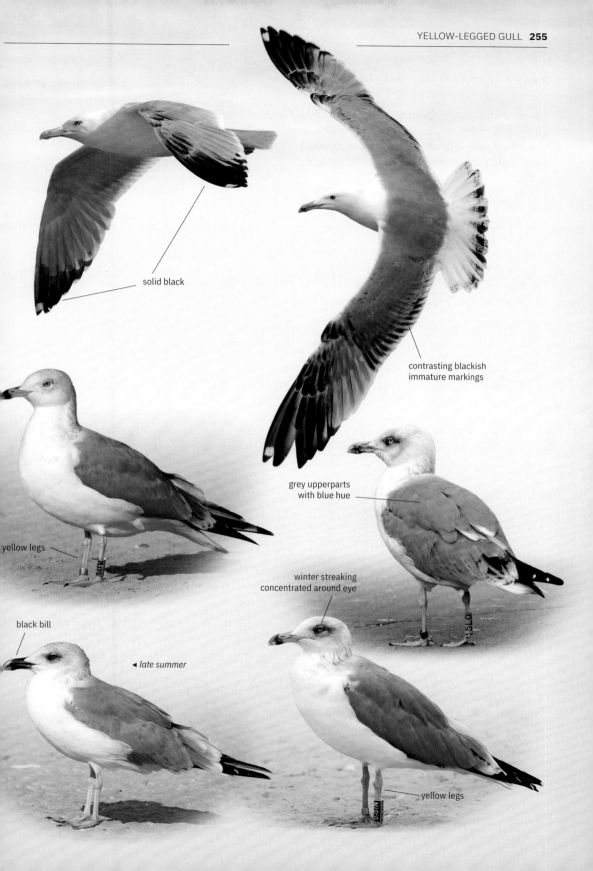

solid black

contrasting blackish
immature markings

grey upperparts
with blue hue

yellow legs

winter streaking
concentrated around eye

black bill

◄ *late summer*

yellow legs

# Armenian Gull
## *Larus armenicus*

▶ **STRUCTURE**
Averages slightly smaller than Yellow-legged and Caspian Gulls, with shorter, deep, stubby bill and more rounded head with steep forehead. These structural features are important for identification, since plumage of, especially, first-cycle birds is really variable. The distance between bill tip and the feathering at base of upper mandible is often shorter than the distance between this feathering and the eye. In addition, the culmen curves down steeply at the tip, creating a blunt end on the bill, which does not show much of a hooked tip.

*Note*: For differences from Steppe Gull, see the account on that taxon.

## Adult

In this plumage, most similar to Steppe Gull and Yellow-legged Gull. Differs from the latter in its slightly darker grey upperparts, wider, solid black bill band (at least in winter), and more extensive black pattern on outer primaries. The dark iris is another useful difference, although a few breeding birds show lemon yellow iris. The black bill band can be absent during the breeding season, but then the bill usually has a more orange colour than in Yellow-legged Gull. The primary pattern is characterised by completely black outer webs right up to the primary coverts on the outermost 3 primaries (P8–P10) in many birds, creating a large, rectangular black panel on the upperside of the outer hand. A completely black outer web of P8 is seen only rarely in adult Yellow-legged Gull (except for Azorean birds). Many Armenian Gulls show black on both webs of P4, which is again rare in adult Yellow-legged. The combination of both features (extensive black on P8 and on P4) is not seen in adult Yellow-legged Gulls, except in the Azores (where adult birds have staring pale iris). Subadult Yellow-legged Gulls can show more extensive black on the primaries and bill than adults, thus suggesting Armenian Gull, but normally show traces of immaturity, such as dark spots on alula or large dark spots on primary coverts. The bill may have a duller colour than in adult Armenian. Further differences are the different structure (see above) and slightly paler grey upperparts. The iris is usually pale at this age.

Adult Armenian Gull is rather easily told from Caspian Gull by its solid black panel on upperwing and the much shorter tongue on underside of P10. Note also the brighter bill colour and darker grey upperparts. At least in winter, the black bill band is wider and more solid than in most Caspian Gulls. Structure also differs, Caspian having on average longer legs, longer bill, and more sloping forehead.

For birders in Western Europe, who are most familiar with the nominate subspecies of Common Gull, the slightly larger size, darker grey upperparts, bright bill colour, white head, and extensive black on outer primaries of the Russian subspecies *heinei* may cause confusion. On occasion, distant birds have been mistaken for Armenian, despite their smaller size, clearly thinner bill and narrower wings. At closer range, the red gonys spot of Armenian should clinch the identification.

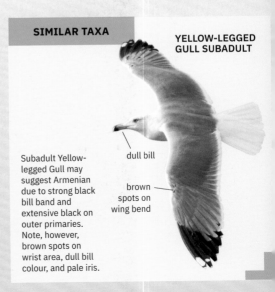

**SIMILAR TAXA**

**YELLOW-LEGGED GULL SUBADULT**

dull bill

brown spots on wing bend

Subadult Yellow-legged Gull may suggest Armenian due to strong black bill band and extensive black on outer primaries. Note, however, brown spots on wrist area, dull bill colour, and pale iris.

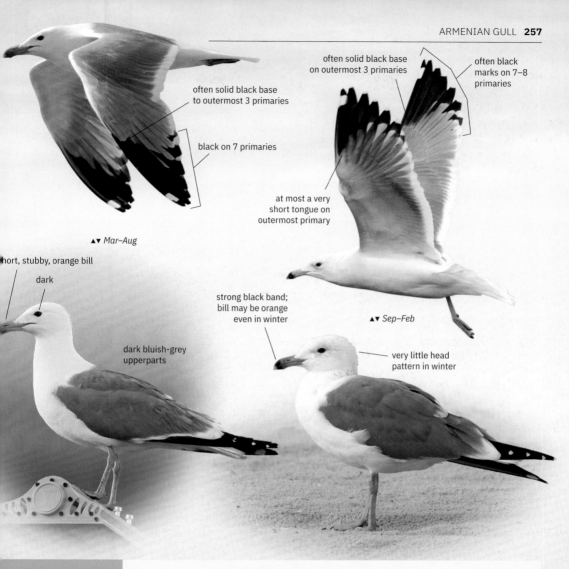

often solid black base
on outermost 3 primaries

often black
marks on 7–8
primaries

often solid black base
to outermost 3 primaries

black on 7 primaries

at most a very
short tongue on
outermost primary

▲▼ *Mar–Aug*

▲▼ *Sep–Feb*

short, stubby, orange bill

dark

strong black band;
bill may be orange
even in winter

very little head
pattern in winter

dark bluish-grey
upperparts

---

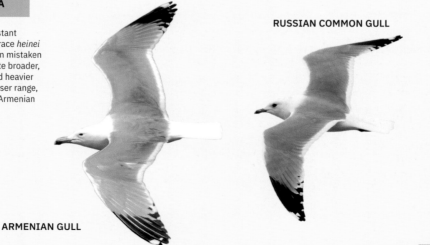

## SIMILAR TAXA

In the Middle East, distant
Common Gulls of the race *heinei*
have occasionally been mistaken
for Armenian Gull. Note broader,
less pointed wings and heavier
bill of the latter. At closer range,
the red gonys spot of Armenian
is a clear difference.

**RUSSIAN COMMON GULL**

**ARMENIAN GULL**

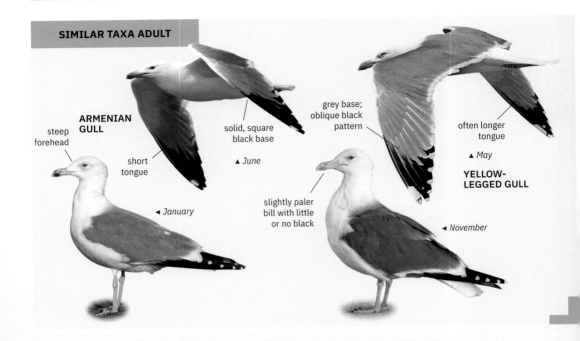

SIMILAR TAXA ADULT

**ARMENIAN GULL**

steep forehead

short tongue

solid, square black base

◄ *January*

▲ *June*

slightly paler bill with little or no black

grey base; oblique black pattern

often longer tongue

▲ *May*

**YELLOW-LEGGED GULL**

◄ *November*

# First cycle

During the first cycle, the plumage is variable, some birds retaining most of the juvenile feathers except the upper scapulars well into September, while others have undergone extensive moult in the scapulars and wing coverts by then. The plumage overlaps widely with that of Yellow-legged Gull, but there are some average differences that may be helpful in some cases:

- The greater coverts, including the outers, may show a lot of white, while they are largely brown in Yellow-legged, especially the outer feathers.
- Newly moulted, post-juvenile scapulars may occasionally show a slightly thinner anchor pattern than in typical Yellow-legged Gull.
- The flank pattern may at times be strongest at the rear, where it may consist of thick, V-shaped chevrons. In Yellow-legged, the pattern on the rear flank more often consists of thin, vertical

bars that are not more obvious than the other flank markings. The difference is subtle but could be used as a supporting feature in some cases.
- The underwing is largely pale, while in Yellow-legged it is most often brown, with pale median coverts only.
- The inner primaries tend to show dark brown outer webs and pale silvery inners, thus creating a two-tone impression that is more distinct than in Yellow-legged.

First-cycle Caspian Gull lacks dark mask around the eye and typically shows brown greater coverts with pale tips. The flank pattern is usually weaker, less coarse than in Armenian, and the tail shows a broader black band with often a few extra, thin black bands towards the base. During autumn, the bill often turns largely (dull) pinkish, while in Armenian it often remains blackish, sometimes with pale base on the lower mandible.

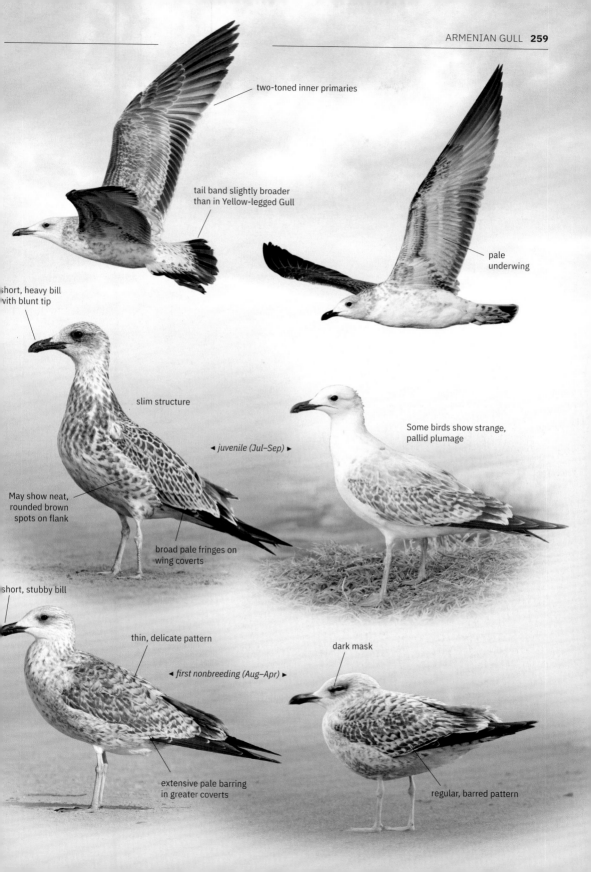

two-toned inner primaries

tail band slightly broader than in Yellow-legged Gull

pale underwing

short, heavy bill with blunt tip

slim structure

◄ *juvenile (Jul–Sep)* ►

Some birds show strange, pallid plumage

May show neat, rounded brown spots on flank

broad pale fringes on wing coverts

short, stubby bill

thin, delicate pattern

◄ *first nonbreeding (Aug–Apr)* ►

dark mask

extensive pale barring in greater coverts

regular, barred pattern

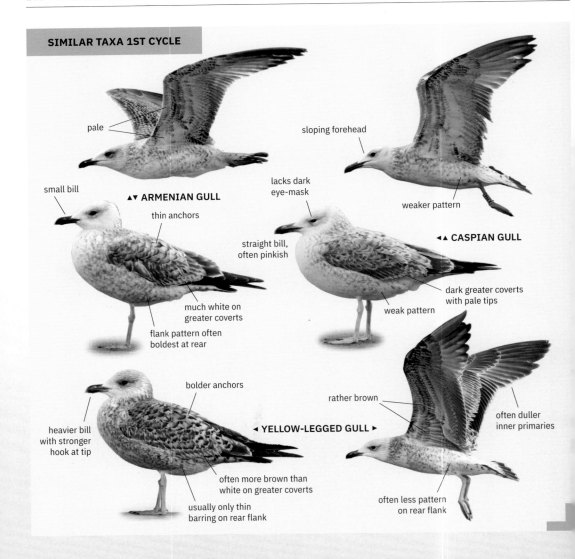

SIMILAR TAXA 1ST CYCLE

pale

sloping forehead

lacks dark
eye-mask

small bill

weaker pattern

**▲▼ ARMENIAN GULL**

thin anchors

**◄▲ CASPIAN GULL**

straight bill,
often pinkish

much white on
greater coverts

dark greater coverts
with pale tips

weak pattern

flank pattern often
boldest at rear

bolder anchors

rather brown

often duller
inner primaries

heavier bill
with stronger
hook at tip

**◄ YELLOW-LEGGED GULL ►**

often more brown than
white on greater coverts

often less pattern
on rear flank

usually only thin
barring on rear flank

## Second cycle

At this age, the grey upperparts are starting to develop. In addition, some birds differ from Yellow-legged Gull in showing broad, pale sandy or white colour on most of the wing coverts, including the outer greater coverts. This may create the impression of pallid wings contrasting against a dark grey 'saddle'. The underwing is typically pale, including the axillaries, which may show bold dark spots at the tips. The bill often looks bicoloured, and may have already turned yellowish at the base in winter.

By spring, it can show orange colour. Second-cycle Yellow-legged Gulls more often retain a dark bill throughout winter.

Second-cycle Caspian Gull typically shows browner greater coverts and paler grey upperparts than Armenian Gull. The bill usually has a dull colour. Many birds show a (small) white mirror on P10, which may be visible not only in flight but also on the underside of the folded wingtip in a standing bird. In flight, a short but distinct pale tongue is visible on the underside of P10, unlike in Armenian Gulls of this age category.

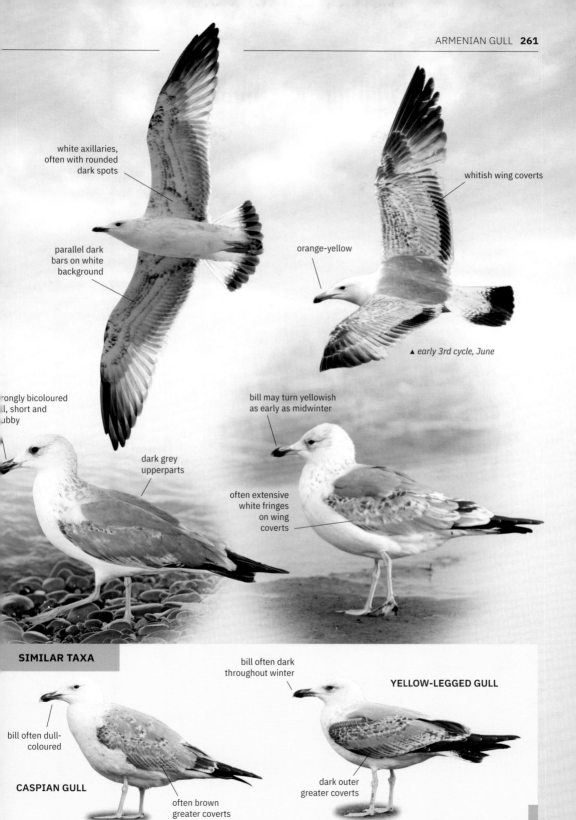

white axillaries, often with rounded dark spots

whitish wing coverts

parallel dark bars on white background

orange-yellow

▲ *early 3rd cycle, June*

rongly bicoloured ll, short and ubby

bill may turn yellowish as early as midwinter

dark grey upperparts

often extensive white fringes on wing coverts

**SIMILAR TAXA**

bill often dark throughout winter

**YELLOW-LEGGED GULL**

bill often dull-coloured

**CASPIAN GULL**

often brown greater coverts

dark outer greater coverts

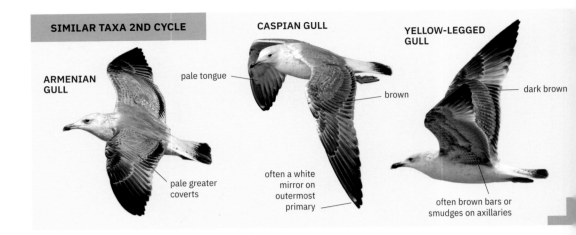

SIMILAR TAXA 2ND CYCLE

CASPIAN GULL

YELLOW-LEGGED GULL

ARMENIAN GULL

pale tongue

brown

dark brown

pale greater coverts

often a white mirror on outermost primary

often brown bars or smudges on axillaries

# Third cycle

At this age, the identification features are similar to those of adults. Differences from Yellow-legged Gull include a dark iris, darker grey upperparts, and more extensive black on outer primaries. If any brown colour remains on the upperwing coverts it is usually paler than in Yellow-legged. Bill colour is often already bright yellow or orange. In flight, the outer 4 primaries (P7–P10) often show black outer webs up to the primary coverts, forming a solid, rectangular black panel. A few Yellow-legged Gulls show similar extent of black, but even in such birds small grey wedges are often visible at the base of the black outer primaries, for example, on P8.

Third-cycle Caspian Gull shows paler grey upperparts, duller bill and legs, and different primary pattern: from below, the pale tongues on outer primaries are clearly longer than in Armenian, and from above, some grey is usually visible at the base of the outer 4–5 primaries. Some birds already show two white mirrors (on P9–P10), while third-cycle Armenian at most shows only one.

▶ **RANGE**

A high-altitude breeder of mountain lakes in Armenia, eastern Turkey, southern Georgia, and northwestern Iran. In May 2018, the first breeding colonies in Azerbaijan were found at Semkir reservoir. Winters mainly in Israel, but smaller numbers can be found along the southeastern shores of the Black Sea in winter, and in Turkey and northeastern Egypt, including northern Red Sea (Hurghada area). Scarce winter visitor to Cyprus, Bahrain, Iraq, Lebanon, and western and northeastern coasts of Saudi Arabia and Kuwait. Regular vagrant in Greece (outside of Cyprus). One accepted record of an adult bird in Denmark in May 2017 is the only official observation in Western Europe so far.

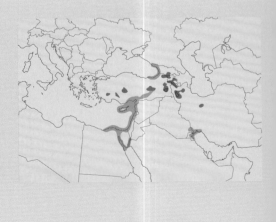

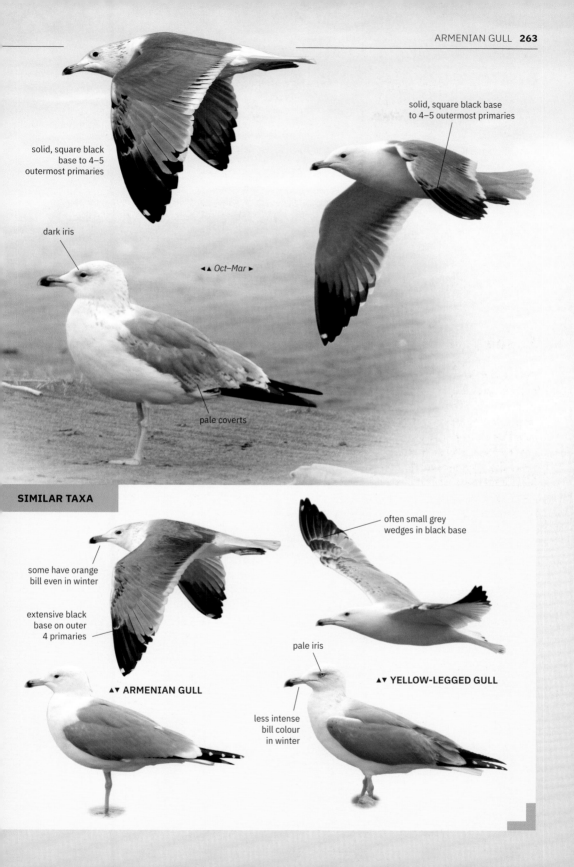

solid, square black base to 4–5 outermost primaries

solid, square black base to 4–5 outermost primaries

dark iris

◂▴ *Oct–Mar* ▸

pale coverts

**SIMILAR TAXA**

often small grey wedges in black base

some have orange bill even in winter

extensive black base on outer 4 primaries

▴▾ **ARMENIAN GULL**

pale iris

▴▾ **YELLOW-LEGGED GULL**

less intense bill colour in winter

# Slaty-backed Gull
## *Larus schistisagus*

### ▶ STRUCTURE

Slaty-backed Gull is a big and stocky gull matching larger individuals of European Herring Gull. Many birds have a peculiar shape due to their bulky body with a slight pot belly, short primary projection, and rather long neck. In many birds, the wings extend only slightly beyond the tail, although this is a variable feature and not always clear. The bill has a relatively slender base and expands around the gonys area, giving it a slightly bulbous look. A helpful feature that may attract attention in a flock of European gulls is a prominent 'secondary skirt': many Slaty-backed Gulls have such broad wings that, on a standing bird, the secondaries project below the greater coverts. Another important clue is the obvious bubblegum pink colour of the legs at all ages.

## Adult

Although adult birds bear a superficial resemblance to both Great and Lesser Black-backed Gulls, they are really quite distinct. Important differences from both these species are the bubblegum pink leg colour, broad white tertial and scapular crescents, and a white 'boa' across the upper mantle. In flight, the broad white trailing edge on the secondaries continues unabated on the inner primaries, where it may even result in pointed white 'spikes' on the feather shafts. In most birds, the white trailing edge also continues even further as large white tongue tips on the outer primaries, creating a subterminal 'string of pearls' there. Neither Great nor Lesser Black-backed Gull show such a string of pearls, and their white tips on the inner primaries are always narrow. The upperparts of adult Slaty-backed Gull range from dark slaty grey, like *graellsii* Lesser Black-backed, to blackish-grey, like *intermedius*. The underside of the outer primaries is mainly dark grey with black tips, and does not contrast much with the dark grey secondaries. Unlike the majority of Great Black-backed Gulls, there is quite a lot of head streaking in winter, and the neck is extensively marked with brown blotches. Adult Great Black-backed also tends to show larger white mirrors on outermost primaries, often lacking any subterminal black on P10.

Adult Vega Gull has paler, bluish-grey upperparts (like Common Gull or Kittiwake), and on underwing the black P10 contrasts against the paler, medium grey inner primaries and secondaries. Also, adult Vega often has a dark iris, as well as a straighter, more slender bill, which may show a greenish tinge in winter.

One important but fortunately rare pitfall is formed by hybrids between Great Black-backed Gull and American or European Herring Gull. However, such hybrids can always be told from adult Slaty-backed by their thinner white trailing edge on the wings, especially on the inner primaries.

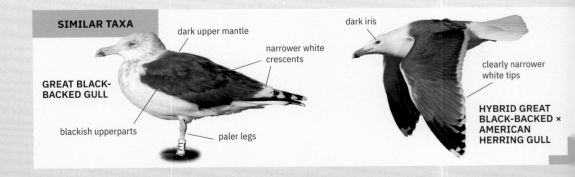

SIMILAR TAXA

GREAT BLACK-BACKED GULL

dark upper mantle

narrower white crescents

blackish upperparts

paler legs

dark iris

clearly narrower white tips

HYBRID GREAT BLACK-BACKED × AMERICAN HERRING GULL

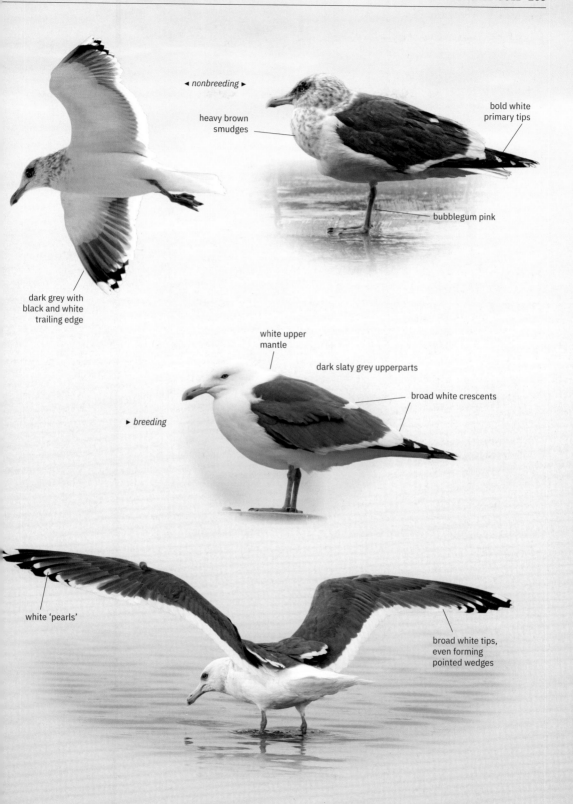

◀ *nonbreeding* ▶

heavy brown smudges

bold white primary tips

bubblegum pink

dark grey with black and white trailing edge

white upper mantle

dark slaty grey upperparts

broad white crescents

▶ *breeding*

white 'pearls'

broad white tips, even forming pointed wedges

# First cycle
____

In this plumage, identification of Slaty-backed Gull is challenging because they can be really variable, ranging from nearly as pale as Glaucous Gull to as dark as Lesser Black-backed Gull. However, typical birds differ from all European gull species in their plain plumage that is less coarsely marked and gives a washed-out, mud brown impression. The visible secondary skirt and the deep pink colour of the legs further help to create a different look.

On a standing bird, the following key characters should be checked:

- The greater coverts lack distinct pattern and range from rather uniformly brown to plain whitish. They are generally paler and less marked than the other wing coverts.
- The primaries are brown rather than black, and show a thin but distinct whitish fringe around their tips.
- The tertials show a simple, plain brown centre with neat whitish fringe.
- Moulted (post-juvenile) scapulars often look rather grey and show only a simple pattern (such as just a dark shaft streak).
- Underparts look uniformly brown and tend to lack streaking.
- Some birds show rather strong brown mask around the eye.

In flight, important points are the uniformly brown underwing coverts and axillaries, lacking any barred pattern, and the extensively dark tail. The primaries are also a key feature. These feathers are brown rather than blackish, and the outer ones show pale inner webs, which from below create the impression of a pale, sometimes even translucent outer hand with dark tips. The inner primaries are mud brown and, unlike European Herring Gull, do not contrast much with the outer ones. Unlike Lesser Black-backed Gull, they show isolated dark subterminal spots. In quite a few birds, the inner primaries become obviously whitish towards their tips, creating a distinctive piebald pattern. A few European Herring Gulls, especially of subspecies *argentatus*, and 'Viking Gulls' (hybrid Glaucous × European Herring Gull) may show pale brown wingtips but still differ in most of the above feature as well as paler bill base than most Slaty-backed of same age.

Vega Gulls of this age category show blackish wingtips, barred greater coverts, and a more evenly straight bill. In flight, they show a strong contrast between pale inner primaries and blackish outers, while the tail base often shows a distinctly barred pattern. The axillaries (and underwing coverts) too may show fine barring.

First-cycle American Herring Gulls share the dark tail of Slaty-backed, but they show denser barring on the tail coverts, making the rump area look browner. Their greater coverts are at least as dark as the rest of the wing coverts and often show a speckled or densely barred pattern. In flight, they show generally more contrast between pale inner primaries and dark outers. Note also their slimmer structure, lack of secondary skirt, somewhat straighter bill, and duller leg colour.

First-cycle Glaucous-winged Gull shows paler wingtips (not darker than the tertials), densely speckled greater coverts that do not look paler than the rest of the wing coverts, and darker, brownish-pink legs. The face often looks uniformly brown-grey, lacking distinct streaking or dark eye patch. The rump area looks mainly brown due to dense spotting (often more whitish in Slaty-backed), and the underside of the outer primaries is very pale. New scapulars look plain medium grey, whereas they are patterned or dark slaty grey in Slaty-backed

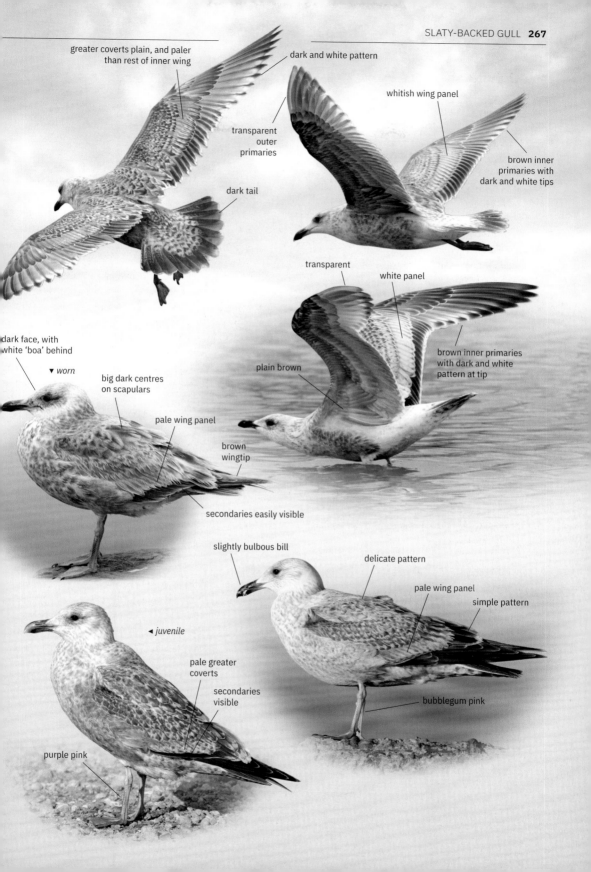

greater coverts plain, and paler than rest of inner wing

dark and white pattern

whitish wing panel

transparent outer primaries

brown inner primaries with dark and white tips

dark tail

transparent

white panel

brown inner primaries with dark and white pattern at tip

dark face, with white 'boa' behind

plain brown

▼ *worn*

big dark centres on scapulars

pale wing panel

brown wingtip

secondaries easily visible

slightly bulbous bill

delicate pattern

pale wing panel

simple pattern

◄ *juvenile*

pale greater coverts

secondaries visible

purple pink

bubblegum pink

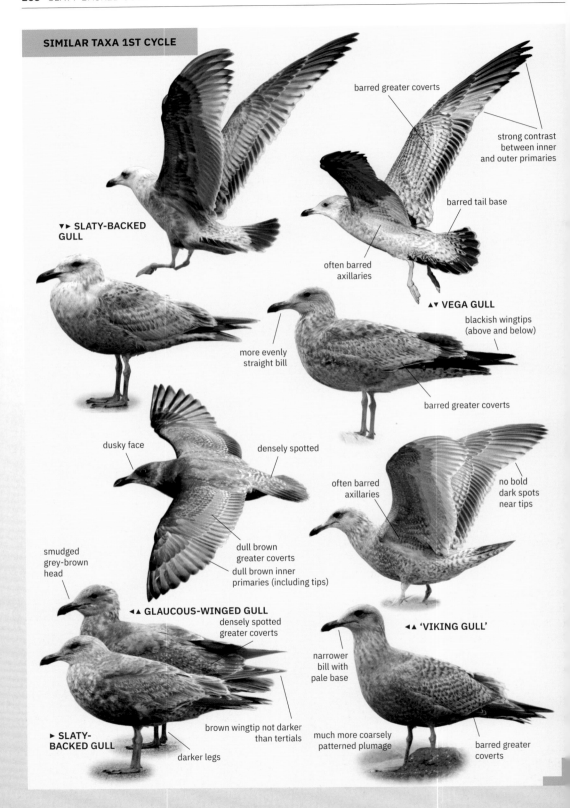

**SIMILAR TAXA 1ST CYCLE**

▼► **SLATY-BACKED GULL**

barred greater coverts

strong contrast between inner and outer primaries

barred tail base

often barred axillaries

▲▼ **VEGA GULL**

blackish wingtips (above and below)

more evenly straight bill

barred greater coverts

dusky face

densely spotted

often barred axillaries

no bold dark spots near tips

smudged grey-brown head

dull brown greater coverts

dull brown inner primaries (including tips)

◄▲ **GLAUCOUS-WINGED GULL**

densely spotted greater coverts

◄▲ **'VIKING GULL'**

narrower bill with pale base

► **SLATY-BACKED GULL**

brown wingtip not darker than tertials

much more coarsely patterned plumage

barred greater coverts

darker legs

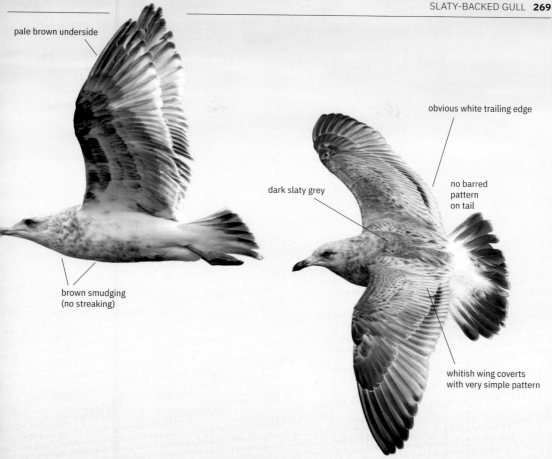

pale brown underside

brown smudging
(no streaking)

dark slaty grey

obvious white trailing edge

no barred
pattern
on tail

whitish wing coverts
with very simple pattern

# Second cycle

At this age, identification is supported by the incoming slate grey colour on the upperparts. The iris often becomes pale and may then contrast clearly against the brown mask around the eye. By late winter, the very simple pattern of the wing coverts often bleaches to uniform whitish, creating a strong contrast against the dark grey mantle.

In flight, typical birds show broad white tips on the secondaries, and a two-tone pattern on outer primaries due to pale inner and brown outer webs.

Some northern European Herring Gulls can look very dark grey on upperparts, with brown wingtips and bright pink legs, creating a real pitfall. The following details are helpful:

- Such Herring Gulls often show well-defined, dark streaks across the head, whereas second-cycle Slaty-backed typically show brown, washed-out blotches or smudges.
- They show narrower white trailing edge on the secondaries.
- They often show a barred pattern on axillaries (more uniform in Slaty-backed).
- Their greater coverts often show a spotted or barred pattern; if, however, these feathers are uniformly brown, they look as dark as the tertials (versus paler in Slaty-backed).
- They often show coarse dark spots or bars at base of tail feathers, whereas second-cycle Slaty-backed has largely dark tail.

Second-cycle Vega Gull shows blackish wingtips, paler, bluish-grey scapulars, a more evenly straight bill, and often a certain degree of coarse speckling or wavy barring on the wing coverts.

Second-cycle American Herring Gull differs in much the same way as Vega Gull, but any incoming adult-like scapulars are even paler silvery grey.

Lesser Black-backed Gulls show similar colour of fresh upperpart feathers but can easily be told by their black wingtips that clearly extend beyond the tail, dull pink to yellowish-pink leg colour, and coarsely patterned white underparts. In addition, some wing coverts often show coarsely speckled or spotted pattern.

In second-cycle Glaucous-winged Gull, the plumage is very uniform, with paler outer primaries than in Slaty-backed Gull and paler grey adult-like scapulars. The greater coverts are not paler than the tertials. The iris is dark. In flight, the rump area looks very brown, and a white trailing edge on the secondaries is lacking.

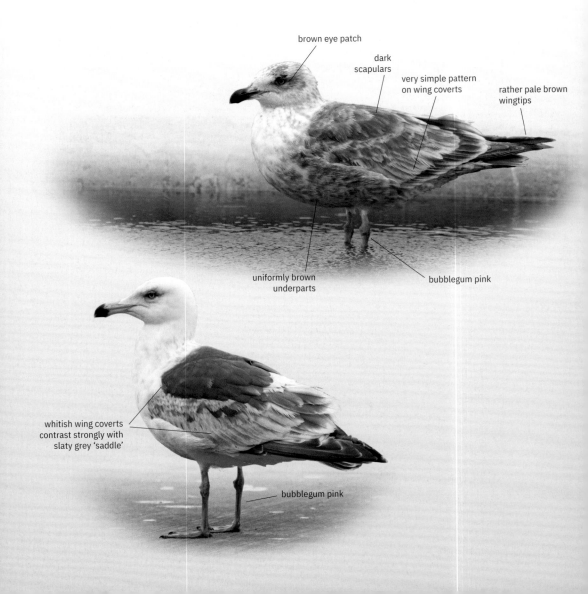

brown eye patch

dark scapulars

very simple pattern on wing coverts

rather pale brown wingtips

uniformly brown underparts

bubblegum pink

whitish wing coverts contrast strongly with slaty grey 'saddle'

bubblegum pink

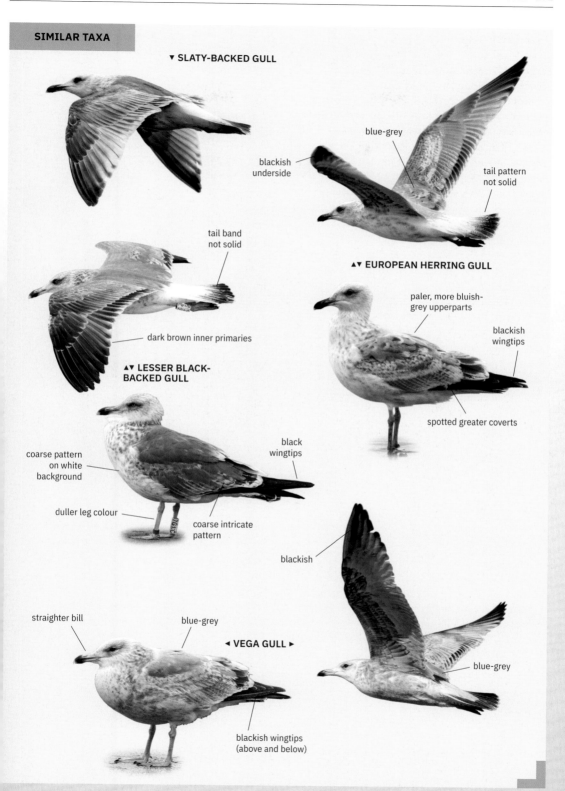

▼ SLATY-BACKED GULL

blue-grey

blackish
underside

tail pattern
not solid

tail band
not solid

▲▼ EUROPEAN HERRING GULL

paler, more bluish-
grey upperparts

blackish
wingtips

dark brown inner primaries

▲▼ LESSER BLACK-
BACKED GULL

spotted greater coverts

black
wingtips

coarse pattern
on white
background

duller leg colour

coarse intricate
pattern

blackish

straighter bill

blue-grey

◄ VEGA GULL ►

blue-grey

blackish wingtips
(above and below)

# Third cycle

Slaty-backed Gulls of this age class generally resemble adults and are often distinctive. The string of pearls on outer primaries may be less obvious, but all other characters (such as the broad white tips on secondaries and inner primaries) are already present. Also relevant are the extensive brown blotches on underparts and extensive solid black colour on tail, which help distinguish third-cycle Slaty-backed from European gulls. Note also the bubblegum pink legs, as well as the white boa across the upper mantle.

In addition to the above characters, third-cycle Great Black-backed Gull differs in its blackish upperparts, often dark iris, and sometimes larger white mirrors on outermost primaries.

Third-cycle Lesser Black-backed Gull has solid black outer primaries, lacking the contrast between dark outer and paler inner webs of Slaty-backed Gull. The underside of the outermost primaries is also black, clearly darker than the grey inner primaries and secondaries. Structurally, Lesser Black-backed Gulls are very different, lacking the 'inflated body' impression.

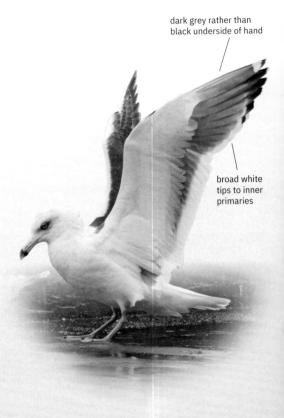

dark grey rather than black underside of hand

broad white tips to inner primaries

**▶ RANGE**

A breeding bird of the Russian Far East, from Cape Navarin (Chukotka) south to the northern tip of North Korea, including the Commander Islands, Russia and Hokkaido, Japan. Its winter distribution extends south to encompass Korea, the extreme northeast of China, much of Japan, and Taiwan.

There has been a remarkable increase in the number of records of vagrant birds across North America since the 1990s. The first for the Western Palearctic was found in Lithuania in 2008, but since 2011 records have been nearly annual, with birds observed in England, Iceland, Finland, Belarus, Ireland (2), Poland, and Sweden. All records involve adult or subadult birds, with the exception of the Swedish record, which was a first cycle.

Identification in the Pacific region is hampered by a certain degree of interbreeding with Glaucous-winged and with Vega Gull. In addition, hybridisation between certain species on the American west coast, like Glaucous-winged × American Herring Gull, may result in birds that resemble Slaty-backed, at least in first-cycle plumages. Although none of these hybrids have been recorded in the Western Palearctic so far, any candidate Slaty-backed Gull that shows more than one anomalous feature should be looked at very critically.

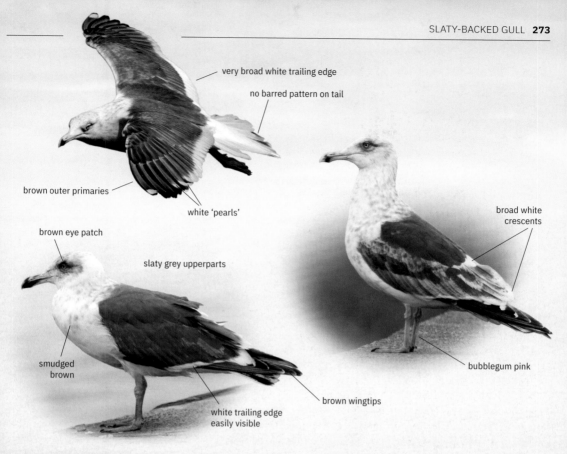

very broad white trailing edge

no barred pattern on tail

brown outer primaries

white 'pearls'

broad white crescents

brown eye patch

slaty grey upperparts

smudged brown

bubblegum pink

brown wingtips

white trailing edge easily visible

## SIMILAR TAXA

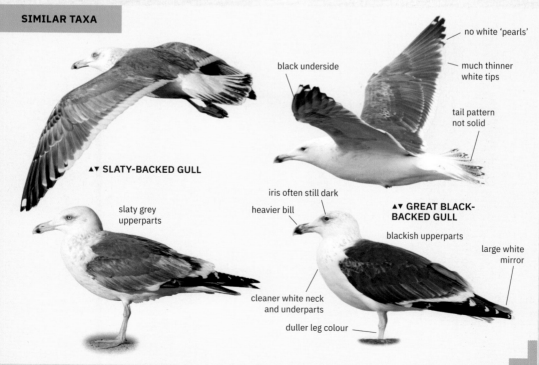

no white 'pearls'

black underside

much thinner white tips

tail pattern not solid

▲▼ SLATY-BACKED GULL

slaty grey upperparts

iris often still dark

heavier bill

▲▼ GREAT BLACK-BACKED GULL

blackish upperparts

large white mirror

cleaner white neck and underparts

duller leg colour

# Lesser Black-backed Gull
## Larus fuscus graellsii and L. f. intermedius

▶ **STRUCTURE**
An elegant large gull with lighter posture than closely related Yellow-legged or Herring Gull. Has slimmer body with longer rear end. At rest, may look surprisingly short-legged, creating a 'pot-bellied' look, especially in subspecies

*intermedius*. Great Black-backed Gull is much heavier and more powerful, with shorter primary projection. Lesser Black-backed Gull has a rather pear-shaped head, while Yellow-legged Gull (and, to a lesser extent, Herring Gull too) has more angular head shape. The bill is

slightly thinner; Herring and Yellow-legged Gulls have a more powerful, sometimes stubby bill.

## Adult

The upperparts are slate grey (in the subspecies *graellsii*) and blackish-grey (in *intermedius*), the latter matching Great Black-backed Gull in colour. The legs are saturated yellow, as in Yellow-legged Gull (which has paler bluish-grey upperparts).

Lesser Black-backed Gull has limited white in the wingtip, obviously less than Great Black-backed or European Herring Gull. The mirror on P9 is small or absent. Black markings on P4 and even P3 are not uncommon. In flight, the underwing shows an extensive dark grey trailing edge (unlike Herring Gulls).

Compared with Yellow-legged Gull, Lesser Black-backed Gulls (especially *graellsii*) have more extensive head and neck markings in winter.

There is much overlap with Baltic Gull (*Larus fuscus fuscus*). Any white-headed bird in winter with blackish upperparts and late or arrested primary moult is likely to be *intermedius* or *fuscus*, but racial identification is seriously hampered by extensive individual variation in moult timing and upperpart coloration in *intermedius* (see Baltic Gull, p.282).

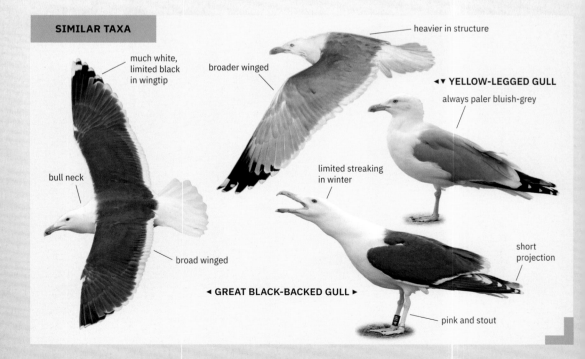

**SIMILAR TAXA**

much white, limited black in wingtip

broader winged

heavier in structure

◀▼ **YELLOW-LEGGED GULL**

always paler bluish-grey

bull neck

limited streaking in winter

broad winged

short projection

◀ **GREAT BLACK-BACKED GULL** ▶

pink and stout

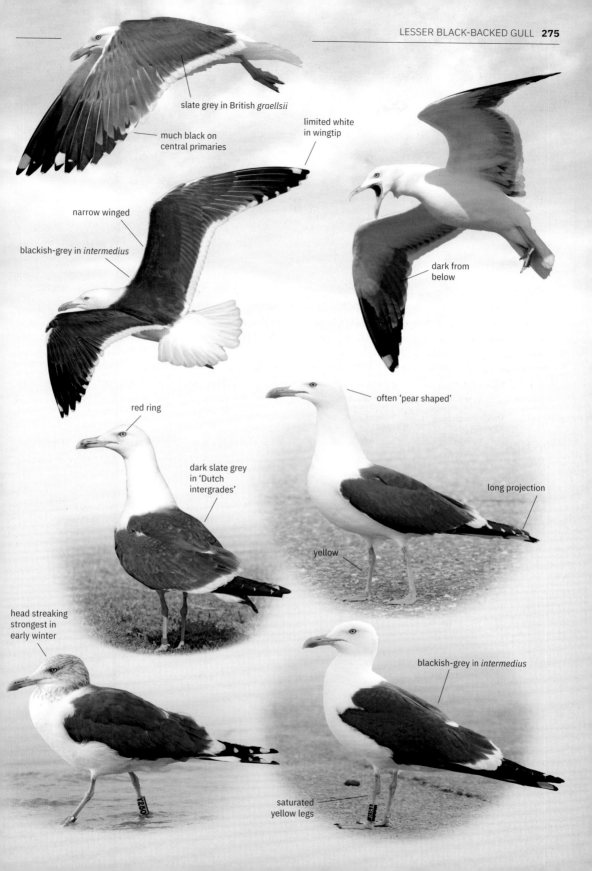

slate grey in British *graellsii*

much black on central primaries

limited white in wingtip

narrow winged

blackish-grey in *intermedius*

dark from below

red ring

often 'pear shaped'

dark slate grey in 'Dutch intergrades'

long projection

yellow

head streaking strongest in early winter

blackish-grey in *intermedius*

saturated yellow legs

# First cycle

First-cycle birds show an overall dark chocolate brown aspect, darker than the grey-brown aspect in Herring Gull and different from the warmer reddish-brown first-cycle Yellow-legged Gull. In flight, the most prominent feature is the dark wing with dark inner primaries, which are only slightly duller brown on the inner webs, hardly showing any contrast to the dark outer primaries and dark secondaries. Same-age Herring Gulls have obviously pale inner primaries, creating a so-called 'window'. Yellow-legged Gulls have more contrasting pattern on inner primaries.

At rest, the juvenile primaries stand out as blackish in Lesser Black-backed Gull, darker than in same-age Herring Gull (which often has pale fringe around the tips when feathers are fresh).

The juvenile tail shows a broad blackish band contrasting with the white base. Although there is some overlap, Yellow-legged Gull usually has narrower tail band and cleaner white tail base.

The tertials are dark with only narrow pale fringes in Lesser Black-backed, unlike the deeply notched feathers in Herring and Great Black-backed Gulls. The pattern of the tertials is repeated on the dark brown coverts: broad dark centres and narrow fringes, especially on the outer coverts.

In winter, most birds remain fairly streaked on the underparts and head. Some show whitish, nearly unmarked head towards the end of the first cycle, unlike most Herring Gulls of this age.

The thin short legs have extensive dark shins, unlike the stouter, salmon pink legs of Yellow-legged Gull. Unlike the other large gull species, an extensive post-juvenile moult in late winter is rather common in the Lesser Black-backed group. Especially *intermedius* may replace all coverts, the tail feathers (told from juvenile feathers by the prominent white tips), and even secondaries (fresh feathers show broad white tips). In spring, such birds may resemble first-cycle Heuglin's Gull (see p.290).

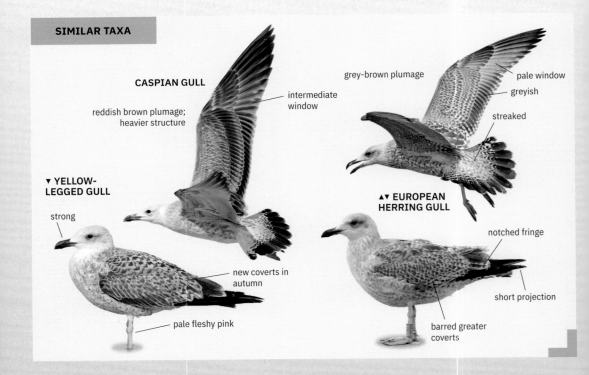

SIMILAR TAXA

CASPIAN GULL

reddish brown plumage; heavier structure

intermediate window

grey-brown plumage

pale window

greyish

streaked

▼ YELLOW-LEGGED GULL

strong

▲▼ EUROPEAN HERRING GULL

notched fringe

new coverts in autumn

short projection

pale fleshy pink

barred greater coverts

spotted base

broad blackish band

blackish-brown

dark

new

new

◄ intermedius *type in spring*

old

new

new

◄ *advanced* intermedius *type in spring with most flight feathers replaced in winter*

narrow fringe

long projection

ark outer greater coverts

◄ *advanced* intermedius *type after winter moult*

new

new tail

dark patch

contrasting chocolate juvenile plumage

dark centres

long projection

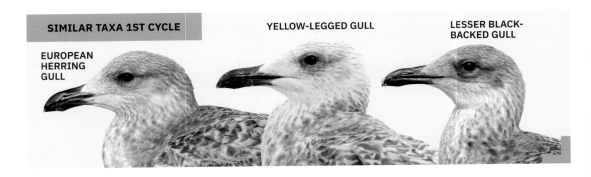

SIMILAR TAXA 1ST CYCLE

EUROPEAN HERRING GULL

YELLOW-LEGGED GULL

LESSER BLACK-BACKED GULL

## Second cycle

Second-cycle birds are variable. Classic second-cycle *graellsii* in winter have at least a few grey feathers on upperparts indicating the grey tone of the adult plumage, making separation from Herring and Yellow-legged Gulls much easier.

The primaries are dark blackish-brown, with rounded tips and no white mirror on P10 (which is commonly present in, e.g., Great Black-backed and Caspian Gulls of this age). The inner primaries are dark brown, without 'arrowheads' at the tips (as shown by most Herring Gulls); some birds may have paler brown inner webs.

Many second-cycle birds replace a few tail feathers in winter and then show a mixed pattern with alternating black and white feathers, unlike Herring and Yellow-legged Gulls. In spring, second-cycle Lesser Black-backed Gull can be identified by the slate grey upperparts, yellow legs, and tri-coloured bill.

Again, a late winter moult is common. The most advanced birds (often *intermedius*) show a completely white tail and a mix of new and old flight feathers. Such a moult scheme is unlikely in the Herring Gull group, but very common in *fuscus* and *heuglini* (see those taxa for identification criteria).

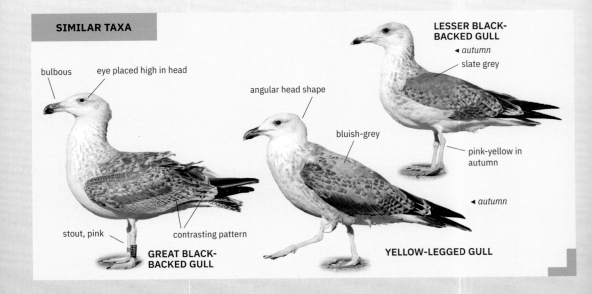

SIMILAR TAXA

LESSER BLACK-BACKED GULL

◄ *autumn*

slate grey

bulbous

eye placed high in head

angular head shape

bluish-grey

pink-yellow in autumn

◄ *autumn*

stout, pink

contrasting pattern

GREAT BLACK-BACKED GULL

YELLOW-LEGGED GULL

variable head
streaking in winter

grey saddle reveals
adult grey tone

commonly tail band broken
by some white feathers

tricoloured bill

dark inner
primaries

moult division: new
inner primaries and
old outer primaries

◄ *advanced 2nd cycle in spring*

white tail

tricoloured

grey saddle contrasts
with brown coverts

◄ *classic bird in spring*

◄ *advanced bird in spring, with most
primaries replaced and now adult-like*

slate grey

new primaries
with white tips

yellow

# Third cycle

Identification is often straightforward: third-cycle birds resemble adults, except for some traces of immaturity. The upperparts and upperwings show adult-like colour and the legs are yellowish (some may show dull pink-yellow legs in autumn and much black on the bill in the first half of winter). The winter head and neck markings are often more extensive than in Yellow-legged and Great Black-backed Gulls of similar age.

Traces of immaturity can be found in the tail (black spots), underwing coverts (dark marks) and primary coverts (extensive dark brown centres). However, clear-cut blackish centres on the primary coverts are commonly also shown by old adult birds in this species.

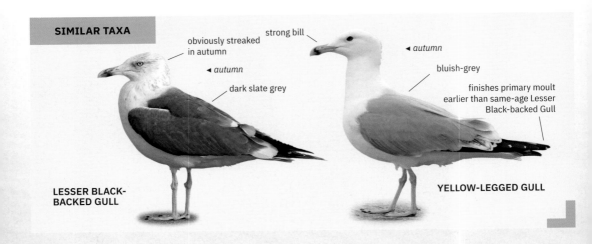

**SIMILAR TAXA**

obviously streaked in autumn

strong bill

◂ *autumn*

◂ *autumn*

dark slate grey

bluish-grey

finishes primary moult earlier than same-age Lesser Black-backed Gull

**LESSER BLACK-BACKED GULL**

**YELLOW-LEGGED GULL**

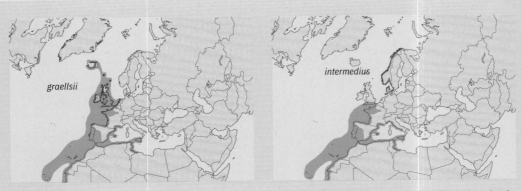

*graellsii*

*intermedius*

## ▶ RANGE

Long-distance migrant, breeding in Western Europe (ssp. *graellsii*) and Northern Europe (ssp. *intermedius*). There is a zone of intergradation between the two subspecies in the Low Countries and North Germany, and these populations are sometimes referred to as 'Dutch intergrades'. It has expanded its range southwards along the Atlantic coast to the Iberian Peninsula. The main migration route follows the Atlantic coast into Iberia and West Africa, but substantial numbers spend mild winters in Northwest Europe, especially in Britain and western France.

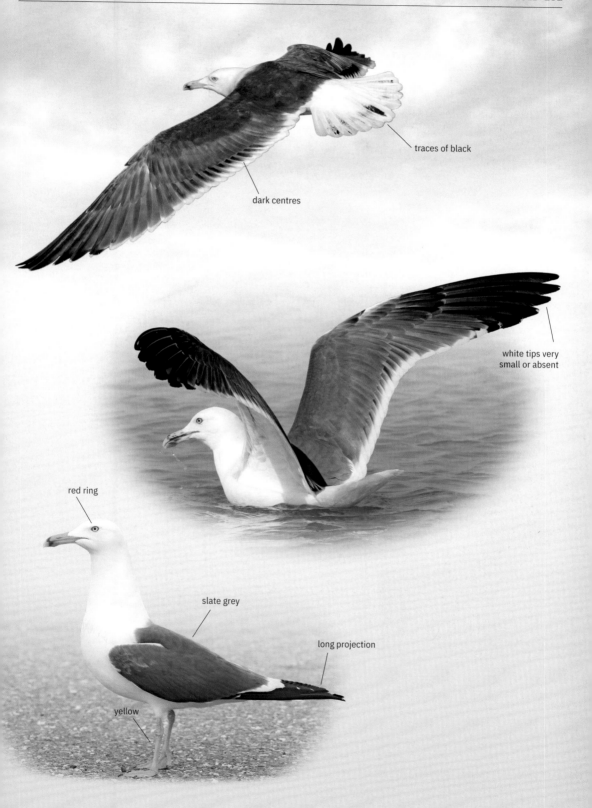

traces of black

dark centres

white tips very
small or absent

red ring

slate grey

long projection

yellow

# Baltic Gull
## *Larus fuscus fuscus*

▶ **STRUCTURE**
This large gull is closely related to Heuglin's Gull and western Lesser Black-backed Gull, especially *intermedius*. *Fuscus* is structurally at the extreme end among large gulls: it is the smallest, with proportionately long wings and a thin bill. Classic Baltic Gulls have short legs and narrow long wings that extend far beyond the tail. They also have a slender body, while *intermedius* often appears more pot-bellied.

## Adult

Baltic Gull has blackish upperparts matching the black primaries—a feature shared with Great Black-backed Gull, but that species is much larger, bulkier, and stronger, and has pink legs. The legs are yellow in Baltic Gull. A minority of *intermedius* Lesser Black-backed Gull have blackish upperparts as well.

*Fuscus* has a late moult; the complete moult is postponed during migration and takes place on the wintering grounds. Throughout winter, it remains rather white-headed. In adults, the wingtip shows extensive black; the mirror on P9 is tiny or absent, and the mirror on P10 is small and separated from the white tip by a broad black subterminal band.

Ring readings have indicated that *intermedius* can be as dark as *fuscus* and can also have a late moult (outer primaries still growing in January, as in *fuscus*). Therefore, positive identification of extralimital adult Baltic Gull is possible only in ringed birds. Still, an adult bird that combines black upperparts with restricted primary moult in September–October (at most P1–P2 replaced and moult suspended for migration) is more likely a *fuscus*.

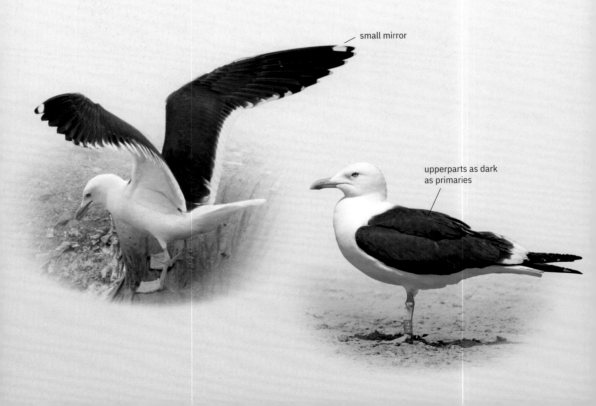

small mirror

upperparts as dark as primaries

## SIMILAR TAXA

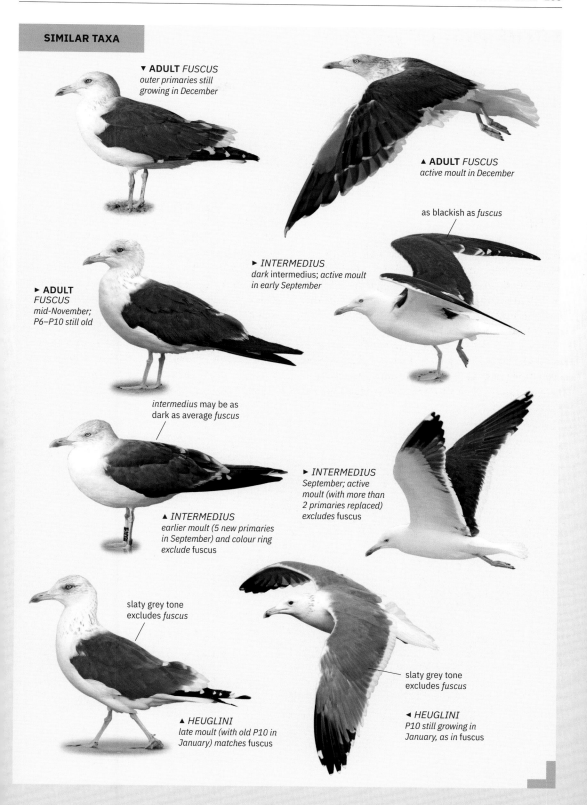

▼ **ADULT** *FUSCUS*
outer primaries still
growing in December

▲ **ADULT** *FUSCUS*
active moult in December

as blackish as *fuscus*

► *INTERMEDIUS*
*dark* intermedius; *active moult
in early September*

► **ADULT**
*FUSCUS*
mid-November;
P6–P10 still old

*intermedius* may be as
dark as average *fuscus*

► *INTERMEDIUS*
September; active
moult (with more than
2 primaries replaced)
excludes fuscus

▲ *INTERMEDIUS*
earlier moult (5 new primaries
in September) and colour ring
exclude fuscus

slaty grey tone
excludes *fuscus*

slaty grey tone
excludes *fuscus*

◄ *HEUGLINI*
P10 still growing in
January, as in fuscus

▲ *HEUGLINI*
late moult (with old P10 in
January) matches fuscus

# First cycle

Juvenile *fuscus* have no unique characteristics that separate them from *intermedius* or *heuglini*. However, small females with contrasting plumage may stand out, especially if showing the following features:

- Small and slender posture, with long wings, short legs and fine bill.
- Head and underparts very pale, almost whitish, with sharp, delicate streaking.
- Crisp upperparts without buffish or warm tones and with neat, white-fringed coverts.
- Rump and uppertail coverts obviously pale, whitish.

The best window of opportunity to identify vagrant birds is in spring and early summer, when some characteristic first-cycle birds return from the wintering grounds. In spring, first-cycle Baltic Gulls returning to Europe show a fresh second-generation plumage including second-generation primaries, which appear glossy black, unlike the worn, faded primaries of other taxa. Such birds can be identified even without a ring, when they show the following features:

- All tail feathers, secondaries, and at least 8 primaries replaced for second-generation feathers. New tail feathers and secondaries show broad white tips (lacking in juvenile feathers, which are worn in spring); new primaries are much darker, fresh, and glossy.

- Upperparts and wing are very dark and uniform chocolate brown (without a distinct pattern); any recently acquired feathers are solid blackish.
- Pale underwing, with dark streaking on whitish background.

The only other taxon regularly moulting primaries in its first winter is Heuglin's Gull (in 10% of first-cycle birds—see also p.292). In spring they are more reminiscent of Caspian Gull due to a white head and densely streaked hindneck ('boa'), and they show slate grey feathers on the upperparts (blackish in Baltic Gull).

First-cycle *fuscus* that have replaced all flight feathers are very similar to second-cycle *graellsii/intermedius*, but the latter may have already started replacing its inner primaries in late May (when *fuscus* shows no moult), and its outer primaries are dull blackish and worn, not shiny black and fresh. Even the most advanced first-cycle *fuscus* still show brown spots on the flanks, while many second-cycle *graellsii/intermedius* have clean white underparts.

Occasionally, birds turn up in spring outside the normal range of Baltic Gull that closely match *fuscus* but do not tick all the boxes. They are referred to as '*fuscoides*'. Some of these birds are probably from the overlap zone between *fuscus* and *intermedius* in central Norway. They combine advanced moult in winter (a *fuscus* trait) with rather barred pattern or slate grey colour on the upperparts (an *intermedius* trait).

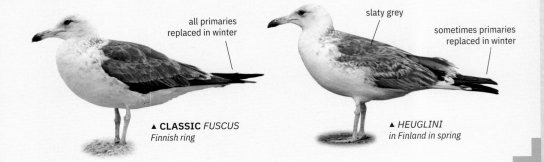

**SIMILAR TAXA**

all primaries replaced in winter

▲ **CLASSIC** *FUSCUS*
*Finnish ring*

slaty grey

sometimes primaries replaced in winter

▲ *HEUGLINI*
*in Finland in spring*

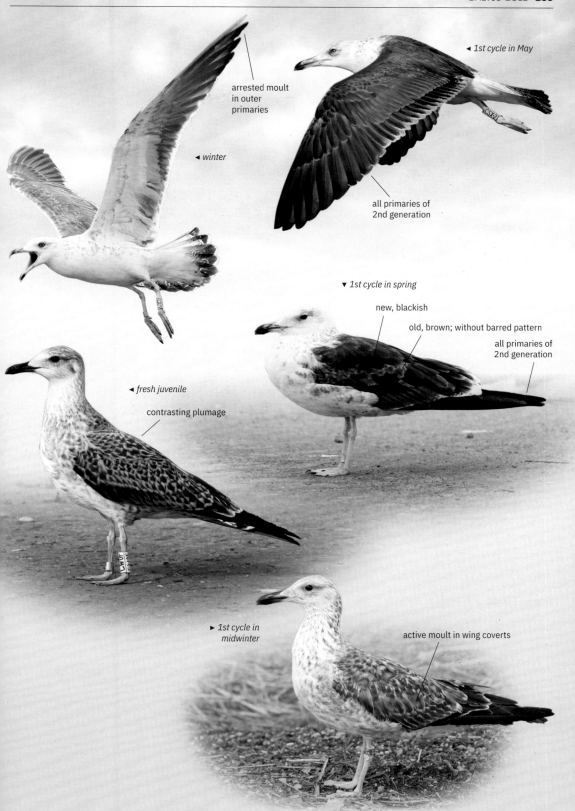

arrested moult
in outer
primaries

◄ *winter*

◄ *1st cycle in May*

all primaries of
2nd generation

▼ *1st cycle in spring*

new, blackish

old, brown; without barred pattern

all primaries of
2nd generation

◄ *fresh juvenile*

contrasting plumage

► *1st cycle in
midwinter*

active moult in wing coverts

**SIMILAR TAXA 1ST CYCLE**

arrested moult at P2

► FUSCOIDES
in Western Europe
in spring, with
fewer than 8 new
primaries

new tail

all secondaries new

barred pattern

advanced moult in May

few old secondaries

◄ FUSCOIDES
in Western Europe in
May with barred coverts

only outer primaries
replaced in winter

▲ HEUGLINI
in Finland in spring
(slaty grey scapulars
exclude fuscus)

## Second cycle

In autumn, any second-cycle Lesser Black-backed
Gull with three generations of primaries and with
fresh blackish wing coverts or scapulars should be a
Baltic Gull. In other seasons, too much variation in
*intermedius* makes identification impossible, even
though classic second-cycle *fuscus* in spring is a
striking bird.

Again, the complete moult takes place in winter,
and many birds return to Europe in spring showing
advanced, adult-like plumage. A key feature in
second-cycle *fuscus* is a moult contrast in the outer
primaries in spring. However, second-cycle
*intermedius* may overlap in both upperpart tone
and moult strategy, replacing primaries in
midwinter. Therefore, in spring or early summer
they too may show a moult division in the
primaries. Positive identification of extralimital
second-cycle *fuscus* is possible only in birds ringed
as chicks in a Baltic Gull colony.

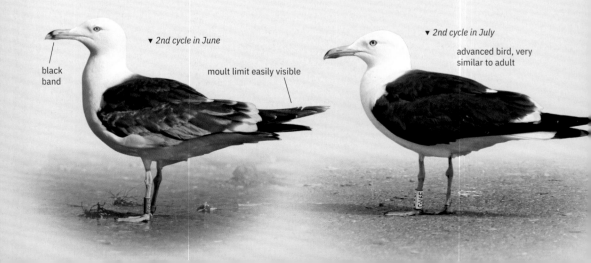

black
band

▼ *2nd cycle in June*

moult limit easily visible

▼ *2nd cycle in July*

advanced bird, very
similar to adult

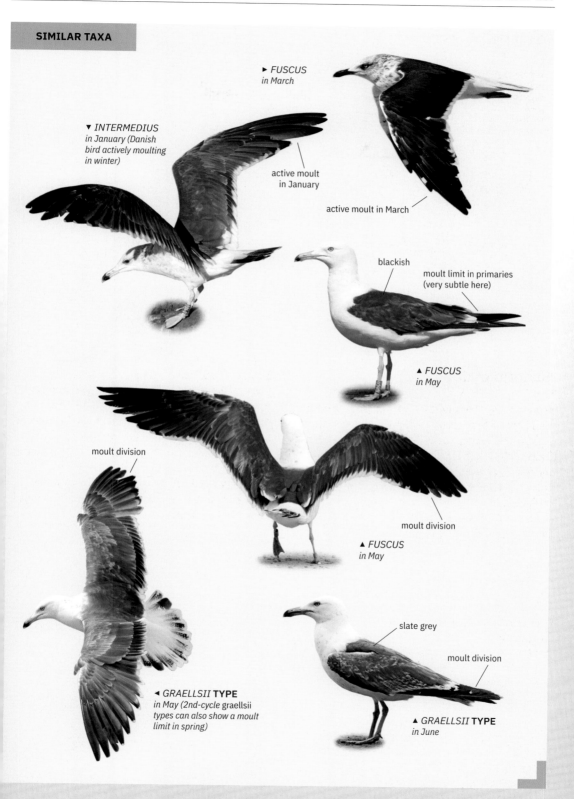

**SIMILAR TAXA**

► *FUSCUS*
in March

▼ *INTERMEDIUS*
in January (Danish
bird actively moulting
in winter)

active moult
in January

active moult in March

blackish

moult limit in primaries
(very subtle here)

▲ *FUSCUS*
in May

moult division

moult division

▲ *FUSCUS*
in May

slate grey

moult division

◄ *GRAELLSII* **TYPE**
in May (2nd-cycle graellsii
types can also show a moult
limit in spring)

▲ *GRAELLSII* **TYPE**
in June

# Third cycle

In general, Baltic Gull quickly develops adult-like plumage, and many third-cycle birds in spring are inseparable from full adults, unless age is revealed by ring data. For third-cycle birds, the same identification criteria apply as listed under adults.

Third-cycle Baltic Gulls may be striking birds as they show multiple generations of primaries in summer combined with blackish upperparts. Still, the darkest birds from the *intermedius* population overlap in all features, and therefore only ringed third-cycle Baltic Gulls are acceptable in a vagrant context.

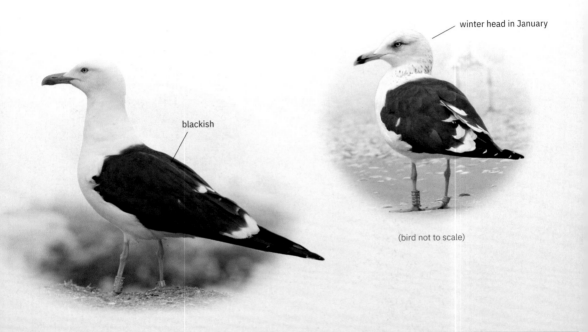

winter head in January

blackish

(bird not to scale)

▶ **RANGE**

Baltic Gull breeds in Finland, northwestern Russia, the Swedish east coast, and on the islands of Nordland, Norway. The Baltic Gull population is vulnerable, suffering from low reproduction rate due mainly to disease and predation of chicks by Herring Gulls. The total population decreased rapidly to only 15,000 breeding pairs in the 2010s.

It is a long-distance migrant, with a direct flight to the Middle East and Arabia, and therefore has adopted a moult strategy with complete moult in winter, after migration. The majority of birds winter in the Great Lakes of the Rift Valley in East Africa. It is a regular vagrant to Western Europe, though the true number of records is unknown because of identification problems.

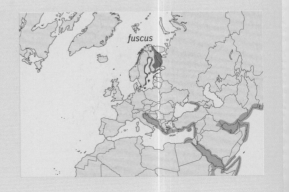

*fuscus*

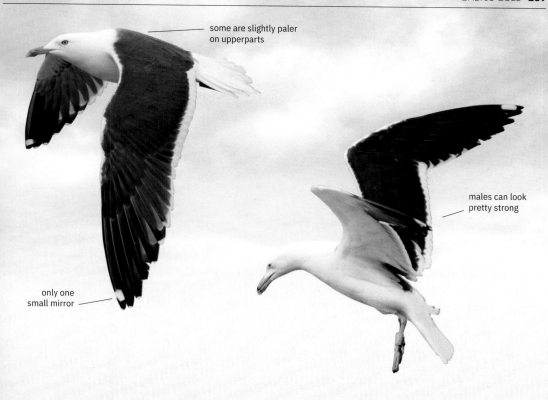

some are slightly paler
on upperparts

males can look
pretty strong

only one
small mirror

## SIMILAR TAXA

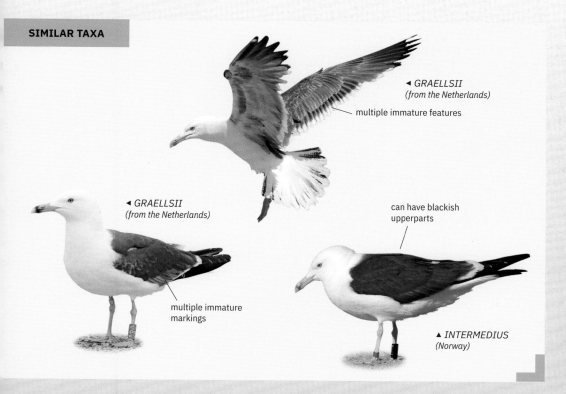

◄ *GRAELLSII*
*(from the Netherlands)*

multiple immature features

◄ *GRAELLSII*
*(from the Netherlands)*

can have blackish
upperparts

multiple immature
markings

▲ *INTERMEDIUS*
*(Norway)*

# Heuglin's Gull
## *Larus (fuscus) heuglini*

▶ **STRUCTURE**
Heuglin's Gull is similar to other members of the Lesser Black-backed Gull complex, but with relatively small head, a droopy, slimmer bill, and longer-looking legs than the western taxa.

*Heuglini* sits between *fuscus* and *L. argentatus* in size, structurally closer to *fuscus* due to the long wings. *Graellsii* has a more compact structure and, on average, a thicker bill. Some large male *heuglini* may recall Caspian Gull *L. cachinnans* and are then structurally quite different from *fuscus*.

## Adult

Paler than nominate *fuscus*, with which it shares its range, but very similar to *graellsii* Lesser Black-backed Gull in upperpart grey tone, although it often has a blue cast to the grey upperparts. The adult plumage overlaps extensively with that of western taxa, with only subtle differences. *Heuglini* has more black and less white in the wingtip than western taxa. A common wingtip pattern includes a broad black subterminal band on P10 (i.e., the white mirror sits far from the feather tip, unlike most *graellsii*) and no mirror on P9. Ideally, the base of P10 has a pure white underside and does not contrast with the white underwing coverts (in *graellsii* the underside of P10 always has a grey base).

Adult *heuglini* commonly has pure white tongue-tips on P8 and especially P7, which sit between the grey base and the black subterminal band. Thus, the grey tongues are distinctly separated from the black on the inner webs; such whitish tongue-tips are either absent or ill-defined at most in *graellsii*.

In midwinter, many *heuglini* remain mainly white-headed with coarser dark spots on the hindneck and sides of the breast, creating a pattern reminiscent of Caspian Gull.

Another feature in which *heuglini* differs from most western taxa is moult timing. *Heuglini*, being a long-distance migrant, is a late moulting species, finishing the complete moult on the wintering grounds in late January or February (which is only exceptionally shown by the western taxa).

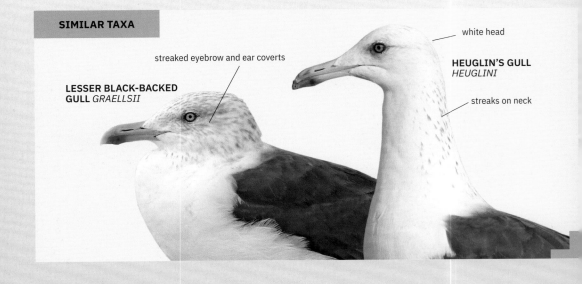

**SIMILAR TAXA**

streaked eyebrow and ear coverts

**LESSER BLACK-BACKED GULL** *GRAELLSII*

white head

**HEUGLIN'S GULL** *HEUGLINI*

streaks on neck

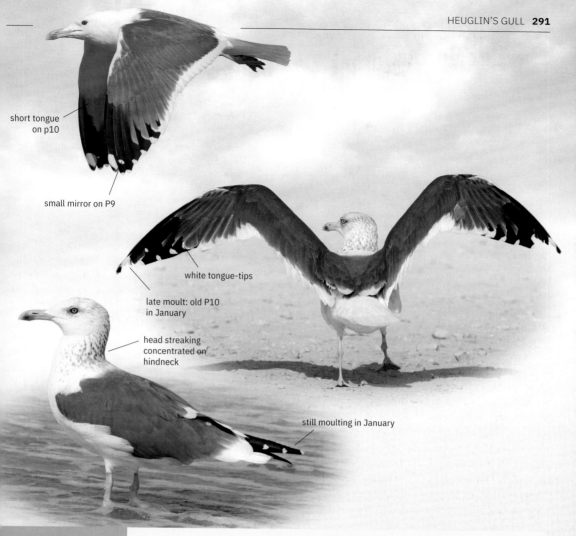

short tongue
on p10

small mirror on P9

white tongue-tips

late moult: old P10
in January

head streaking
concentrated on
hindneck

still moulting in January

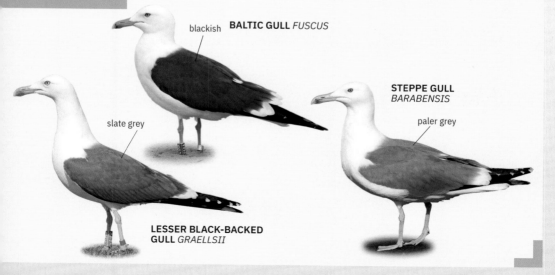

**SIMILAR TAXA**

blackish  **BALTIC GULL** *FUSCUS*

**STEPPE GULL**
*BARABENSIS*

slate grey

paler grey

**LESSER BLACK-BACKED
GULL** *GRAELLSII*

**SIMILAR TAXA ADULT**

**BALTIC GULL** *FUSCUS*

**HEUGLIN'S GULL**
*HEUGLINI*

long, narrow wings

moulting
primaries in
January

rectangular broad,
pale tongue

no white
tongue-tips

**LESSER
BLACK-BACKED
GULL** *GRAELLSII*

**STEPPE GULL**
*BARABENSIS*

# First cycle

Juveniles are similar to juvenile Baltic Gull, sharing the contrasting plumage when fresh, and most birds are inseparable; perhaps only the extremes can be identified (large males, for which see Structure), but even that is not so clear. As in *fuscus*, full juvenile plumage is retained well into the winter. *Heuglini* more often has paler inner webs on the inner primaries, and extreme birds are referred to as 'Herring Gull types'. Unlike Lesser Black-backed Gulls, these types have deeply notched patterns on greater coverts and show pale inner primaries. However, unlike Herring Gull, they have a solid dark tip on the inner primaries, and the outer webs lack the distinct pale subterminal spots.

For identifying first-cycle birds, the ideal time frame is May–June, when they arrive in northern Europe. Lesser Black-backed Gulls are highly variable and are therefore classified into three different 'types' here, regardless of subspecies.

Type A birds are retarded in moult; that is, most wing coverts, tertials, and all the flight feathers are

still juvenile in spring. Most *graellsii* Lesser Black-backed Gulls belong to this type, as do many Heuglin's Gulls. Type A Heuglin's Gulls are indistinguishable from Western European birds, except perhaps for the fresh condition of juvenile feathers, often still with surprisingly neat white fringes on the wing coverts.

Type B birds are referred to as '*intermedius* type', based on ring readings. They have an extensive post-juvenile wing covert moult in the second half of winter, and by early summer they also show a new tail and new secondaries. Heuglin's Gulls of this type are strikingly white on the underparts, and they often have bluish-grey feathers in the upperparts. At present, there are no safe criteria to separate type B *heuglini* from type B *intermedius*.

Type C birds follow a *fuscus* moult strategy; that is they replace primaries in the post-juvenile moult during their first winter. A minority (10%—see also p.284) of Heuglin's Gulls belong to this type, in which the number of renewed primaries varies largely and the sequence is variable. Sometimes new primaries are mixed randomly between old feathers,

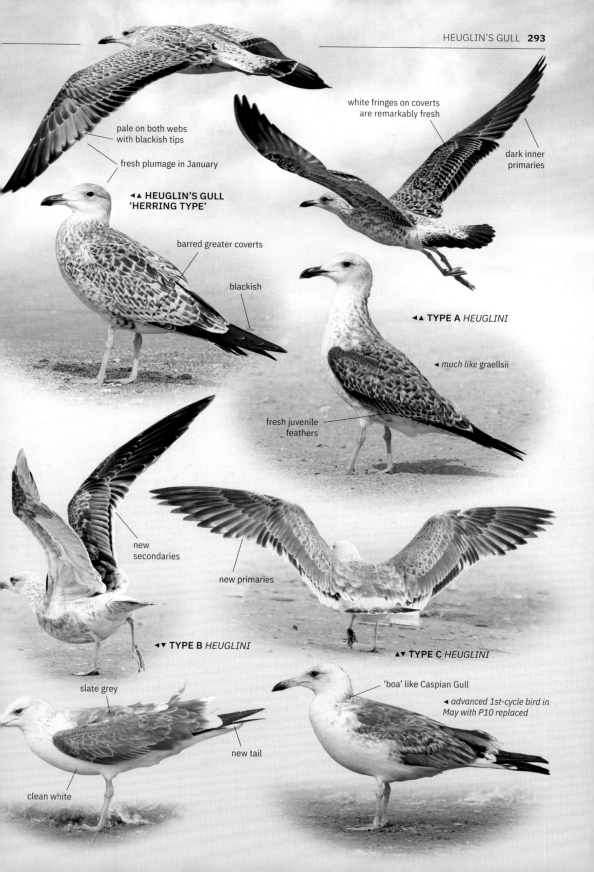

pale on both webs
with blackish tips

fresh plumage in January

white fringes on coverts
are remarkably fresh

dark inner
primaries

◄▲ **HEUGLIN'S GULL
'HERRING TYPE'**

barred greater coverts

blackish

◄▲ **TYPE A** *HEUGLINI*

◄ *much like* graellsii

fresh juvenile
feathers

new
secondaries

new primaries

◄▼ **TYPE B** *HEUGLINI*

▲▼ **TYPE C** *HEUGLINI*

slate grey

new tail

'boa' like Caspian Gull

◄ *advanced 1st-cycle bird in
May with P10 replaced*

clean white

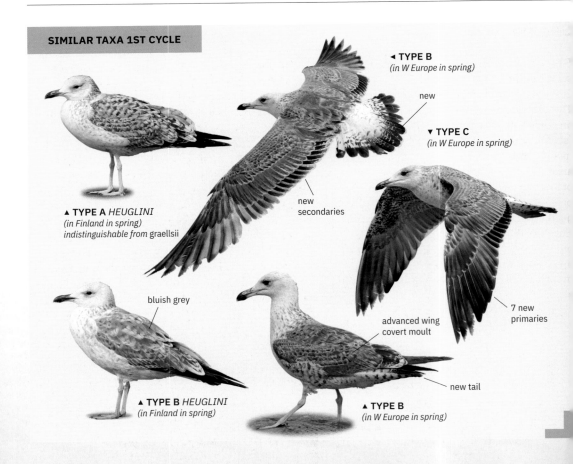

**SIMILAR TAXA 1ST CYCLE**

◄ **TYPE B**
*(in W Europe in spring)*

new

▼ **TYPE C**
*(in W Europe in spring)*

new
secondaries

▲ **TYPE A** *HEUGLINI*
*(in Finland in spring)*
*indistinguishable from* graellsii

bluish grey

7 new
primaries

advanced wing
covert moult

new tail

▲ **TYPE B** *HEUGLINI*
*(in Finland in spring)*

▲ **TYPE B**
*(in W Europe in spring)*

although the pattern is more or less symmetrical in both wings. These individuals also replace wing coverts and scapulars, in which case the grey tone of such advanced birds excludes *fuscus*. In addition, these bluish-grey feathers regularly show broad white fringes, creating a more 'frosty' look than in other Lesser Black-backed Gulls.

Type C *heuglini* with replaced primaries should attract attention in spring because they appear white on the head and underparts. Most show dense spotting on the hindneck, like Caspian Gull. Structurally, they may recall *cachinnans* as well, but differences from that species include darker inner primaries, dark underwing coverts, broader tail

band, and often renewed tail feathers and secondaries (Caspian Gulls do not replace flight feathers in the post-juvenile moult). Also, juvenile *cachinnans* moults much earlier than *heuglini*. In May–June, the plumage of *cachinnans* is worn and bleached, while that of *heuglini* appears rather fresh.

Lesser Black-backed Gulls of the races *graellsii* and *intermedius* do not moult primaries during their first winter. However, some birds turn up with replaced primaries in Western Europe in spring. They are believed to originate from the overlap zone of *intermedius* and *fuscus* in northern Norway.

For separation from Steppe Gull, see that taxon (p.298).

# Second cycle

*uscus* and *heuglini* in immature plumages show
ome significant differences from most western
esser Black-backed Gulls and most other large gulls.
hey develop more quickly into adult-like plumage,
nd they both show large variation in moult strategy
uch as arrested moult, or so-called stepwise
oult). This strategy is linked to migration (breeding
eas are located far north, and birds follow a very
oad, trans-continental migration route), and
obably also to climatic conditions in the winter
uarters. From spring onwards, second-cycle
euglin's Gulls show brown, second-generation
imaries in combination with adult-like grey
pperparts, allowing separation from all other forms
. their distribution range, except *intermedius*-type
rds.

Second-cycle Heuglin's Gulls share the wintering
grounds with Steppe Gulls (which have paler grey
upperparts) and Baltic Gulls (which have almost
blackish upperparts). Therefore, in good light
conditions, identification should be possible there
based on mantle colour.

Distinguishing extralimital *heuglini* in a flock of
western Lesser Black-backed Gulls is as difficult as it
is for adult plumage. Still, second-cycle *heuglini*
often show a clean white head set off against sharp,
pencil-like streaks on the hindneck (like Caspian
Gull), while many western birds in their second
cycle appear heavily streaked and mottled on the
head. Also, a mirror on P10 is not uncommon in
second-cycle Heuglin's Gull (a feature shared with
Baltic Gull, and likely related to the seasonal timing
of moult). Many second-cycle *intermedius* have

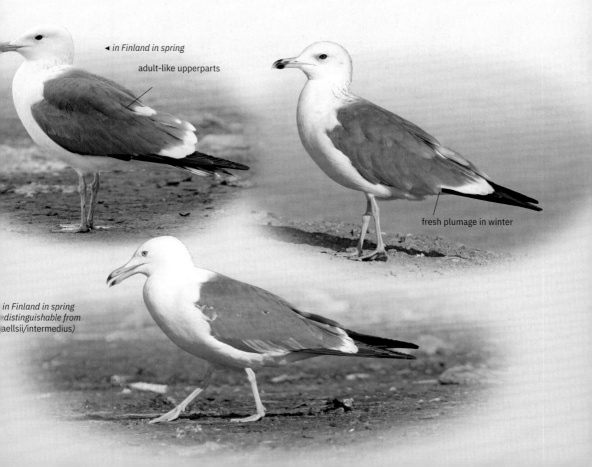

◄ *in Finland in spring*

adult-like upperparts

fresh plumage in winter

*in Finland in spring*
*distinguishable from*
*aellsii/intermedius)*

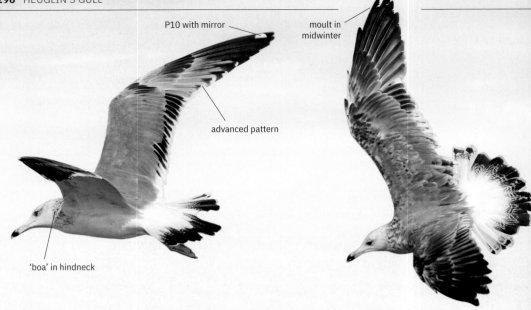

P10 with mirror

moult in midwinter

advanced pattern

'boa' in hindneck

darker grey upperparts, lacking a bluish hue, and only rarely show a mirror on P10.

By late winter some birds show advanced, arrested moult (which means that their fully grown flight feathers are a mix of adult-like and brown feathers),

and this certainly attracts attention in Western Europe. However, ring readings have demonstrated that second-cycle *intermedius* and *graellsii* may adopt this moult strategy as well.

## SIMILAR TAXA

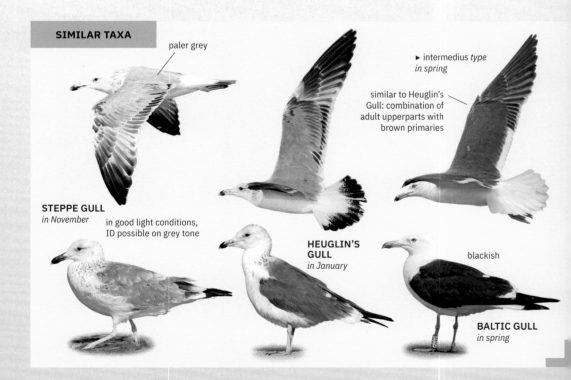

paler grey

► intermedius *type in spring*

similar to Heuglin's Gull: combination of adult upperparts with brown primaries

**STEPPE GULL** *in November*

in good light conditions, ID possible on grey tone

**HEUGLIN'S GULL** *in January*

blackish

**BALTIC GULL** *in spring*

# Third cycle

For identification of this age-class, see adult.

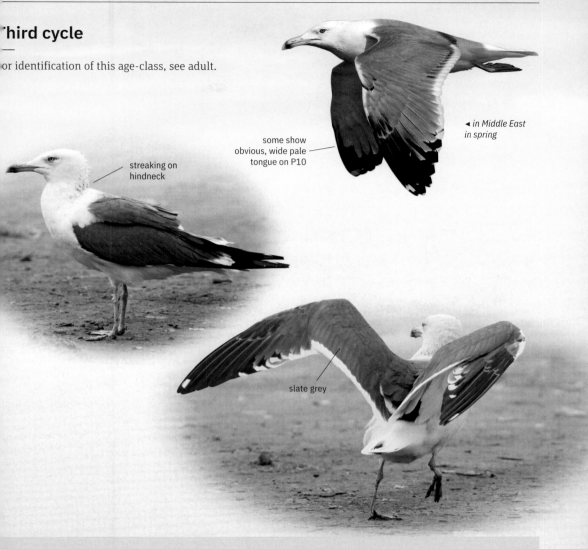

◀ *in Middle East in spring*

some show obvious, wide pale tongue on P10

streaking on hindneck

slate grey

## ▶ RANGE

Heuglin's Gull, sometimes called Siberian Gull, is a tundra breeder in northern Russia and, like Baltic Gull, is a long-distance migrant to the Middle East and East Africa—a journey of more than 6,000 km. In the eastern part of its breeding range, birds become larger and show paler grey upperparts (*taimyrensis*, considered a separate taxon by some authors), and this population migrates to eastern Asia (coasts of the Yellow Sea and Japanese Sea).

Heuglin's Gull is a regular migrant to Finland and probably also to eastern and southeastern Europe. In Western Europe, there are accepted records from Austria (4) and Germany (6). *Taimyrensis* has not been recorded with certainty in the (wider) Western Palearctic and is therefore not treated here.

*heuglini*

# Steppe Gull
## *Larus (fuscus?) barabensis*

▶ **STRUCTURE**
An elegant gull with slim, elongated body, small head with sloping forehead, and relatively thin bill. Slightly smaller than Caspian Gull, with shorter legs.

Identification criteria and plumage variation of Steppe Gull—especially immature birds—are still unclear, and identification of individual birds outside their usual range is fraught with difficulty. In addition, some interbreeding may be going on with Caspian Gull in Kazakhstan and with Heuglin's Gull in Central Russia.

The taxonomic position of Steppe Gull is unclear. Its mitochondrial DNA is very similar to that of Heuglin's Gull, but its display call seems different, more like a low-pitched Caspian Gull. The notes are hurried, have a 'laughing' quality, and actually sound very similar to Armenian Gull.

## Adult

Similar to Caspian Gull but with darker grey upperparts (same shade as Armenian Gull) and brighter green or bright yellow legs. At rest, the underside of the wingtip is predominantly black, with only a small white mirror showing. The longest primary shows a thick, solid black, subterminal band (usually thin, broken, or absent in adult Caspian—but beware that the black pattern of P9 may be shimmering through). In flight, the outer wing shows more extensive black than in Caspian Gull; 7–8 primaries are marked with black (usually only 6 in adult Caspian), and the tongue on the outermost primary tends to be short, covering not more than half the length of the feather. In addition, Steppe Gull has a later breeding season

and therefore also a later moult. Adults are often still growing their outermost primary in December–early January, while Caspian Gull has already completed its moult in November.

Has smaller head and slightly thinner, straighter bill than Heuglin's Gull, and the upperparts are slightly paler, with more of a bluish tinge. Heuglin's shows head streaking in nonbreeding plumage and more often shows a pale iris than Steppe. In flight, there is usually only one white mirror on each wing, while adult Steppe often has two, and the outermost 3–4 primaries are solid black right up to the primary coverts (Steppe often has a small grey base on some of these feathers). The tongue on the outermost primary is usually very short and narrow. The underside of the flight feathers is slightly darker grey than in Steppe, but the difference is subtle, and good light is needed to assess it. Heuglin's Gull has a very late breeding season, and many birds are still growing their outermost primary in Feb–Mar.

Differs from Armenian Gull in its slightly thinner, more pointed bill with thinner, less solid black band. The bill of adult Armenian Gull usually has a strikingly bright colour, sometimes even orange, and shows a broad black band in winter. In flight, the wing pattern of Armenian Gull is similar to that of Heuglin's Gull, that is, with solid black 3–4 outer primaries and with only a very short tongue on underside of the outermost primary.

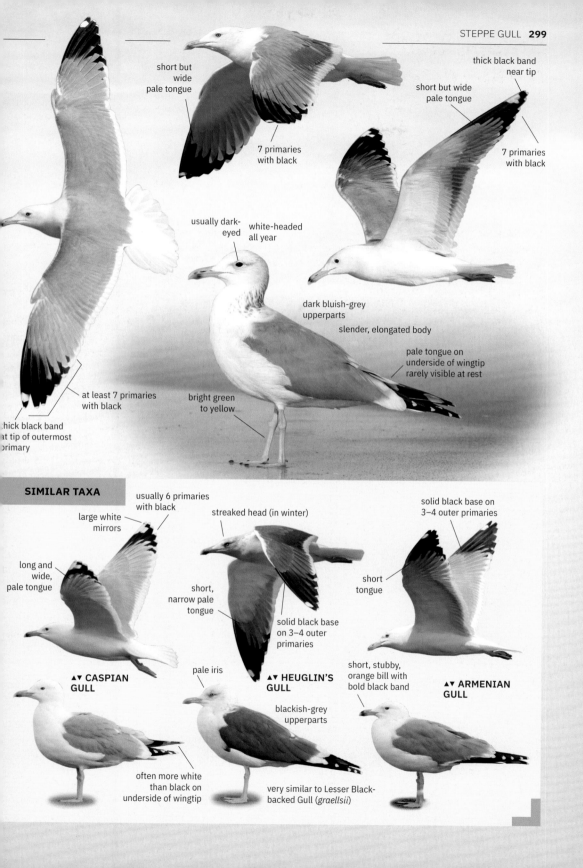

short but wide pale tongue

7 primaries with black

thick black band near tip

short but wide pale tongue

7 primaries with black

usually dark-eyed

white-headed all year

dark bluish-grey upperparts

slender, elongated body

pale tongue on underside of wingtip rarely visible at rest

at least 7 primaries with black

bright green to yellow

thick black band at tip of outermost primary

**SIMILAR TAXA**

usually 6 primaries with black

large white mirrors

long and wide, pale tongue

▲▼ CASPIAN GULL

often more white than black on underside of wingtip

streaked head (in winter)

short, narrow pale tongue

solid black base on 3–4 outer primaries

pale iris

▲▼ HEUGLIN'S GULL

blackish-grey upperparts

short, stubby, orange bill with bold black band

very similar to Lesser Black-backed Gull (*graellsii*)

solid black base on 3–4 outer primaries

short tongue

▲▼ ARMENIAN GULL

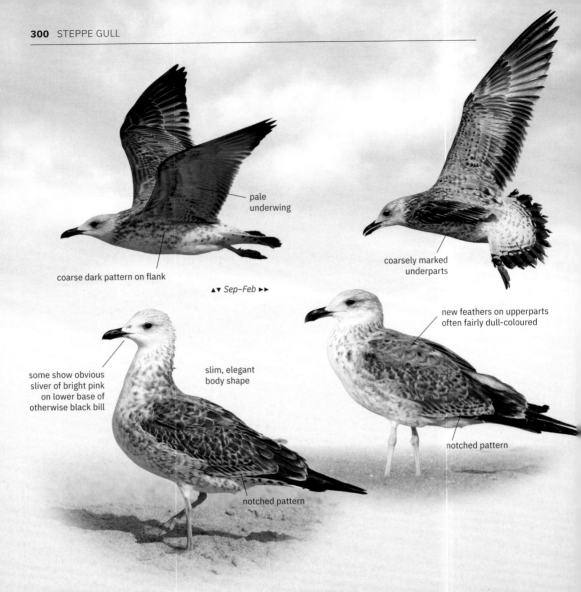

pale underwing

coarse dark pattern on flank

coarsely marked underparts

*▲▼ Sep–Feb ▶▶*

new feathers on upperparts often fairly dull-coloured

some show obvious sliver of bright pink on lower base of otherwise black bill

slim, elegant body shape

notched pattern

notched pattern

## First cycle

First-cycle Steppe Gull is very similar to Caspian Gull, and it is doubtful that individual birds can be identified with confidence outside of their usual range. Moulted (post-juvenile) scapulars often look somewhat darker grey or duller than in Caspian, with broader blackish spots, but there is certainly overlap. The flanks can be more coarsely patterned, the greater coverts can show more of a barred pattern, and the edges on the dark tertial centres can look jagged. Some birds show a rather typical bill pattern: blackish throughout, but with a sliver of bright pink restricted to the base of the lower mandible. In

Caspian Gull, the pink colour is usually dull, and present on both mandibles.

Because of its late hatching date and its migration strategy, first-cycle Heuglin's Gull tends to retain its juvenile plumage well into winter, and therefore moult timing can be used to separate it from Steppe Gull in winter. The upperparts look scalloped all autumn rather than spotted or barred as in the latter. In general, the juvenile feathers of Heuglin's remain in better condition throughout winter. In the second half of winter, Heuglin's is in active moult and its feathers look fresh, while Steppe looks worn. Many Heuglin's Gulls retain a full set of 10 remarkably fresh, juvenile primaries until June of their second calendar year, while

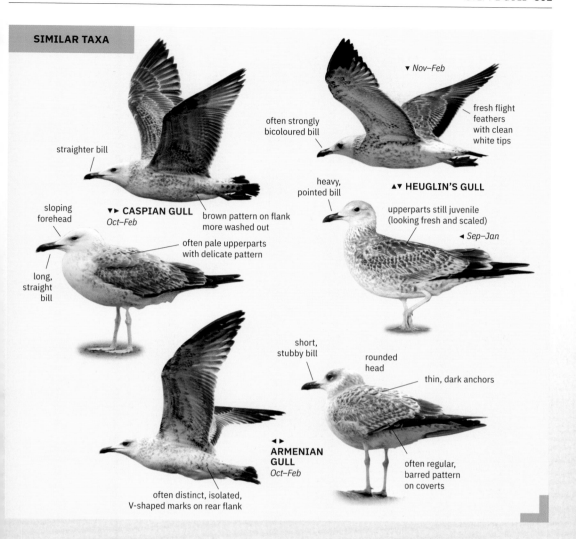

**SIMILAR TAXA**

▼ Nov–Feb

fresh flight feathers with clean white tips

often strongly bicoloured bill

straighter bill

▲▼ HEUGLIN'S GULL

heavy, pointed bill

sloping forehead

▼► CASPIAN GULL
*Oct–Feb*

brown pattern on flank more washed out

upperparts still juvenile (looking fresh and scaled)

◄ Sep–Jan

often pale upperparts with delicate pattern

long, straight bill

short, stubby bill

rounded head

thin, dark anchors

◄►
ARMENIAN GULL
*Oct–Feb*

often regular, barred pattern on coverts

often distinct, isolated, V-shaped marks on rear flank

Steppe starts replacing its inner primaries in May. Some advanced Heuglin's already replace a few primaries during the midwinter moult and then suspend, which is something we have not seen proof of in first-cycle Steppe. Such new primaries have a shiny black colour and contrast against the dull, dark brown, juvenile primaries. Also, unlike Steppe Gull, Heuglin's Gull can retain many juvenile wing coverts (still looking remarkably fresh) into April–June of its second calendar year. Moulted (post-juvenile) scapulars can show a simpler pattern than in Steppe Gull: plain grey, with just a thin, blackish shaft streak—but the pattern is variable and certainly overlaps that of Steppe.

First-cycle Steppe Gull differs from Armenian Gull mainly in its slightly thinner, more pointed bill. Most Armenian Gulls have a characteristic short, stubby bill. The plumage of first-cycle Armenian is really variable but tends to differ slightly from Steppe in its stronger dark mask around the eye and more regularly barred pattern on the juvenile greater coverts. In addition, some first-cycle Armenian Gulls show fairly characteristic >-shaped chevrons on rear flank.

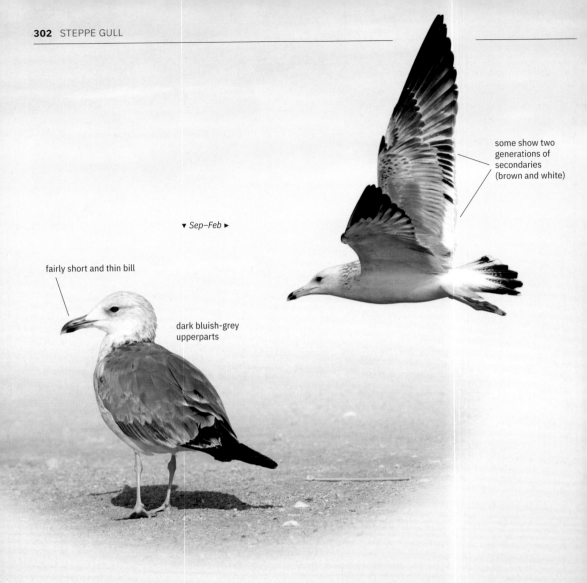

some show two
generations of
secondaries
(brown and white)

▼ *Sep–Feb* ▶

fairly short and thin bill

dark bluish-grey
upperparts

## Second cycle

At this age, most Steppe Gulls have acquired their typical, dark bluish-grey upperparts. Some show a more retarded plumage with coarse dark markings on flanks still (unlike Caspian Gull) and with large dark spots or bars on upperparts. In flight, retarded birds tend to show darker inner primaries than Caspian Gull. Some advanced birds may show two generations of secondaries (a mixture of dark brown, second-generation feathers and white or bluish-grey, third-generation feathers, all of the same length). Except when they are actively moulting (in summer)

Caspian Gulls only rarely show more than one generation of secondaries.

Second-cycle Heuglin's Gull is very similar, but the upperparts are slightly darker, slaty grey. Unlike Steppe, some second-cycle Heuglin's Gulls already replace a few primaries during the partial midwinter moult; new primaries are adult-like, with a prominent white tip.

Many second-cycle Armenian Gulls show characteristic whitish fringes on wing coverts, giving the upperwing a pallid appearance. Some second-cycle Steppe Gulls already show a (small) white mirror on the outermost primary, which is not the case in Armenian. Note also the short, stubby bill.

## SIMILAR TAXA

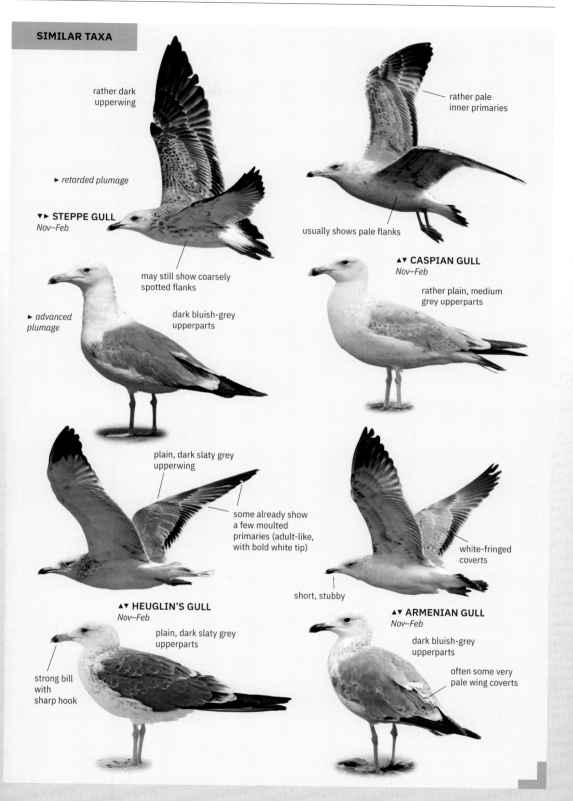

rather dark
upperwing

rather pale
inner primaries

► *retarded plumage*

▼► **STEPPE GULL**
*Nov–Feb*

usually shows pale flanks

may still show coarsely
spotted flanks

▲▼ **CASPIAN GULL**
*Nov–Feb*

rather plain, medium
grey upperparts

► *advanced
plumage*

dark bluish-grey
upperparts

plain, dark slaty grey
upperwing

some already show
a few moulted
primaries (adult-like,
with bold white tip)

white-fringed
coverts

short, stubby

▲▼ **HEUGLIN'S GULL**
*Nov–Feb*

plain, dark slaty grey
upperparts

▲▼ **ARMENIAN GULL**
*Nov–Feb*

dark bluish-grey
upperparts

often some very
pale wing coverts

strong bill
with
sharp hook

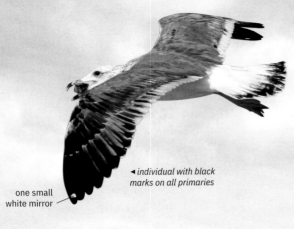

wide pale tongue

black marks on most primaries

◄ *individual with black marks on all primaries*

one small white mirror

white head with dark eye

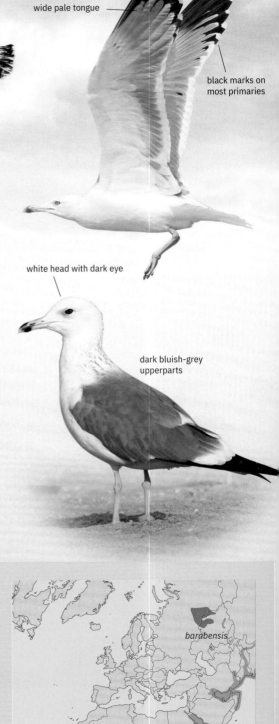

dark bluish-grey upperparts

## Third cycle

Large gulls of this age category generally resemble adults, but with more extensive black on their primaries and duller bare parts. Thus, the solid black tip on the outermost primary is not a very useful feature since third-cycle Caspian Gull can show it too. Fortunately, many third-cycle Caspian Gulls already show a long, pale tongue on this feather. In Steppe Gull, the upperparts are darker grey, and the legs are brighter green or yellow. Most primaries (8–10) show black markings, as opposed to 6–8 in Caspian.

Differs from third-cycle Heuglin's and Armenian Gulls in much the same way as adults. In addition, leg colour is often brighter than in Heuglin's at this age.

▶ **RANGE**

Breeds from southwestern Siberia to southeastern Urals, and also in parts of northern Kazakhstan, although many birds apparently show mixed characters of Caspian Gull there. Small numbers may breed (much) further west, for example in the Penza Oblast, which is approximately 500 km southeast of Moscow. Winters in western India and the Arabian Peninsula, including the Red Sea, where significant numbers occur north up to the Hurghada area in Egypt.

*barabensis*

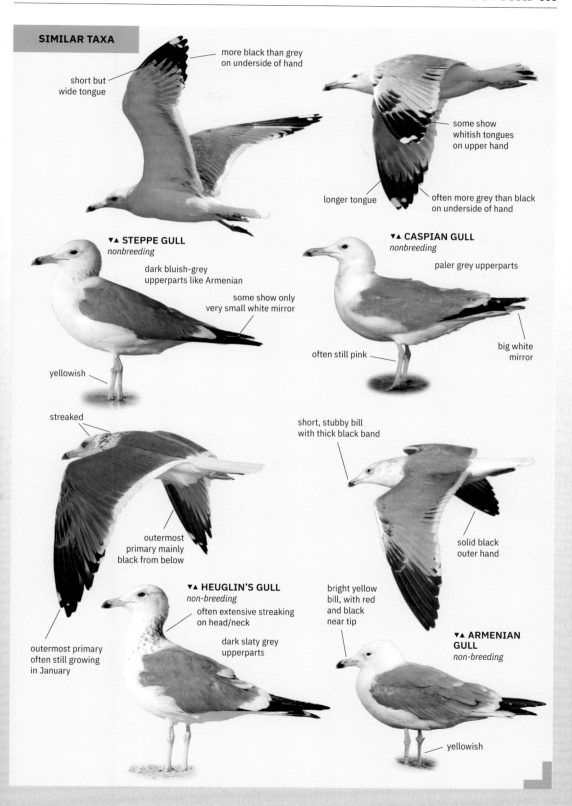

**SIMILAR TAXA**

more black than grey
on underside of hand

short but
wide tongue

some show
whitish tongues
on upper hand

longer tongue

often more grey than black
on underside of hand

**▼▲ STEPPE GULL**
*nonbreeding*

dark bluish-grey
upperparts like Armenian

some show only
very small white mirror

yellowish

**▼▲ CASPIAN GULL**
*nonbreeding*

paler grey upperparts

often still pink

big white
mirror

streaked

short, stubby bill
with thick black band

outermost
primary mainly
black from below

solid black
outer hand

outermost primary
often still growing
in January

**▼▲ HEUGLIN'S GULL**
*non-breeding*

often extensive streaking
on head/neck

dark slaty grey
upperparts

bright yellow
bill, with red
and black
near tip

**▼▲ ARMENIAN
GULL**
*non-breeding*

yellowish

# 'Viking Gull'
## *Larus argentatus* × *hyperboreus*

> ▶ **STRUCTURE**
> Size and structure are generally similar to European Herring Gull, but sometimes with slightly longer, straighter bill reminiscent of Glaucous Gull.

'Viking Gull' is the colloquial name for hybrids between Glaucous and European Herring Gull. Glaucous also hybridises with American Herring Gull in Canada (producing so-called 'Nelson's Gull') and occasionally with Vega Gull (e.g., in Alaska). These Nearctic and Pacific hybrids have not been recorded in the Western Palearctic and are presumably very similar to 'Viking Gull'. They are not treated in this book.

## Adult

The plumage is variable, with palest birds showing pale wingtips like Glaucous Gull and darkest like Herring Gull. There seem to be more birds in the latter category, although the primary pattern is usually different. Herring Gulls breeding in Iceland are of the subspecies *argenteus*, thus showing relatively extensive black on outer primaries. In hybrids, which are the product of mixed breeding between one species with black wingtips and one with white wingtips, this is less

extensive and may result in a broken black pattern on P6, a long pale tongue on P10 (longer than two-thirds the length of the feather), or only a short black wedge on the outer web of P8 (shorter than half the length of the feather). There is often a prominent white tongue-tip (or 'pearl') on P8 and usually no black mark on P5. Variation in *argenteus* makes it difficult or even impossible to identify such hybrids outside their usual range, although a white mirror on P8 (if present) seems to be a reliable feature. Other birds are more obvious, showing rather pale wingtips with just a few black or dark grey streaks on outermost primaries. A small number of adult hybrids lack dark markings on the wingtip altogether and strongly resemble Glaucous Gull, although their outer primaries show more extensive grey colour that is well demarcated from the narrow white primary tips. In adult Glaucous Gull, the outermost primaries show extensive white tips that cover nearly half the feather length and fade more gradually into the grey base of the feathers.

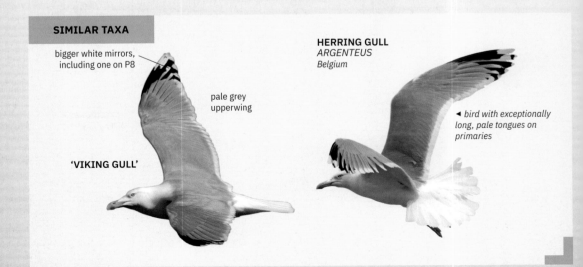

**SIMILAR TAXA**

bigger white mirrors, including one on P8

pale grey upperwing

'VIKING GULL'

**HERRING GULL**
*ARGENTEUS*
*Belgium*

◀ bird with exceptionally long, pale tongues on primaries

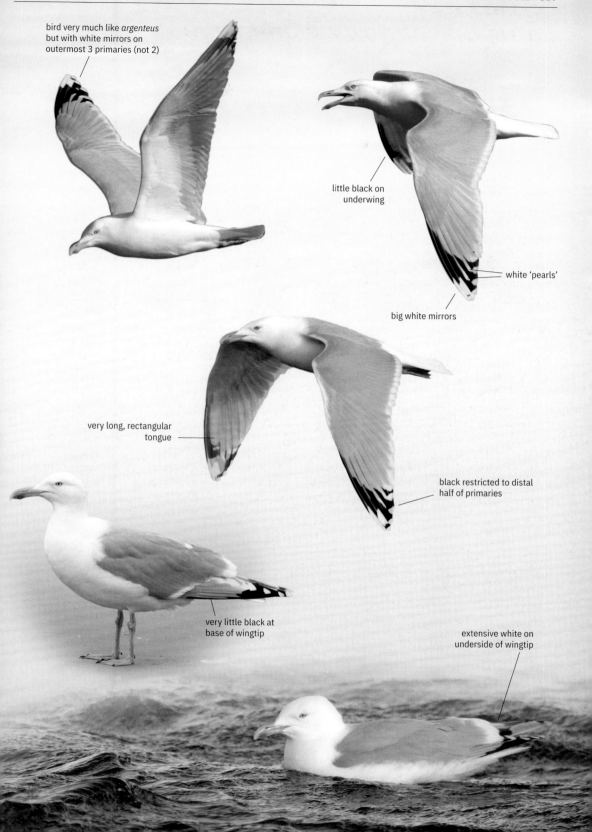

bird very much like *argenteus* but with white mirrors on outermost 3 primaries (not 2)

little black on underwing

white 'pearls'

big white mirrors

very long, rectangular tongue

black restricted to distal half of primaries

very little black at base of wingtip

extensive white on underside of wingtip

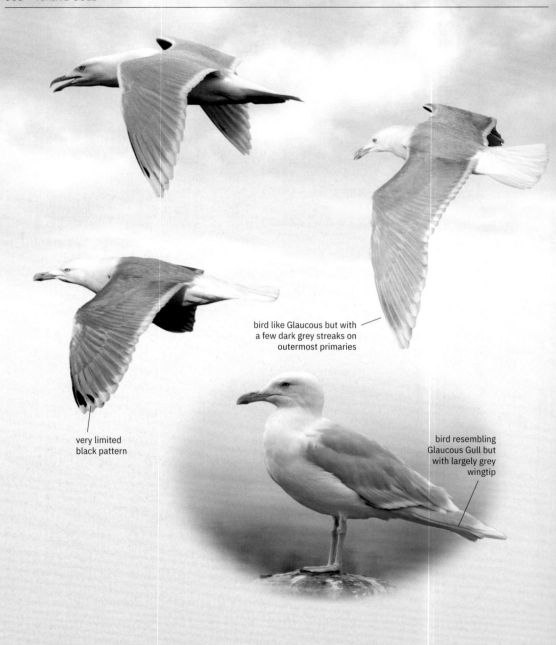

bird like Glaucous but with
a few dark grey streaks on
outermost primaries

very limited
black pattern

bird resembling
Glaucous Gull but
with largely grey
wingtip

Birds with extensive black on wingtips but with long, pale tongue on outermost primary may suggest American Herring Gull, but hybrids appear never to show a complete black band on P5. In addition, the white mirror on P10 usually lacks any dark subterminal marks, unlike adult *smithsonianus*.

Adult Herring Gulls of the subspecies *argentatus* can show limited black on the wingtips, but such birds show darker grey upperparts than the Icelandic hybrids.

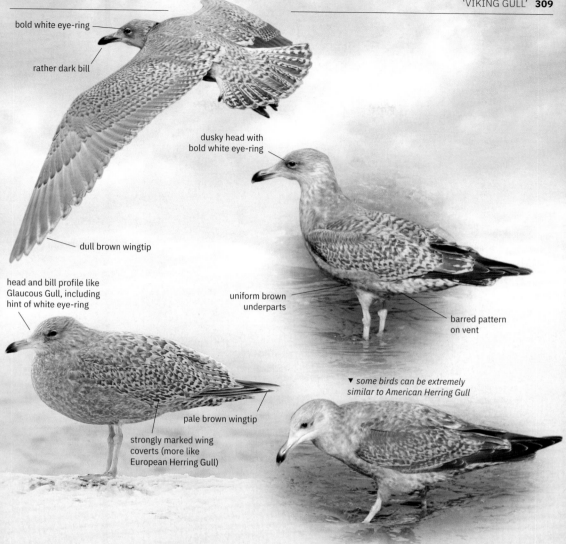

bold white eye-ring

rather dark bill

dusky head with bold white eye-ring

dull brown wingtip

head and bill profile like Glaucous Gull, including hint of white eye-ring

uniform brown underparts

barred pattern on vent

*▼ some birds can be extremely similar to American Herring Gull*

pale brown wingtip

strongly marked wing coverts (more like European Herring Gull)

## First cycle

The plumage is again really variable. Birds that resemble Glaucous Gull can usually be told by their pale brown rather than whitish wingtips, more coarsely marked wing coverts and tertials, and, from autumn on, distinct dark barring on the scapulars. First-cycle Glaucous Gulls retain their juvenile plumage throughout the winter; any pattern on the scapulars is therefore not darker than the (juvenile) wing coverts. Told from Kumlien's Gull (which can show brown wingtips and a few moulted scapulars during the first winter)

by the more coarsely marked wing coverts and tertials, duller leg colour, as well as size and shape, notably the longer, heavier bill. Very pale European Herring Gulls also occur, for example, among local breeding birds in Denmark and southern Sweden, and pale brown wingtips are therefore certainly not unique to hybrids. However, such birds apparently do not show a bold white eye-ring.

Other birds are more clearly intermediate between both parent species, showing, for example, delicately patterned, milky-brown plumage and long, extensively pink bill of Glaucous but dark wingtip of European Herring, and such birds are

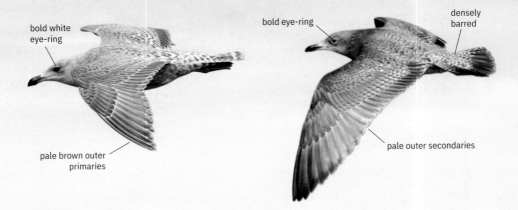

bold white
eye-ring

bold eye-ring

densely
barred

pale brown outer
primaries

pale outer secondaries

among those most easily recognised outside their usual range.

Darker birds may have very dark brown wingtips and strongly resemble European Herring Gull. Influence of Glaucous Gull may still show in the rather uniform brown head with bold white eye-ring, and in pale outer secondaries (in flight). Many dark birds show more uniform brown body than *argenteus*, dark tail, more densely barred uppertail coverts, and barred pattern not only on undertail coverts but also on vent. These features make them actually more similar to American Herring Gull, and identification can be problematic. Subtle details will usually differ, though: the inner greater coverts of such dark hybrids are often whiter with more regular, parallel dark barring; the uppertail coverts are more coarsely marked, often showing big, rounded, dark spots rather than thin, horizontal barring; the underparts may look somewhat spotted rather than smooth velvety brown; the hindneck may look streaked and the face rather dusky (American Herring Gull often shows uniform brown neck and rather pale head); and the undertail coverts may be more sparsely barred. In flight, the outer secondaries and the underside of the outermost primaries may be pale.

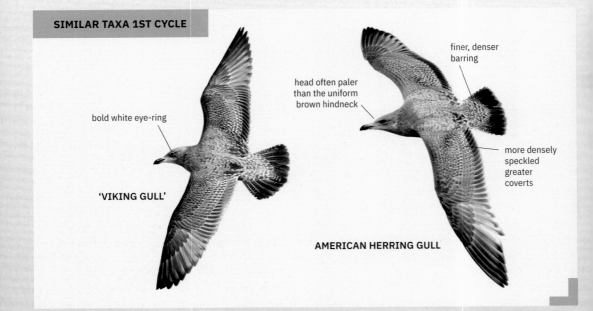

**SIMILAR TAXA 1ST CYCLE**

bold white
eye-ring

'VIKING GULL'

head often paler
than the uniform
brown hindneck

finer, denser
barring

more densely
speckled
greater
coverts

**AMERICAN HERRING GULL**

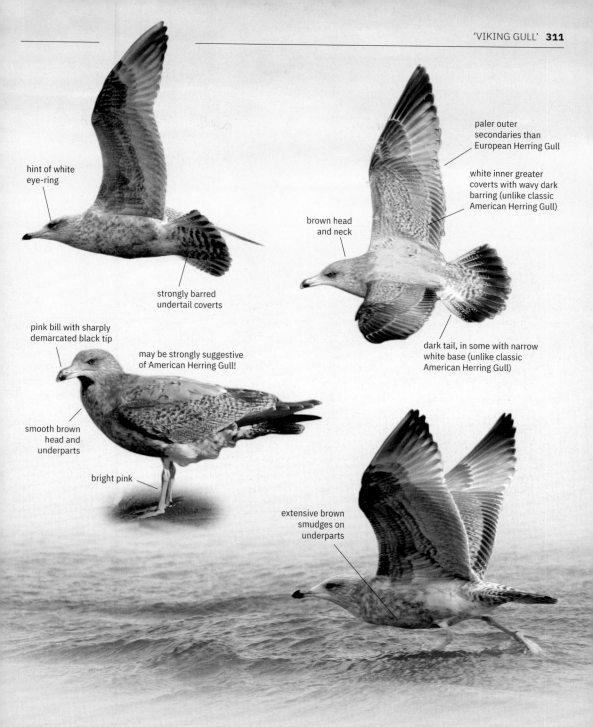

hint of white eye-ring

strongly barred undertail coverts

paler outer secondaries than European Herring Gull

white inner greater coverts with wavy dark barring (unlike classic American Herring Gull)

brown head and neck

dark tail, in some with narrow white base (unlike classic American Herring Gull)

pink bill with sharply demarcated black tip

may be strongly suggestive of American Herring Gull!

smooth brown head and underparts

bright pink

extensive brown smudges on underparts

# Second cycle

At this age the plumage is again variable, although the number of dark birds is quite striking.

Second-cycle Glaucous Gulls can show a brown hue on the wingtip, but the outer primaries are still the palest part of the upperwing and remain a key feature; pale hybrids generally show dull brown outer primaries that do not appear paler than the rest of the wing. Structure is important, too; Glaucous shows a somewhat straighter bill, and its wingtips extend only slightly beyond the tail, while

in hybrids the wing projection is often more like Herring Gull.

Dark hybrids may strongly suggest American Herring Gull but show on average more coarsely barred inner greater coverts, pale outer secondaries, and coarsely spotted underparts. The outer tail feathers may show a (partly) white base. This can be the case in some second-cycle American Herring Gulls too, but such birds of this species are scarce and therefore not the most expected in a vagrant context.

## Third cycle

Variable plumage, but birds with intermediate characters seem the most common. They show pale brown to dark slaty grey wingtips, often with pale fringes at rest, which separates them from both parent species. Told from nominate *argentatus* Herring Gull by the paler grey upperparts and from Kumlien's Gull mainly by size, different bill and head shape, and paler pink legs.

As in their second cycle, third-cycle Glaucous Gulls can show a pale brown hue on the outer primaries, but the colour does not contrast with the rest of the wing and is usually paler than the primary coverts.

▶ **RANGE**

Hybridisation between Glaucous and European Herring Gulls (of the race *argenteus*) has been extensively studied in Iceland. DNA research has shown that introgression* between these two species is extensive in the south of the country, and that Herring Gull genes are dominant. This has resulted in hybrids and backcrosses** that may look very similar to European Herring Gulls, but with a few Glaucous-like features. In addition, some of the traits inherited from Glaucous Gull may combine to produce birds that strongly resemble American Herring Gull, surprisingly. For instance, immature hybrids may show a dark tail, uniform brown body, densely barred tail coverts, and a long bill with extensive pink base.

\* Gene flow from one taxon to another due to repeated interbreeding.
\*\* Interbreeding between a hybrid and one of its parent species.

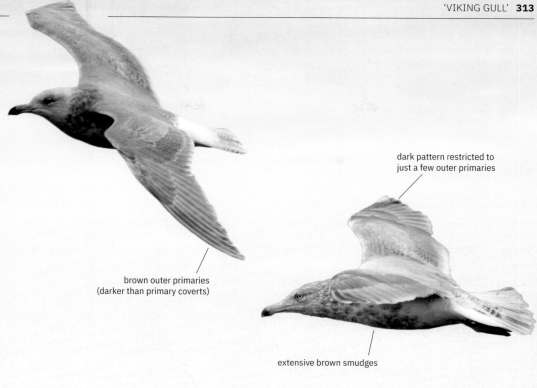

dark pattern restricted to
just a few outer primaries

brown outer primaries
(darker than primary coverts)

extensive brown smudges

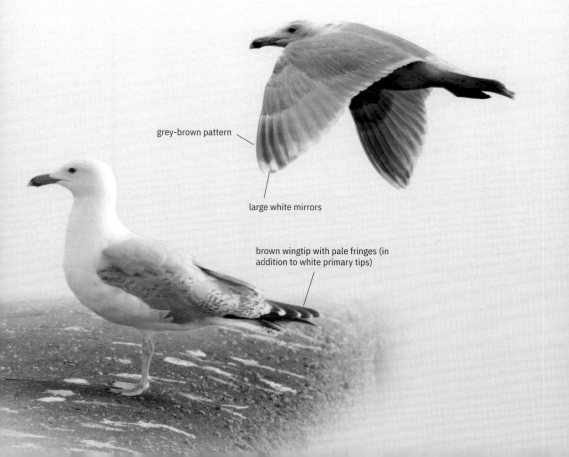

grey-brown pattern

large white mirrors

brown wingtip with pale fringes (in
addition to white primary tips)

# Large Hybrid Gulls

## Introduction

In the course of time, gull species increase and decrease their breeding ranges. New contact zones develop, which trigger interbreeding between species, especially in the early stages of colonisation, when genuine partners are scant.

Some overlapping breeding ranges have existed for decades, leading to a 'hybrid swarm' in which first-generation hybrids and all kinds of backcrosses complicate the picture. Hybrids may look intermediate between the parent species, but occasionally they develop a divergent plumage. Herring × Glaucous Gulls on Iceland are an example of a hybrid pool (see the account on 'Viking Gull', p.306) in which some birds may appear surprisingly similar to another species (American Herring Gull).

Odd-looking gulls often raise the question: is this a 'pure bird' or is it a hybrid? The answer requires a thorough understanding of the individual variation in pure birds, as well as a general idea of what hybrids look like (preferably based on colour-ringed birds). It may be helpful to know that hybrids often show more than one odd feature, and that they are quite rare in most parts of Europe. Also, there is no shame in leaving a gull unidentified.

## Caspian × European Herring Gull

Caspian Gull has extended its range westwards in Central Europe, where it hybridises with Herring Gull—nowadays a regular hybrid combination in Europe. Photographs of ringed birds from the colony along the river Wizla in Poland and birds from East German colonies show that plumage details are often intermediate between the parent species. However, some birds may recall Yellow-legged Gull in first-cycle and second-cycle plumages.

First-cycle birds often look and sound like Caspian Gull but show some odd traits like deeply notched greater coverts and tertials (a Herring Gull trait), or dense streaking on the head (typical of Herring Gull). Other first cycles show the pale brown-grey plumage and bold anchor patterns on new scapulars typical of Herring Gull, but they combine these features with replaced wing coverts (rare in Herring, common in Caspian) and typical Caspian display call.

Second- and third-cycle hybrids may be recognised by a combination of the contrasting pattern on secondaries and tertials of Caspian Gull with the vermiculation on inner primaries, streaked head, and pale iris of Herring. Some birds combine a classic Caspian Gull bill, 'boa' on hindneck, and dark iris with Herring Gull greater covert pattern, and in this respect they may recall Yellow-legged Gull.

After more than two decades of interbreeding in central Poland and eastern Germany, the many backcrosses make it simply impossible to assign each individual, even ringed birds (since ringers do not always identify the parents). Odd-looking birds may better be left unidentified, since it may be impossible to decide if the odd bird is really a backcross or simply the product of individual variation in pure birds (which is often extensive).

Occasionally, Caspian Gull also hybridises with Yellow-legged Gull and with Lesser Black-backed Gull.

For more details on the identification of hybrids Caspian × Herring Gull, including a table for scoring multiple features, see Gibbins et al. 2011.

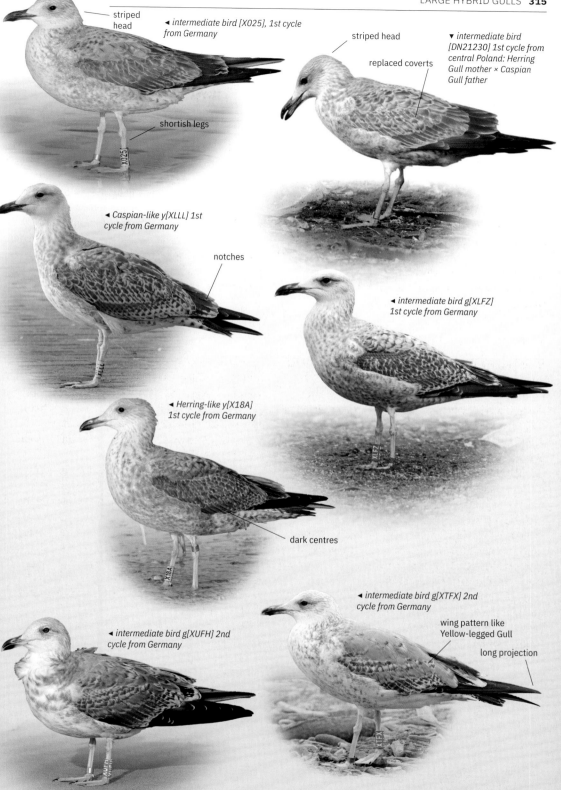

striped head

◄ *intermediate bird [X025], 1st cycle from Germany*

shortish legs

striped head

replaced coverts

▼ *intermediate bird [DN21230] 1st cycle from central Poland: Herring Gull mother × Caspian Gull father*

◄ *Caspian-like y[XLLL] 1st cycle from Germany*

notches

◄ *intermediate bird g[XLFZ] 1st cycle from Germany*

◄ *Herring-like y[X18A] 1st cycle from Germany*

dark centres

◄ *intermediate bird g[XTFX] 2nd cycle from Germany*

wing pattern like Yellow-legged Gull

long projection

◄ *intermediate bird g[XUFH] 2nd cycle from Germany*

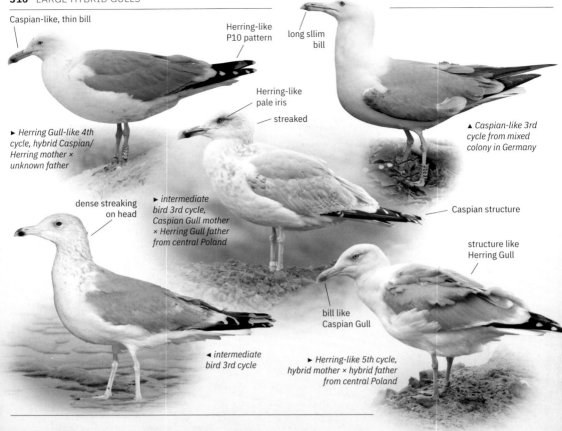

Caspian-like, thin bill

► Herring Gull-like 4th cycle, hybrid Caspian/ Herring mother × unknown father

Herring-like P10 pattern

long sllim bill

Herring-like pale iris

streaked

▲ Caspian-like 3rd cycle from mixed colony in Germany

dense streaking on head

► intermediate bird 3rd cycle, Caspian Gull mother × Herring Gull father from central Poland

Caspian structure

structure like Herring Gull

bill like Caspian Gull

◄ intermediate bird 3rd cycle

► Herring-like 5th cycle, hybrid mother × hybrid father from central Poland

# Lesser Black-backed × European Herring Gull or × Yellow-legged Gull

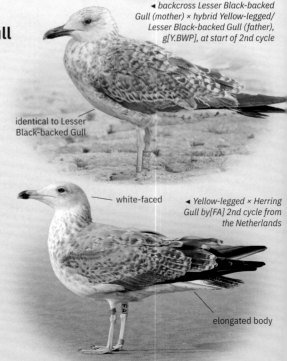

◄ backcross Lesser Black-backed Gull (mother) × hybrid Yellow-legged/ Lesser Black-backed Gull (father), g[Y.BWP], at start of 2nd cycle

Even though the breeding ranges of European Herring and Lesser Black-backed Gulls have overlapped for more than a century now, these species may still interbreed in long-established colonies. It may come as a surprise that they still form mixed couples while so many potential 'pure' partners are available.

From the early 1990s, Yellow-legged Gull rapidly extended its range northwards, but the increase has halted and the species has not colonised Northwest Europe. At the northern edges of its range, Yellow-legged Gull hybridises with both Herring and Lesser Black-backed Gulls.

Juvenile and immature hybrids are very hard to tell from 'pure' birds, as illustrated by the images here. Adult hybrids, however, can be recognised by colour of mantle and bare parts, primary pattern, broad white tertial edges, and broad white trailing edges on the wing.

identical to Lesser Black-backed Gull

white-faced

◄ Yellow-legged × Herring Gull by[FA] 2nd cycle from the Netherlands

elongated body

▼ *Yellow-legged × Lesser Black-backed Gull g[Y.BAM] adult from the Netherlands*

▼ *Yellow-legged × Herring Gull zy[M.T] 7th cycle from the Netherlands*

basically similar to a Yellow-legged Gull with less black on outer primaries

overall: like a pale Lesser Black-backed Gull

identical to Lesser Black-backed Gull; grey tone still within variation of that species

◄ *backcross Lesser Black-backed Gull (mother) × hybrid Yellow-legged/Lesser Black-backed Gull (father) g[Y.BWP] 4th cycle*

◄ *Herring × Yellow-legged Gull w[9.8] adult from the Netherlands*

intermediate grey

red orbital ring

◄ *Herring × Yellow-legged Gull b[1.E] adult from the Netherlands*

broad white crescent

## ▶ THE HYBRID ZONE IN CENTRAL RUSSIA

Ivanovo Oblast in Central Russia holds a wide zone of intergradation* of several large gull taxa (Caspian Gull, Steppe Gull, Heuglin's Gull, and hybrids/intergrades). These birds are migratory, and ringed birds from this area have been observed in the Middle East. They may resemble Caspian Gull, but with darker grey upperparts and streaked head. They may look like odd Steppe Gulls or exceptionally early moulting Heuglin's Gulls, but they show only limited black on the outer web of P8 (not reaching the primary coverts), a large mirror on P10 merging with the white tip, a large mirror on P9, or a long pale tongue on the underside of P10 (although more data

on the variability of the latter feature is needed in pure Heuglin's Gull).

A ringing program has started in this region, and it will be interesting to see the variation in plumage characteristics. For the moment, one should keep in mind the possibility that odd Caspian, Steppe or Heuglin's-like birds may be from an intergradation zone in Central Russia.

*\* See definition on p.110.*

# Bibliography

Adriaens, P., Alfrey, P., Gibbins, C. & López Velasco, D., 2020. Identification of Azores Gull. *Dutch Birding*, **42**(5):303–334.

Adriaens, P. & Gibbins, C., 2016. Identification of the *Larus canus* complex. *Dutch Birding*, **38**:1–64.

Adriaens, P. & Mactavish B., 2004. Identification of adult American Herring Gull. *Dutch Birding*, **26**:151–179.

Altenburg, R. G. M., Meulmeester, L., Muusse, M. J. M., Muusse, T. O. V. & Wolf, P. A., 2011. Field identification criteria for second calendar-year Baltic Gull. *Dutch Birding*, **33**:304–311.

Dunne, P. & Karlson, K. T., 2019. *Gulls Simplified: A Comparative Approach to Identification*. New Jersey, Princeton University Press.

Gibbins, C. & Garner, M., 2013. The in-between age of the in-between Gull: Identification of second-winter Thayer's Gull. Available online: http://www.gull-research. org/papers/papers5/cg_mg_identification-of-second-winter-thayers.pdf.

Gibbins, C., Neubauer, G. & Small, B. J., 2011. Identification of Caspian Gull, Part 2: Phenotypic variability and the field characteristics of hybrids. *British Birds*, **104**:702–742.

Gill, F., Donsker, D. & Rasmussen, P. (Eds). 2021. IOC World Bird List (v11.1). doi: 10.14344/IOC.ML.11.1

Grant, P. J., 1986. *Gulls: A Guide to Identification*. 2nd edition. Calton, Poyser.

Howell, S. N. G., 2010. *Molt in North American Birds*. New York, Houghton Mifflin Harcourt.

Howell, S. N. G., Corben, C., Pyle, P. & Rogers, D. I., 2003. The first basic problem: a review of molt and plumage homologies. *Condor*, **105**:635–653.

Howell, S. N. G. & Dunn, J. L., 2007. *Gulls of the Americas*. Boston & New York, Houghton Mifflin Harcourt.

Howell, S. N. G. & Elliott, M. T., 2001. Identification and variation of winter adult Thayer's Gulls with comments on taxonomy. *Alula*, **7**:13–144.

Howell, S. N. G. & Mactavish, B., 2003. Identification and variation of winter adult Kumlien's Gulls. *Alula*, **9**:2–15.

Jaramillo, A., 2020. Photo Salon: First-cycle Slaty-backed Gulls in Japan. *North American Birds* **71**(2): 24–37.

Johnsen, A., Rindal, E., Ericson, P. G. P. *et al.*, 2010. DNA barcoding of Scandinavian birds reveals divergent lineages in trans-Atlantic species. *Journal of Ornithology*, **151**:565–578.

Kwon, Y. S., Kim, J. H., Choe, J. C. & Park, Y. C., 2012. Low resolution of mitochondrial COI barcodes for identifying species of the genus *Larus* (Charadriiformes: Laridae). *Mitochondrial DNA*, **23**:2, 157–166.

Lonergan, P. & Mullarney, K., 2004. Identification of American Herring Gull in a western European context. *Dutch Birding* **26**: 1–35.

Muusse, M., Muusse, T., Buijs, R.-J., Altenburg, R., Gibbins, C. & Luijendijk B.-J., 2011. Phenotypic characteristics and moult commencement in breeding Dutch Herring Gulls *Larus argentatus* & Lesser Black-backed Gulls *L. fuscus*. *Seabird*, **24**:42–59.

Olsen, K. M., 2018. *Gulls of the World: A Photographic Guide*. London, Helm.

Olsen, K. M. & Larsson, H., 2004. *Gulls of Europe, Asia and North America*. London, Helm.

Pieplow, N., 2017. *Peterson Field Guide to Bird Sounds of Western North America*. New York, Houghton Mifflin Harcourt.

Rauste, V., 1999. Kennzeichen und Mauser von "Baltischen Heringsmöwen" *Larus* (*fuscus*) *fuscus* und "Tundramöwen" *L.* (*fuscus*) *heuglini*. *Limicola*, **13**:105–128 & 13:153–188.

Reyt, S. & Prunier, J. G., 2021. Ageing and plumage variation in Audouin's Gull. *Dutch Birding* **43**(2): 85–112.

Shirihai, H. & Svensson, L., 2018. *Handbook of Western Palearctic Birds. Passerines*. London, Bloomsbury.

Sonsthagen, S. A., Chesser, T., Bell, D. A. & Dove, C. J., 2012. Hybridization among Arctic White-headed Gulls (*Larus* spp.) obscures the genetic legacy of the Pleistocene. *Ecology and Evolution*, **2**(6):1278–1295.

Sternkopf, V., 2011. Molekulargenetische Untersuchung in der Gruppe der Möwen (Laridae) zur Erforschung der Verwandtschaftsbeziehungen und phylogeographischer Differenzierung – [Molecular analysis in gulls (Laridae) to reveal genetical relationship and phylogeographic differentiation]. Dissertation. University of Greifswald.

Stewart, P., 2006. The primary moult of the Lesser Black-backed Gull *L. fuscus*. Available online: http://gull-research.org/papers/LBBGUMoult.pdf.

Vigfúsdóttir, F., Pálsson S. & Ingólfsson A., 2008. Hybridization of Glaucous Gull (*Larus hyperboreus*) and Herring Gull (*Larus argentatus*) in Iceland: Mitochondrial and Microsatellite Data. *Philosophical Transactions of the Royal Society B*, **363**: 2851–2860.

Winters, R., 2006. Moult and plumage variation in immature Lesser Black-backed Gulls in the Netherlands. *Dutch Birding*, **28**:140–157.

Zink, R. M., Rohwer, S., Andreev, A. V. & Dittman, D. L., 1995. Trans-Beringia comparisons of mitochondrial DNA differentiation in birds. *Condor*, **97**:639–649.

# Photographic Credits

t: top; c: center; b: bottom; l: left; r: right.

**Alex Abela:** 22l, 99bc, 103br, 125tl, 125tr, 125c, 126tr, 126br, 127t, 127cl, 127cr, 127bl, 127br, 129tl, 129tr, 129c, 129bl, 129br, 132cr, 211tl, 211tr
**Peter Adriaens:** 8, 9tl, 9tr, 9br, 10t, 10c, 10bl, 10br , 11cl, 11cr, 11b, 15l, 15r, 16l, 16r, 17l, 17r, 22r, 23, 26r, 27tr, 27c, 28tl, 28tr, 28bl, 29tl, 29tr, 36l, 39bl, 41tl, 50tl, 52bl, 52br, 55tl, 55cb, 55bc, 56tc, 56bc, 56br, 68tl, 69r, 69c, 69b, 70tl, 71tl, 71tr, 71br, 78tl, 78bl, 78br, 79tl, 79c, 79bl, 79br, 80tl, 80c, 80tr, 80bl, 80br, 81t, 81c, 81br, 82tl, 82tr, 82b, 83tl, 84tr, 84br, 86bl, 86bct, 88, 89t, 89c, 89b, 90tl, 91tl, 91tr, 92tl, 92tr, 93tl, 93tr, 93bl, 93br, 94tl, 94b, 104, 105tl, 105tr, 105cl, 105cr, 106tl, 106tr, 106cr, 106bl, 106br, 107tl, 107tr, 108c, 108b, 109tl, 109tr, 109cl, 109cr, 109br, 111t, 111ctl, 111ctr, 111bcr, 111br, 112, 113tl, 113tr, 113cl, 113b, 114tl, 114tr, 114cl, 114cr, 114bl, 114br, 115tl, 115tr, 115c, 115bl, 115br, 117tl, 117tr, 117cl, 117cr, 117bcl, 117tl, 117br, 119tl, 119bl, 119br, 120tr, 120bl, 120br, 121tl, 121cl, 121cr, 121 bl, 121br, 123tl, 123tr, 123cl, 123bl, 128r, 132br, 138c, 138b, 154tr, 158tl, 160tl, 160tr, 160bl, 160br, 161tl, 161tr, 161bl, 161br, 162tl, 162tr, 162c, 162bl, 162br, 163tl, 163tr, 163cl, 163cr, 163bl, 163br, 164, 165tl, 165cl, 165c, 165cr, 165br, 167tl, 167tr, 167cl, 167cr, 167bl, 167br, 170tr, 170br, 172tl, 172cl, 172cr, 172br, 177br, 180 (tout sauf 180t), 181tl, 181tr, 181tc, 181cl, 181b, 182tr, 182c, 182br, 183l, 183r, 184t, 184c, 184b, 185tr, 185cl, 186tl, 186c, 187tl, 187tr, 189tl, 189tr, 189tc, 189cl, 189c, 189cr, 189bl, 189br, 190tl, 190tr, 191tl, 191cl, 191cr, 192tl, 192tr, 192b, 193tl, 193tr, 193cbr, 193br, 194, 195tl, 195tr, 195ctr, 195cbl, 195cbr, 195bl, 195br, 207tr, 207cr, 215bl, 217cbr, 218bl, 218br, 219tr, 221tl, 221c, 222ctl, 222ctr, 222cbl, 223t, 223cl, 223cr, 223b, 225tr, 225br, 226l, 227bl, 228ctr, 231cbr, 233cb, 233b, 234r, 235cr, 236l, 236r, 237tl, 237bl, 238cl, 238cr, 238bl, 238br, 239tl, 239tr, 239br, 240tl, 240ctr, 240cbr, 240bl, 241tl, 241tr, 241cr, 241bl, 241br, 242tl, 242tr, 242bl, 242br, 243tl, 243tb, 243bl, 243br, 244l, 245cr, 245br, 246, 248cbr, 248bl, 248br, 249t, 249b, 250t, 250c, 250b, 251tl, 251tr, 251ctl, 251ctr, 251cbl, 251cbr, 253t, 255tl, 256, 257tl, 257tr, 257bl, 257br, 258tl, 258tr, 258bl, 259br, 260tl, 260cl, 260cr, 260bl, 260br, 261tl, 261tr, 261cr, 261bl, 261br, 262r, 263tr, 263tc, 263cr, 263bl, 263br, 265tl, 265tr, 265c, 265b, 267tl, 267tr, 267cl, 267cr, 267bl, 267br, 268tl, 268tr, 268ctl, 268ctr, 268cbl, 268cbr, 268bl, 268br, 269l, 269r, 270t, 270b, 271tl, 271tr, 271ctl, 271ctr, 271c, 271bl, 271br, 272, 273t, 273ctl, 273ctr, 273cbl, 273cbr, 273bl, 273br, 299cbl, 299tr, 299bl, 299bc, 299tr, 301tl, 301cl, 301bl, 301br, 303tr, 303ctr, 303cbr, 305tr, 305br, 306l, 306r, 307tl, 307tr, 307c, 307bl, 307br, 308tl, 308tr, 308bl, 309tl, 309tr, 309br, 310tl, 310tr, 310bl, 310br, 311tl, 311tr, 311bl, 311br, 313tl, 313bl, 313br
**Ross Ahmed:** 141b, 299tl
**Asier Aldalur:** 237br, 245tl, 245tr, 245cl, 245bl
**Tormod Amundsen:** 169tr
**Steve Arena:** 43cr, 45b, 46tl, 55cr, 62, 69tl, 70bl, 73br, 74tr, 186tr, 240br, 264r
**Akimichi Ariga:** 125bcr
**Aurélien Audevard:** 38tr, 38br, 39tl, 39tr, 39c, 39br, 40t, 40cl, 40cr, 40bl, 40br, 41c, 41b, 68bl, 172cl, 173bl, 173br
**Amar Ayyash:** 42tl, 43b, 45tl, 45tr, 45cl, 70tr, 70br, 72bl, 73cr, 74tl, 75t, 76t, 77b, 207tl, 209tl, 209bl, 211cl, 213tl, 213tr, 213ctl, 214c, 215tr, 215cl, 218cl, 218cr, 222bl, 225cl, 225bl
**Renato Bagarrao:** 135bl
**Carl Baggott:** 54, 187bl, 247tl, 275br
**Amir Ben Dov:** 120tc, 135tl, 135tr, 136t, 137c, 139tl, 139b, 140l, 140r, 158bl, 257cr, 258bl, 259tl, 259tr, 259cl, 259cr, 259bl, 262l, 263tl, 263cl, 278tr, 282r, 283tl, 283tr, 283ctl, 283ctr, 285tl, 285b, 288r, 291t, 291bc, 292tl, 297tl, 305cbr

**Tom Benson:** 73tr, 73bl
**Richard Bonser:** 58bl, 176bl, 237tr, 239bl, 240ctl
**Jan-Kees Bossenbroek:** 31c
**Phil Boswell:** 91bl
**Bernard Bougeard:** 32, 72tr, 72br, 181cr
**Andreas Buchheim:** 31tr, 159tr
**Pierre Cabard:** 36c
**Andrew Cannizzaro:** 207br
**Ekaterina Chernetsova:** 59c
**Pierre Crouzier:** 63t
**Alan Curry:** 170bl, 186bl
**Diederik D'Hert:** 30t
**Edouard Dansette:** 27tl, 27br, 28cl, 36r, 37bl, 44br, 58l, 59tl, 63c, 137br
**Douwe de Boer:** 57bl
**Armin Deutsch:** 315tr, 315cr, 315cb, 316tl, 316tc, 316cr
**Ken Drozd:** 64t, 64b, 66tl
**Daan Drukker:** 238tc, 239tr
**Philippe J. Dubois:** 34t, 34cl, 34b, 35bl, 37cr, 50c, 51tr, 51c, 52tc, 53tl, 65br, 74br, 138tr, 185bl, 185br
**Paul Dufour:** 133br, 168bl
**Alix d'Entremont:** 209tr, 209br, 213ctr
**Marcin Faber:** 303bl
**Guy Flohart:** 185cr
**Claude Gaillemin:** 135bl
**Salvador García:** 134
**Chris Gibbins:** 46tr, 47tl, 47tr, 47cl, 47cr, 48tl, 48tr, 48bc, 49tl, 49tr, 49c, 49bl, 49br, 55tr, 56tr, 84tl, 84bl, 85tl, 85tr, 85bl, 85br, 86tl, 86tr, 87l, 87c, 87r, 90tr, 92bl, 95tl, 95br, 97t, 97b, 106cl, 110, 111cbl, 131l, 131r, 132tl, 132bl, 133tr, 133c, 133bl, 139cl, 139cr, 150l, 150r, 151t, 151cl, 151cr, 151b, 152tl, 152tc, 152tr, 153t, 153c, 153b, 154tl, 154cl, 154bl, 155tl, 155tr, 155tc, 155cl, 155cr, 155b, 156l, 156r, 157tl, 157tr, 157cl, 157cr, 157b, 158tl, 158c, 159tl, 159b, 171tl, 171tr, 171cl, 171bl, 175cr, 176t, 178t, 178br, 180t, 182tl, 182bl, 187br, 198bl, 216, 217tr, 217ct, 217b, 219tl, 219c, 219bl, 219br, 220t, 220b, 221tr, 221bl, 221br, 222tl, 223bl, 223br, 224tl, 225tl, 227br, 228tc, 228br, 231ctr, 232t, 248cbl, 274t, 283bl, 283br, 290r, 291cl, 291cr, 291br, 292tl, 292br, 293tl, 293tr, 293ctl, 293ctr, 295tr, 296tl, 296tr, 296c, 296bc, 299t, 299tc, 299tr, 300tr, 302l, 302r, 303ctl, 304b
**Thijs Glastra:** 172bl, 173t
**Julien Gonin:** 26l
**Karl-Johan Granholm:** 66tc
**Lee Gregory:** 55bl, 57tl
**Mohamed Habib:** 92bl, 96
**Rob Halff:** 169b
**Pieter Hilgeman:** 58l
**Alain Hofmans:** 37cl, 37br
**Franck Hollander:** 77t, 77c
**Frits Hoogeveen:** 37tr
**Petteri Hytönen:** 95tr, 95bl, 97c, 304tr, 305cbl, 305bl
**Fabrice Jallu:** 42tr, 51tl, 59br, 60c, 60b, 61tl, 61tr, 61bl, 61bc, 61br, 66tr, 66c, 66bc
**Wietze Janse:** 55cl
**Frédéric Jiguet:** 38c, 130, 313tr
**Dave Johnson:** 73cl
**James Kennerley:** 305ctl
**Juho Könönen:** 152ct, 152cr
**Keisuke Kirihara:** 86bcb
**Marcel Klootwijk:** 178cr